VIEIRA DA SILVA

VIEIRA DA SILVA

BY JACQUES LASSAIGNE AND GUY WEELEN

Rizzoli
NEW YORK

Published in the United States of America
in 1979 by:

*R*IZZOLI *INTERNATIONAL PUBLICATIONS, INC.*
712 Fifth Avenue/ New York 10019

French-language edition:
© *1978 by Ediciones Polígrafa, S. A. - Barcelona (Spain)*
and Éditions Cercle d'Art - Paris

Translated by John Shepley

Library of Congress Catalog Card Number: 78-57909
ISBN 0-8478-0191-8

CONTENTS

TEXT BY GUY WEELEN

TEXT BY JACQUES LASSAIGNE

QUOTATIONS: Paul Klee, page 7; Roger Caillois, page 10; Vera Linhartova, page 44; Colette, page 48; Pierre Descargues, page 50; Rainer Maria Rilke, page 57; Erasmus, page 72; Marcel Proust, page 74; Fountain of the Lions, the Alhambra, page 76; Solzhenitsyn, page 78; Pierre Reverdy, page 83; Christopher Smart, page 92; Vieira da Silva, page 96; Descartes, page 97.

There are two mountains / where it is bright and clear;
The mountain of beasts / and the mountain of the gods.
But between them lies / the dark valley of men.
When one of them once / looks up to the heights,
An irrepressible regret / grips him as an omen,
He who knows / that he does not know.
For those who do not know / that they do not know
And for those / who know that they know.

Paul Klee

1. Chambord. Lantern of the château.

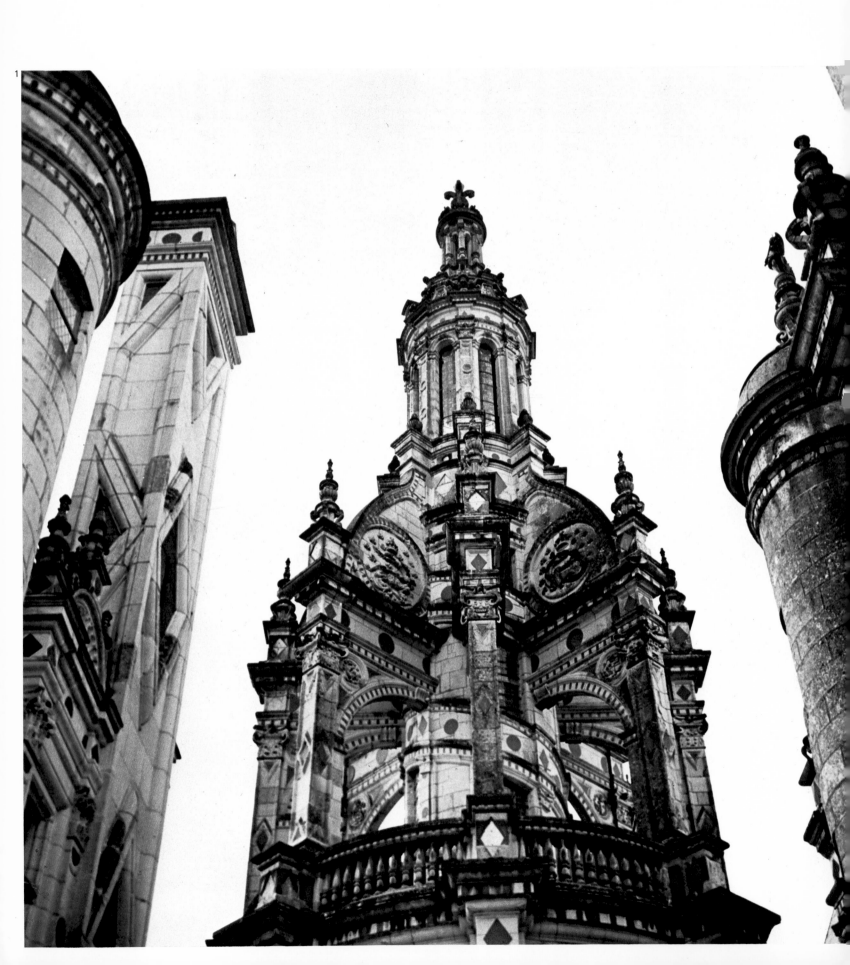

2. Cathedral of Angers. Nave. Window of right transept.

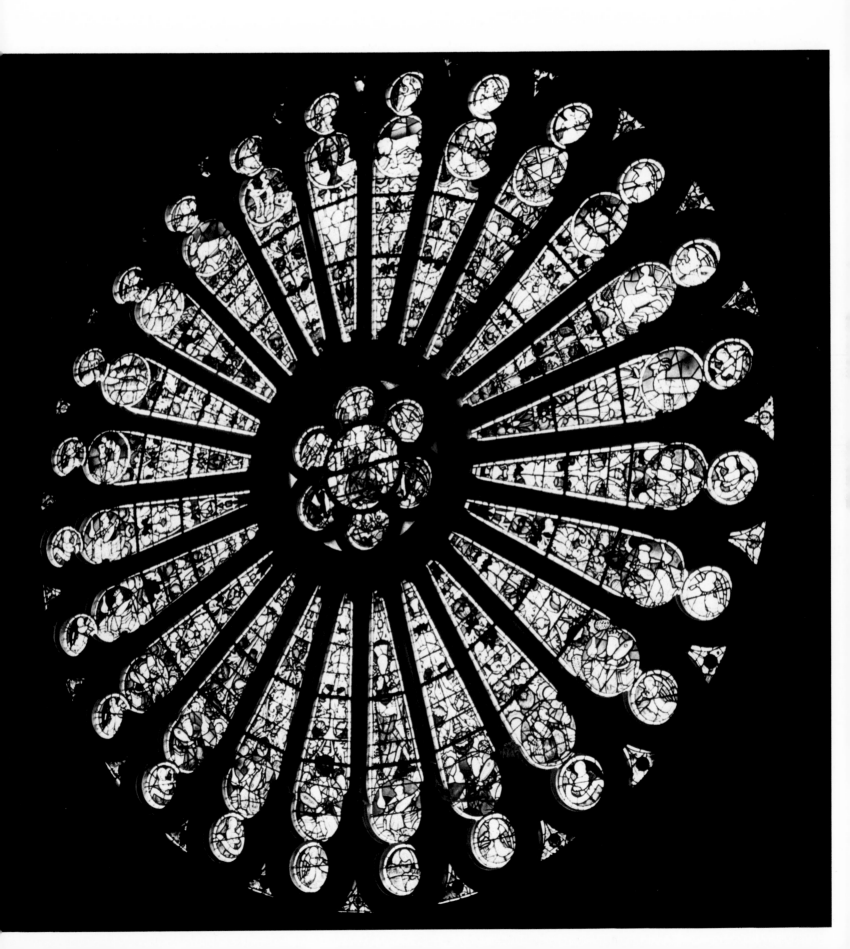

"Architecture and nature appear in frequent symbiosis. In houses, the flowered carpet on which the table and chairs stand is a veritable parterre where genuine vegetation sprouts. In a forest, the trees end in Gothic vaults. The ground is covered with moss and brambles, with primroses. On the trunks one sees the bark and the line of the missing boughs, then the branches spread in almost regular ribs that meet to form pointed arches. They scarcely betray any longer their plant origin. Other times, the trees have developed a gigantic architecture à la Piranesi; a colossal task of carpentry has created causeways between the trunks that make it possible to pass from one to another, bridges whose daring arches straddle the void, an interlacing of diverse paths that all seem cut from the living wood, as if the multitude of trees had become only one."

Roger Caillois
Inventaire d'un Monde
N.R.F. No. 204. Gallimard

Travel

Contradiction is a live spring. For restless Vieira da Silva, the studio is her place *par excellence.* It is also her shell. Nothing prompts her to leave it. Everything keeps her at home, and most of the trips she has undertaken were made out of necessity or fatigue. One cannot always say no. On the other hand, she likes excursions. Those little one-day trips for which she doesn't need a suitcase. She likes to make discoveries, but it is with renewed joy that she takes the old routes back. She stakes them out, sees them again, foresees them, and from a distance of years she locates once more her selected and preferred point of view; she is amazed by, regrets, or marvels at the changes brought by time. She is afraid of roads, the train is restful. For the splendors of seas of clouds she prefers the airplane.

Against long trips Vieira da Silva has careful objections to set forth. First of all: they break the harmony of work, of the days devoted to painting. But also, because of their multiple incidents, they destroy that inner silence that is always so difficult to attain. In order to find the mechanisms again, one has to rewind them, to oil them once more. They are too delicate, too painful to handle. Therefore the best solution would be never to stir from one place: the Studio. Isn't it true that familiar, protected surroundings offer an always different world? Everyone knows it is impossible to bathe twice in the same water in the same river.

Second: whatever hinders her need to paint gnaws at her conscience and her sense of duty toward painting.

She is very demanding and accepts no compromises, no accommodations. The spontaneous, elementary impulse is to discard anything that comes to distract her or deflect her from the path that leads her to her easel.

Third: it is a fact that Vieira da Silva, surprising as it may seem, is lazy. That is the term she uses. She should not be taken literally. Rather it is "meticulous" that we should suppose her to mean. Each thing must fit with precision. Each detail counts, must be elaborated and find its exact position. It is a slow, subtle progression, complicating each decision and adding weight to each action. Webs of conflicting tendencies, of equal forces that tend to cancel each other out and leave the mind uncertain as to the decision to be taken. So many victories to win before glimpsing the solution means a series of trials so wearing that in the end

3. Hastings (England). The theater and the pier at the beginning of the century.

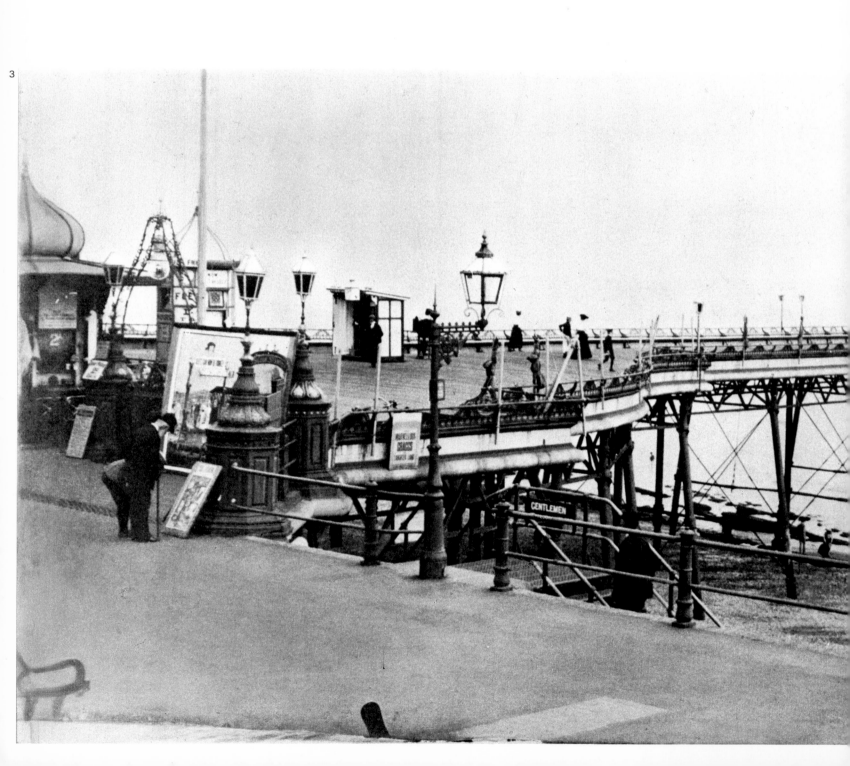

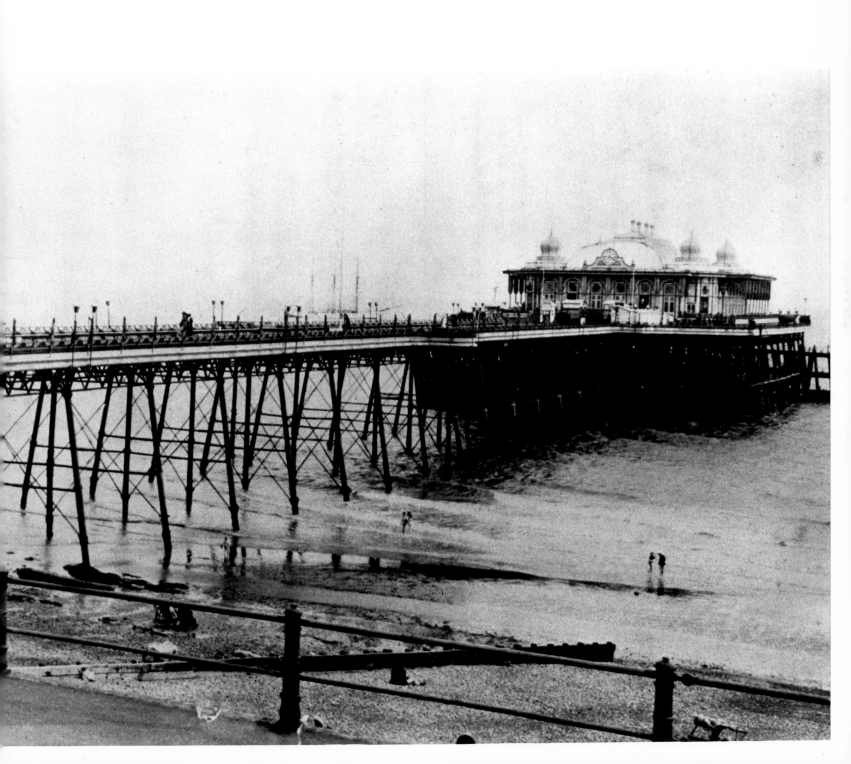

irresolution becomes a painful, even cruel state with which a new battle must still be fought. It is too much.

The fourth, finally, would be (and the fact has been verified): Vieira da Silva does not have to go to the spot in order to know. Perhaps she even sees better before being there, so as not to see any longer when she is.

Thus, geography: we are dealing here with something problematical, a hypothetical geography. Certainly in the eyes of the historian these trips have been made, lived. Certainly, in the years indicated, Vieira da Silva stayed in those various places. But was she really there, or was she elsewhere? Elsewhere, one could wager.

Here is the profound reason that makes her a citizen of the world, and explains her hatred of frontiers, customs, passports. Rather than to the earth Vieira da Silva is attached to light, to the light she finds on the Atlantic coasts of both Portugal and Brittany, the light of the canals of Holland, of the wide estuaries of the Schelde, the Tagus, or the Seine, the light of Paris, the light that rims the roofs of Florence or Lisbon. That silvery light that keeps the eye awake, which one experiences for an instant when the sky is gray, which the eye feasts on, a cloud dispels, and whose return is anxiously awaited. That light for which the heart remains nostalgic and whose sudden absence traces a line of sadness in the face. That very light that over the years ricochets under her hand from one painting to another.

But it is not a simple map that these images compose. Green of the meadows, yellow of the sands, dotted lines for the frontiers, blue of the rivers and seas. These are only signs to soothe the imagination, to provide beacons for the wanderings of reverie. There is another geography, that of the active gaze. Vast itineraries with hazardous encounters. Subterranean networks, links established between contradictions, unexpected analogies. Abrupt changes along the way to cover the tracks, sudden stops to knot or unravel new entanglements. These images — sought, joined, then mounted like a film — tell other possible stories. It would be naive to think them descriptive, to give them the simple meaning of relays or stations. They may be things seen, they are things that are possible, or dreamed. But they exist only as seized by the imagination, which draws from them all the combi-

4. Reclining tomb figures. Batalha (Portugal).

nations they contain. Thus none of them can be safely chosen.

Finally, Vieira da Silva likes remoteness. It is at a distance that she sees, that she may hear. There is a "hidden dimension" there that she has invented for her own use, and which has to do with both the Great Wall of China and with territory. There she walks, there she often locks herself in, to emerge suddenly and capture a moment, like an eagle swooping on its prey and returning with a stroke of its wings to the entangled brushwood of its aerie.

16

5. Basel. Spalentor.

Switzerland

For this little girl born in Lisbon, the most distant memories lie in Switzerland: snow in abundance, swirls of it through branches powdered with sugar crystals, screech of ice skates, shouts, laughter, prickling needles of frost, games, toboggans... This whiteness-memory? One may ask oneself the question, but attractions and reflections also appear very early in her work (1930). It was here too that she first encountered death, the cruel snowman.

Then much later, the painter's return, this time for exhibitions. Basel, Bern, Geneva, Lausanne, Zürich, for the institutions and collectors of this country welcomed her painting very soon. Several times to Basel, where the execution of the embroidered tapestries for the University required her presence. Finally Lausanne — the first museum outside France after the war to express its confidence in her, by acquiring *The Hanging City.*

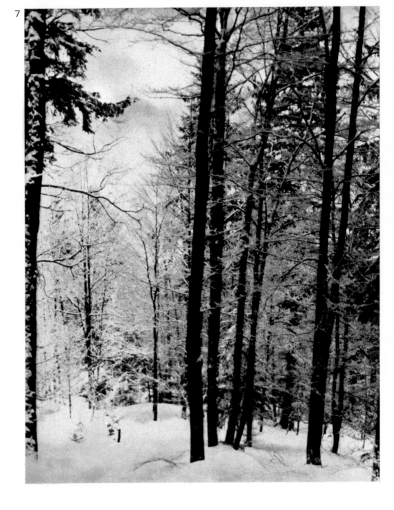

18

Portugal

Vieira da Silva's first years were restless ones. With her father and mother she went everywhere: France, England, Switzerland. For a long time Portugal had been suffering from political instability. There was unrest in the countryside, then in Lisbon. Clashes broke out here and there, occasionally giving rise to violent riots. Monarchists and republicans confronted each other. In the center of the city where she then resided, she lived in an apartment with closed shutters, listening to the tumult in the street, to the sound of bullets. Long, slow hours when conflicting news brought anxiety and uncertainty. Then, once the rumors were quieted, fear and epidemics gripped the city.

Whenever Vieira da Silva recalls those troubled times, in seeking her deepest impressions, she may say: "I lived uprooted, without however being so. Of course, I had a house in Lisbon, I had a family, perhaps even habits, but I could never know what the next day would bring me." Plans were impossible. If by chance she still made some, an unforeseen event, a new departure would come to upset or cancel them. To this insidiously felt uncertainty were added those sounds of earthquakes, those tremors, those prophetic precursors of disasters that were always possible

to imagine: imperceptible cracks, displaced objects, the clinking of chandeliers. Then death: every day the news of it came, and in the afternoon another alarm. It knocked with hasty taps at almost every door. Faces furtively glimpsed one day in the drawing room of the dark apartment, friends of the family, little girl friend or distant relative, still others struck by fever, disease, but some of them killed. Voices and gestures lost, friendships hardly born and broken at once, sheared memories. Tomorrow took the form of a suspended interrogation.

Heavy atmosphere, stuffed with emotions, with tensions, heavy, very heavy for a little girl. This weight seems to have been very heavy since it still exists today. Why then should we be surprised at the seriousness, the gravity she lent to all her acts, all her activities? The smallest thing had to be studied attentively in order to discover its secrets. Each thing had its consequences. Any decision had to be ripened slowly. There was nothing that might not have profound echoes demanding to be understood and unfailingly taken up. Why should we be surprised at this suffocating feeling of solitude? A solitude vast as an ocean, where the white sails of laughter and mischief,

8. The Siren. 1935. Poem by Camoëns. Oil on wood, 30×61 cm. Private collection, Paris.

"Onde pode acolher-se um fraco humano,
Onde terá segura á curta vida,
Que nao se arme e se indigne o céu sereno
Contra um bicho da terra tao pequeno."

Camoëns

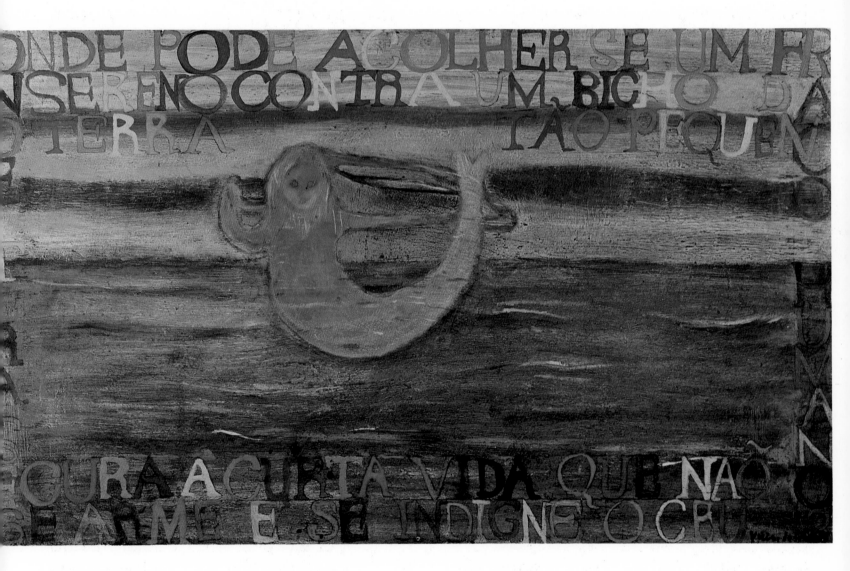

the foaming wake of forgetfulness, of joy gathered in the light of the sunlit moment, too seldom appeared.

These political changes did not disturb the family setting. At the end of the nineteenth century, her maternal grandfather had founded the newspaper *O Seculo,* liberal in tendency, whose ideas and attitudes were to act as a link between the two regimes.

Soon she left again. Her sick father died in Leysin. New travels: London,

where she recalls having visited the museums with her aunt, but mostly Hastings. For her, a shining event: a performance of *A Midsummer Night's Dream* at the theater on the pier. The strangeness of the place, this fixed ship, this theater on the waves, the enchantment of it; everything was superb, everything was even too beautiful for this wide-eyed little girl. From then on she was watched over every day by Oberon, Titania and Puck.

In 1913, she returned to Portugal. She left it in 1928, sure of her choices, determined. Lisbon, Sintra — Portugal remains one of the pivots of her imagination. Her memory is full of it, her eyes nourished by it. In order to work there in silence and solitude, in order to see her mother who lived there until 1957, she has often gone back.

She has been rather slow in taking the time to visit it. If for several years now Portugal has finally realized that in Vieira da Silva it has a great painter, it took it a long time to believe it. Of course, a few faithful friends, a few poets, a few artists had known it for some time, but her enterprise was disconcerting, seemed too strange, even bizarre. It was perceived as an attempt to dissolve social relations that ought to be maintained at all costs.

Dangerous and disquieting, her generous way of presenting the world met with a careful silence at the very least, sometimes with the acrimony of those condemned to immobility.

Portugal is present in her painting in many ways: the glorified harmony of blue and white; the imperative manner of encircling a form that she perceives in the architecture of the Alentejo; the meditation on the square for which the azulejo may be the germ; the trembling light that she discovered as a child on the beaches of the Atlantic; the trapped perspective of which Lisbon, a city built on seven hills and often ravaged by earthquakes, bears the traces; the feeling of motion under its apparent fixity — again like Lisbon, which, spread along the banks of the Tagus, all seems to be drifting away toward the high seas.

In truth, however, Vieira da Silva has no other homeland but painting. And the signs she invents, her plastic language and syntax, belong to all. Profoundly, amicably, they are meant for all.

9. Contributors to the newspapers *O Seculo* and *A Epoca*.
10. Unrest at the time of the establishment of the Republic of Portugal. Lisbon around 1910.
11. Establishment of the Constitution of 1911. A voting table installed in a church.
12. Lisbon. Belém. Interior of the church of the Hieronymites.
13. Casa dos Bicos. Lisbon.

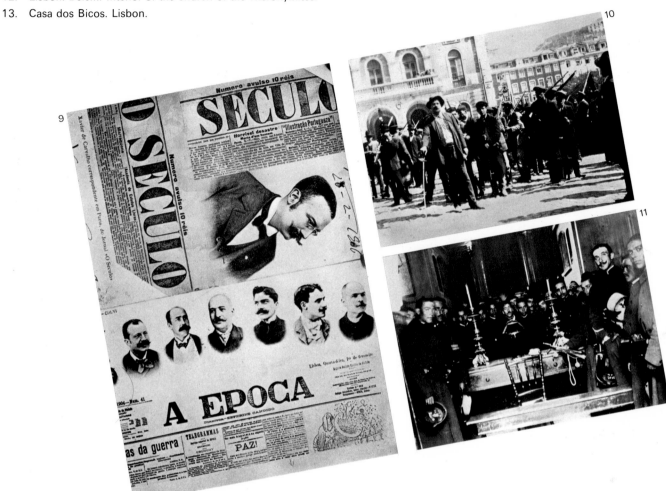

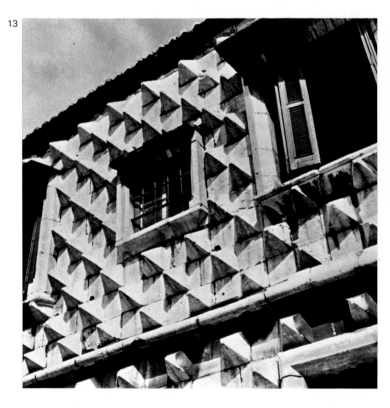

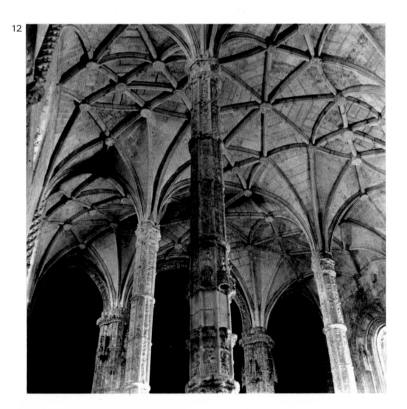

14. Lisbon. Rua Augusta.

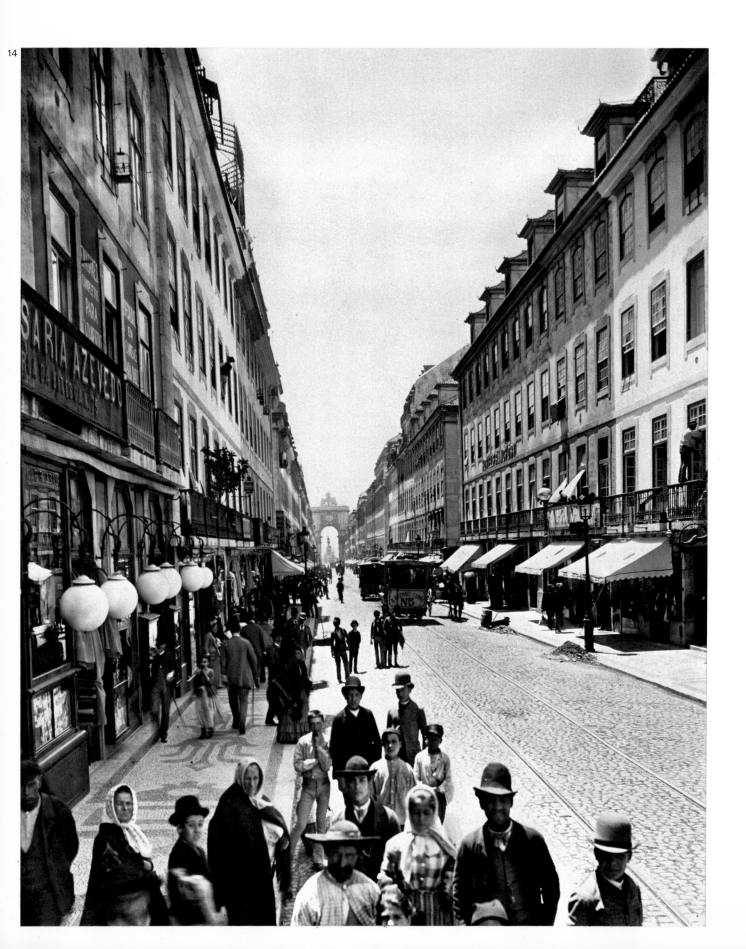

15. Windows. Lisbon.

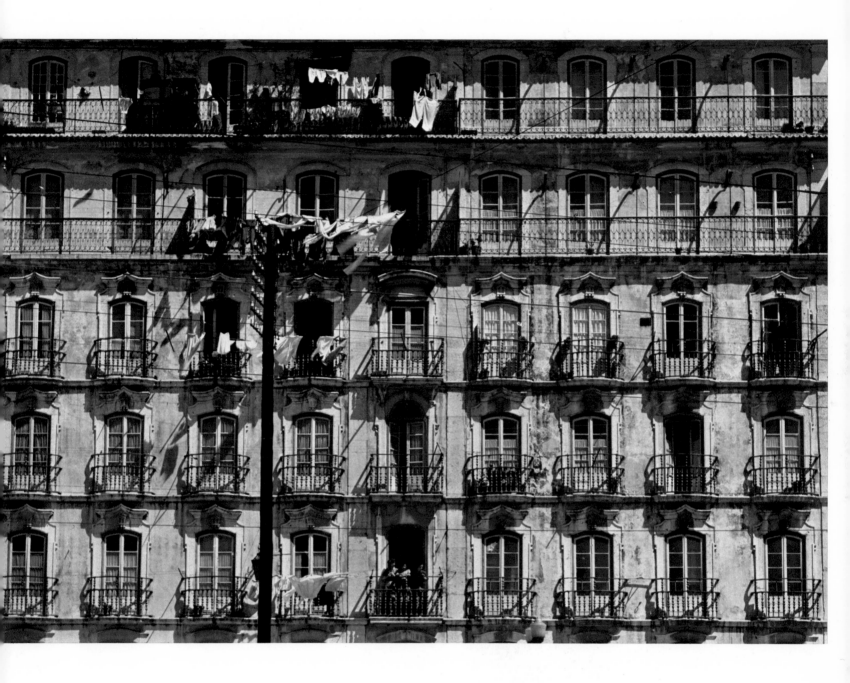

16. Vieira da Silva, Arpad Szenes, the poet Mário Cesariny, and the painter Manuel Cargaleiro. Portugal, 1962.
17. Praça Pedro IV. View from above. Lisbon.
18. Wharf on the Tagus. Lisbon.
19. Aqueducto des Aguas Livres. Lisbon.

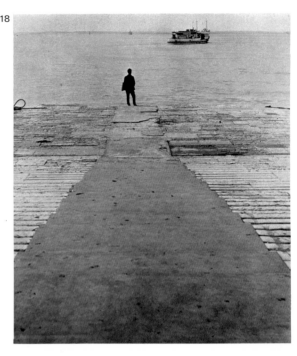

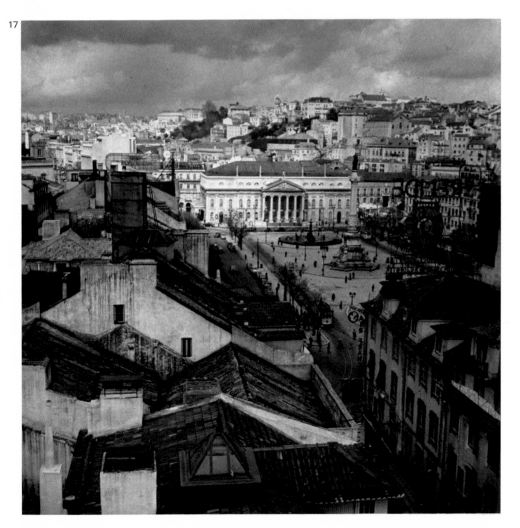

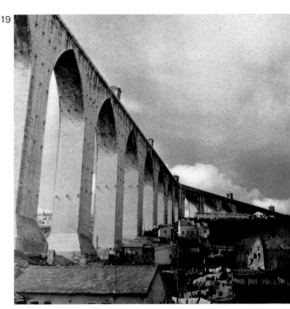

20. A street in Lisbon.

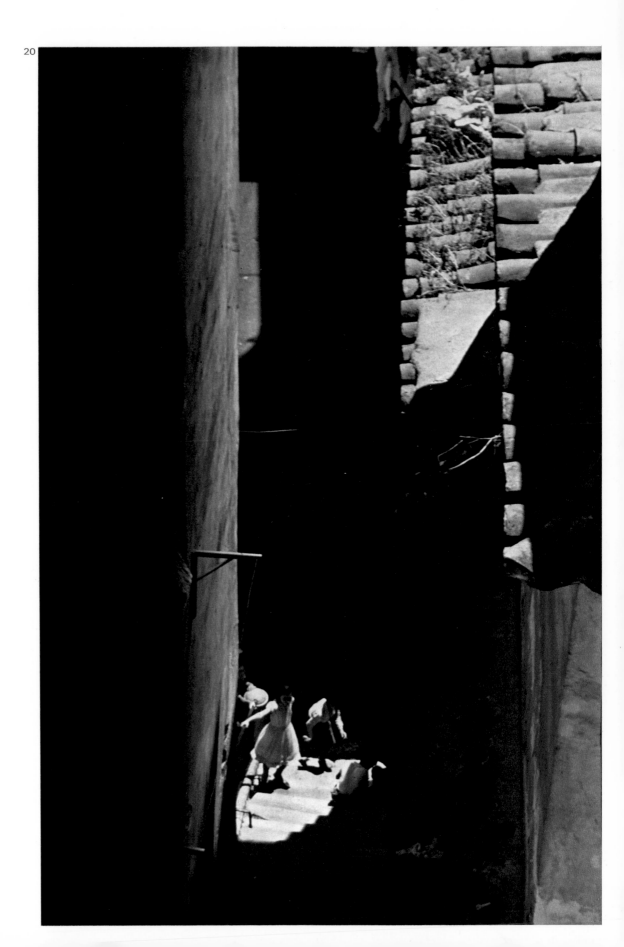

21. Studio. Lisbon, 1962.
22. Studio. Lisbon.
23. Praça das Amoreiras. Lisbon.
24. Studio. Lisbon.

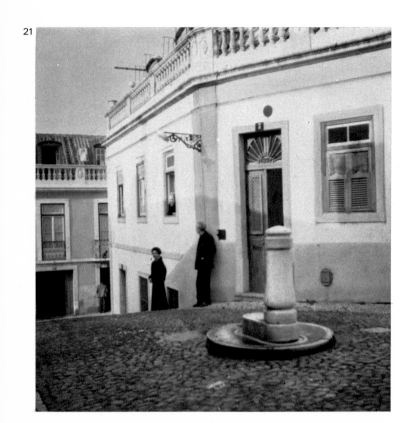

25. Nazaré (Portugal).

26. Evora. Fountain in the courtyard of the University.

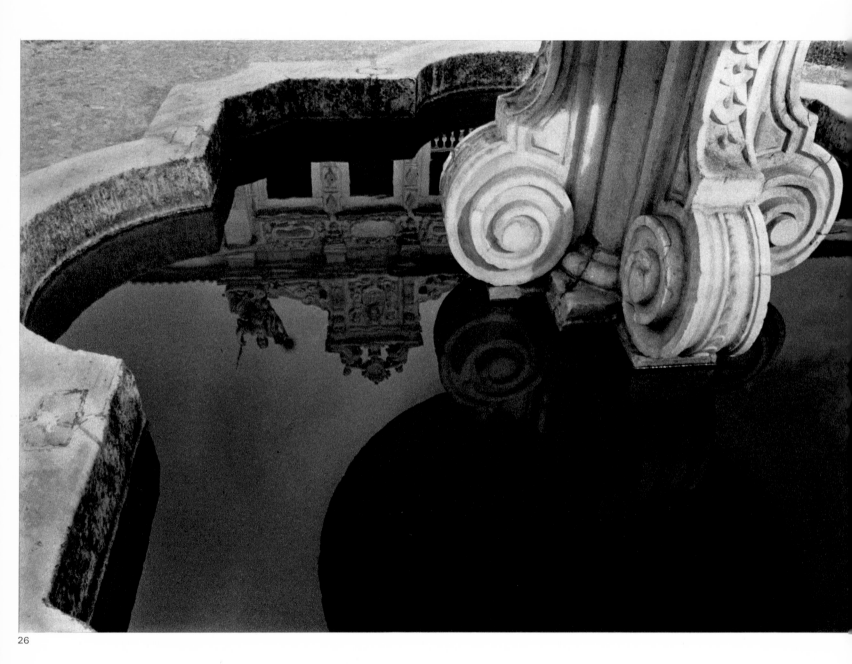

27. Fountain near Arraiolos.

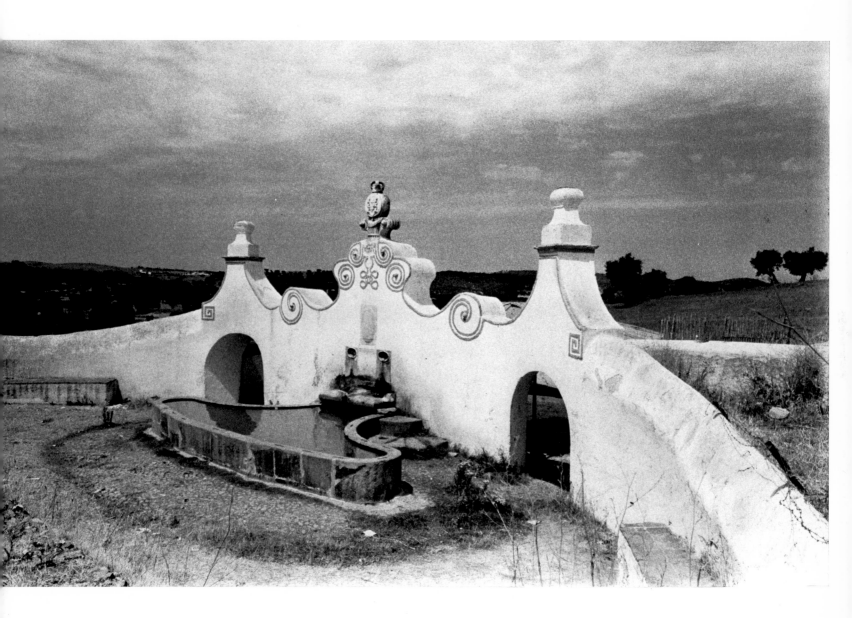

28. Algarve. Tavira.
29. Vault, balcony, and azulejos. Obidos (Portugal).
30. Oporto (Portugal).
31. Oporto (Portugal).
32. Vieira and Arpad With Maria de Conceição Homen. Portugal, 1958.

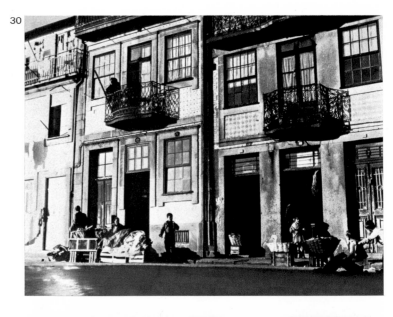

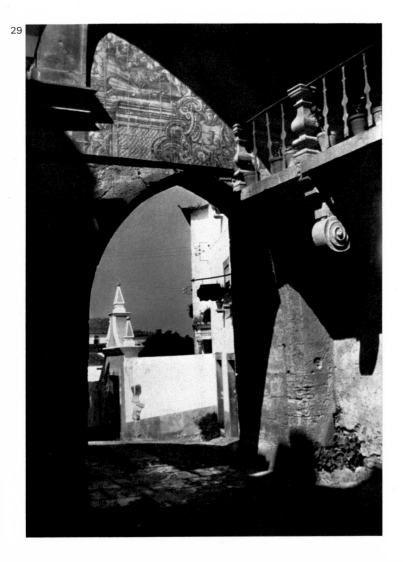

33. Evora. University courtyard.
34. Sintra. 1958.

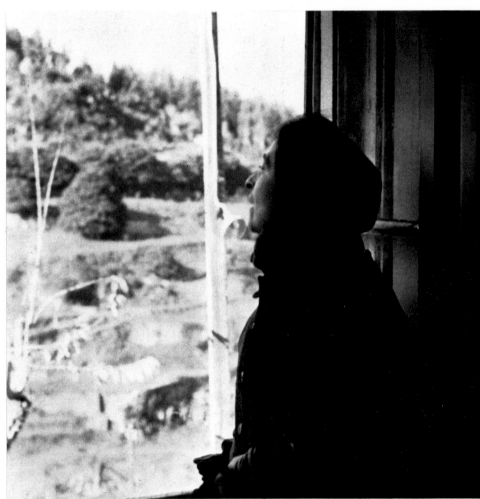

34

32

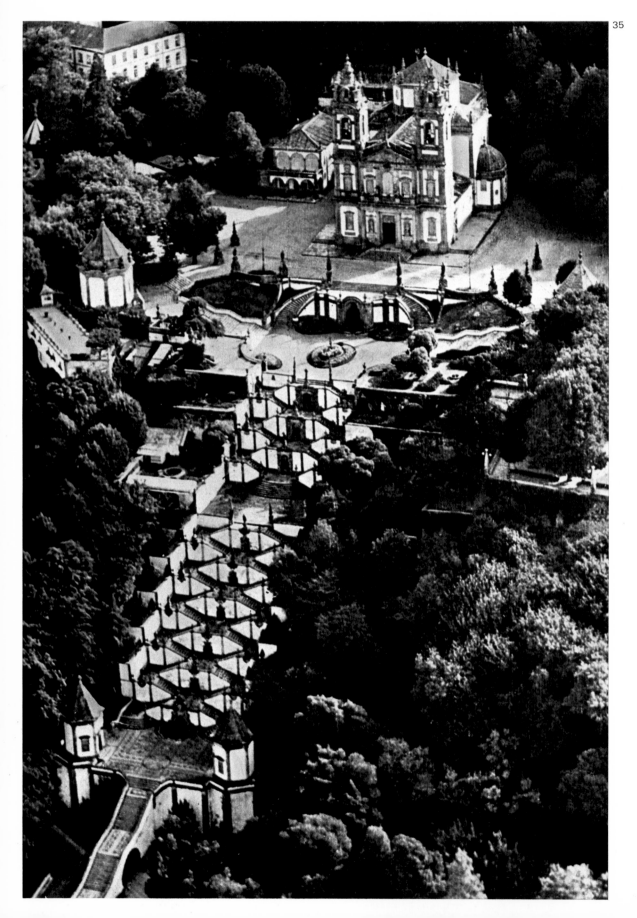

35

36. Alcobaça. Side nave of the Santa Maria monastery. 12th century.

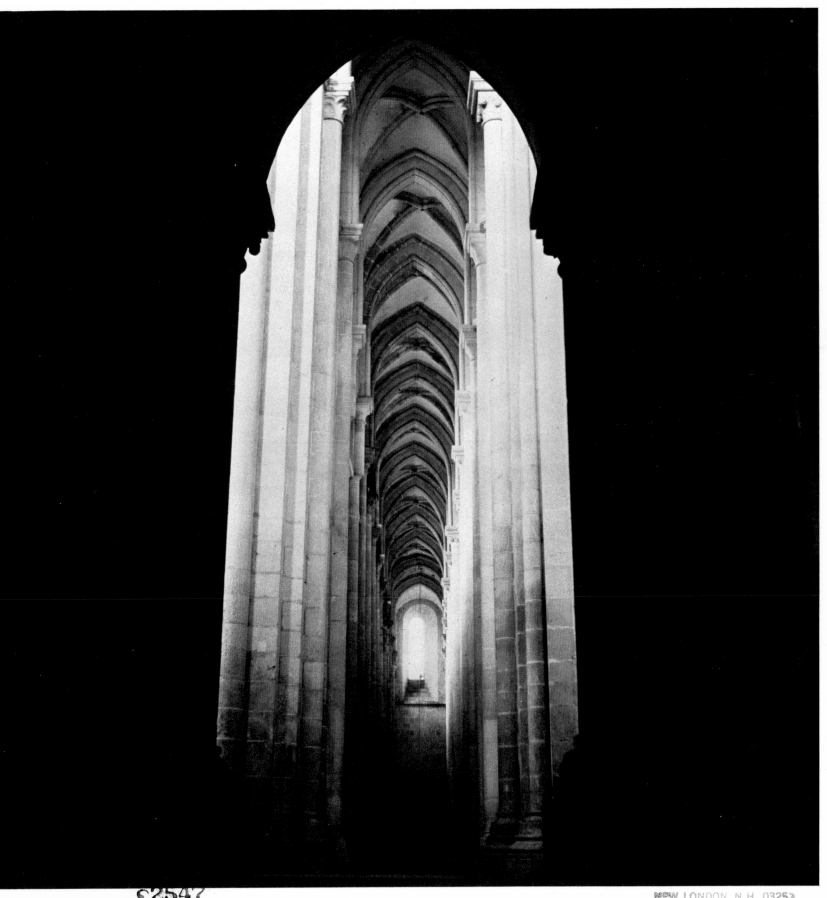

37. Castelejo beach. Algarve.
38. Salt marshes. Northern Portugal.
39. Salt marshes. Northern Portugal.
40. Nets drying at Camara de Lobos. Madeira.
41. Nets on the beach.

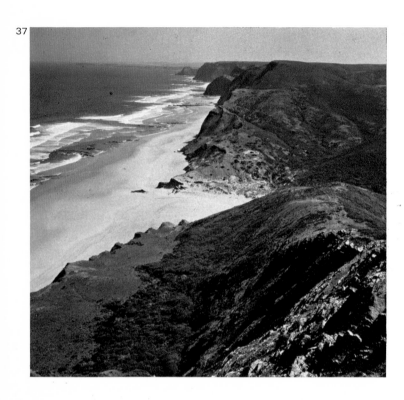

42. Boats at Nazaré.

42

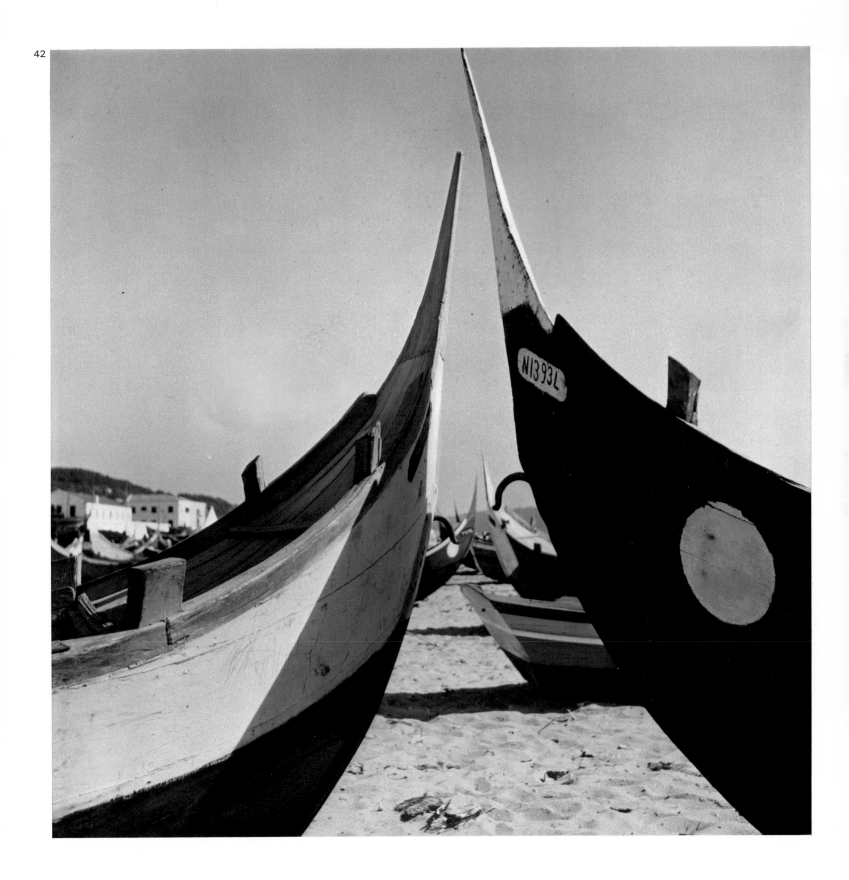

Azulejos

The word is probably of Arabic origin. It can also be written in the singular; nevertheless this small decorated ceramic square is thought of in the plural. Originally from Andalusia or the Levant, they were used in Portugal as early as the fifteenth century for interior and exterior decoration. When in the eighteenth century the Marquis of Pombal encouraged the Portuguese industry, its use spread; the mystical marriage of blue and white prevailed. Then a real tidal wave occurred. Azulejos climbed over all surfaces. Prolific plants, they insinuated themselves and invaded all the walls, mounted with the stairs, turned in the galleries. They burgeoned in obscure corners, flourished in the most unexpected, least frequented recesses. Geometric designs, luxuriant intertwinings, floral or animal motifs — all the garlands were exploited. They are a feast for the eyes. Rich or rustic, they adjust themselves to all places, adapt themselves to all circumstances, and challenge the imagination. In the convents they make up large, edifying murals; they are educational in the universities and even culinary in kitchens. In churches they can be sumptuous, they join in the praise, they complete the architecture but modify it as well, breaking up or stabilizing the perspective. They ac-

company royal solemnities, princely festivities, military parades, bourgeois privacy, and daily wretchedness.

In gardens and parks they multiply the vegetation, enter into battle with it, and succeed in rivaling it. They cover the fountains, line the basins, distill freshness in the patios, encircle the groves, organize the disorders of nature. Ripples of water distort them, the hart's-tongue fern shatters them. The frost cracks and loosens them. They are interchangeable. They lend themselves to all combinations. They mix air and water, vegetable and mineral. Of fire they make fireworks. They disperse what is heavy, give weight to what is light. Unmatching squares, mutilated sentences with no sequel, words, they reassemble themselves to be read once more.

New stories in assembled quotations, they recompose history. They confuse the centuries, upset chronology, disturb the arrangement of images, and contradict their sequence. They are movement itself and guide the traveler in a faraway country. They are fanfares, they are cowbells. They are multicolored, and even the white itself takes on all colorations. The sun extinguishes them, in the moonlight they shine. When the homespun robe

43. Azulejo. 16th century. Collection of the artist.

is parted, it allows a glimpse of the lord's embroidered coat.

When belatedly the kitchens — divided by the river — of the convent of Alcobaça were covered with white azulejos, austerity was joined with the gleam of mother-of-pearl, the ultramarine blue border serving to establish the vigor of the plans, design the space, and measure the intensity of the glitter.

When one knows that in Portugal and Brazil the pavements in the towns are made of small stone cubes that undulate, combine, and disintegrate as one walks, one can see what is thereby offered to the obsessional workings of the imagination.

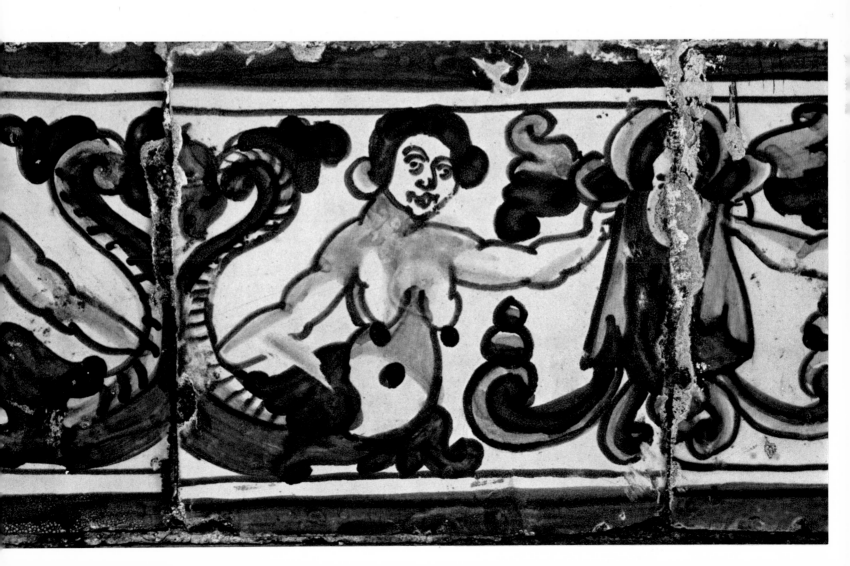

44. Azulejo. 18th century. Collection of the artist.

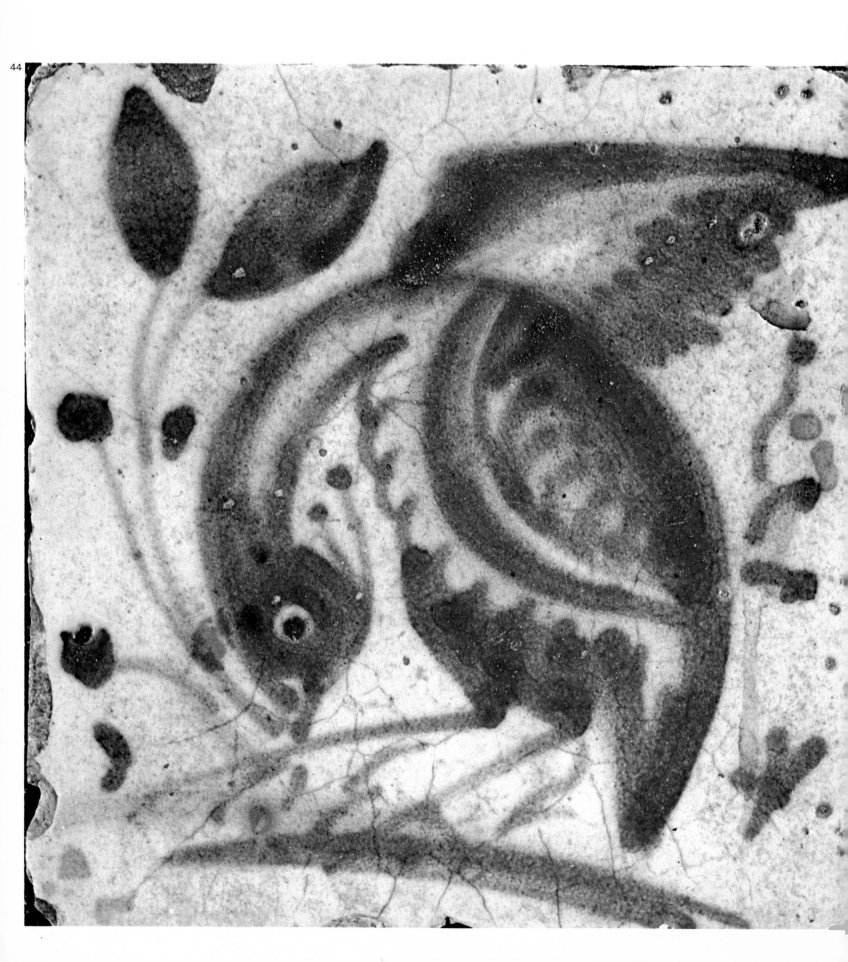

45. Azulejo. 18th century. Collection of the artist.
46. Azulejos. 18th century. Arrangement by Vieira da Silva.

45

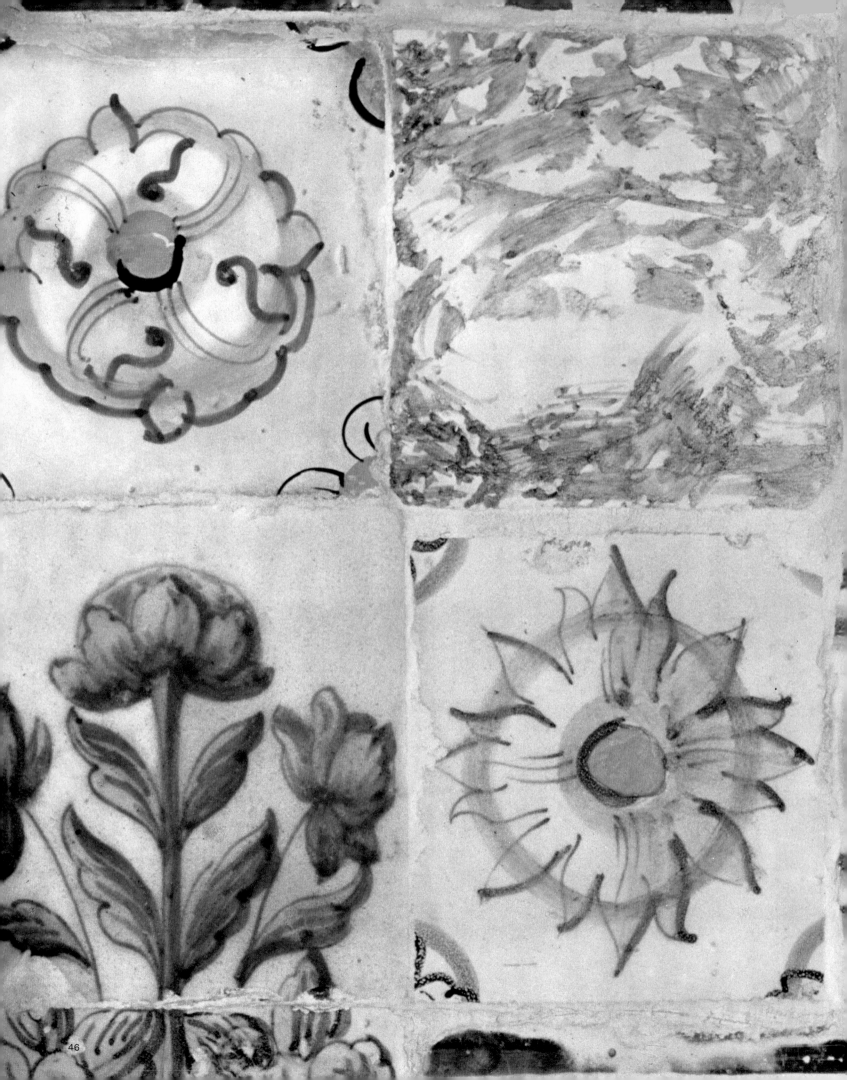

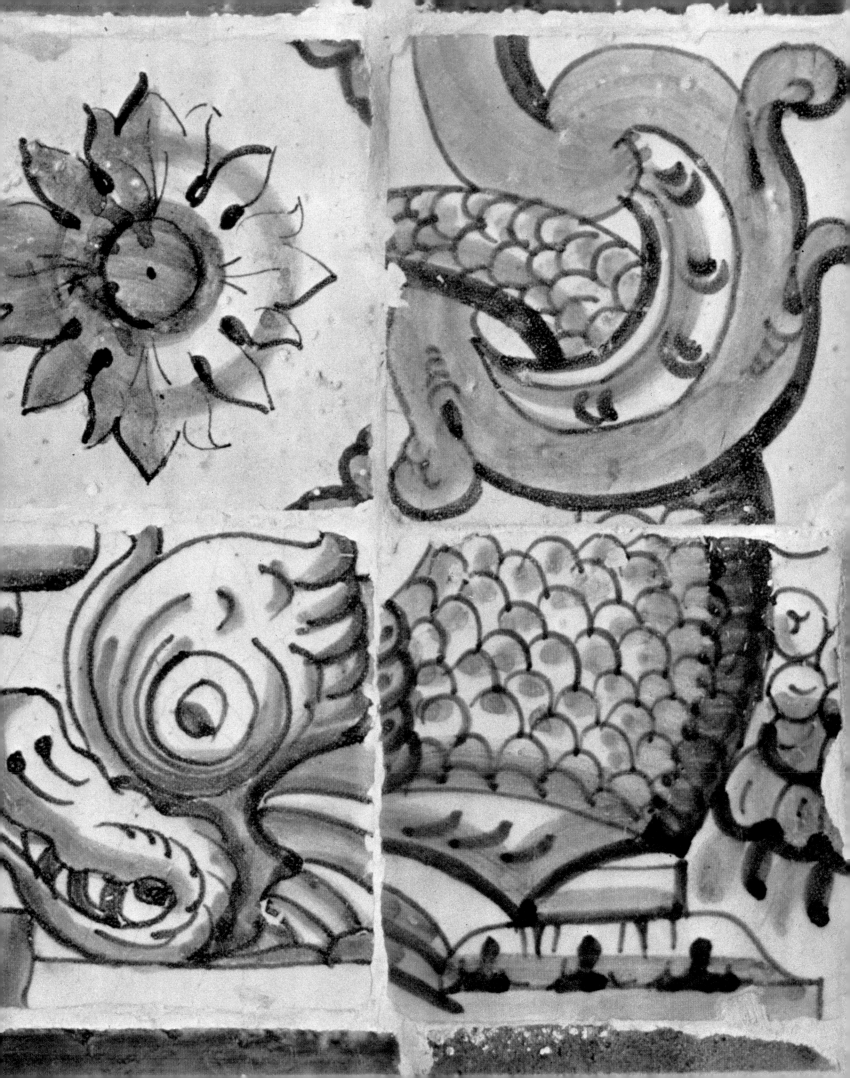

47

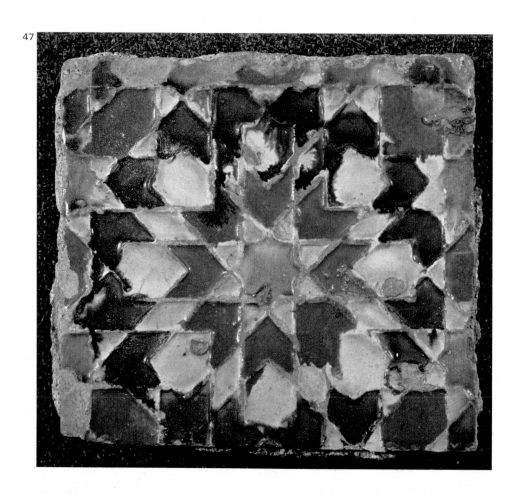

48

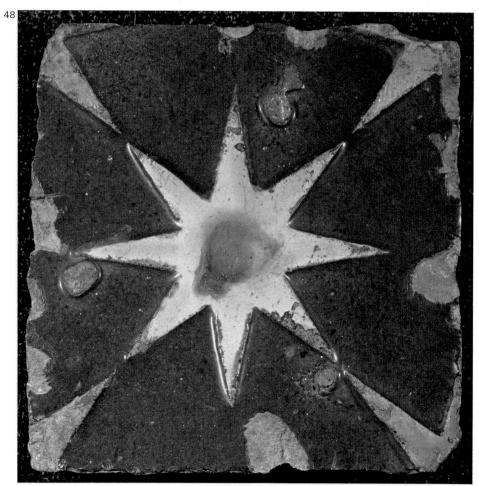

47. Azulejo. Hispano-Arabic, 15th century. Collection of the artist.
48. Azulejo. Hispano-Arabic, 15th century. Collection of the artist.
49. Azulejos. 18th century. Arrangement by Vieira da Silva.

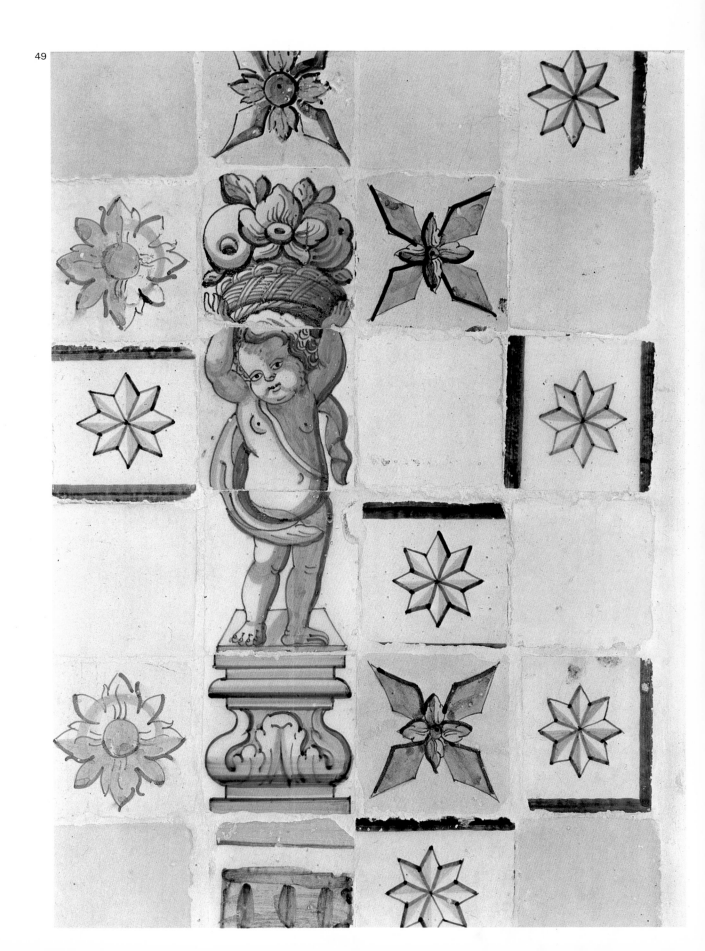

49

Paris

"Place Furstemberg at dawn, a particularly long, sleepless night. A small square, rectangular and deserted, with an eight-branched lamppost in the middle, surrounded by four trees. My thoughts are no longer altogether nocturnal, nor do they belong to the day that is just beginning, from which I am moreover separated by approaching sleep. I catch myself in the very act of simulation. In that white moment, suspended between two temporalities, I realize that what seemed indispensable to me is fundamentally not so important after all. As though all present ties were detached from their objects, as though they bristled in all directions without even seeking anything to cling to. I am the lamppost in the middle of the square, I am the trees around it, I am the pale gray façades, I am the slits in the shutters, the forest of chimneys on the roofs, and the monotonous white sky. I feel my soul incredibly at peace: the only thing that surprises me is to think that not long ago, perhaps even very shortly before, I still wanted something. That I was thinking of the various ways of reaching it and of getting to it faster. I am the foliage on these trees, I am the light of the lamppost, I am the smoke from the chimneys, and the imperceptible mist that creates a nimbus around the barely risen sun. Every-thing is white, as though covered with snow or frost. About this moment, I am not mistaken. I switch the fetters, which all of a sudden have no weight, from one hand to the other. Furthermore, the earth is no longer subject to attraction, and it no longer exerts any. I am suspended on a ray of sunlight, I sway above the pavement. Then someone opens a window with a bang, someone says something, and his voice soars above the peaceful square and the adjoining alleyways; I fall back suddenly on my two feet, and the square instantly recaptures its most multicolored appearance."

Vera Linhartova - "Chimère"
Troisième mouvement
Argile, No. 1, Winter 1973

50

50. Maillol. *Hommage à Cézanne.* Jardin des Tuileries. Paris.
51. Ile Saint-Louis. Paris.
52. Bakery window. Paris.
53. Street fair. Paris, 1930.
54. Elevated métro. Boulevard de la Gare. Paris.

51

53

54

52

55. Bibliothèque Nationale. 200-meter gallery. Paris.

56. Tubular architecture. Paris.

48

57

58

59
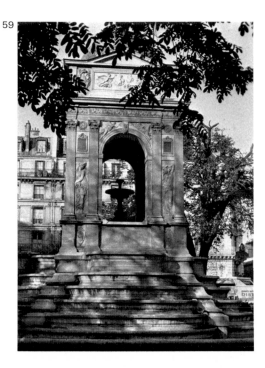

60
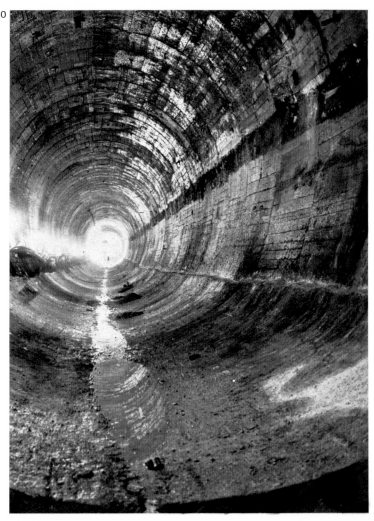

''Fifteen hundred days. One thousand days and over five hundred more. As many days and nights as are needed for a child to be born, to grow, to talk, to become an intelligent and delightful human being; enough days for complete and flourishing creatures to descend in frightful numbers into death. In fifteen hundred days of war and oppression, of organized destruction, does not a people abandon even hope?

''Ours astonished its tormenters and the demoniac fantasy by which they laid claim to humor.''

Colette
L'Etoile Vesper

61. Construction. Paris.

Portraits

"Vieira is seated near her stove, in the mirage of a high studio whose sky is in the image of her paintings: flight of beams, suspended frames, balustrades, ladders. She talks and night comes and a large lighted lamp throws the rafters of her mysterious attic even higher, makes her loose hair even longer, her dark dress heavier. A shock will sway the illumination and when the angles of the shadows move on the ceiling, when the watercolor she holds in her hand opens itself suddenly to our unconscious and eternal desires to flee, one no longer feels but one thing: one has left the earth, the studio is drifting slowly away into the night."

Pierre Descargues
Vieira da Silva, 1949, P.L.F.

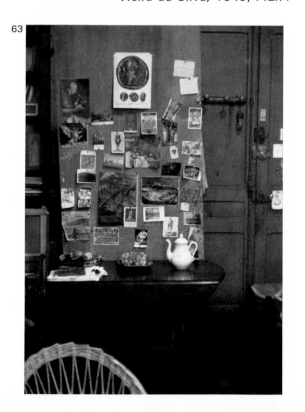

65
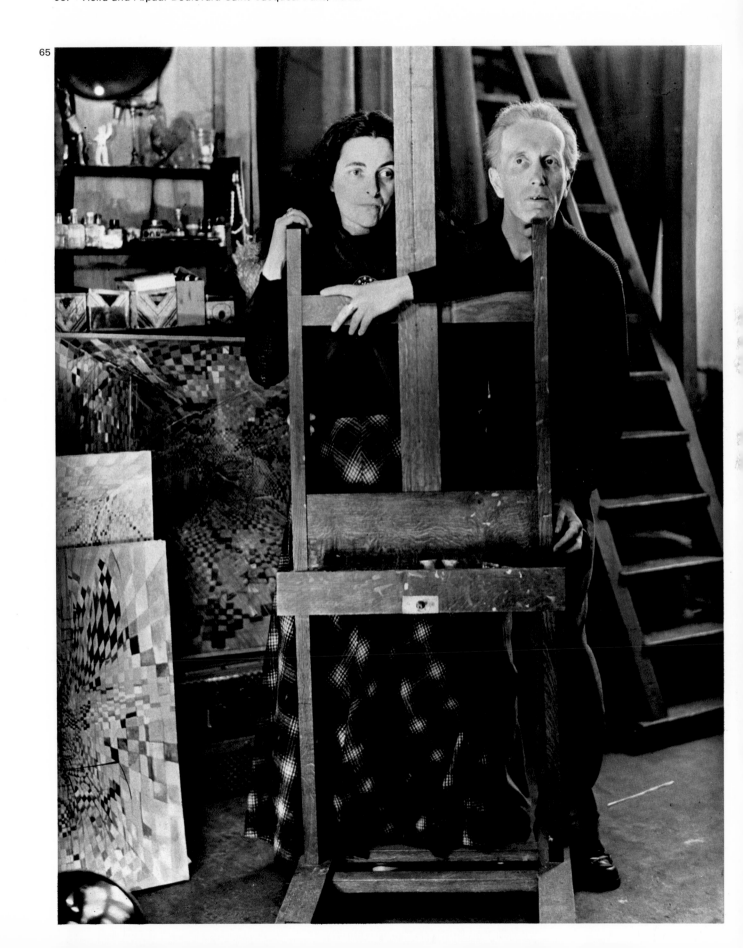

66. Vieira in Sylvestre. Brazil.

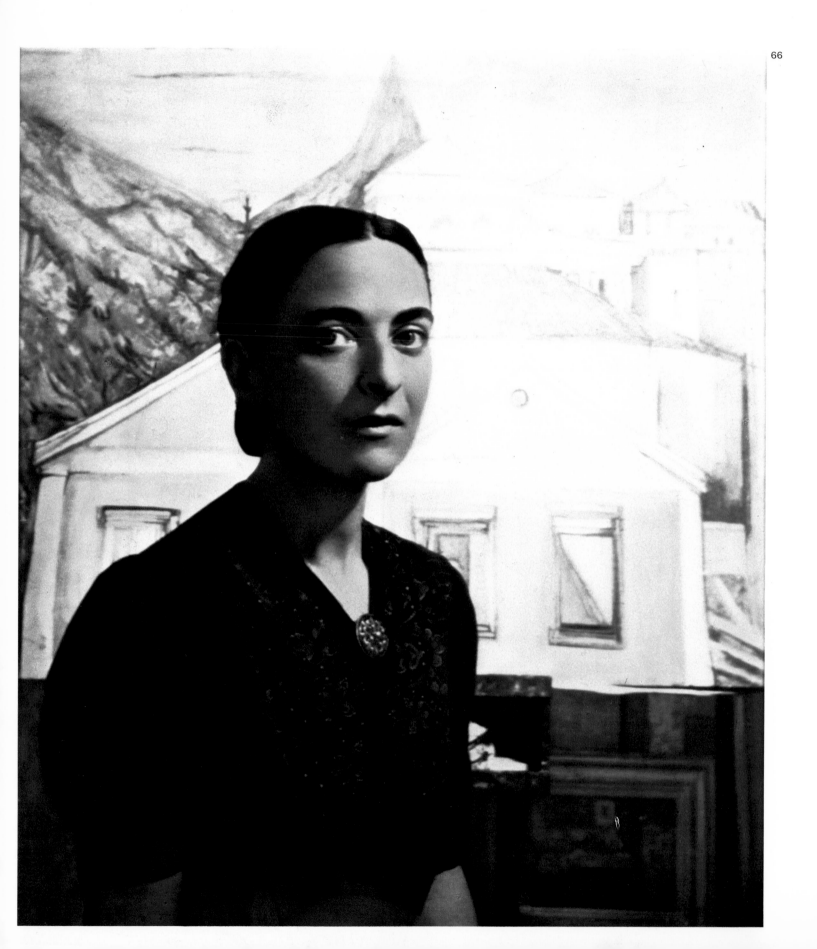

67. Studio on the Boulevard Saint-Jacques, Paris, 1949.

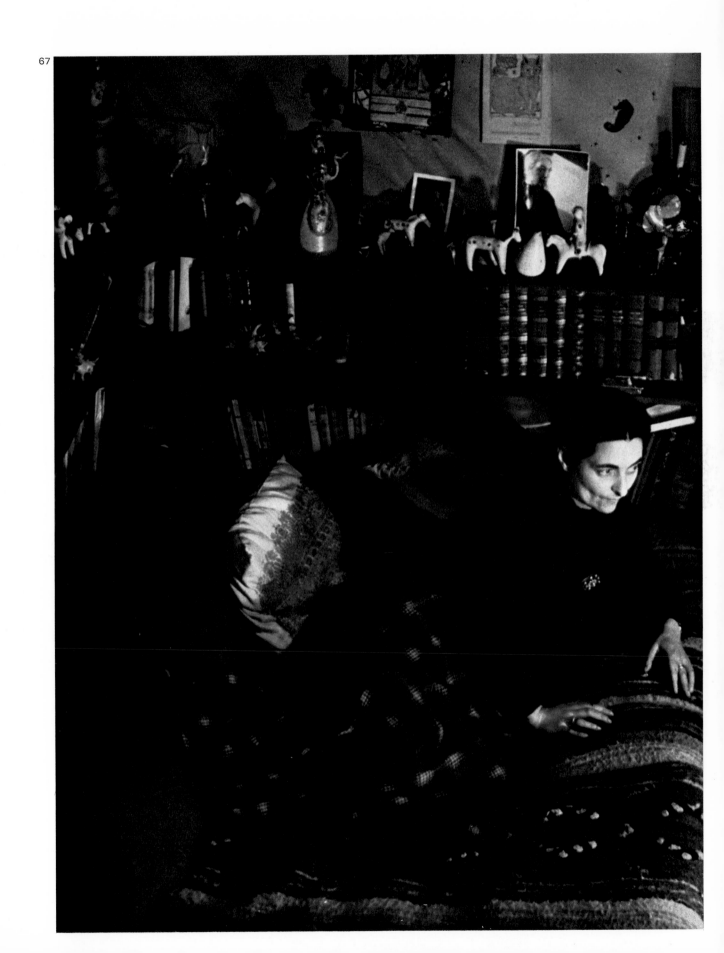

67

Music

As early as the age of five, Vieira da Silva studied the piano. She had already heard a lot of music in her family. This early interest was later transformed into a real passion, whose intensity was to be constant, without however competing with painting.

Vieira da Silva has said so herself: music brings her a deep joy, even stronger than the joys aroused by painting. She almost always listens to music while working. She takes her time in front of her easel, she goes early to her studio to hear the re-broadcast of a concert. Her curiosity is vast. It extends from plainsong to contemporary music. She likes to analyze works and performances, and to deepen her knowledge by reading.

It is not unusual for her to make use of a musical term or reference in giving a title to a painting. People have spoken of the relationship that exists between her works and music. She herself establishes connections, points out certain similarities.

Certainly for Vieira da Silva painting is an instrument of discovery and knowledge. Through it, by it, she seeks an order, one that is perhaps never attained, but is sought from painting to painting, always hoped for, always awaited. For her, painting is surely a quasi-religious enterprise. The endeavors of certain mystics, certain artists, certain mathematicians are parallel. Through different paths and different disciplines, their goal seems to be the same. They question the world to discover order. In the immense diversity of the forms that compose the visible universe, it is tempting to bring to light harmonies and relationships. This is exactly what Vieira da Silva ardently seeks to do through painting.

Acording to Georges Duby, in the eleventh century music had the power to lead one to knowledge, because first of all it was the perception of harmonies and rhythms. It was accompanied by the science of numbers, since the relations between figures were based on arithmetical ratios that made it possible to unveil the secrets existing between things.

Through them, intuitively, the soul would proceed toward God. And art seemed to have no other goal but to make visible "the harmonic structure of the world, to lay out in their ideal place a certain number of signs constituting the secret language of the inaccessible by which the inexpressible is finally expressed."

68. Mozart. Score of *Don Giovanni.*
69. Manuscript page of a Beethoven étude, with corrections.
 Bibliothèque du Conservatoire de Musique, Paris.

Like an eleventh-century monk shut up in his monastery, Vieira da Silva, cloistered in her studio, also strives "to interpret the motions of the universe and to give them meaning."

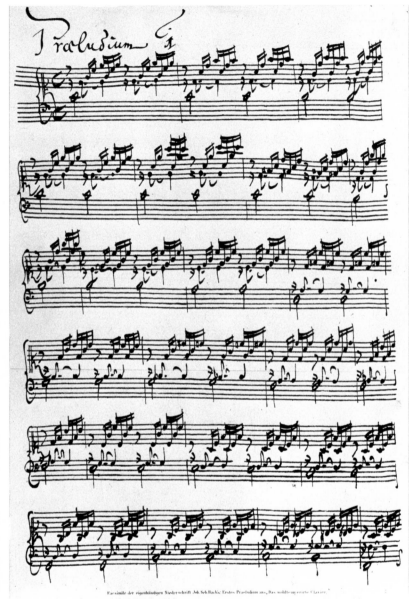

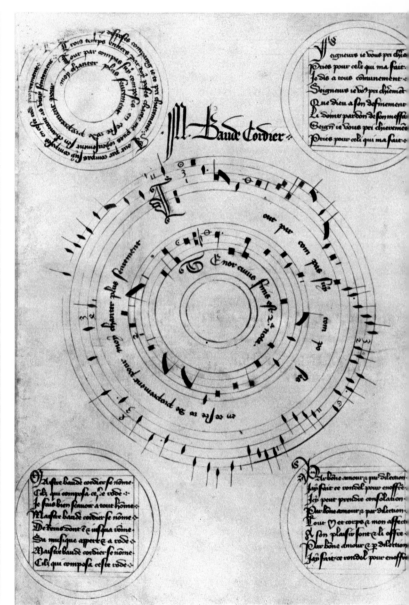

70. First Prelude from *The Well-Tempered Clavier,* by J. S. Bach.

71. Score of a song by Baude Cordier, French musician of the 15th century. Musée de Chantilly.

72. Music book in the shape of a heart. Between 1460 and 1476. Bibliothèque Nationale. Collection Rothschild. Paris.

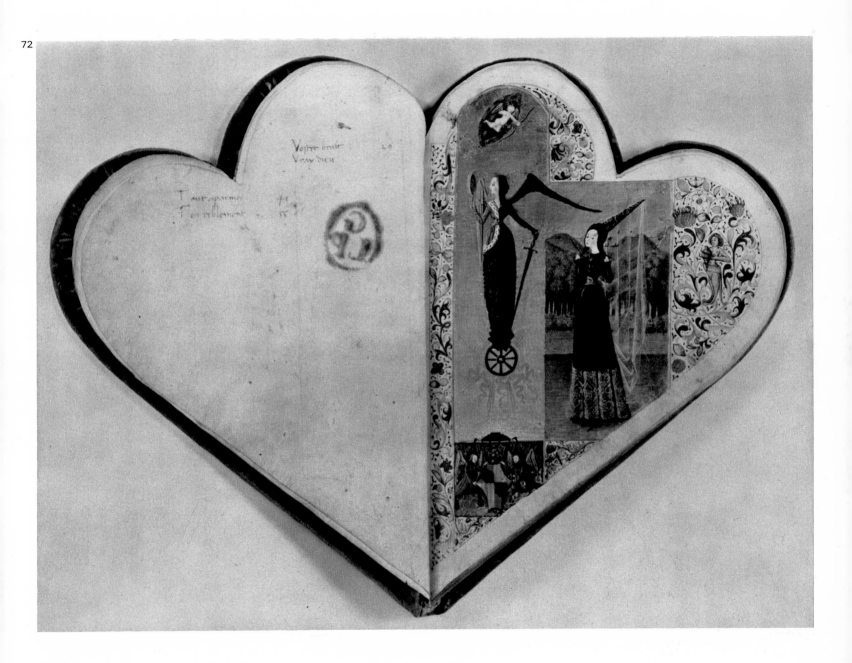

On February 23, 1921, Rainer Maria Rilke wrote in reference to certain works of Paul Klee: "What is upsetting, after the disappearance of the subject properly speaking, is that by now music and graphic art take each other for subject. This short circuit of the arts, unbeknownst to nature and even to inspiration, is for me the most disquieting phenomenon of today, though nevertheless a liberating one."

Letters to Merline

Brazil

Of all her journeys this was the longest. The weightiest adventure, the most charged. Brazil is a long story. Seven years (1940-47) of steady and anxious work remain, work upset by daily worries, by the anxiety of days with the color of bad news. Many studies, abandoned out of distress rather than lassitude. Small canvases with haunting objects, with phantom faces. Few works of large size, but all devoted to a distant reality. Separation enhances their brightness. Squares and streets of Lisbon, winding cities of childhood woven with the thousand threads of starry memory, or else paintings of dreams, of fears, of premonitions, of flights, as though the spirit separated from the body were living elsewhere and lost.

Enormous Brazil — the immensity of the land made itself felt from the beginning. Crackling Brazil, acid Brazil, then sweetish like a fruit full of sugar and studded with cloves.

Something still remains of it, and above all the welcome she received from Brazilian poets, especially Murilo Mendes, Cecilia Meirels, Anibal Machado. Creative friendships, active and cloudless, but also all those meetings, those familiar presences, those discussions, those generous and serious intellects, those open minds: ''Brains that measure up to the land, to the country,'' she says in order to characterize them. Thanks to them, exile did not altogether have the bitterness of solitude.

73

73. Hotel International. Rio de Janeiro, 1945.
74. Rio de Janeiro. The bay.

74

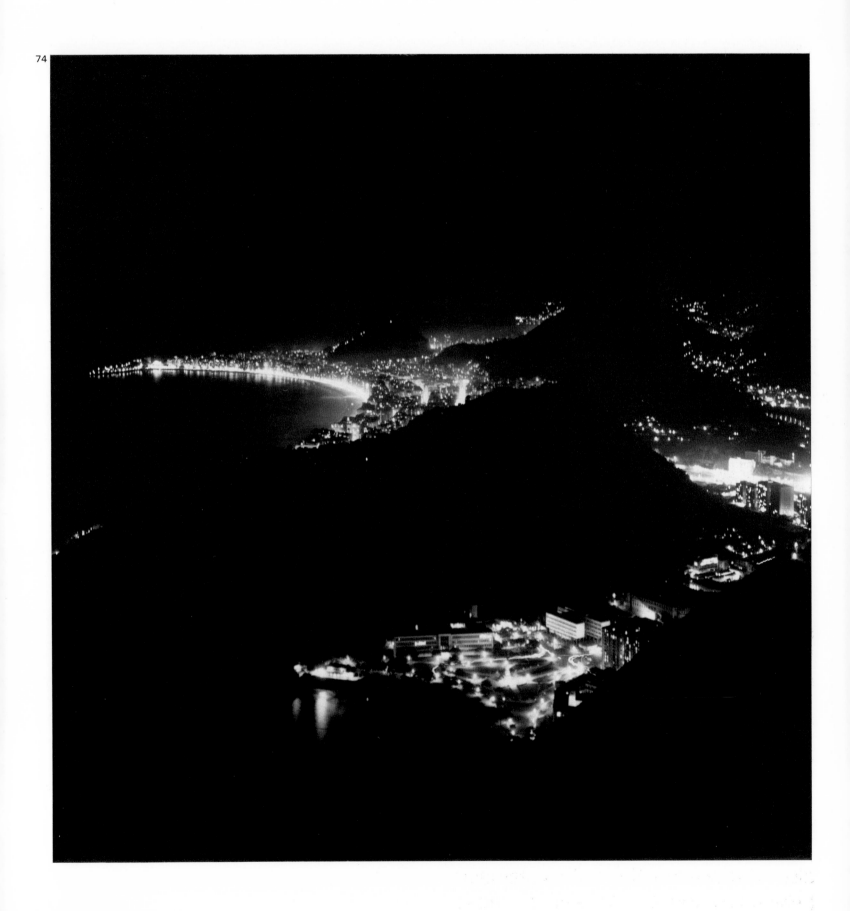

60

75. Vieira and Arpad in Sylvestre. 1946.
76. Vieira, 1944-45.
77. Arpad and Vieira in Rio de Janeiro, 1941-42.

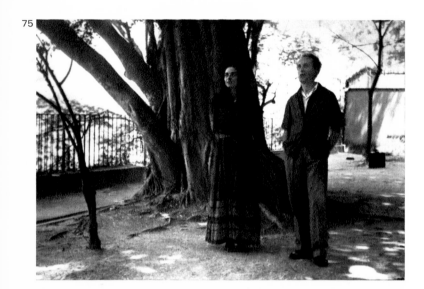

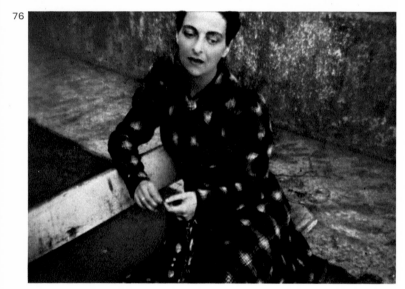

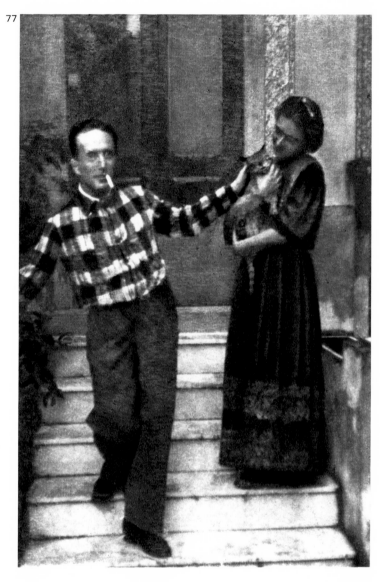

78. Vieira and Arpad. Hotel International. Rio de Janeiro, 1945.

78

79. At the exhibition. Rio de Janeiro, 1942.
80. Hotel International. Rio de Janeiro, 1945.

79

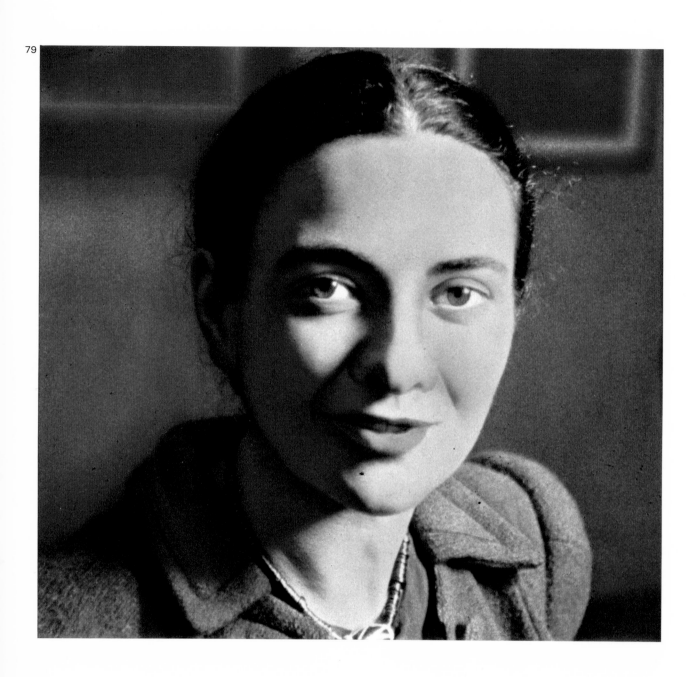

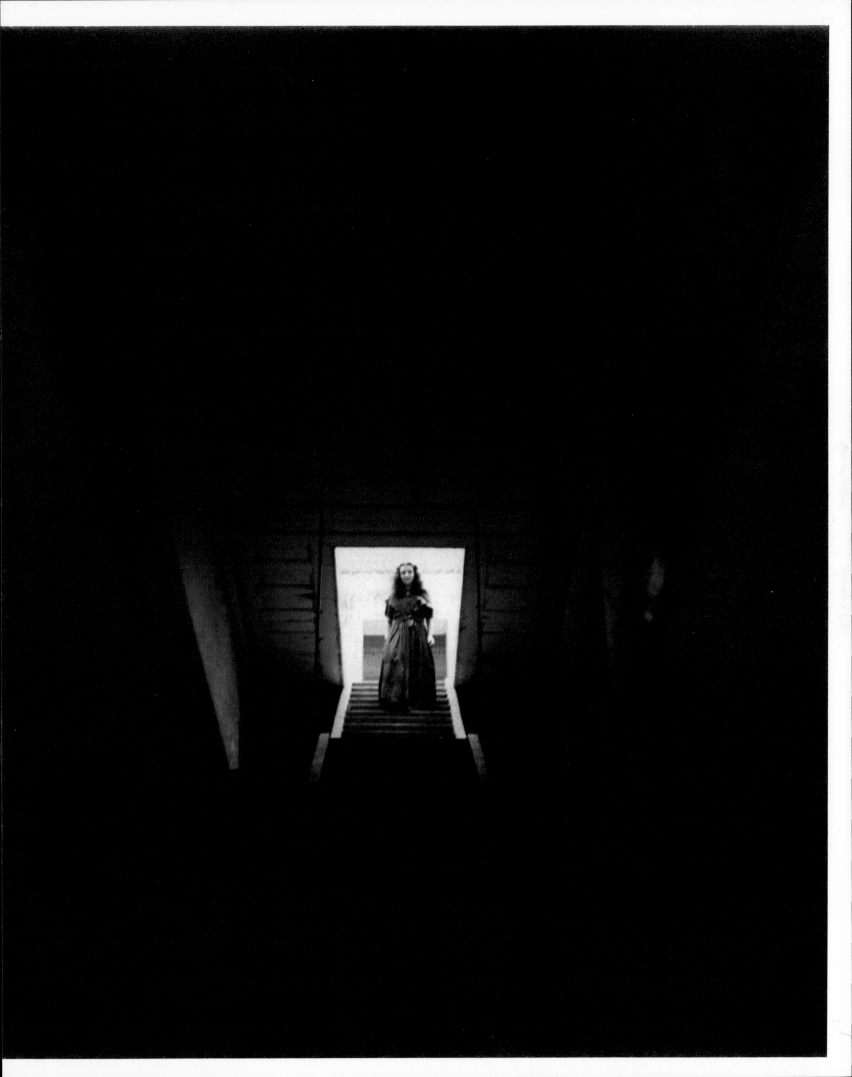

France

When in 1928 Vieira da Silva, after a long debate with herself, decided to leave Lisbon, she had exhausted all her arguments.

Having started drawing at the age of eleven, she had worked hard at painting and sculpture. A bold and courageous young girl, she had rejected easy solutions and taken courses in anatomy at the School of Medicine. If she chose to leave, it was not because she felt she had exhausted everything in Portugal, that was not in her mind, but because something else was happening elsewhere. Without being informed in detail, she had a presentiment; she guessed. The stake was important.

Thirty years later, responding to a questionnaire from America, she notes in a rough draft: "unknown space." The first idea, around which her reflections take shape. Then she specifies: "I came to Paris for intellectual reasons, quite beyond any practical ones....From the port of Lisbon, one used to sail long ago to discover the world and then to populate it. In Paris, one discovers it on the spot at every moment.... And then Paris populates the space with its creations. If I had not come to Paris at that exact moment in 1928, I would not have been able to go on working. I needed the instrument with which one departs for unknown space, and it was only in Paris that I could find it.

"The influence of France on me, I can't define it in words. My paintings define it. Since I was born into a family of intellectuals, the influence of France on me goes back, if I may say so, to the egg."

Too busy with her painting, she took her time about traveling around the country. Carried by train from one place to another, she gazed at the countryside worked over the centuries by man, who had left his mark everywhere, as much in the piling up of stones as in the arrangement of the tilled fields. She felt at home here. Hadn't she learned to walk in the streets of Paris, and along the paths of its parks? Today her mother lies buried in a small village in Le Gâtinais.

With its usual slowness and reluctance, the administration finally consented to grant her French citizenship in 1956.

81. Interior bell in wood. Church of Loreux, Sologne.
82. Bourges. Saint-Etienne Cathedral.

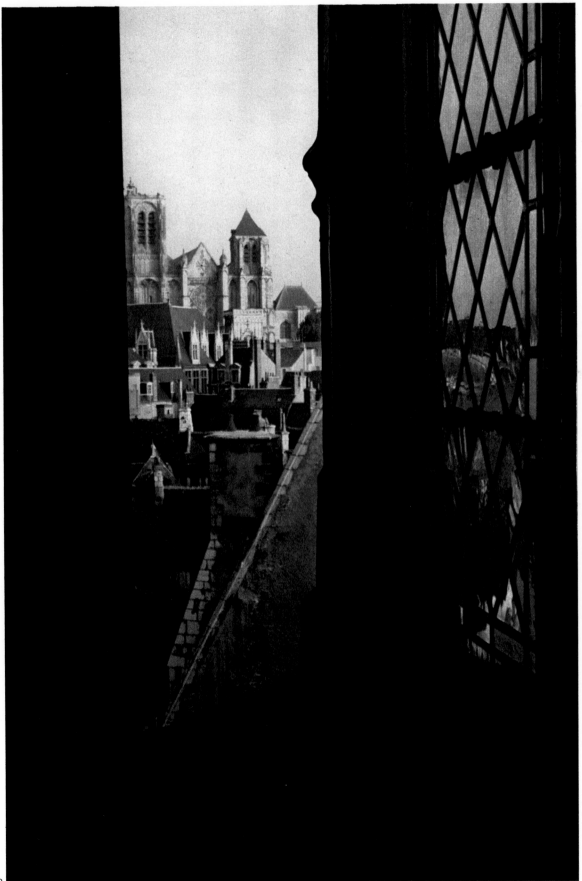

82

Brittany

Of all the regions of France, Brittany is surely the one that Vieira da Silva has visited most, the one for which she all of a sudden feels homesick. Portuguese explorers of lands, surveyors of oceans — it was from Cabo de São Vicente that the ships of Henry the Navigator sailed. It was from a similar hammered-out coast that Breton captains also embarked. At Cap Finistère as at Cabo de São Vicente, the same irremediable fissure, the same blasted rocks. The lacerated and stubborn water, however, will some day end by triumphing over them.

This would be therefore the only journey, the only move that is always welcomed. The mere idea of it makes her happy and threatens to topple her resistance.

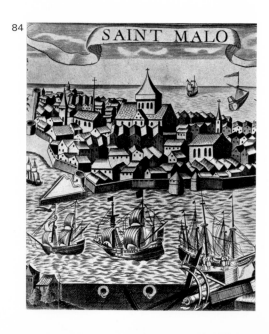

83. Brittany. Mont Saint-Michel.
84. Saint-Malo. Brittany. 17th-century engraving.
85. Menhir of Saint-Duzec. Côtes-du-Nord. Brittany.
86. Brittany. Mont Saint-Michel.
87. Fountain of the church of Saint-Duzec. Côtes-du-Nord. Brittany.

85

87

86
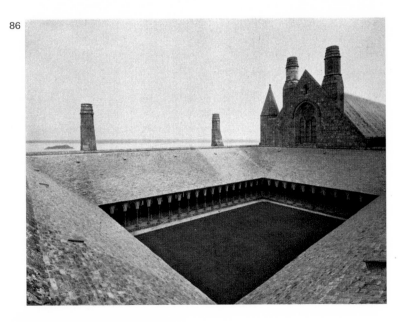

Marseilles

Why Marseilles? For the transporter bridge. Vieira da Silva spent a short time there before the war. The network of this large structure erected against the Mediterranean sky was a discovery, perhaps an encounter. It triggered something. It was not graphics that was revealed to her, but a new relationship appeared: the continuous line eroded by the light. In the brightness it becomes so tenuous that it can be replaced by a vibration. This is a visual observation that accords with the auditory impression of a musician. The lightness of a shrill, drawn-out note produced by the string of a violin is astonishing, sometimes surprising, and fills one with wonder. It is indeed a question of surprise and wonder. In music as well she feels these effects. In the theme or even the embellishment, this superimposition, this trill for example, which is not expected in the development, which like a parsimonious spot of color gives rise to song, exalts all that comes before and all that will follow. This contradiction, perhaps even this rupture, which in the construction is transformed into an appeal, into nostalgia, leaves the eye, the ear, suspended at the brink of the inexplicable. This incident, dictated by fate, alerts the dreamer, provokes his awakening, upsets the rhythm of his heart. Some-

thing had changed. She had just understood what whe wanted to know, even if the benefit derived from it at the time remained latent. The hand had also to learn. But she knew.

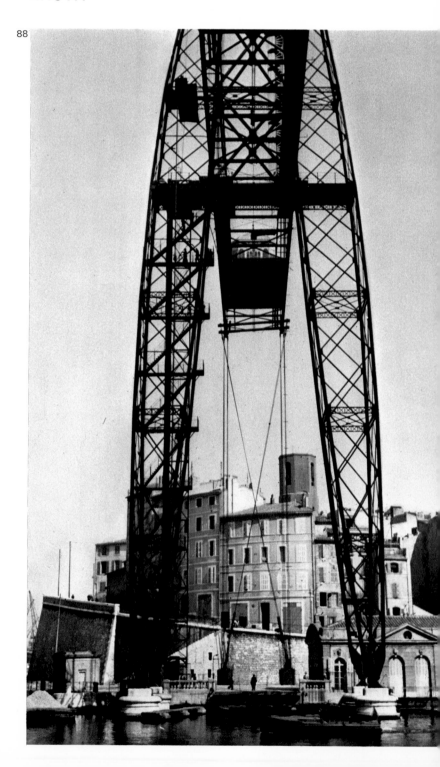

88

88. Transporter bridge seen from moving platform. Marseilles.
89. View of transporter·bridge (destroyed in 1941). Marseilles.

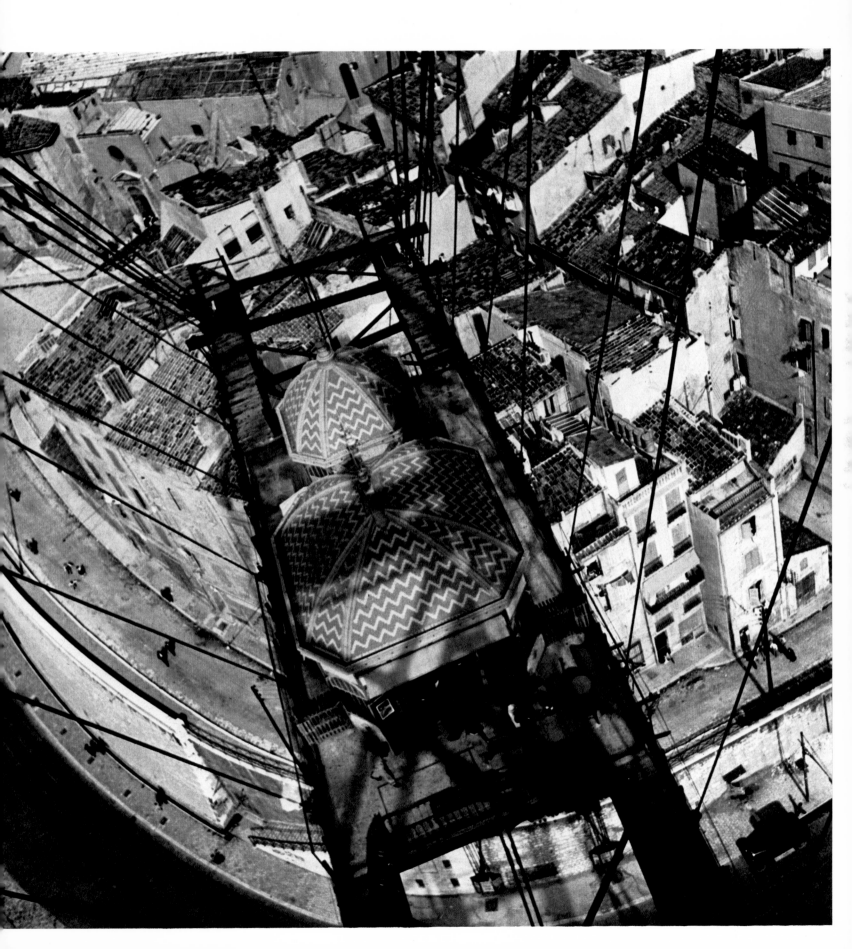

70

90.　The Wolf. 1970. India ink on paper, 35×25.5 cm. Collection René Char, Paris.

90

Murmuring

"So as not to surrender and in order to find my way again, I offend you, but how much I am taken with you, wolf, who is wrongly called funereal, full of the secrets of my hinterland. It is in a mass of legendary love that you leave the virgin forest, hunted by your claw. Wolf, I'm calling you, but you have no nameable reality. Besides, you are unintelligible. Unappearing, compensating, what do I know? Behind your hairless track, I bleed, I cry, I squeeze myself with terror, I forget, I laugh under the trees. Furious and ruthless pursuit, in which everything is pitted against the double prey: you invisible and I tenacious.

"Go on, go, we continue together; and together, though separated, we leap above the shiver of supreme deception to break the ice of the running waters and there recognize ourselves."

René Char
L'Inclémence Lointaine

Holland

"I can already hear the philosophers protesting: 'It is to be unhappy, to be mad, to live in error and ignorance.' Well, my friends, it is to be man! Because truly I do not see why you should call a creature unhappy who lives in accordance with its birth, its upbringing, its nature. Is that not the fate of all that exists? All that remains in its natural state could not be unhappy; otherwise one could say that man is to be pitied for not flying like the birds, not walking on four legs like the quadrupeds, for not having his head armed with horns like the bulls. One could also say that a fine horse is unhappy for not knowing grammar, for not eating meat patties, and that a bull's fate is deplorable because it cannot learn any exercise at the academy."

Erasmus
Praise of Folly

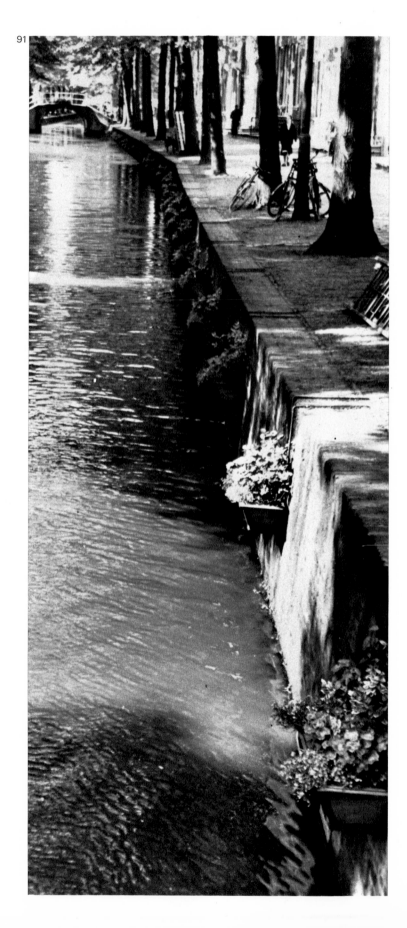

91. Amsterdam.
92. Amsterdam.

New York

"Wings, another breathing apparatus, and one which would allow us to cross immense spaces, would be of no avail to us, because if we were going to Mars or Venus while keeping the same senses, they would impart the same appearance as the things of the earth to everything we might see. The only true voyage, the only fountain of youth, would not be to go toward new landscapes but to have other eyes, to see the universe with the eyes of another, of a hundred others, to see the hundred universes that each of them sees, that each of them is; and this we can do with an Elstir, with a Vinteuil; with the likes of them we truly fly from star to star."

Proust
La Prisonnière

93

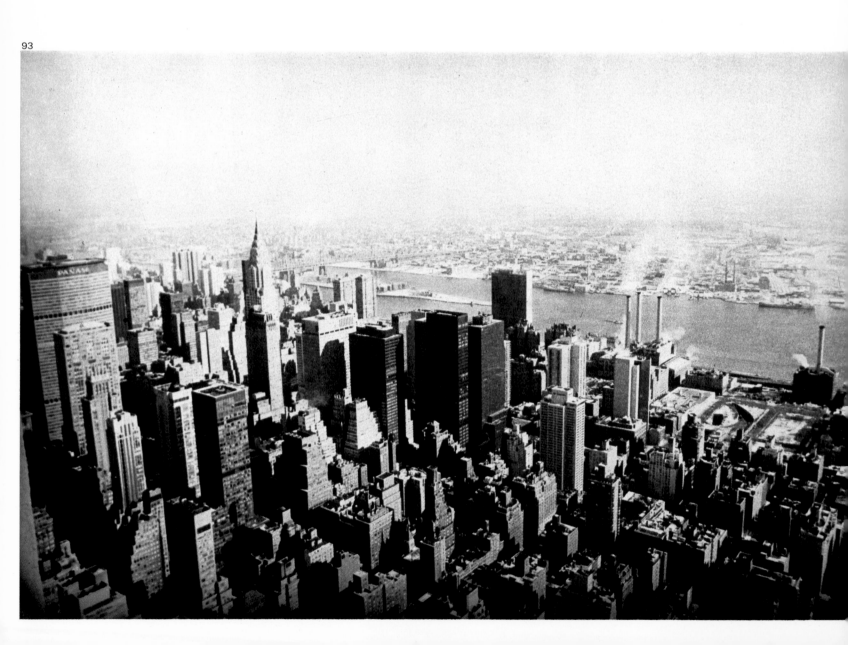

93. New York.
94. New York. Brooklyn Bridge.

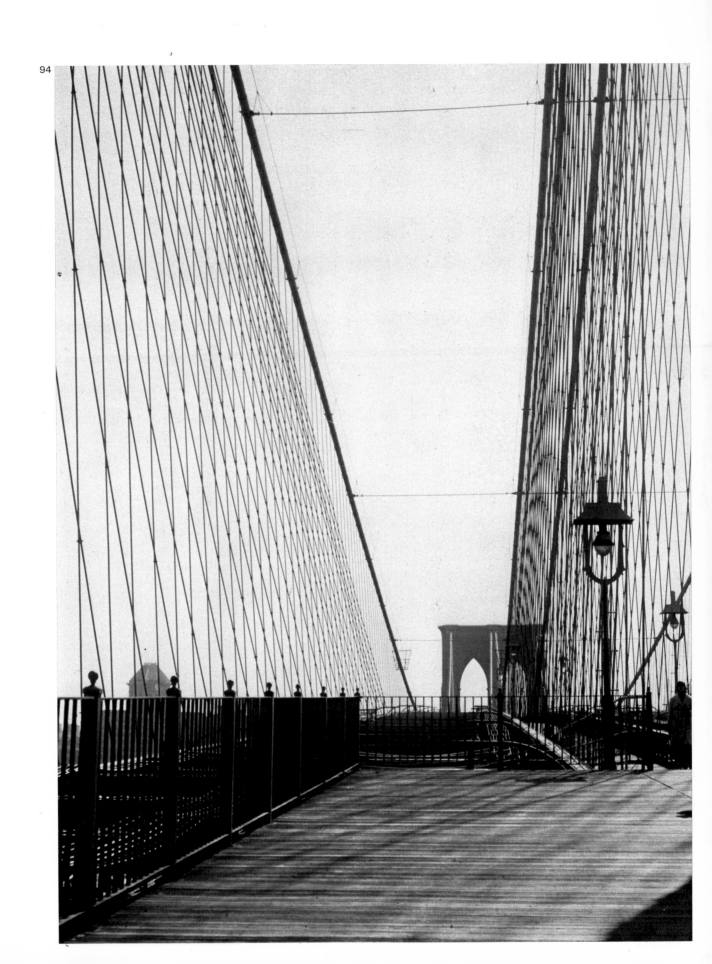

Spain

*"Liquid and solid, water and marble,
unite in such a way that in seeing
it one can no longer tell the
fleeting from the inert."*

Arabic inscription
Fountain of the Lions
The Alhambra, Granada

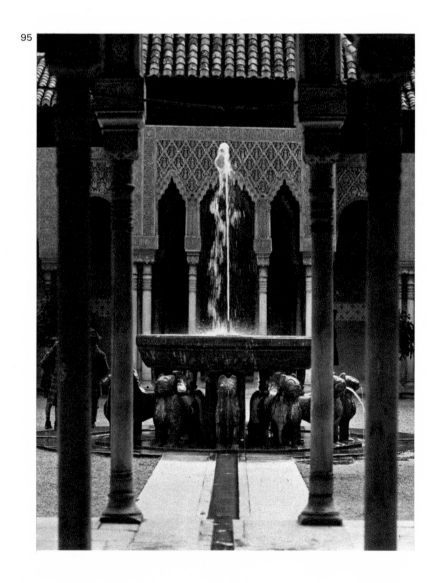

95

95. Fountain of the Lions. Alhambra of Granada.
96. Women's bath in the Palacio de Comares. Alhambra of Granada.

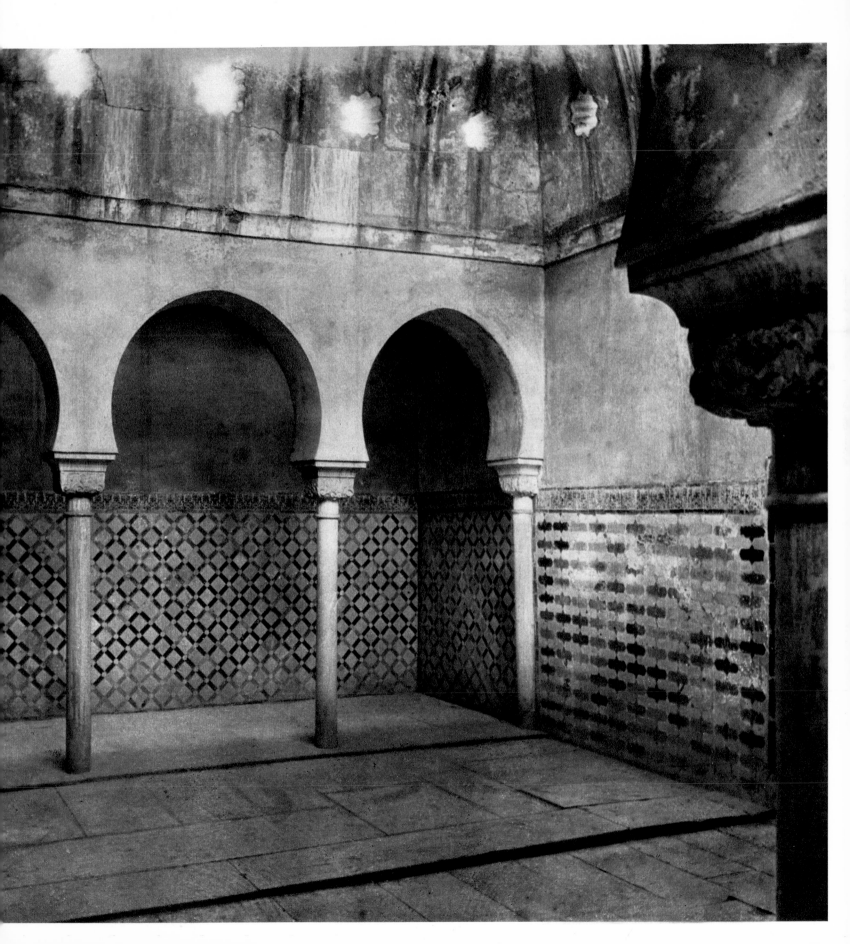

Italy

97. Piazza del Campo. Siena.
98. Bocca della Verità. Church of Santa Maria in Cosmedin. Rome.

"One day Dostoevsky gave vent to this enigmatic remark: 'Beauty will save the world.' For a long time I thought that this was nothing but words. When indeed, in the course of our bloody history, has beauty ever saved anyone? There is nevertheless a certain peculiarity in the very essence of beauty and in the very nature of art: the deep conviction brought about by a real and absolutely irrefutable work of art, and it compels even the most hostile heart to submit."

Solzhenitsyn
L'Express, 4/10 September 1973

97

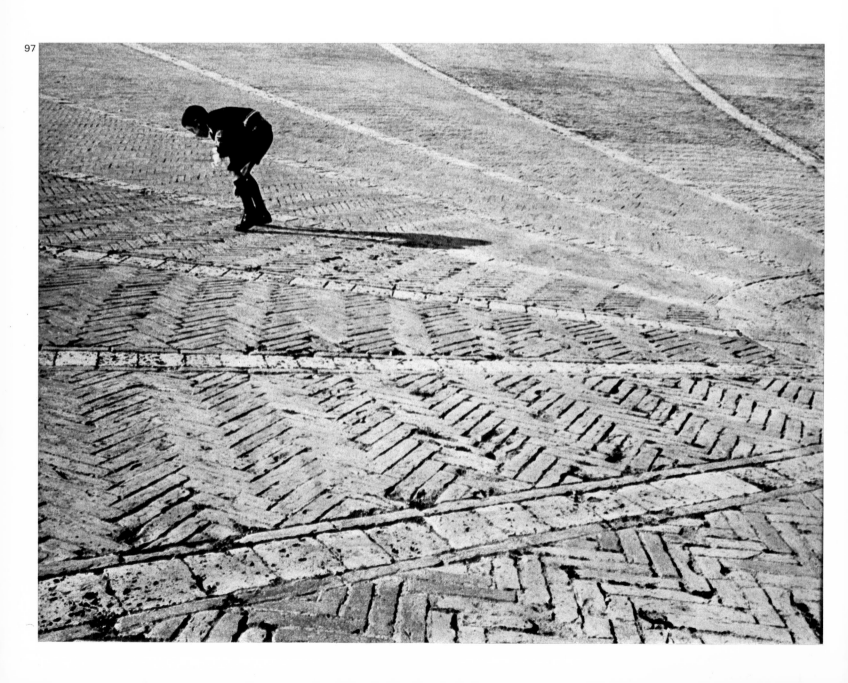

99. A bridge in Venice.

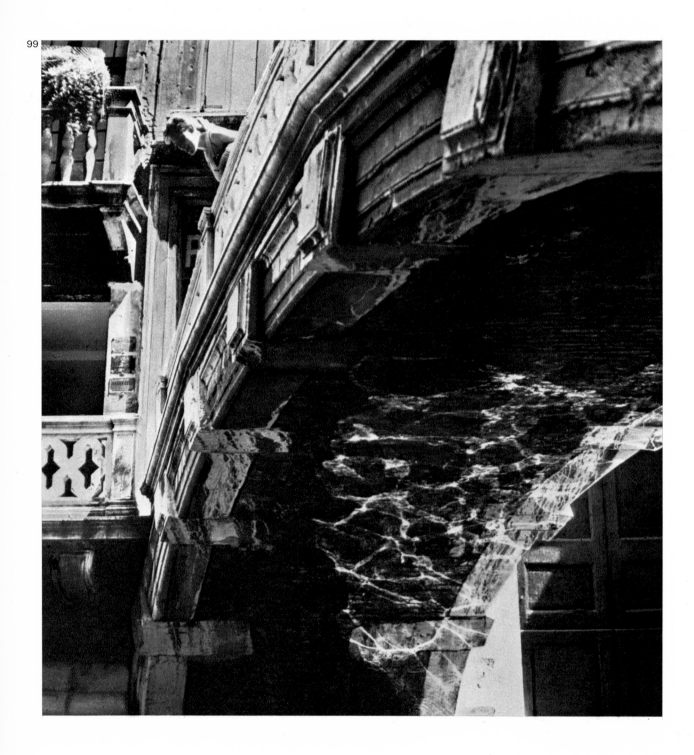

100. The Grand Canal in winter. Venice.

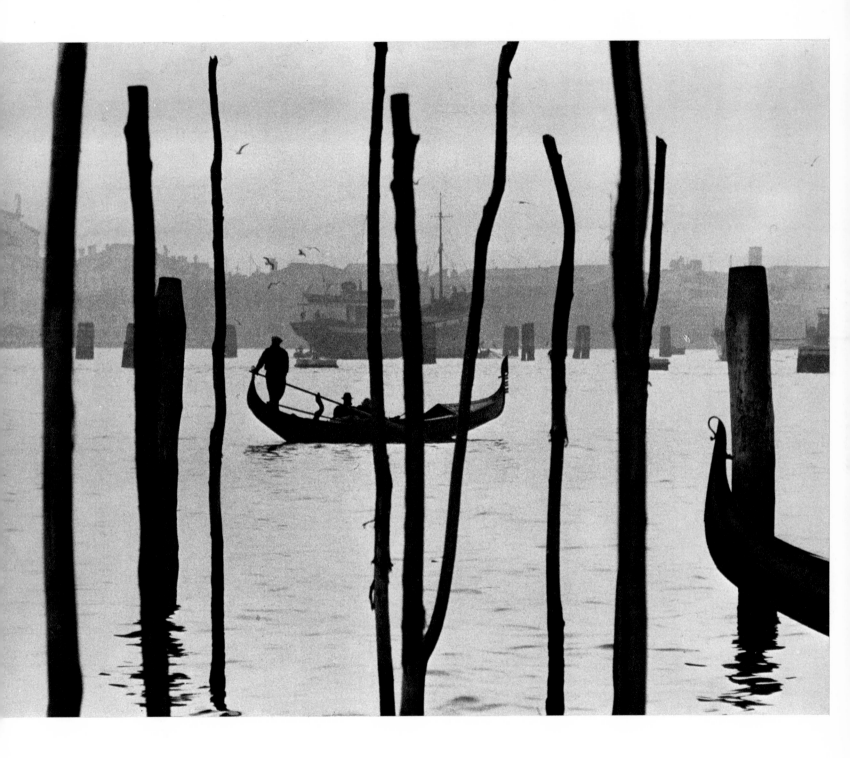

La Maréchalerie

It is in Le Gâtinais, on the edge of La Beauce, whose monotonous immensity corresponds to the immensity of an often moving sky, that Arpad Szenes and Vieira da Silva have chosen to live. Situated on the rim of the only depression in the region, the village lies between the glorious ruins of a castle and the remains of a Gothic abbey with arches suspended over emptiness.

The house, flanked by two large portals, is situated near a small square shaded by linden trees, on a very steep street leading to one of the posterns of the castle. Formerly a farrier's dwelling, it was still used until recently as a farmhouse. It dates from the seventeenth century. The architecture, which has not been transformed, has the traditional proportions of the region: dignified and at the same time arousing nostalgia. A splendid barn, a cowshed — today studios — and a stable are adapted to the body of the central building. The passages and the inner courtyards, now gardens, end at a short distance against the old enclosure wall, pierced with loopholes.

In general, white and blue predominate. Fennel flowers, petunias, and morning glories frame the windows. Japanese anemones, laurustinus, lav-ender, and rosemary adorn the flower beds bordered by old cobblestones. To connect the two levels of the terrain, a few steps lead to a small terrace next to the old well. A trailing vine left over from the vineyards, a wildly growing honeysuckle, form a dense and rustling bower.

It is often, and rightly, thought that artists impose their way of life on the surroundings in which they live. Very often, in fact, the objects with which they surround themselves, their arrangement as well as their choice or even their abandonment, may be a transposition from their world. But one might also think of a phenomenon at once more complex and more mysterious. In the multiplicity of possible choices, the objects that have a long, animated, secret and discontinuous life come to us by obscure paths. Then the question is no longer that of imposing a more or less satisfying arrangement. The artist and the object attracted by his gaze mutually recognize each other. What is more, each reveals itself to the other. There is thus a cognizance that is of a poetic order. Such would seem to be the case of the abode where Vieira da Silva takes refuge for several months of the year, not far from Paris, which she nevertheless misses.

101. Above the fields, the church, the castle in ruins.
102. The Abbey of Saint-Lubin.

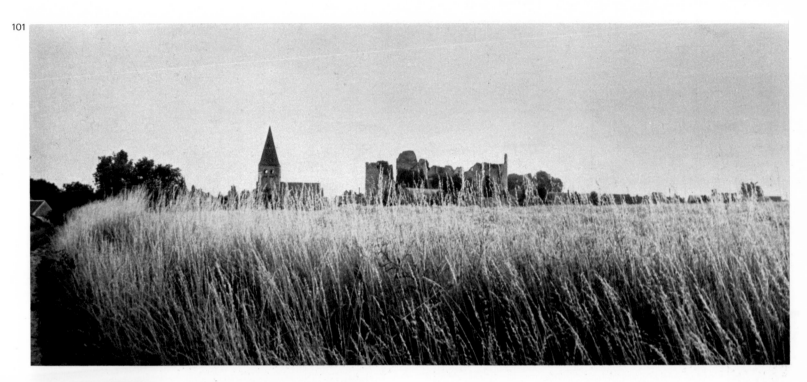

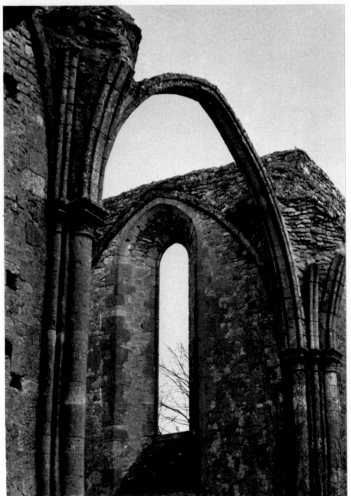

"A strange thing that beauty, which finds it so hard to get acquainted with the useful, finds it just as hard to detach itself from the useless and even sometimes the unpleasant. It is bitterly cold, there is almost no fire, and no bread at the baker's because transport has been held up by a heavy snowfall. The situation is close to becoming tragic. Well, how could we find this village less beautiful, these trees under the snow? The pleasure derived from the sight of them is even stronger, because sharper, than the one we would get from the same landscape on a beautiful spring day."

Pierre Reverdy
Carnets, 1944-45

103. Through the glass door.

104. The forest of beams.

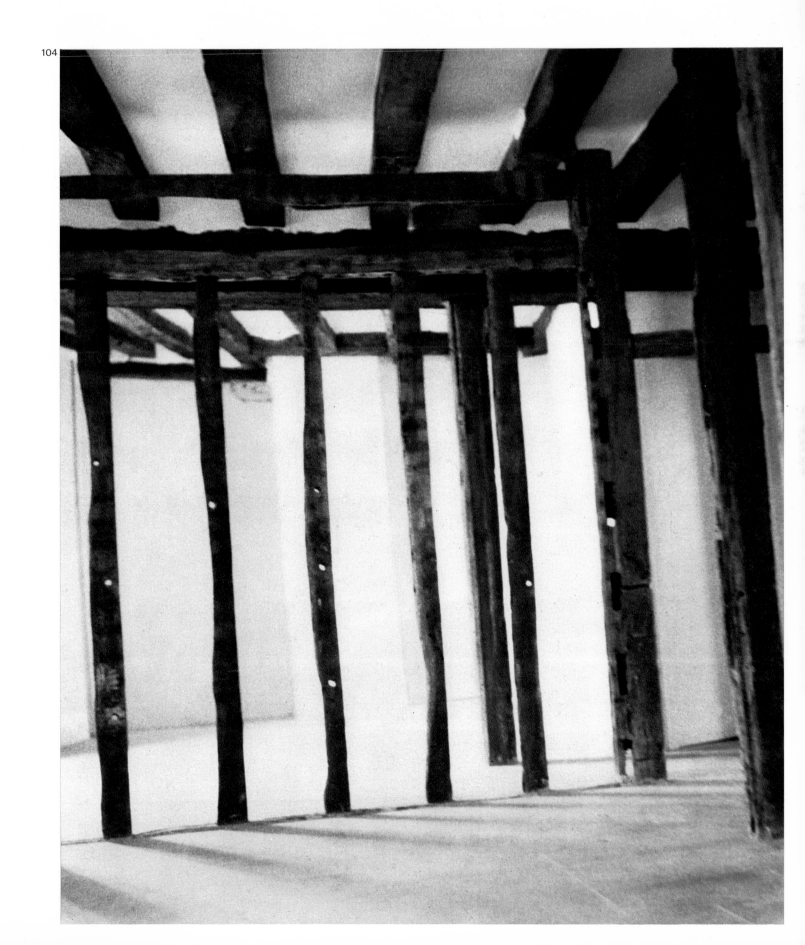

104

105. La Maréchalerie.
106. La Maréchalerie. The conversation.
107. Vieira. 1972.

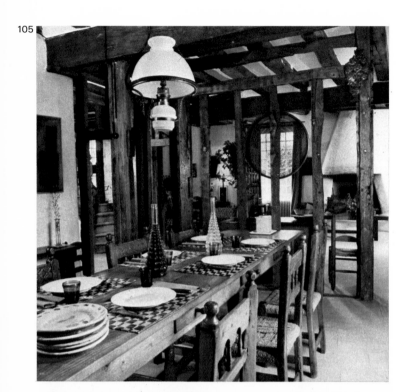

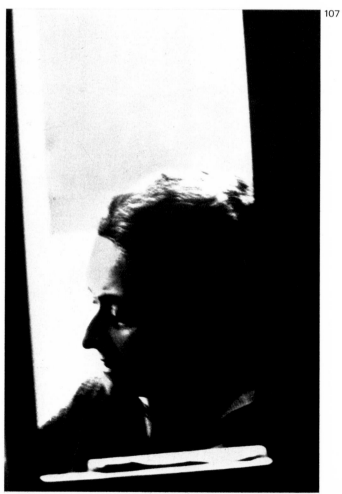

108. La Maréchalerie. Through the window.

108

109

110

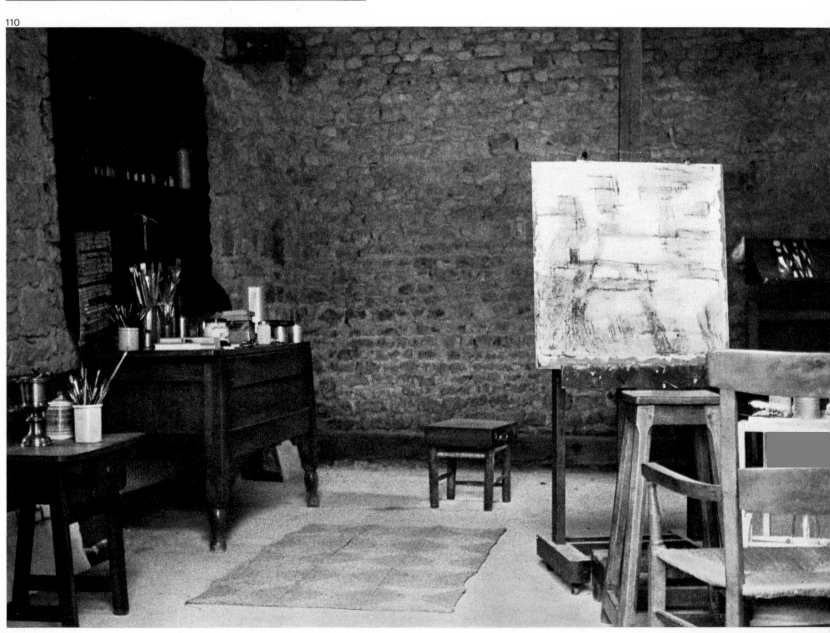

109. Vieira's studio. 1963.
110. La Maréchalerie. The stable transformed into a studio.
111. Sun, moon, front of chest with stars. Studio.

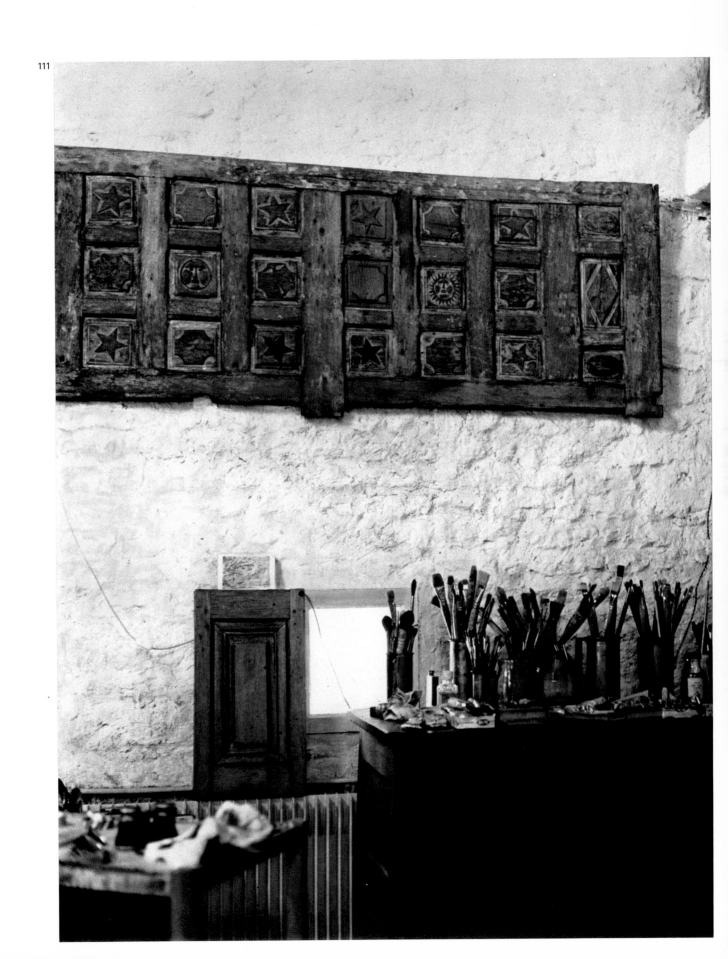

112. The Abbey of Saint-Lubin.

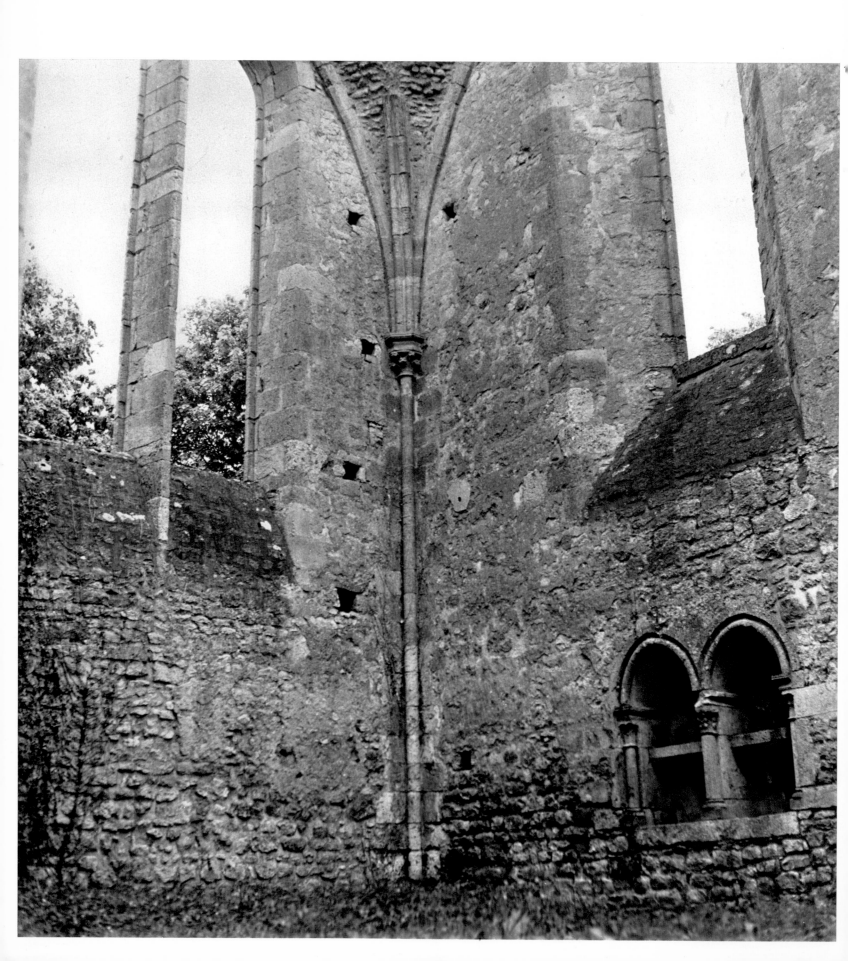

Cats

For Vieira da Silva, her little garden is a universe. In it she discovers processions under the leaves. She glimpses new civilizations amid the gravel, naval battles amid the stones. For her alone the cats of the neighborhood, refined and cultivated, come to act out ancient tragedies. In addition, her cats appreciate Shakespeare in the text, and carefully follow Mozart, their claws out on the open score. But she much deplores their sudden disapproval when hearing Webern or Schoenberg. She may have just discovered the secret of it in learning that a certain chord in E minor had the effect of unnerving the cats!

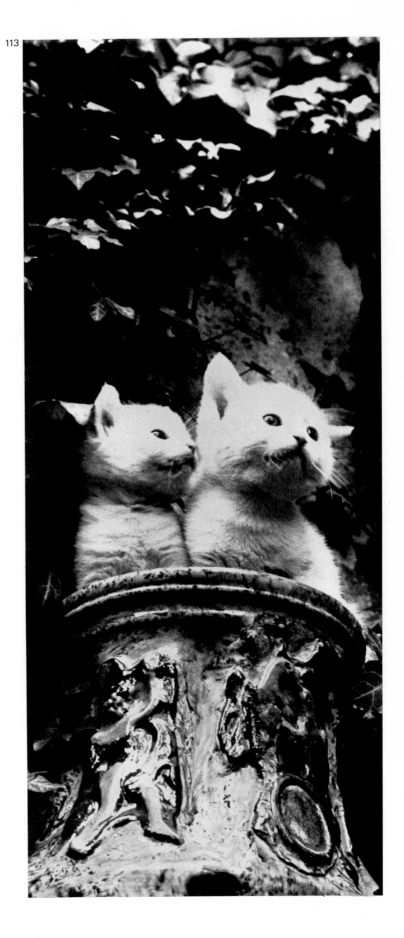

Jubilate Agno

"For I will consider
my Cat Jeoffry.

For he is the servant of
the Living God,
duly and daily serving him.

For at the first glance
of the glory of God in the East
he worships in his own way.

For is this done
by wreathing his body
seven times round
with elegant quickness.

. .

For he keeps
the Lord's watch in the night
against the adversary.

For he counteracts the powers
of darkness by his electrical skin
and glaring eyes.

. .

For in his morning orisons
he loves the sun
and the sun loves him.

. .

For he purrs in thankfulness,
when God tells him
he's a good Cat."

Christopher Smart

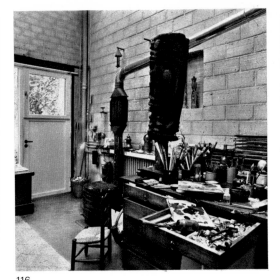

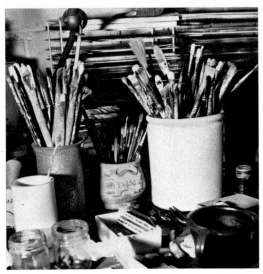

The Studio

114. Between house and studio, the garden. Paris.
115. Toward the garden.
116. Large fernery.
117. Brushes and pots.

In the uncertainty of the circle of the arena, the bull manages to establish his *querencia.* In the hard battle fought by Vieira da Silva against adverse forces, the studio becomes this place, this refuge. Everything there is for the convenience of work. Even the wicker armchair makes itself deeper to receive her in moments of weariness. Nevertheless, depending on the days or moments, it is a lively city, an Atlantic Liner entering harbor, the trans-Siberian railroad, which she dreams of taking some day without ever deciding to set a date. But the most perfect felicity comes from those many secret passages that she succeeds in drilling between her easel, her library close by, and her gardens. Journeys of a few steps that obviously offer her the diversity known only to the fortunate discoverers of faraway lands.

115 116 117

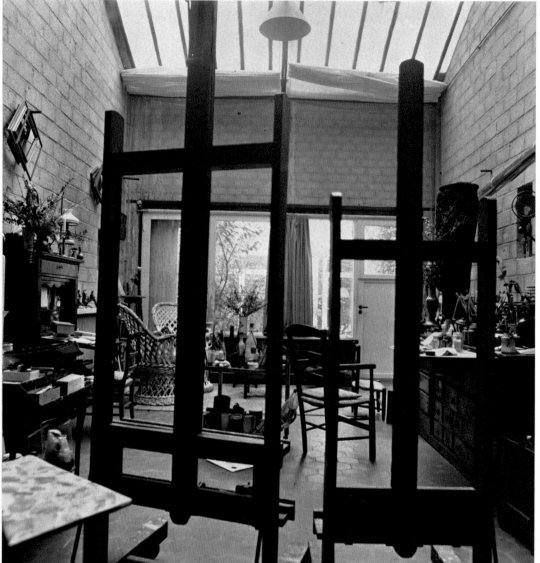

118

119

120

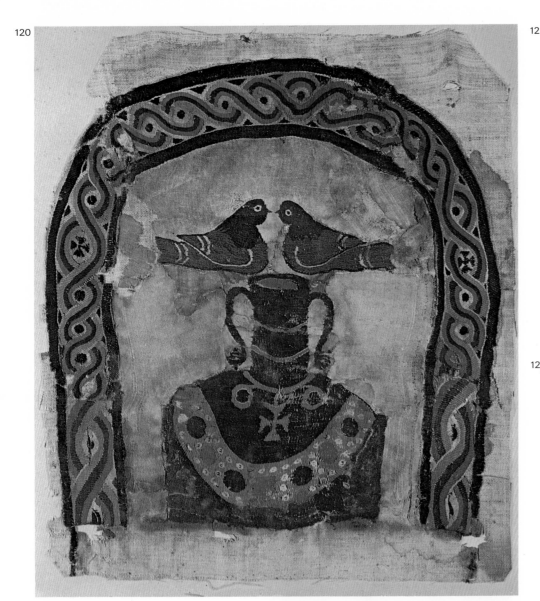

122

123

121

124

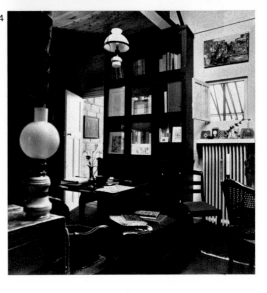

"Each day I am more amazed to 'be'; to revolve in space on a globe....

"We are talked to about reality. Everything amazes me, and I paint my amazement, which is at the same time wonder, terror, laughter, I would exclude none of my amazement. My desire is to make pictures with many different things, with every contradiction, with the unexpected. I would like to become so agile, so sure of my movements, and of my voice, that nothing could escape me, neither the buoyancy of the birds, the weight of the stones, nor the glow of metal. I would like to observe attentively the strings that pull people forward or hold them back. One should go everywhere, dance, play music, sing, fly, plunge into the depths of the sea, watch lovers, enter factories and hospitals, know by heart many poems, the code civil, *and the history of nations. But, alas, painting is long, and the days are short....*

"When I am before my painting and palette, there is a constant effort; a little more white, a little more green, it is too cold, too warm, lines that ascend, that descend, that meet, that part. This means so much in painting and so little in words.

"I believe that it is by adding one small brushstroke after the other,

toiling like the bee, that a picture is made. A painting must have its heart, its nervous system, its bones and its circulation. In its movements it should be like a person and have the tempo of a person's movements. Looking at it one should feel that one is in front of a being that will keep one company, that will tell one tales, that will give one assurance. For a painting is not escape; it should be a friend who speaks to you, who discovers the hidden treasures within you and around you.

"For me, speaking of painting is like playing Blindman's Buff. And while I have been trying to write, I have been haunted by this song:

Can you paint a thought or number
Every fancy in a slumber?
Can you count soft minutes roving
From a dial's point by moving?
Can you grasp a sigh or, lastly,
Rob a virgin's honour chastely?"

John Ford (1586-1640)

Vieira da Silva in *The New Decade: 22 European Painters and Sculptors.*
New York, The Museum of Modern Art, 1955

Of Irresolution

"Irresolution is also a kind of fear which, maintaining the soul as though balanced between several actions that it can accomplish, is the reason why it does not execute any of them, and thus why it has time to choose before deciding, in which it truly has some use that is good; but when it lasts longer than it should, and when it uses for deliberation the time required for action, then it is very bad.

"Now I say that it is a kind of fear, notwithstanding what may happen, when one has the choice between several things whose goodness seems to be quite equal, so that one remains uncertain and irresolute without thereby having any fear; for this sort of irresolution comes only from the subject that presents itself, and not from any emotion of the vital spirits; that is why it is not a passion, except that the fear one has of failing in one's choice increases one's uncertainty. But this fear is so ordinary and so strong in some, that though often they do not have to choose, and see only one thing to take or leave, it restrains them and makes them stop and search needlessly for others; and then there is an excess of irresolution that comes from too great a desire to do well, and from a weakness of the understanding, which having no clear and distinct notions, has only many confused ones: therefore the remedy against this excess is to accustom oneself to forming sure and definite judgments concerning all the things that present themselves, and to believe that one always performs one's duty when one does what one judges to be the best, even though one may judge very badly."

Descartes
Traité des passions de l'âme

For a geography
of time

1908-10	Visits to France, England and Switzerland.
1913	Trip to London. Hastings.
1914	Return to Lisbon.
1928	Arrival in Paris. Italy.
1929	Brittany, Normandy (Honfleur and Le Havre).
1930	Hungary and Transylvania.
1931	Marseilles. Spain.
1935-36	Portugal.
1937	Brittany (Dinard, Saint-Malo, Rennes, Mont Saint-Michel).
1938	Move to Boulevard Saint-Jacques in Paris.
1939	Departure for Portugal.
1940	Brazil (Rio de Janeiro).
1946	Belo Horizonte (State of Minas Gerais).
1947	Return to France.
1948-49	Visits to Normandy (Bagnoles-de-l'Orne) and Brittany.
1950-52	Morbihan (Carnac, Josselin).
1952	London.
1954	Basel.
1955	Amsterdam, Lausanne, Basel.
1956	Residence in Paris (14th arrondissement). Basel.
1957	Portugal.
1958	Germany (Hanover). Portugal, Southern Spain.
1959	Vaucluse (France).
1960	Loiret (France).
1961	New York, Lausanne, Loiret.
1962	Germany (Mannheim, Heidelberg), Portugal, Spain, Loiret.
1963	New York, Lausanne, Loiret.
1964	Grenoble. Italy (Turin, Siena, Florence, Rome). Portugal, Loiret.
1965	France (Finistère), Lausanne, Loiret.
1966	America (New York, Arizona), Mexico. Brittany (Saint-Malo), Vaucluse.
1967	Loiret.
1968	Rheims, Lausanne, Venice, Loiret.
1969	Brittany (Saint-Malo), Loiret.
1970	Loiret, Lisbon, Rheims.
1971	Rennes, Mont Saint-Michel, Montpelier, Vaucluse, Loiret.
1972	Brussels, Loiret.
1973	Montpelier, Rheims, Loiret.
1974	Geneva, Loiret.
1975	Brussels, Bruges, Loiret.
1976	Rome, Barcelona, Loiret, Rheims.
1977	Loiret.

125 and 126. Proposals for an ideal portrait. Cup in the form of an owl, Swiss workmanship — box-wood and vermeil (1561). Musée du Château Mouton-Rothschild, Pauillac, Gironde.

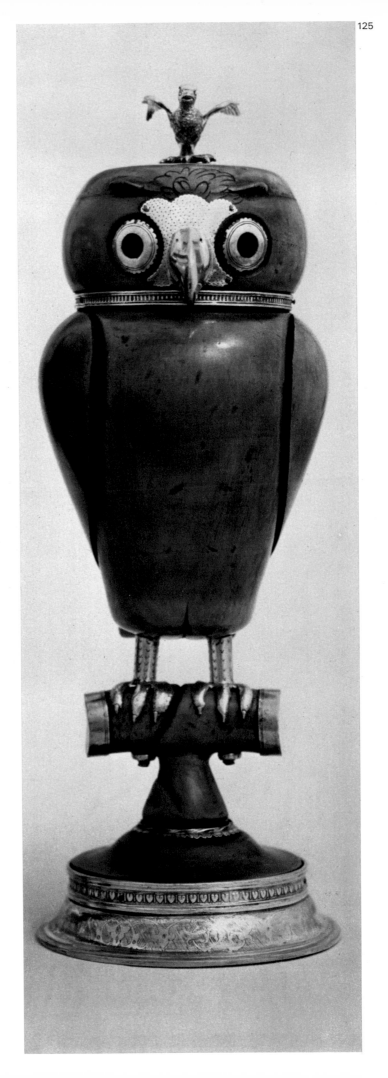

126

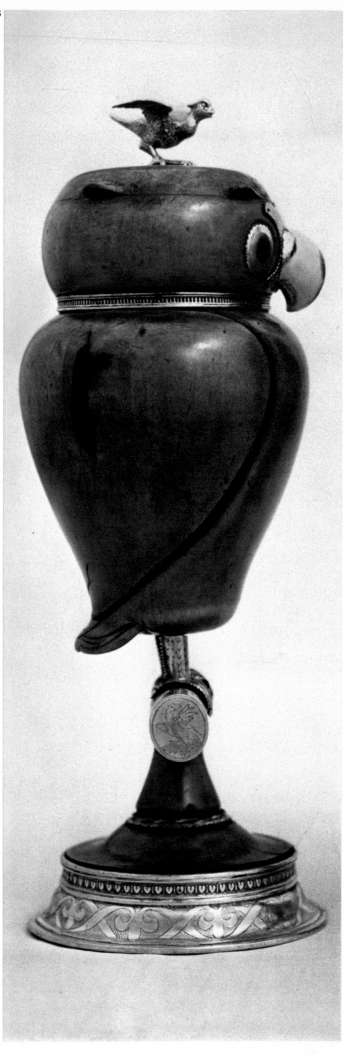

The only child

127. Painting. 1931-33. Oil on canvas 69×24 cm. Collection Isabel de Almeida Simões and Francisco José Simões, Portugal.

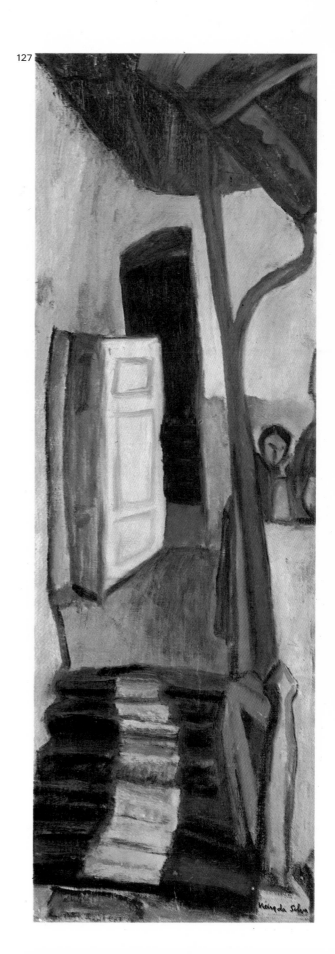
127

An only child, Vieira da Silva was not sent to school; they came to teach her at home. She had no friends. But this isolated child, locked in her individuality and feeling no solidarity with any social group or milieu, was conscious very early in life of belonging to a much larger community. Perhaps because her grandfather, who ran a newspaper, received a great many documents, books and photographs, she felt herself to be at the heart of her time. She remembers having seen Futurist manifestos, programs of the Ballets Russes, whose performances she later attended several times when they stayed fairly long in Lisbon with Fokine.

She would look at foreign art books. From all those messages, all that abundance of photographs, all that printed paper, she was making her honey. In that traditional country, a little remote but naturally restless and agitated, she had the acute feeling at a very early age that the way of life was changing, that something was happening, that everything had to be understood differently, that with the automobile, the airplane, the telephone, everything was becoming movement, transition, that there were no more barriers. And she was at that moment when these changes are about to be experienced in

128. The Cellist. 1930. Oil on paper glued on cardboard, 31×41 cm.
Private collection, Paris.

129. The Cedar. 1932. Oil on canvas, 22×27 cm.
Private collection, Paris.

128
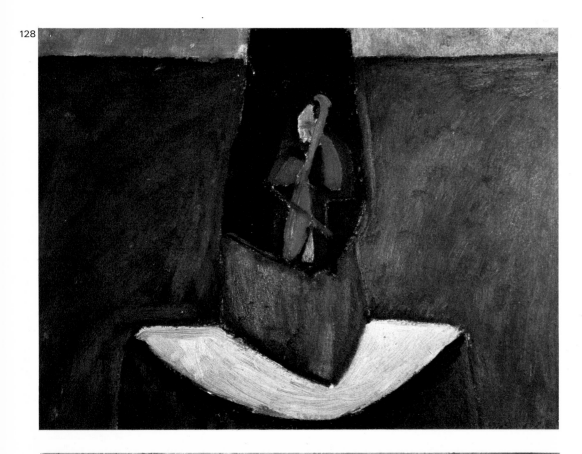

129
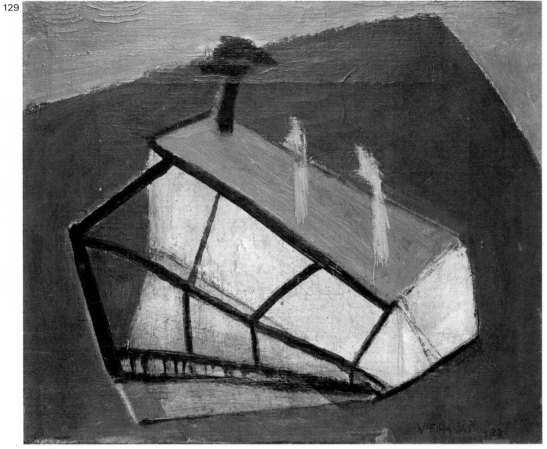

130. Still Life with Books. 1931-32. Oil on canvas, 46×53 cm. Private collection, Paris.

131. Iron Gate (Villa des Camélias). 1931. Oil on canvas, 24×41 cm. Private collection, Paris.

everyone's personal life. Events have 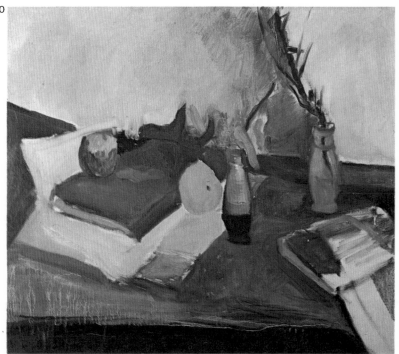 always had a great effect on her.

During the First World War, she already felt the surprising and abnormal things that were happening so far from her country. The wars in Ethiopia and Spain, the Second World War, could only deepen her impressions. The worst was becoming possible. The monstrous, the useless, the absurd, the suicidal character of human decisions burst forth. But even if she was not involved in them, Vieira had an almost concrete

132. La saisie. 1931. Oil on canvas, 16×27 cm. Private collection, Paris.

awareness of them. It was in fact impossible for her to isolate herself from what was happening anywhere else in the world.

When in 1931 she discovered the Prado Museum (but thirty years later she was to have the identical impression), she felt almost physically the terrifying aspect of the works of Goya. It is a true horror, direct and not imaginary, that is described by the painter, who once gave one of his engravings the caption "I Saw This".

This terrifying aspect of life is the real, the everyday. The nightmare surrounds us.

Having made up her mind to enter the world of art, she contented herself with the most conventional studies imaginable. She did a lot of drawing, in the simplest fashion. But it seemed to her that if she succeeded in achieving and retaining a direct contact with the model, she was in less danger of adopting a false style and ruining her hand. That was

132

133. The Tree in Prison. 1932. Enamel paint on canvas, 41×33 cm.
Private collection, Paris.

133

134. The Quay in Marseilles. 1931. Pastel on paper, 40×29 cm.
Private collection, Paris.

135. The Swings. 1931. Oil on canvas, 130×54 cm.
Private collection, Paris.

134

135

probably why, when she left Lisbon to settle in Paris, she had the idea of first taking a course in sculpture, Bourdelle's course at the Grande-Chaumière. It was as if, before approaching the transposition that painting is *par excellence,* she needed to model and to touch the material so as better to apprehend and reproduce reality. It was for her an opportunity to realize that in order to approach and translate the signifi-

136. Villa des Camélias. 1932. Oil on canvas, 46×38 cm.
Private collection, Paris.

136

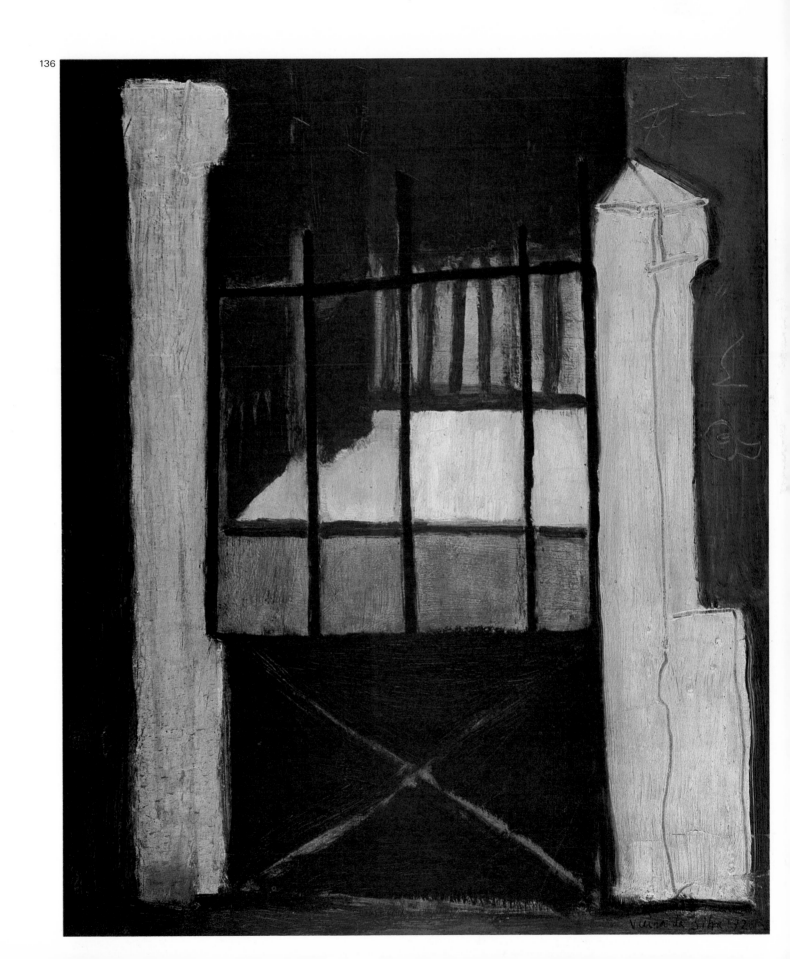

137. The Transporter Bridge. 1931. Oil on canvas, 100×81 cm.
138. Composition. 1936. Oil on canvas, 146×106 cm.
 Private collection, Paris.

cance of what she saw, she must not hesitate to simplify, to unify, and even to warp and distort the expressive line (thus in the first portraits she executed of herself or of Arpad, the face is inscribed in an eloquent arabesque).

For this detour brought her back to painting. Throughout her work one finds the idea that indirect means are more effective in capturing the essential character of the figures and the profound rhythms of nature. Dora Vallier describes this procedure very well when she writes: "It is at all times by ricochet that Vieira da Silva's painting reaches what she aims at."

In fact, this painting is always discovering things. It proves that their truth often resides in their unknown aspect and is best caught by surprise. The artist needs direct contact with a naked and defenseless world.

Even if this method has something spontaneous and improvised about it, Vieira da Silva shows singular perspicacity and constancy in the way she works things out. In Lisbon and Paris, in her formative years, in the travels and periods of exile imposed on her by life, as well as in the peace of her maturity, she has been

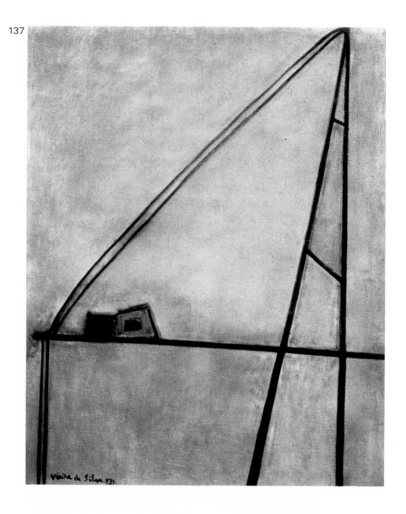

137

first of all herself. The tireless quest that leads her to the encounter with works, poems, and human beings is only a means of asserting herself, of overcoming her shyness, of deepening her disquiet, and planting her solitude in a community of experiment. In Paris, even more than in the free academies of Montparnasse, the Grande-Chaumière and the Académie Scandinave, where she received encouragement from Dufresne and Friesz, it was perhaps with Léger, and with Bissière and his pupils at the Académie Ranson, where she

139. The Procession. Oil on canvas, 38×55 cm.
Private collection, Paris.

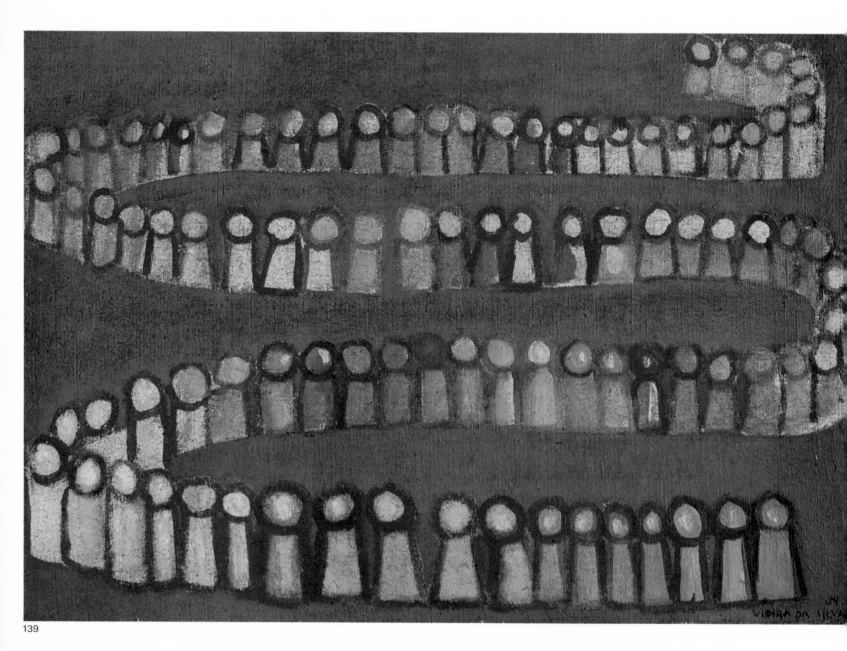

139

worked for a short time, that she encountered the greatest understanding. The friendships she formed there have lasted.

But the most important encounter remains probably that she made with the work of Torres-García, who was then living in Paris and animating by his militant faith the exhibitions of the Cercle et Carré group. Vieira da Silva was one of the rare artists to grasp the importance of this message, which at the time was finding little response. She bought some of Torres-García's paintings, and keeps them today in her house as talismans. A long and fruitful correspondence followed when the Uruguayan artist had returned to his country. She

140. Studio. Lisbon, 1934. Oil on canvas, 115×146 cm.
Private collection, Paris.

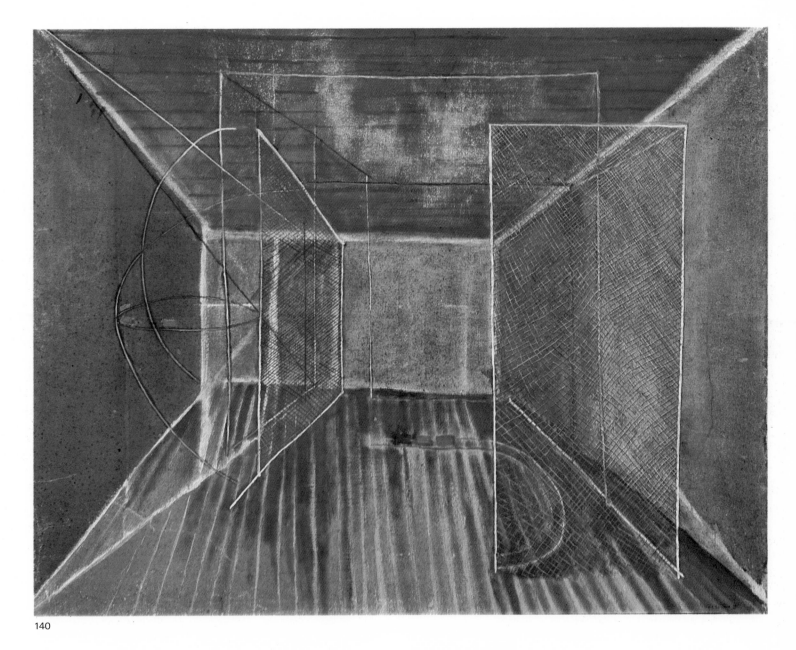

140

drew nourishment from it, and when later she herself had to take refuge in Brazil during the war, the shadow of the old painter protected her.

Though it is very difficult in connection with Vieira da Silva to detect the influences she may have undergone, there can be no doubt that the genius of the great South American painter left its mark on her work. He translates the universe into a complex construction of patterns and rhythms, each symbolizing an architecture, a movement, a way of life.

Vieira da Silva, in the modesty of her youth, did not have the ambition for these vast synthetic compositions, but she learned the lesson of sim-

141. The Flags. 1939. Oil on canvas, 80×140 cm.
Kunstsammlung Nordrhein-Westfalen, Düsseldorf.

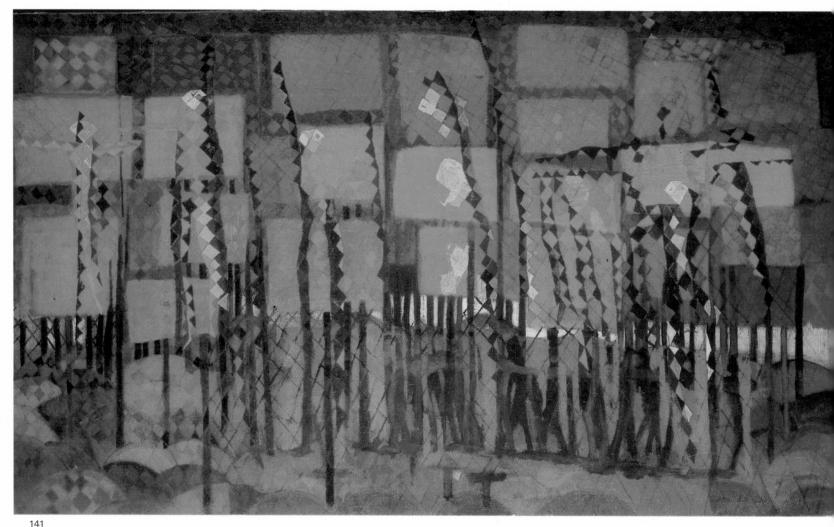

141

plifying each element to reduce it to its structure, and thus came to create a kind of personal alphabet from the external aspects of the world around her. Objects became signs, and with the repetition of these words she was to build her own language.

She roamed the museums and galleries. She entered the small Galerie Jeanne Bucher, and often went to a bookstore on the Boulevard Montparnasse where one could consult the *Cahiers d'Art.* In 1932, she illustrated a children's book; Campigli saw it and mentioned it to Jeanne Bucher, who invited her to come and see her and then organized her first exhibition. The following year, the gallery was decorated by a Christmas tree with small cut-out figures painted by Vieira da Silva. A few years later, she exhibited her paintings with those of Arpad. After Jeanne Bucher's death, her place was taken by Pierre Loeb.

Seeing the night

In an admirable portrait that Arpad painted of his wife in 1940 (now in the Musée d'Art Moderne de la Ville de Paris, where it hangs alongside Vieira's portrait of her husband), one sees Vieira da Silva in profile, in the act of painting, posed in the middle of the picture and leaning slightly forward, attentively, as though resting her elbows on the edge of the world. Her heavy black tresses emphasize the outline of the shawl that covers her shoulders. Her hand, which appears more pointed from the magic wand that extends it, seems to measure its distance from the objects and is directly connected to the threads of the construction that rises like a scaffold on the canvas in front of her, revealing a mode of creation, a mode of life. A mode of creation today definitely elliptical, allusive, implicit of the achieved work, but which at the time still had to assert itself and was doing so fearlessly, almost naively.

One would call it the secretion produced by a child's breath, that iridescence of the soap bubble that emerges at the end of the straw, a network defining space, bending the void, tracing the limits of invisible walls where the bluish and pearly reflections of the light will come to be caught. This continuous line remains attached to the brush that has traced it, forming on the canvas in the process a pyramid of small cubes: the composition of the work to come, its skeleton, the idea and its crutches, ingenious legs of insects.

Thus, before our eyes, the gesture of creation is materialized (though the word is quite improper for an operation that spiritualizes itself in precision), and takes shape in its continuity, its wonder-filled obstinacy. Finally the meshes of this net prove indestructible as it is cast on the water of appearances in order to capture in the depths the fleeing fish, rounded and stubborn volumes. Hence those bursts that merge, those reflections sharp as knives that cross the works of Vieira da Silva, particularly her gouaches of any size, which always teem like fish-tanks.

Indeed Vieira da Silva has recourse to gouache and always with success.

In it she finds, in the apt words of Charles Estienne, her "moment of truth." It is in fact the most direct means of expression, requiring not the careful study of technique, but first and exclusively a *savoir faire,* that of surrendering oneself, in order that it may remain a natural flow in

142. Composition (Lines). 1936. Oil on canvas, 73×92 cm.
Private collection, Paris.

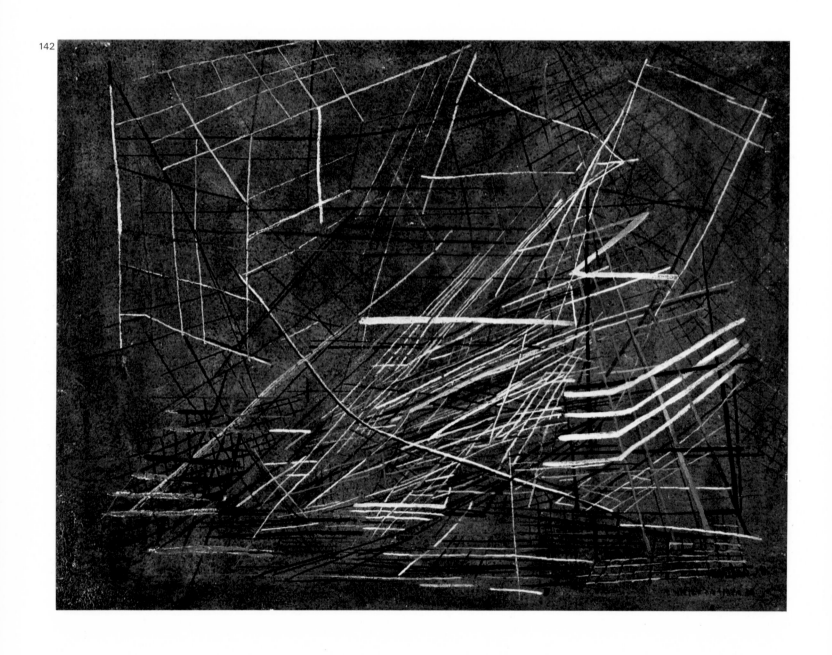
142

143. The Tiled Room. 1935. Oil on canvas, 60×92 cm.
Collection J. Trevelyan, London.

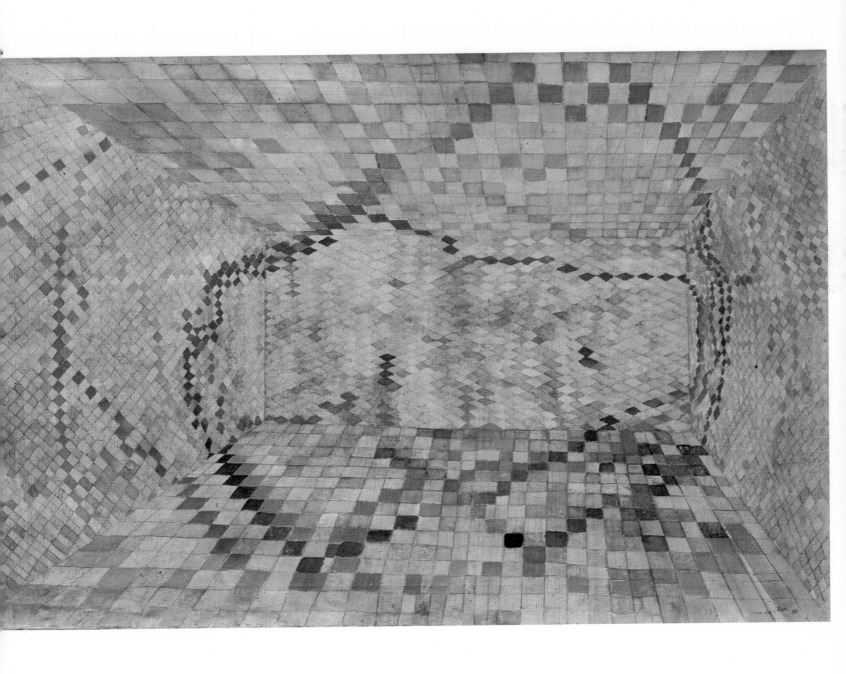

144. Arpad Szenes: Marie Hélène 1. 1940. Oil on canvas, 81×100 cm.
 Lisbon. Musée d'Art Moderne de la Ville de Paris.

145. Portrait of Arpad. 1936. Oil on canvas, 100×82 cm.
 Musée d'Art Moderne de la Ville de Paris.

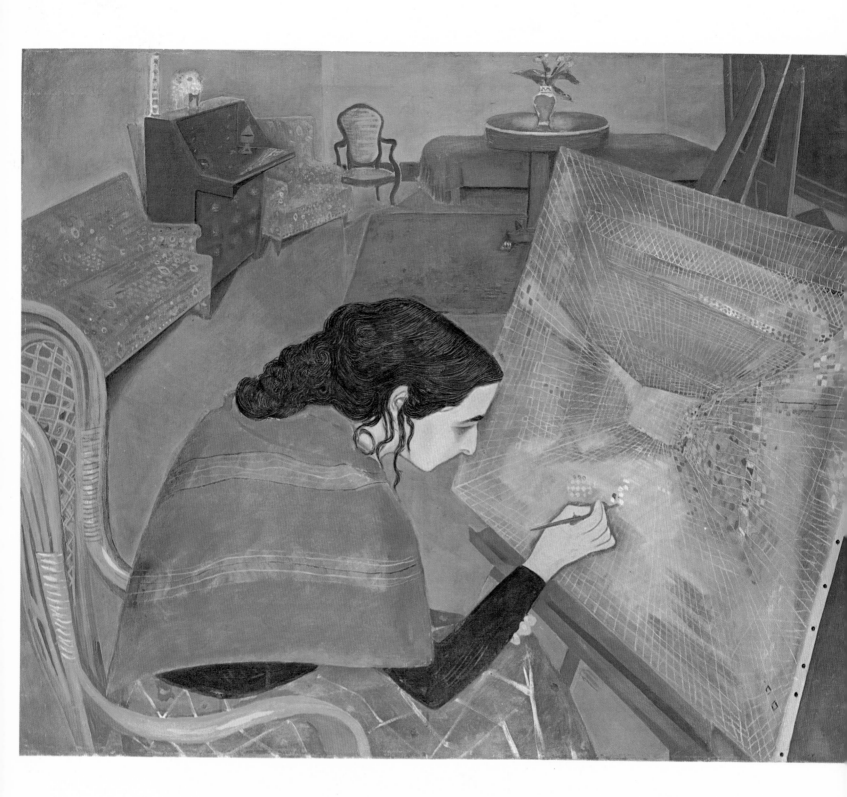

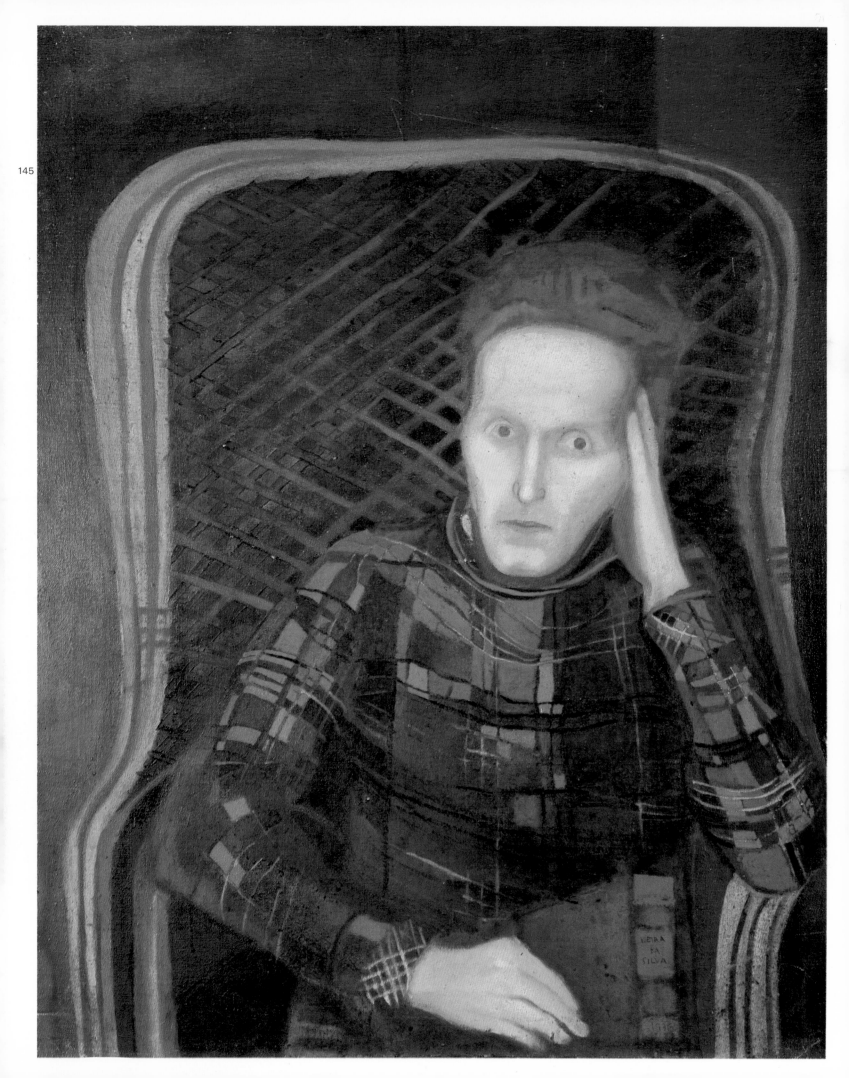

146. The Card Game. 1937. Oil on canvas, 73×92 cm.
Galerie Jeanne Bucher, Paris.

146

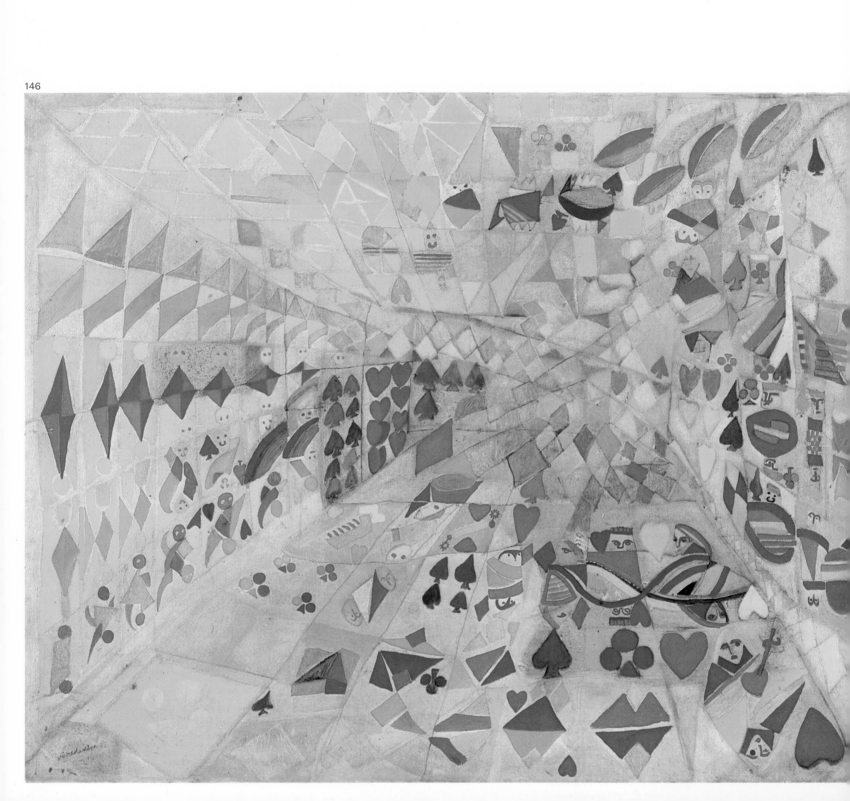

147. La Scala (The Eyes). 1937. Oil on canvas, 60×92 cm.
Galerie Jeanne Bucher, Paris.

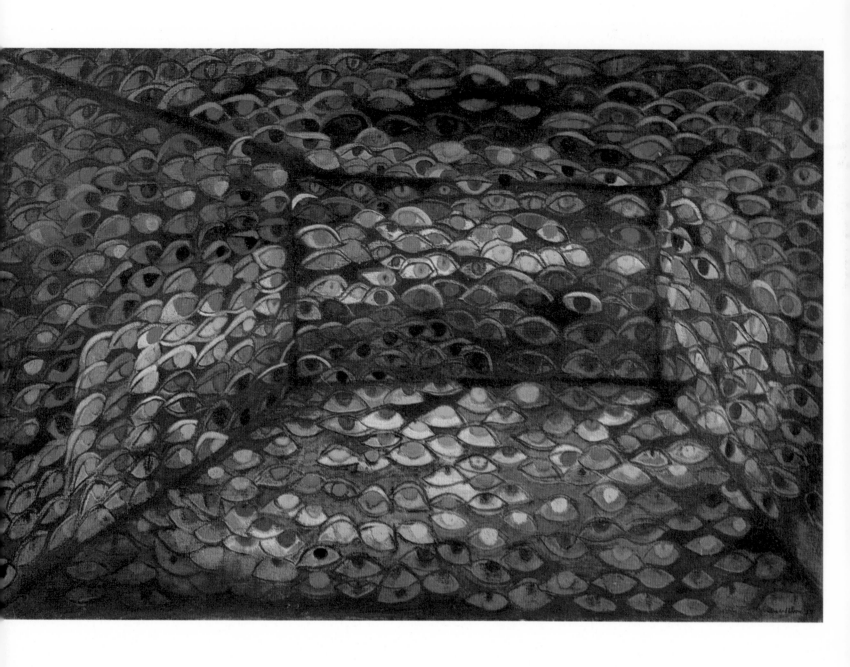

148. Dance (Lozenges). 1938. Oil and wax on canvas, 49.5×150.5 cm. The Museum of Modern Art, New York. Mrs. Charles H. Russell Fund.

149. The Optical Machine. 1937. Oil on canvas, 64×53 cm. Private collection, Paris.

color of ideas and sensations, a fluidity like that of water that washes and flows on. "If painting, oil or distemper," writes Charles Estienne, "engages all the technical possibilities of the painter in the field of material and form, thus interposing between its first gesture and its final fixing on the canvas a whole series of technical gestures that aim at simplifying, it also seeks to depersonalize or at least exteriorize the original burst, thus further removing it, for reasons of style, from the very source of expression." It is quite true that Vieira da Silva's gouaches always give us the idea that we are in contact with the most secret mechanisms of an act of creation.

Years have passed since the 1940 portrait; the harvest has ripened; the work has been accomplished. The flashes glimpsed have been set down, the colors enriched by the alchemy of paint. But the mysterious hunt goes on. The artist still lies in wait, like those night birds she loves, whose gaze functions only when it has to cross darkness and shadow, immobile milestones posted along the paths, which popular belief has made the symbol of perspicacity and wisdom.

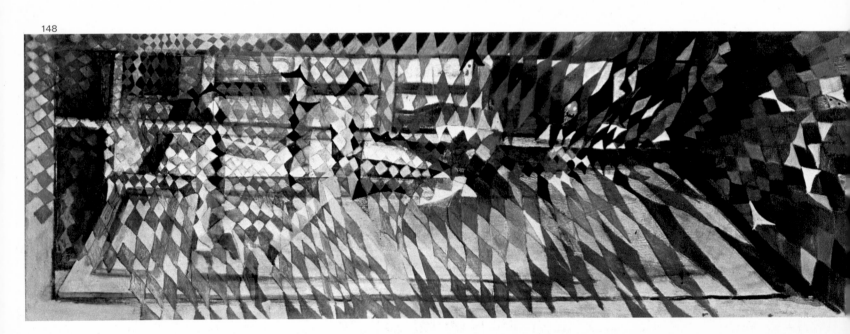

148

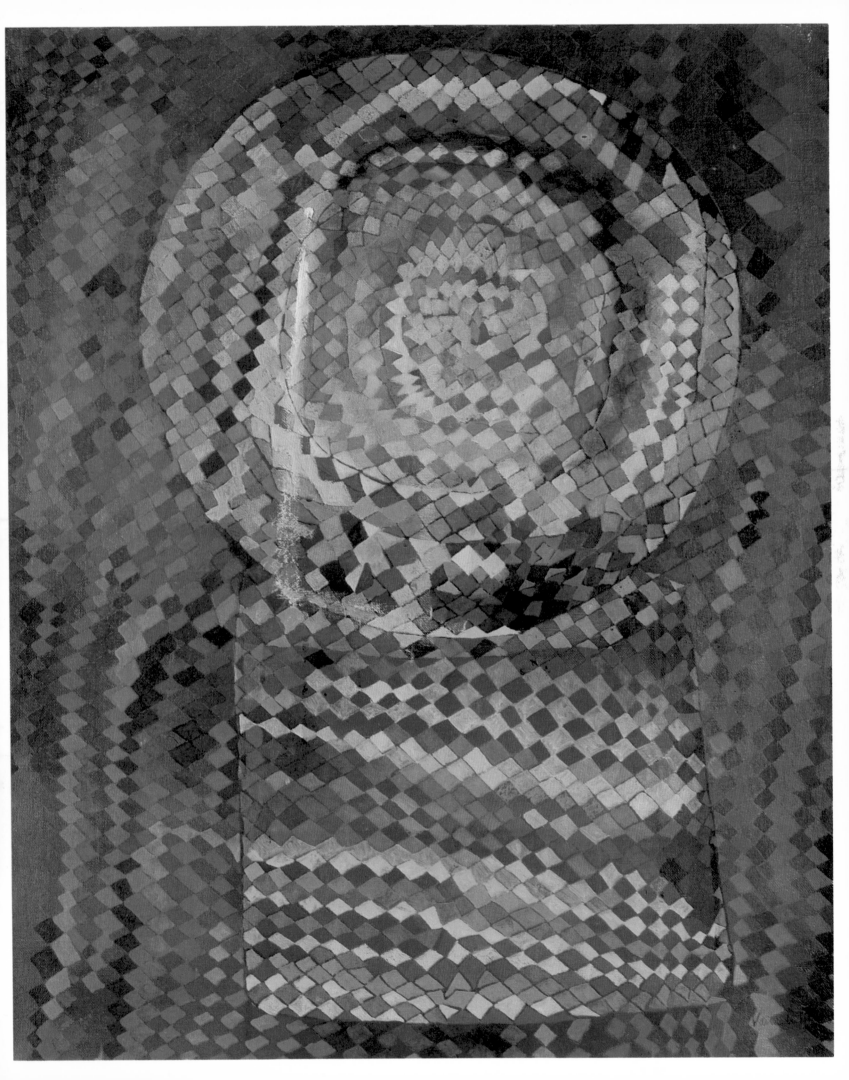

150. Rua da Esperança. Rio, 1941. Gouache on cardboard, 40.7×50.5 cm.

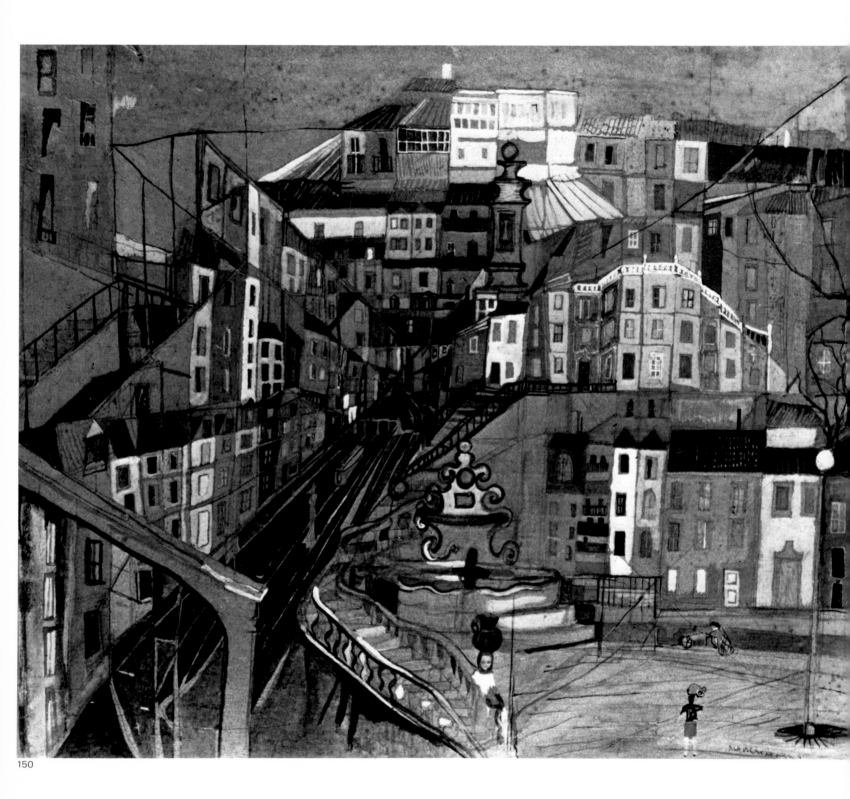

150

151. Blue Lisbon. Rio. 1941-42. Collage, gouache, and typewriter characters, 52×39 cm.
 Collection Helene Carlson, New York.

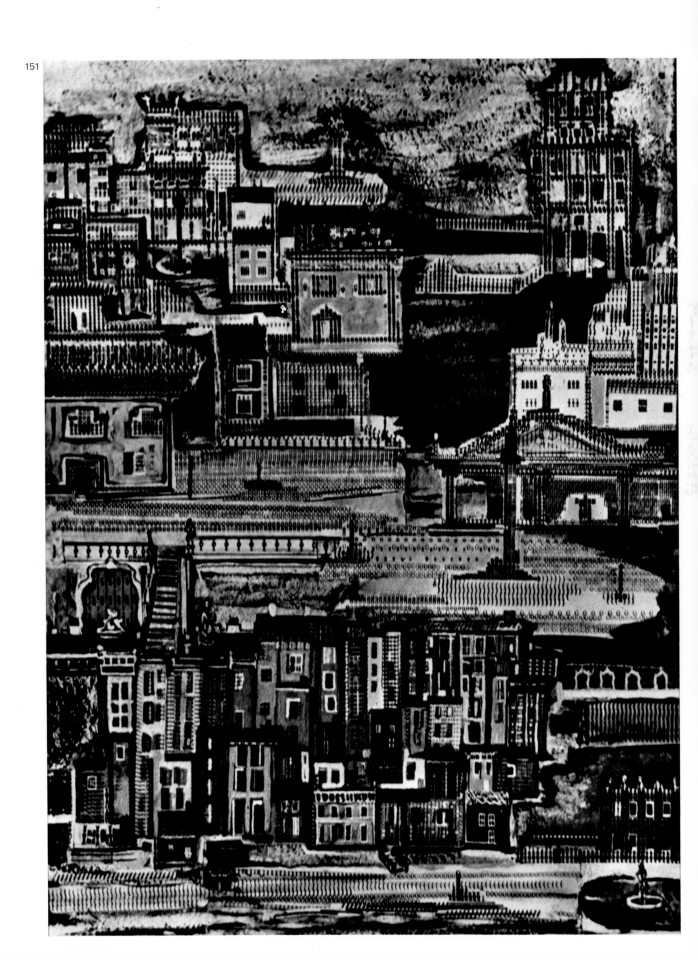

151

152. The Studio, Lisbon. 1940. Oil on canvas, 73×92 cm.
Private collection, New York.
153. The Studio (detail).

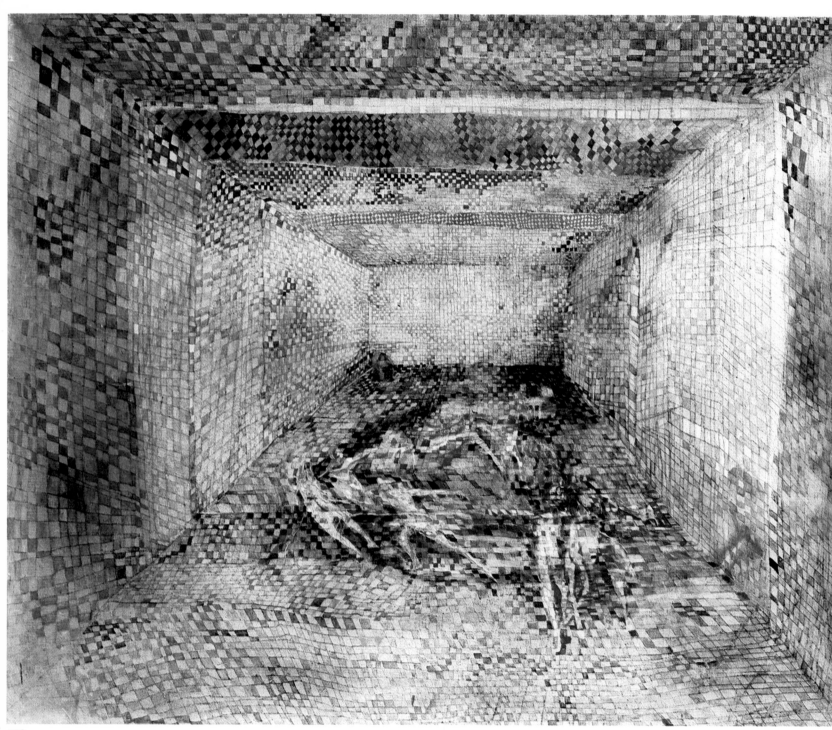

152

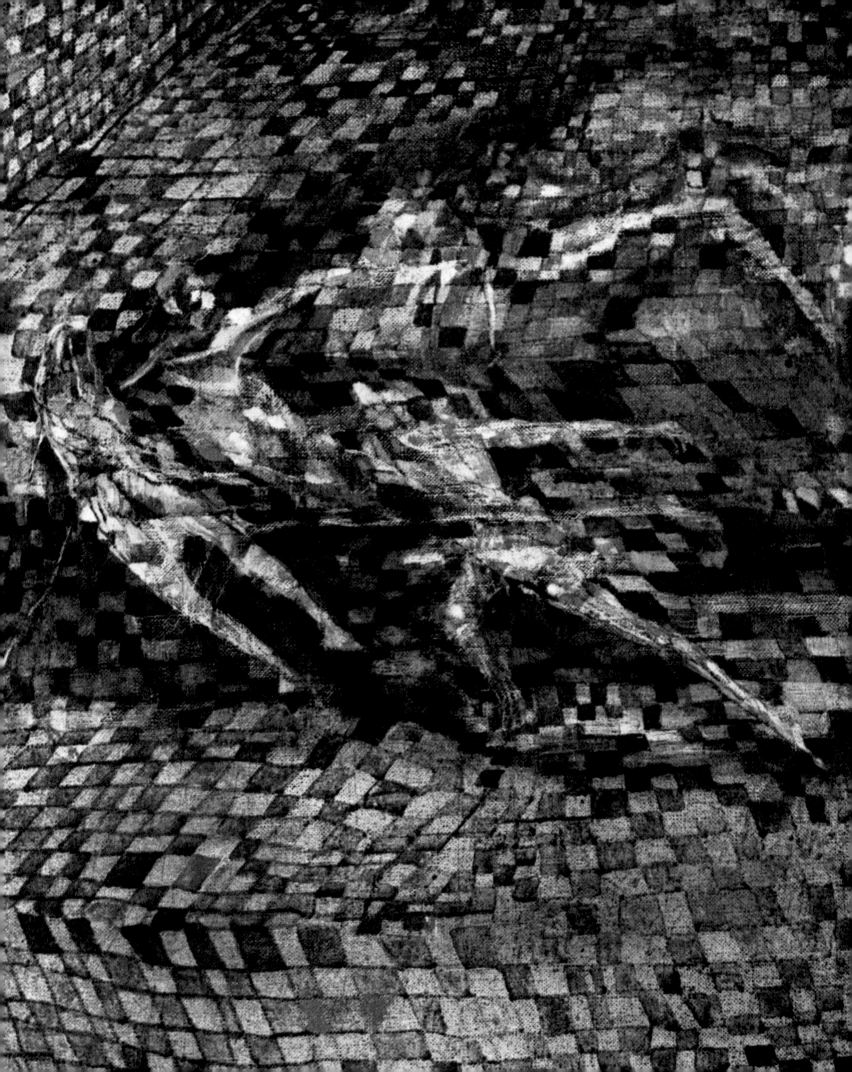

154. The Métro. 1942. Gouache on cardboard, 48×97 cm.
Private collection, Paris.

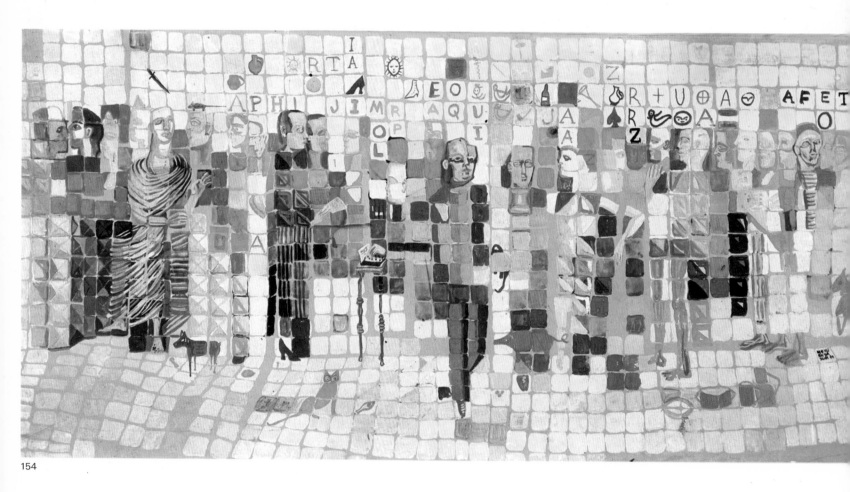

154

155. The Round Table. 1940. Oil on cardboard, 44×52 cm.
 Private collection, Paris.

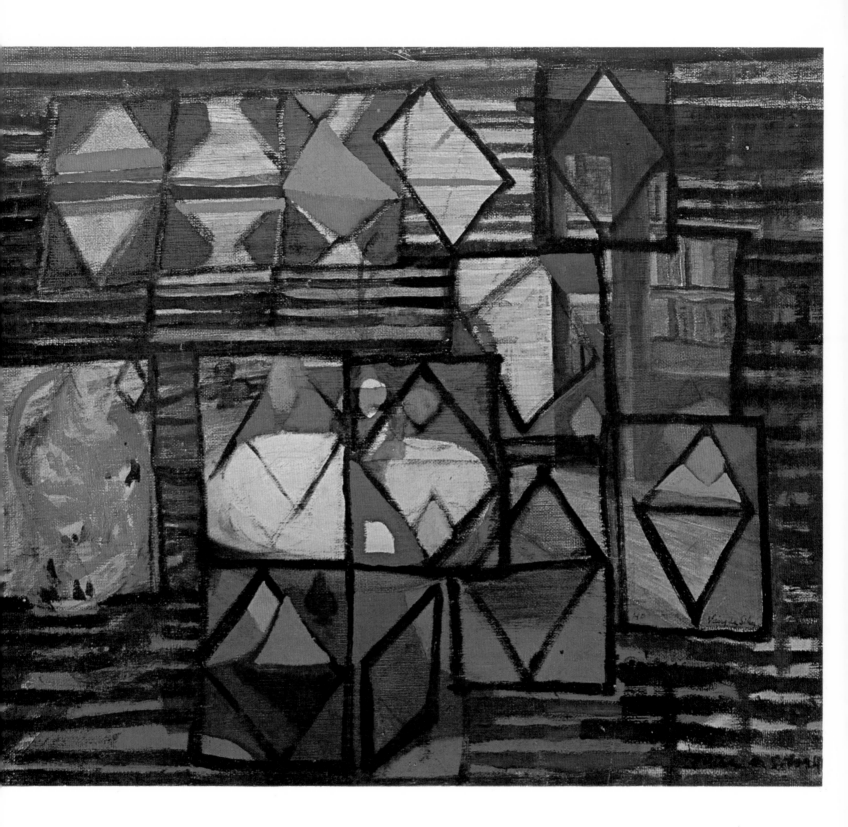

156. The Disaster. 1942. Oil on canvas, 81 × 100 cm.
Private collection, Paris.
157. The Disaster (detail).

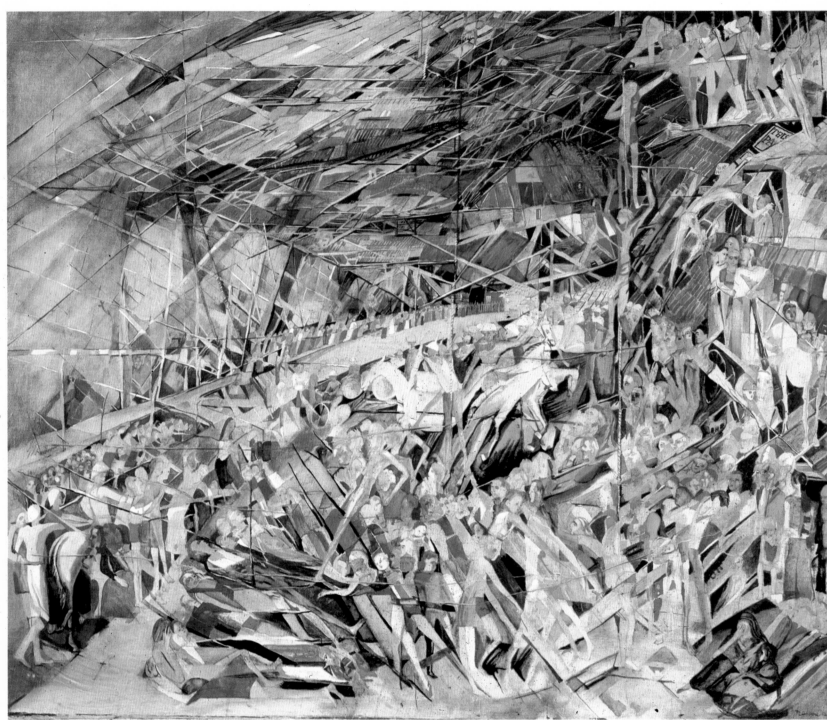

156

158. The Disaster (detail).

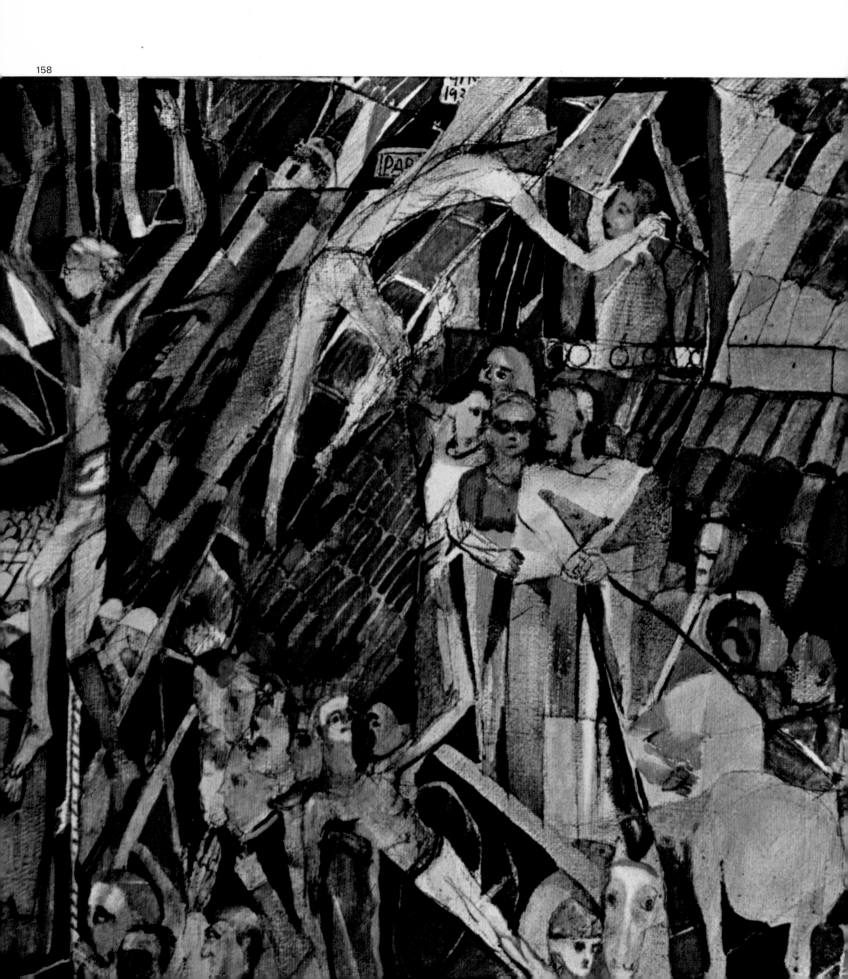

158

159. The Chess Game. 1943. Oil on canvas, 81 × 100 cm.
Musée National d'Art Moderne. Centre d'Art et de Culture Georges Pompidou, Paris.

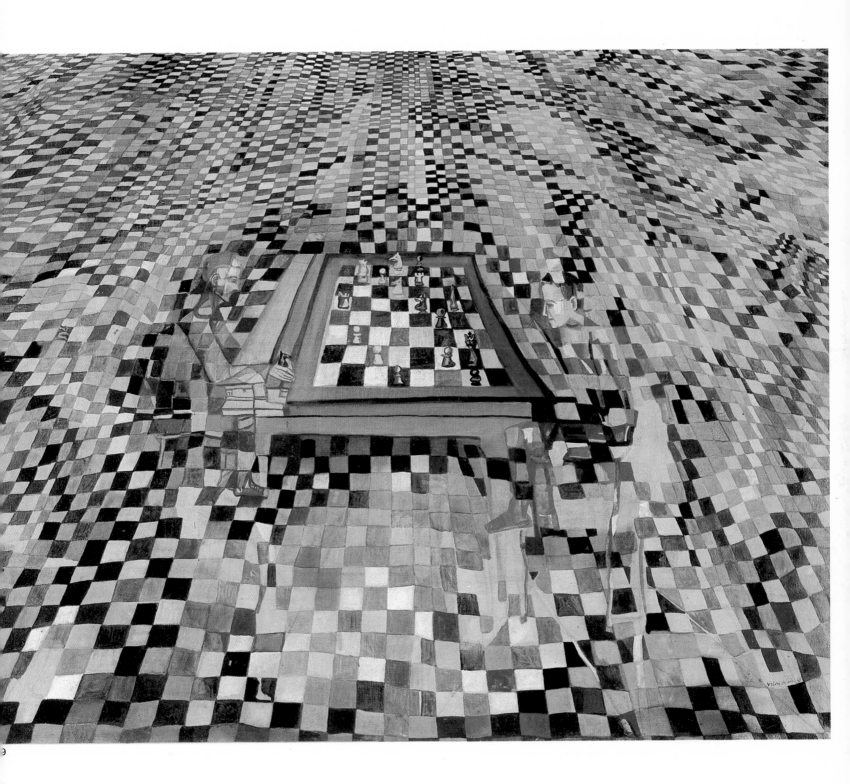

160. The Liberation of Paris. 1944. Oil on canvas, 46×55 cm.
Private collection, Paris.

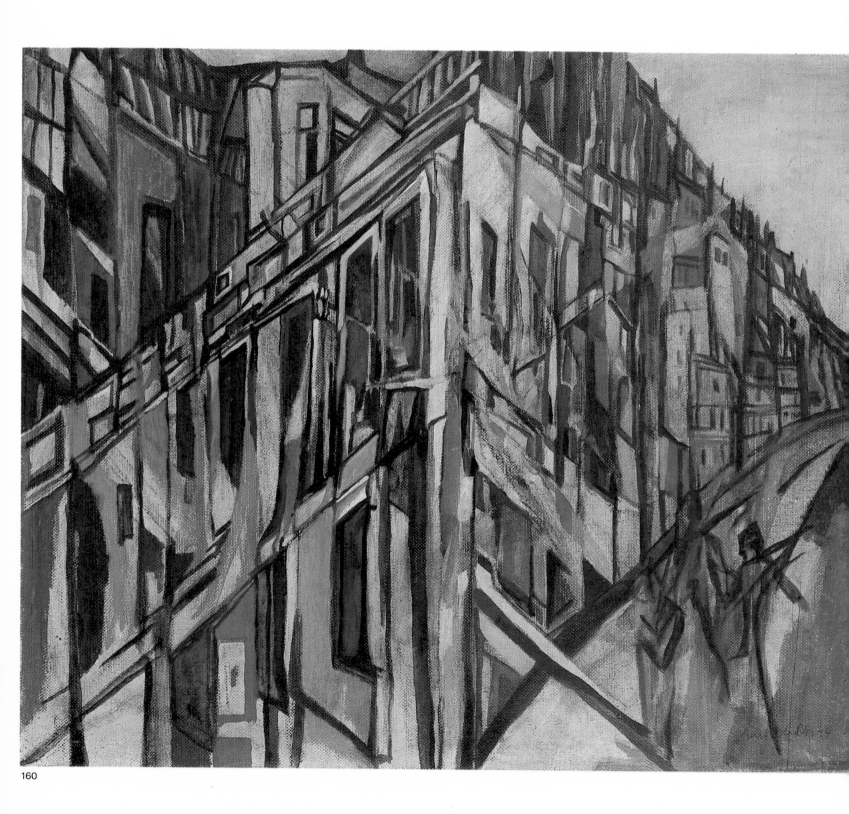

Entering the painting

I meet Vieira da Silva at a time when she is returning to painting after a long period devoted to works for publication, which required considerable research, reading, and concentration. She has even attempted to do portraits of Char and Malraux, to take Char's large head and enclose it in a network of lines, reducing it as a Jivaro Indian would do to make it fit on a small copper plate. With drawing and painting, one can take up the theme again on canvas or on paper, do it over, reduce it. With engraving, one has to try a new line, and each time do the plate again. Of course, Vieira is able to imagine the portrait in some way. She uses recollection and memory. It is easier to reproduce or translate what is there in front of you, but what a temptation it is to give form and countenance to an old impression that has become abstract, purified of reality. Vieira likes to evoke what she has never seen. She acknowledges her sources. When she has imagined war, she recalls that she was much struck at the Prado by Bruegel's *Triumph of Death.*

After this long intermission she goes back to work very timidly, a little as though to a piece of embroidery. She has trouble getting started again. Over the blank canvas she throws a net, a network of lines going in various directions and marked here and there by a pane of light, a window of color where she indicates the shade that is going to dominate the emerging painting. Here blue. "In the summer, blue predominates, as though to refresh me. In winter, it's red, as though to warm me up."

Having thus laid the foundations of her future construction, she can afford to wait for the passing inspiration that will be caught in her nets. Sometimes it is only later that she recognizes what it is. Color has a psychological effect on her, she loves it in all its possibilities. "I have often practised expressing the shades, the variations of a dominant. I've done it for every color, even for the rarest ones, the most seldom used, like yellow. One has to have a very large range of possibilities at one's disposal." Thus, for example, she has just finished a watercolor of 1948, a work as light as a garden of *azulejos.*

But something was missing in it. She has just realized that it was white, since the blank paper, which plays an important role in her watercolors, was no longer sufficient, the paper having yellowed with time. In order to complete it in 1975, therefore, she had to add white paint.

161. Bahia Imagined. 1946. Tempera and oil, 92×73 cm. Private collection, Lisbon.

Vivid colors are not in her nature, but they attract her and she sometimes tries them. When she goes to the paint store, she opens the drawers and stands there fascinated by all the possibilities. In the end, she uses many shades. For her tapestries for the University of Basel, no less than seventy-four wools were required to convey the nuances of her cartoon for the first tapestry. And twenty-four more for the second, or almost a hundred colors. And it is a basically gray work that looks hardly colored at all.

Great colorists — Matisse, Bonnard — write their theories of color in their paintings. Each of their works is like an open book. Matisse is more scientific, but with Bonnard there are miracles. "I remember a still life in the museum in Basel with very light yellow and pink. On a book it says: *Venus.* These are indeed the colors of Venus. Each of Bonnard's paintings has a dominant pushed to the extreme. There are little spots of other colors, pure, barely visible, as though lost."

At a given moment, when Vieira was painting a great deal, she would become exalted, letting herself go in gestural painting, her brush sensitive and nervous. The calm studio of

Yèvres puts her back into peaceful surroundings, where she paints in a more logical and deliberate fashion. She brings up the subject willingly. The truth is that she hates gestures, virtuosity, brio. She does not like beautiful brushwork; what matters to her is something else.

She is pleased with a painting when she feels small enough to enter it. That is why she prefers large canvases, which she finds easier to do well than small ones, because she can move around in them at her ease, as though she were one of the figures she is painting. She needs a space in which she can walk. There she feels herself to be the size of a fly. "Once I was working on a 100 F* and I was doing tiny houses in a landscape of small caves. Suddenly I saw that a very little spider had strung two threads in front of the canvas and was climbing up the façades. It had found the landscape to its scale. I went along with it."

Vieira is much affected by music. Music alters her way of seeing, reveals to her new and unexpected colors. Without this appeal, she would remain locked in a descriptive pictorial world of a respectable, noble, Iberian tradition, a little like

* "100 F" is a size of canvas: 162 × 130 cm.

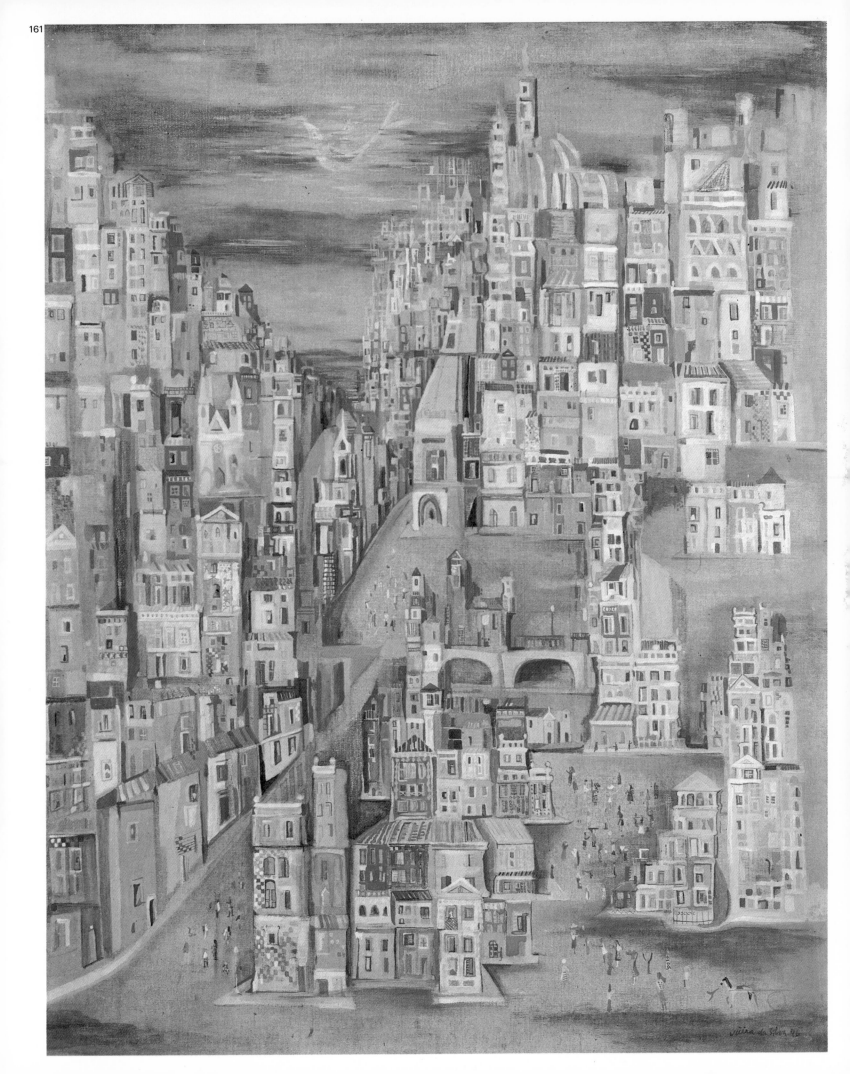

162. The Fire I. 1944. Oil on canvas, 81×100 cm.
Private collection, Lisbon.

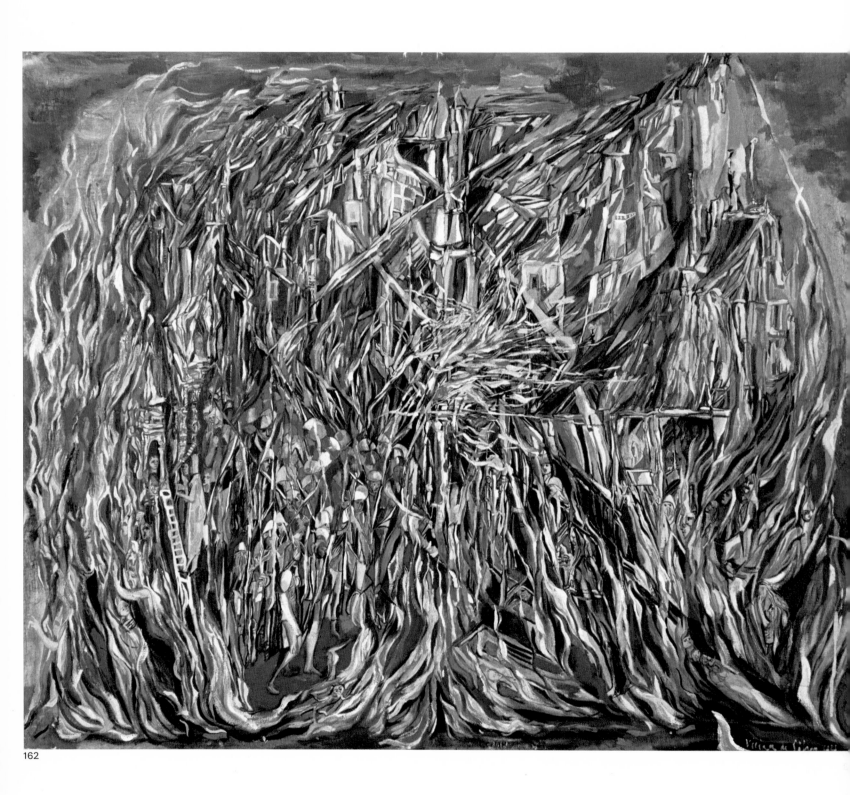

163. The Forest of Errors. 1941. Oil on canvas, 81×100 cm.
Collection Marian Willard Johnson, New York.

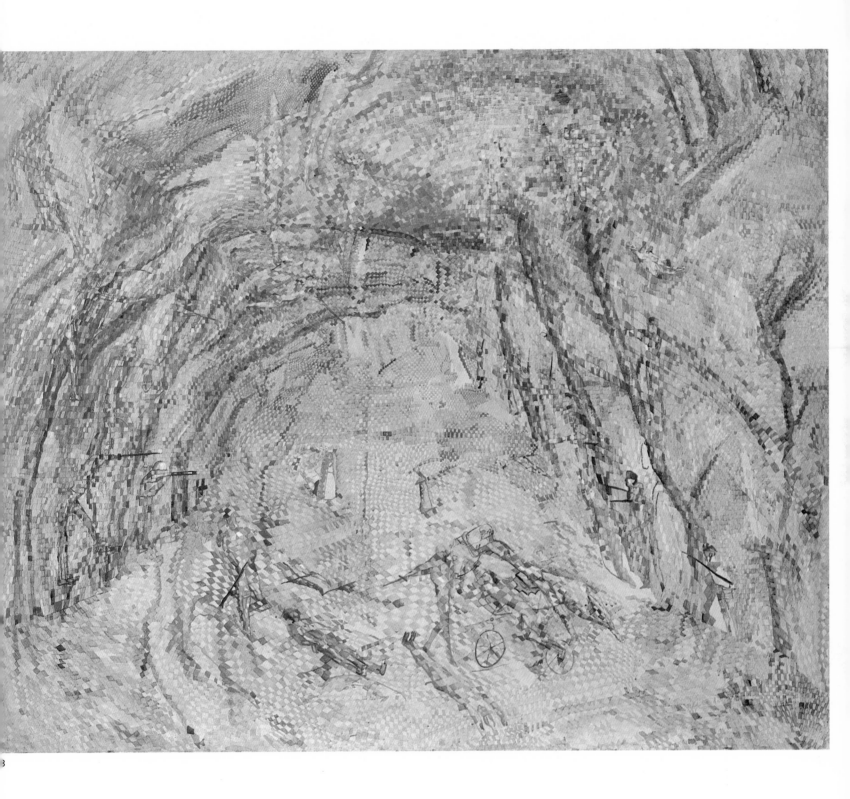

164. Enigma. 1947. Oil on canvas, 90×116 cm.
Private collection, Paris.

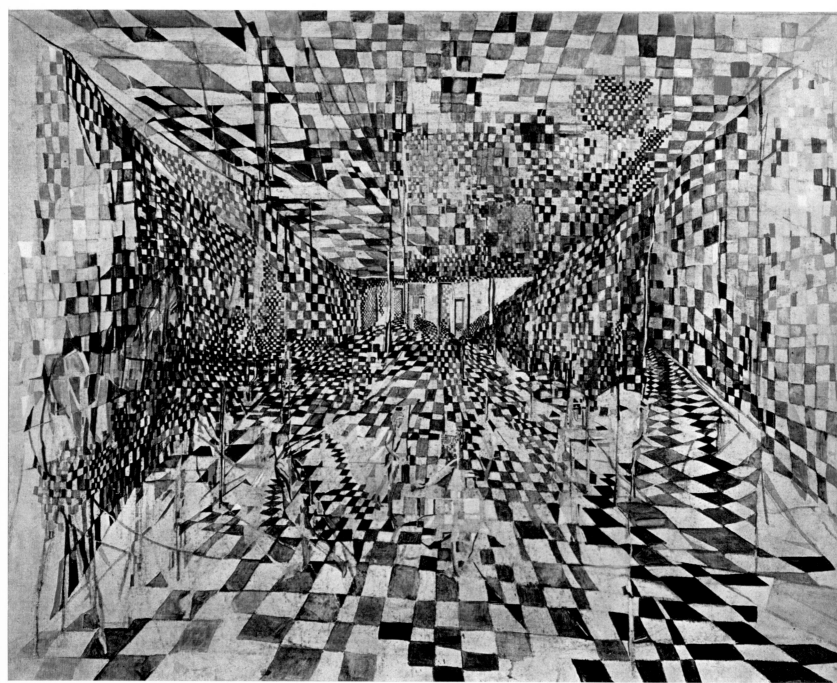

164

165. The Doors. Paris, 1947. Oil on canvas, 27×46 cm.
Collection René Verdier, Villeneuve-sur-Lot.

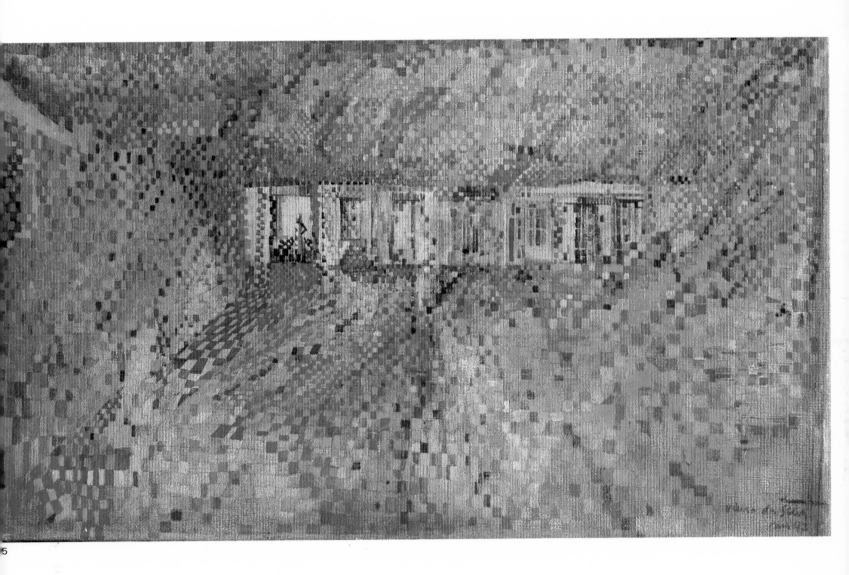

the one that Manet had gone to look for in Madrid in the works of Veláz-quez. Music and the discovery of the Middle Ages revealed to her that there were other times. She set out on her search for the guiding thread, and in Paris she discovered Cézanne.

For her the revelation was *The Card Players.* At a time when there was beginning to be talk of a social art, of an art for the people (1936), she was dazzled by the discovery that no one had ever been closer to the people, to more people, than this bourgeois Cézanne.

"Matisse said that for him the plumb line meant a great deal. For me too there must be a vertical element rising in front of me. The painting must be tense and I must make every effort to achieve that tension, even if I can only do it a little bit at a time. For me there is never too much chemistry."

The canvas rises in front of the painter, but the world he inscribes there is the one he sees from above, from on high. But it could also be the one he sees from underneath, upside down, a cloudy sky with gaps of light.

166. Egypt. 1948. Oil on canvas, 60×73 cm.
Private collection, Paris.

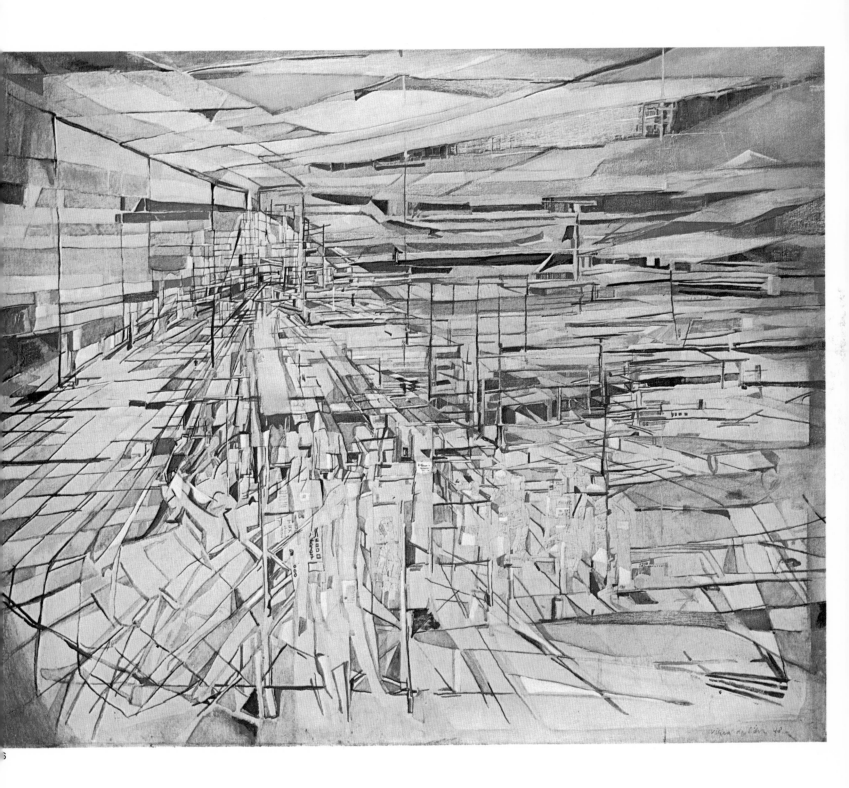

167. Endless Corridor. 1942-48. Oil on canvas, 81×100 cm.
Collection Mrs. E. Sander, London.

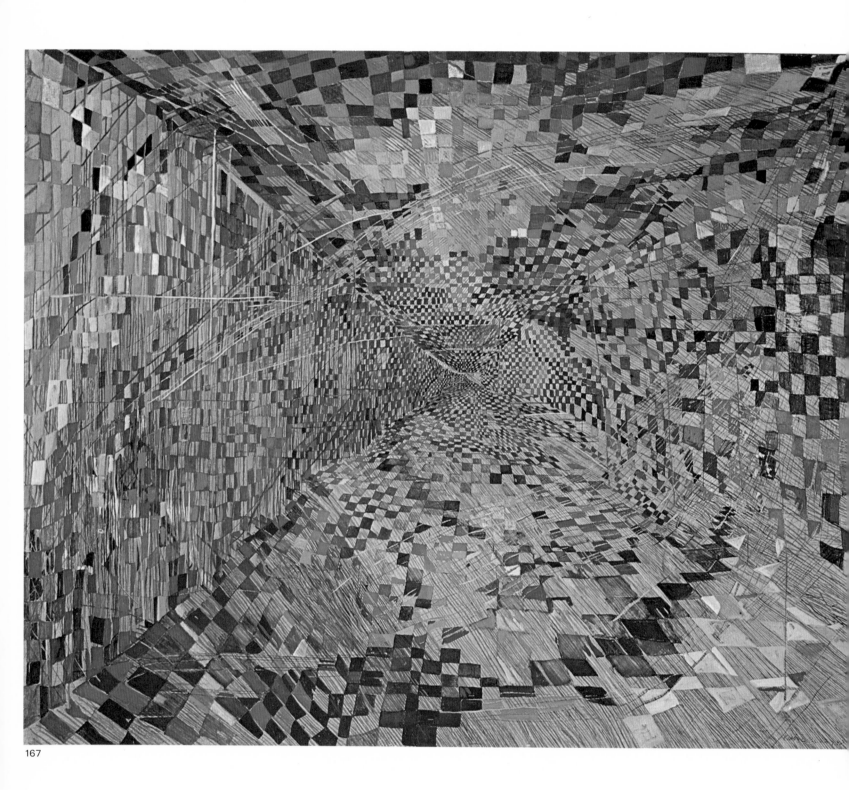

167

168. Delft Tiles. 1948. Oil on wood, 73×92 cm.
Private collection.

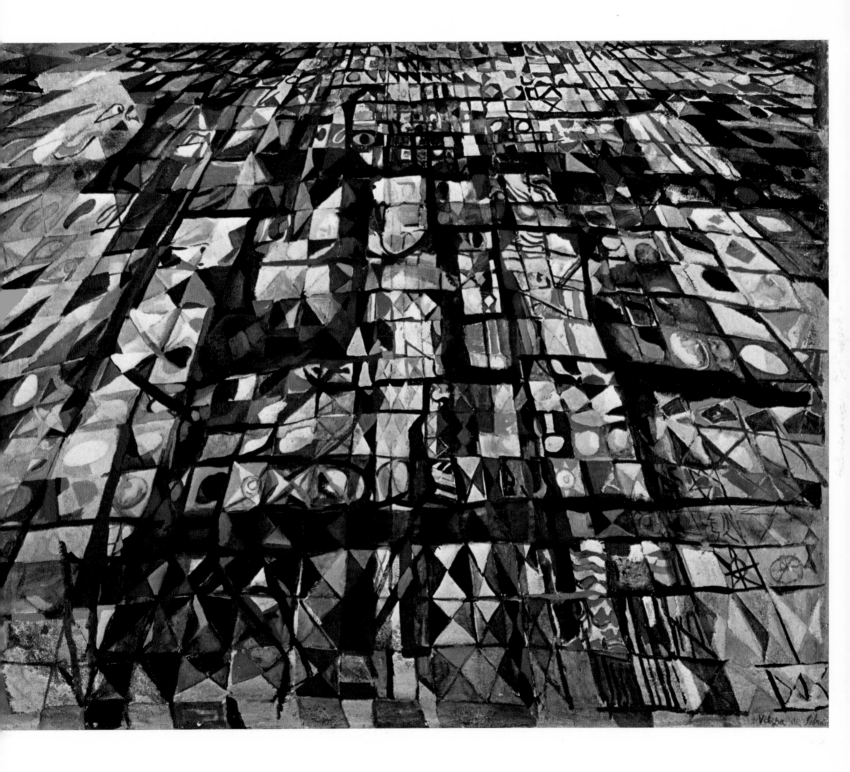

169. The Card Players. 1947-48. Oil on canvas, 80×100 cm.
Collection M. and Mme Louis Franck, Neuilly.

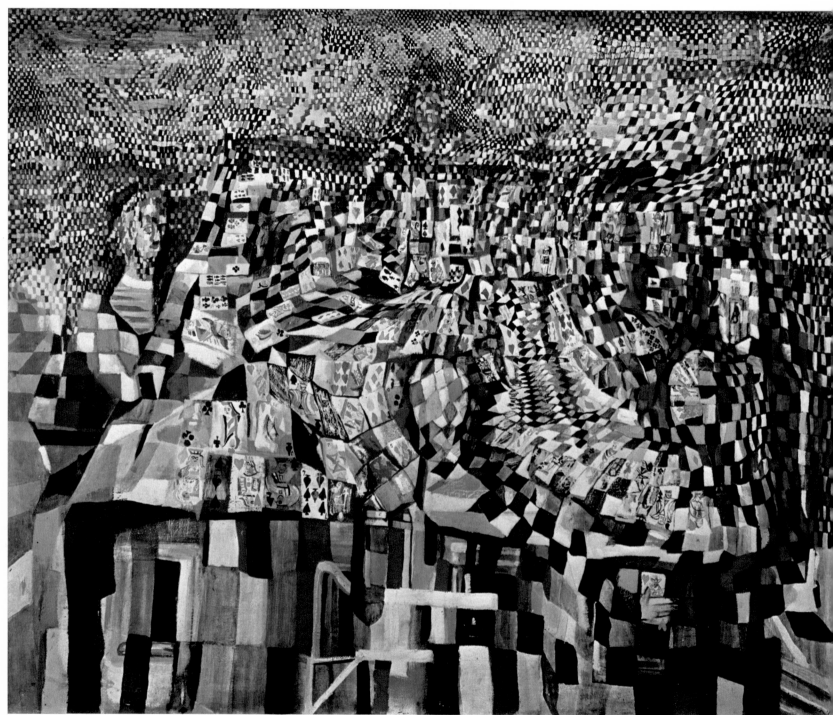

170. The Battle of the Knives. 1948. Oil on canvas, 73×92 cm.
Boymans-van Beuningen Museum, Rotterdam.

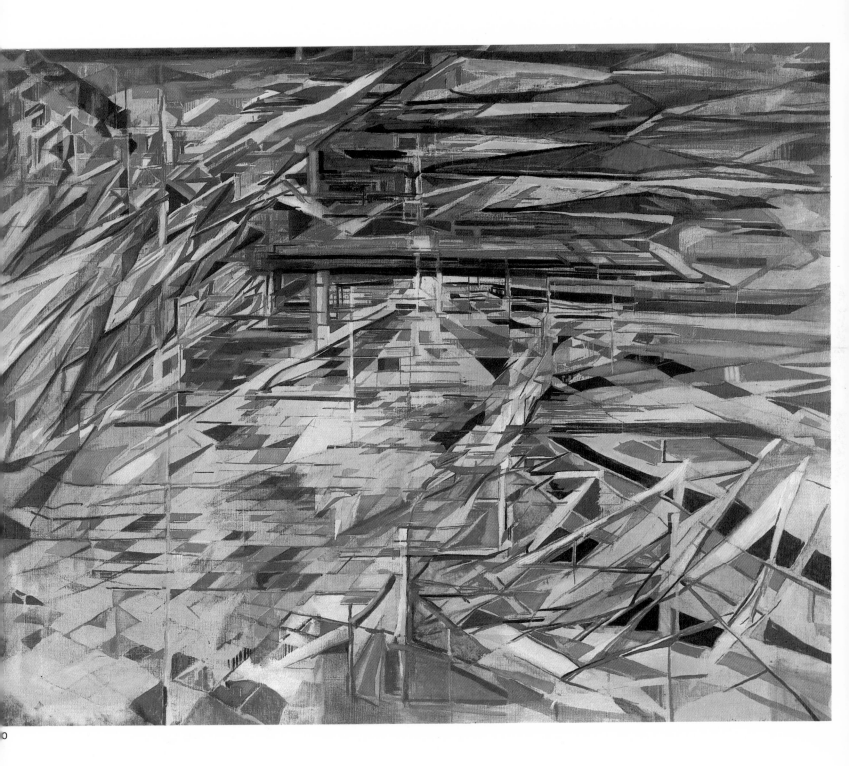

The creative operation

What mysterious mechanism triggers the work of art? One can seek — and most often find — the motif that has served as pretext for the painter, but this is nothing but a point of departure: the real creative operation lies in himself.

At the origin of Vieira da Silva's work there was probably the memory of the tiered architecture of her native city, vertical planes where thousands of nests opened; and on the other hand her constantly renewed meditation before a corner of the studio transformed by predominantly blue porcelain tiles into a colored vista opening on the infinite. Other motifs can be detected: the suspension bridge in the old port of Marseilles, the elevated métro of Paris with its winding curves halfway between sky and earth, the flooded railroad stations. But her architectures, her surroundings, her structures contain a world of flesh that throbs and claims its due by its very existence. "I look at the street," the artist writes, "and see people passing on foot or on various machines, at various speeds. I think of the invisible threads that pull them. They don't have the right to stop. I no longer see them, I try to see the mechanism that moves them. It seems to me that that is perhaps a little of what I am trying to paint."

Thus, in spite of her solitude as an artist, Vieira da Silva penetrates into the cells of the human beehive, there where beings agglutinate like grains of sand on the beach, and her mere presence creates a fraternity between her models and the spectators, between the outside and inside worlds; to the immobility of death, the indifference of nature, she opposes rhythms and movements that are the foundation of life.

Even more than these visual and tactile impressions, there are the feelings experienced by the artist, and with such violence, in the face of injustice, threats of oppression, the weight of stifling forces. There is no gap between her moral attitude and the offerings of her hand and vision.

In her most ethereal architectures real presences crop up like faded figures, to give the scale and significance of the work, and of these sometimes nothing remains but reflections without depth, like luminous filaments.

One thinks of Piranesi's *Prisons,* those "semi-hypnotic" works, as Marguerite Yourcenar called them, in which one would say that between two glances the figures have moved, disappeared, or emerged, and that

171. The Weavers. 1936-48. Oil on canvas, 97×146 cm.
Private collection, Paris.

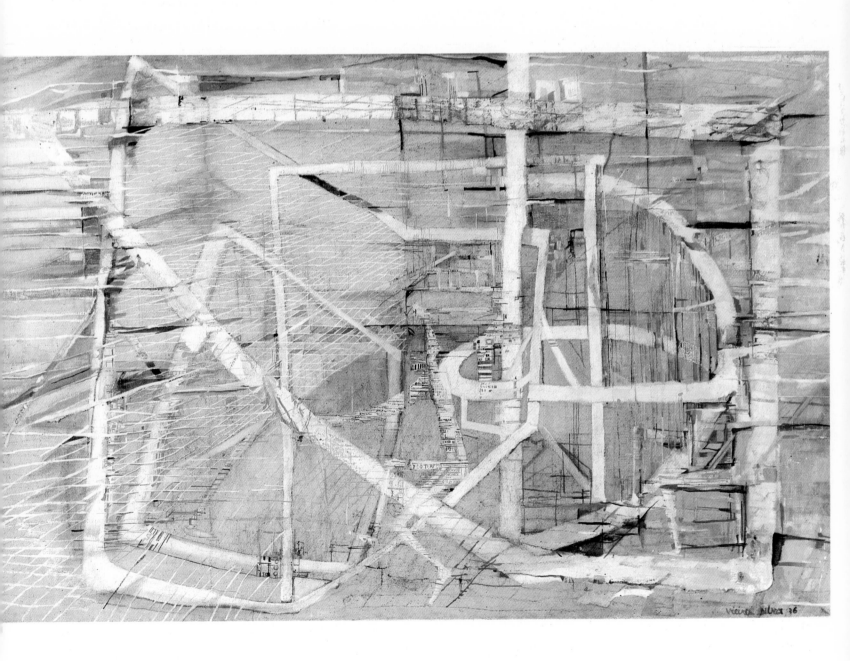

172. Rain. 1949. Oil on canvas, 62×92 cm.
 Private collection, Düsseldorf.

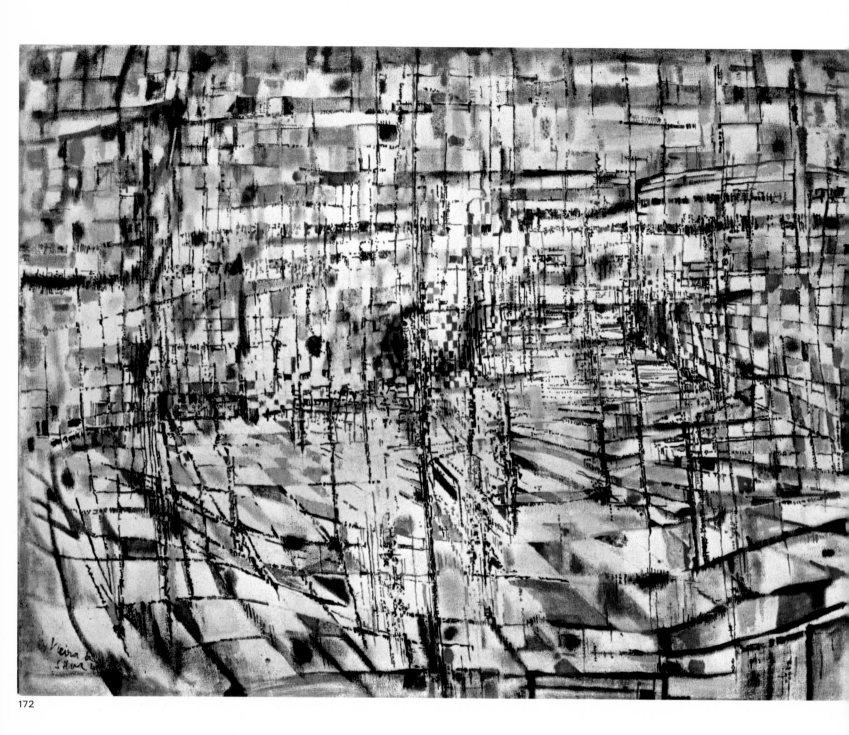

172

173. Normandy. 1949. Tempera on canvas, 41×46 cm.
Galerie Jeanne Bucher, Paris.

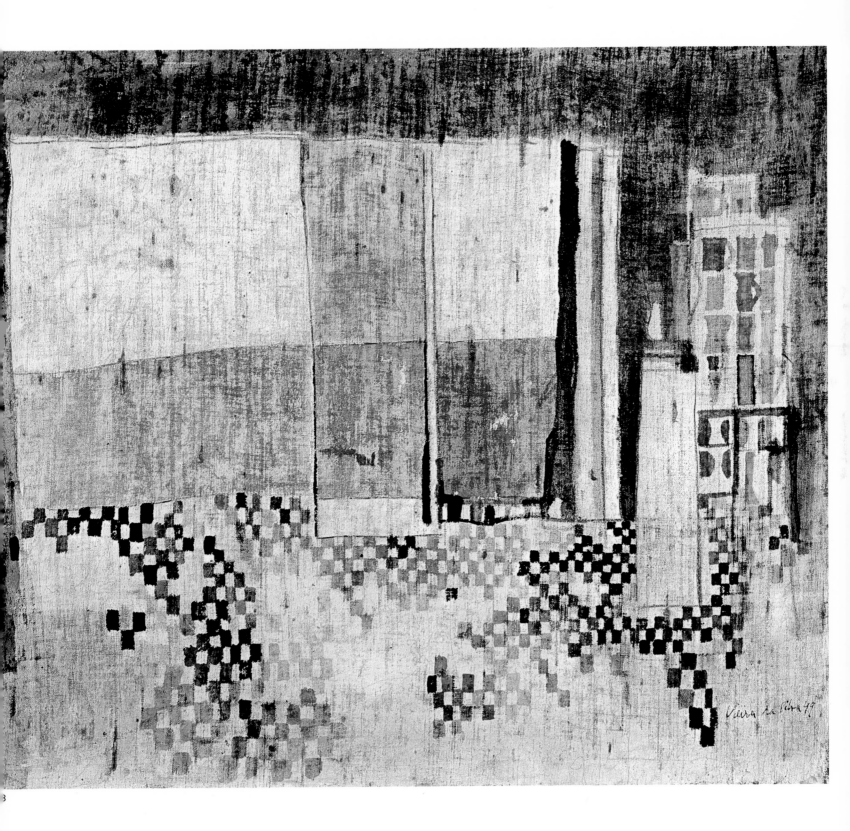

the very places have mysteriously changed.

Interpreting a work of Vieira da Silva requires successive viewings. Each new attempt reveals more underlying patterns, and these are constantly modified by being psychologically overdetermined. Like those fleeting figures of whom only a trace remains in the atmosphere, the painter is present at the heart of her canvas in a maze, a labyrinth of perspectives that lie on different axes. Its dynamism makes the surface burst into fleeing lines, like arrows cleaving the space to reach the depths.

One could not conceive painting more faithfully traced from the development of a thought, with its retreats, its stops at crossings, its narrow corridors, its underground caves, its sudden astonishment. This art is always in mutation, it accepts no limitations, no ending. If it is, however, given to us once, it is in a state that lends itself to new developments that the spectator will himself be able to provide. To be sure, he receives the shock at the moment chosen by the artist, but he may add to it later by the discovery of details and secrets that are not perceptible at first sight but are revealed by progressive familiarity with the work itself. The work is not precisely fixed, or is so only apparently, containing as it does potentialities that are never exhausted.

Vieira da Silva proceeds at first by fairly strong statements, charged with nuances hauntingly and insistently superimposed. Under the light of the imagination, the forms break down into proliferating triangles or squares, whose facets attract and retain subtle and varied colors. The sadness and poverty of the everyday environment are clothed in magical garments. Surpassing their raw state, objects encounter strange kinships: the chessboard is like a tangle of plowed fields; books in the library align themselves as red flames, and the piano divides into glittering sonorities. Beings and objects are then very different from what one had thought one was seeing. In constant metamorphosis, they evolve outside of all logic, escaping their own gravity, and the canvas has become, in René de Solier's apt words, "the place of the hybrid."

But these means, which divulge the richness of the artist's temperament, are constantly dominated by her will. The composition, compact as it is, becomes lighter each time she takes

151

it up again. The colors remain only on spaced tiers. Suggestion becomes indirect, remote, dreamy. Integrating and effacing herself in worlds whose most intimate vibrations she has perceived, the artist communicates to them in her turn the dimensions of her soul. Space is created, immense and deep, superlatively organized. Without abandoning her horizontal deployment of perspectives, her meticulous repetitions with graduated variations, Vieira da Silva counteracts any dispersion by means of powerful and skilfully constructed vertical columns. Grave harmonies resound along their vibrating chords. These lines organize the surface by the distribution of the different groups that constitute it, creating a constant relation between the diverse elements thus individually defined and the macrocosm that they constitute between them.

For everything that lives, human beings, animals, flowers — the objects themselves change — Vieira da Silva expresses love and passionate curiosity, and she would like to introduce them into the work she paints. But unlike collages of outside elements superimposed as such on the canvas, she wants all these small representations of the outside world to be integrated in the canvas, to be directed and digested by the general composition, and become interior.

174. Building Site. 1950. Oil on canvas, 81×100 cm.
Galleria Civica d'Arte Moderna, Turin.

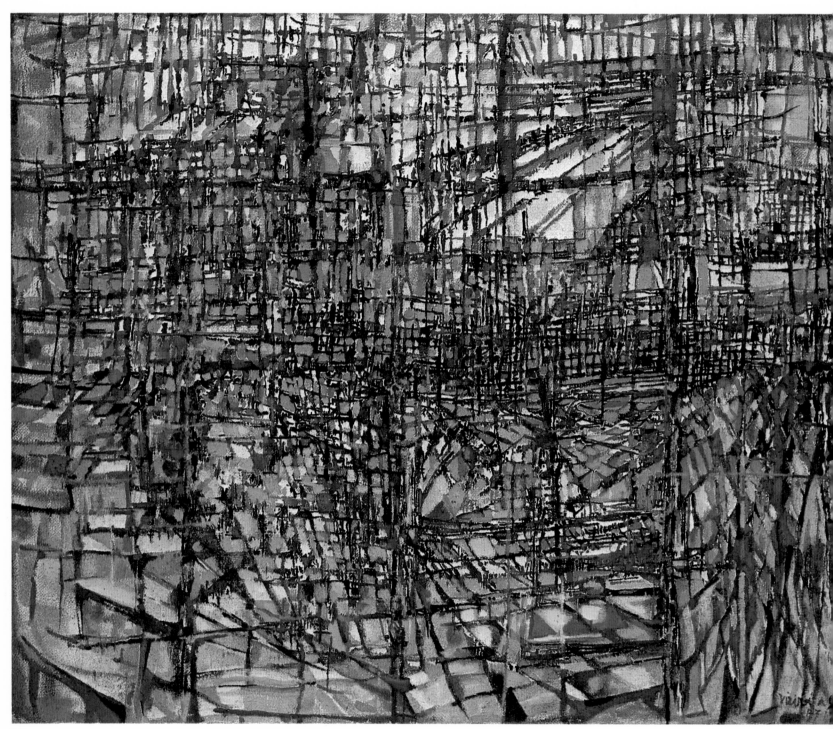

174

175. Interior. 1948. Oil on canvas, 24×27 cm. Private collection, Paris.

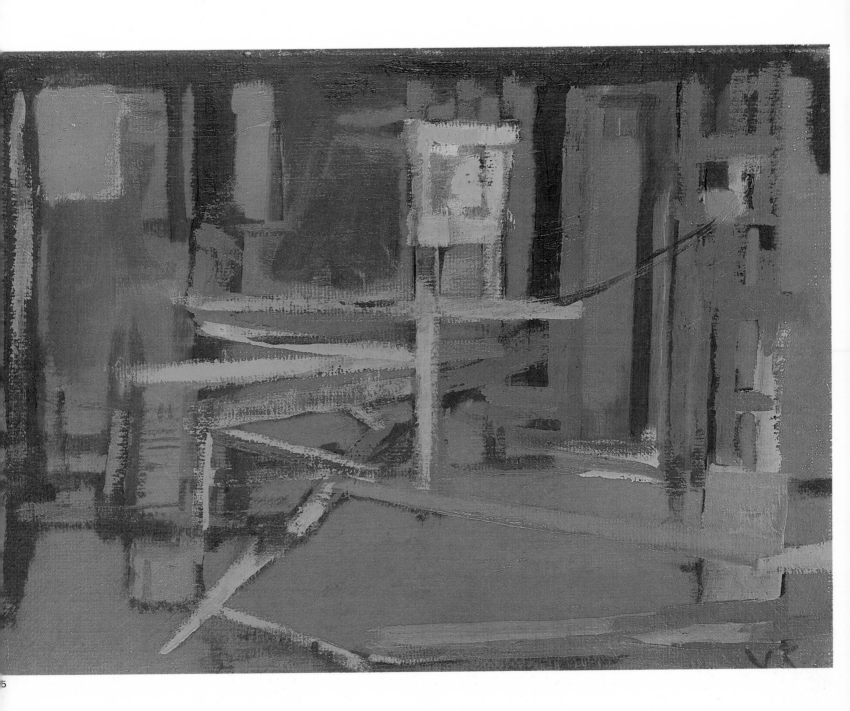

176. Voilà. 1949. Watercolor and typewriter characters on paper, 12.5×17 cm.
Collection Collinet, Paris.

177. Carmo. Paris, 1949. Watercolor on paper mounted on cardboard, 24×19 cm.
Private collection, Paris.

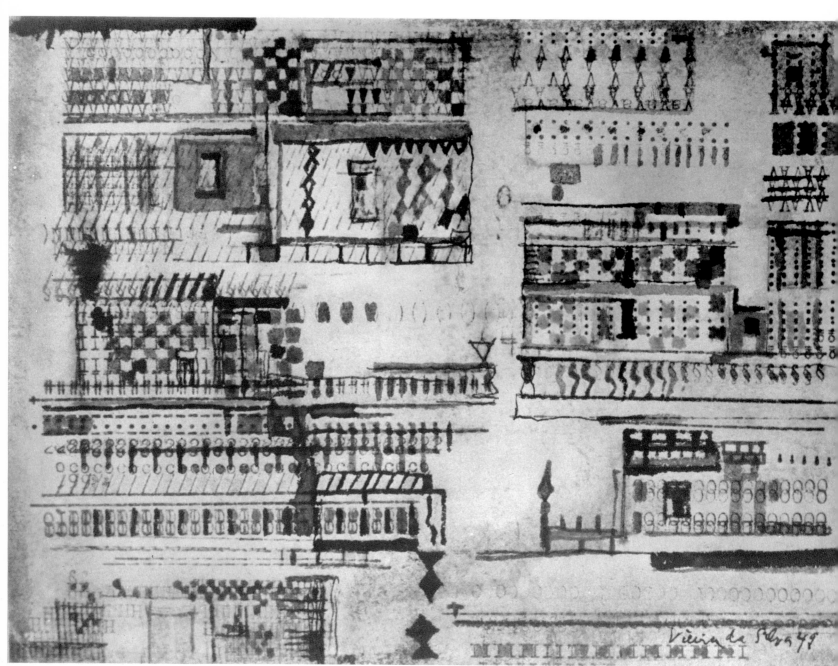

176

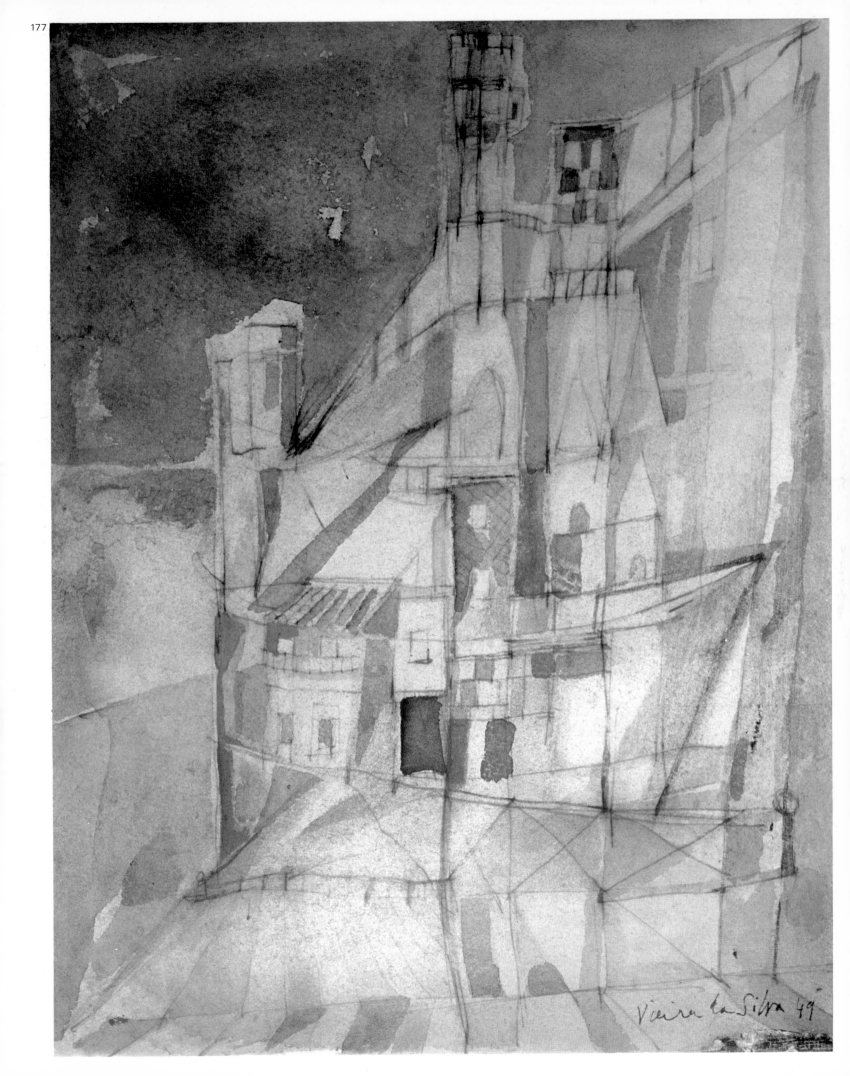

Vieira da Silva 49

178. Untitled. 1949. Gouache on canvas, 45.5×38 cm.
Private collection, Lisbon.

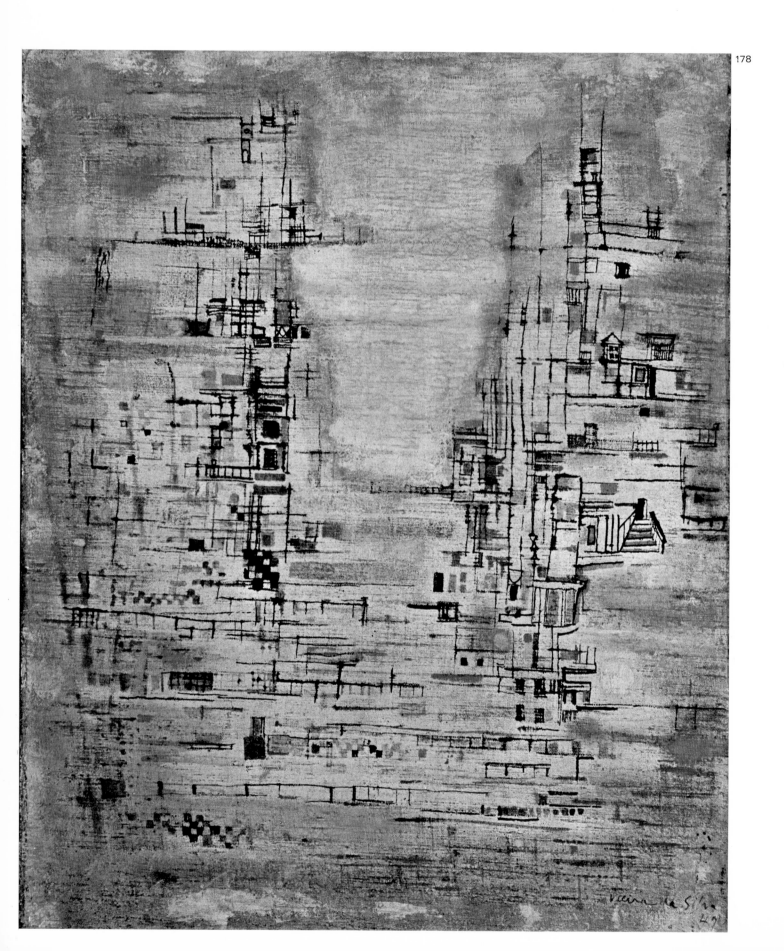

178

179. Painting. 1949. Oil on canvas, 65×80 cm.
Private collection, Lisbon.

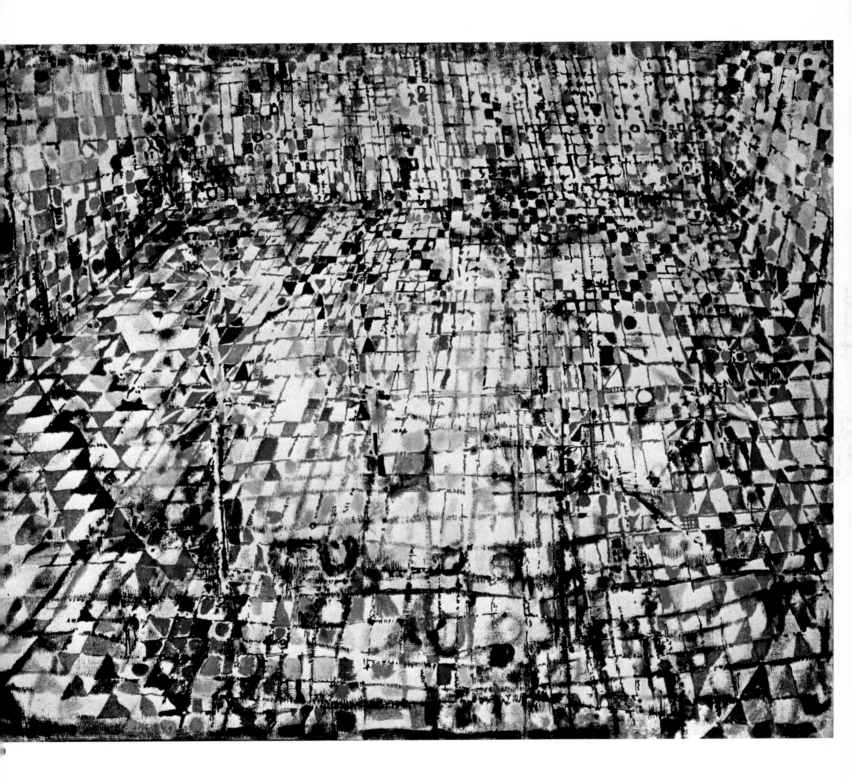

180. Composition (The Dream). 1949-50. Oil on canvas, 130×180 cm.
Private collection, Lisbon.

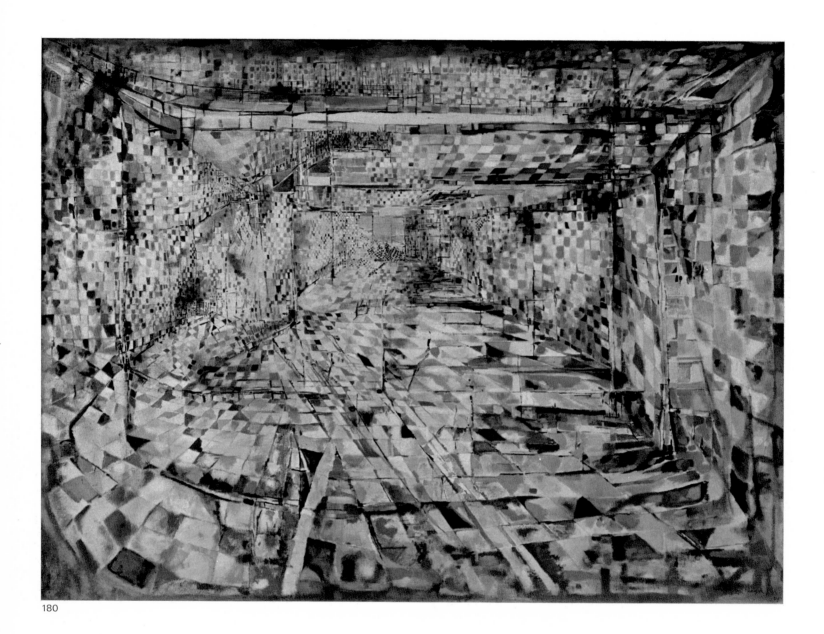

180

181. The Angels' Watch. 1950. Oil on canvas, 60×92 cm.
Private collection, Lisbon.

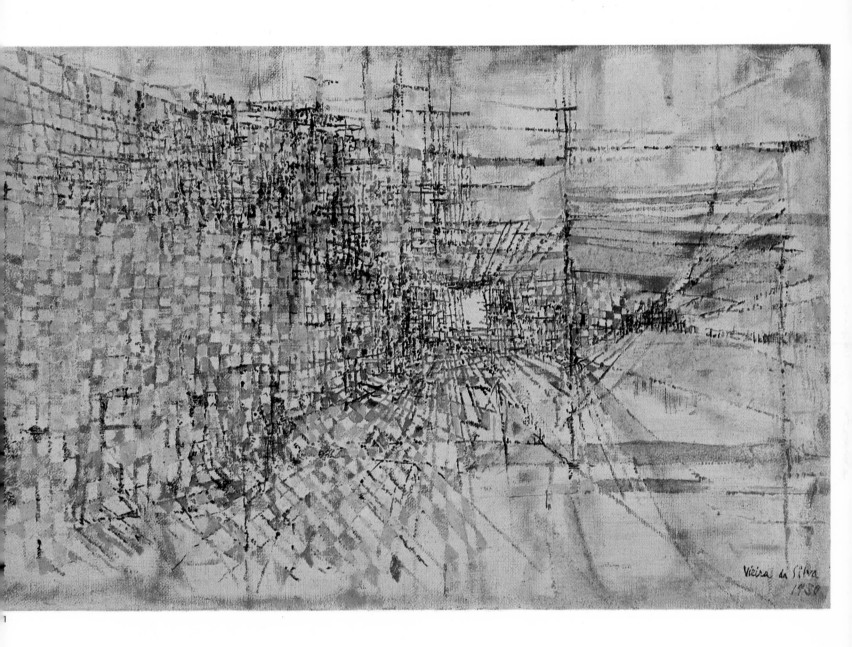

182. Manor in Sologne. 1949. Oil on canvas, 50×61 cm.
Collection Collinet, Paris.

183. The Aviary. 1950. Oil on canvas, 81×116 cm.
Collection G. Desmouliez, Montpelier.

184. Arenas. 1950. Watercolor on paper, 50×65 cm.
Collection Collinet, Paris.

185. The Mirage. 1949. Watercolor and typewriter characters, 14×18.5 cm.
Collection Marion Lefebre Burge, New York.

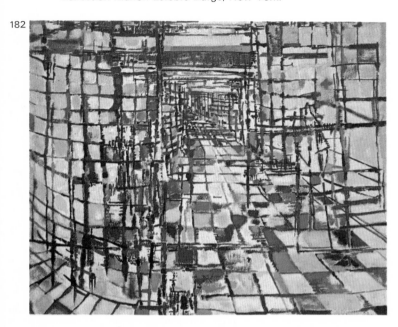

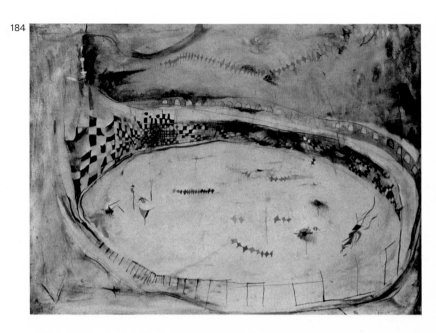

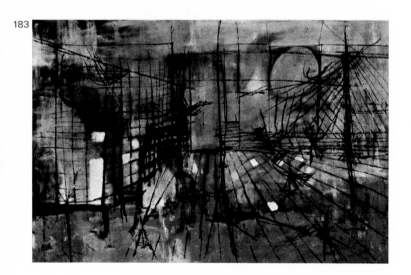

186. Checkmate. 1949-50. Oil on canvas, 89×116 cm.
Private collection, Paris.

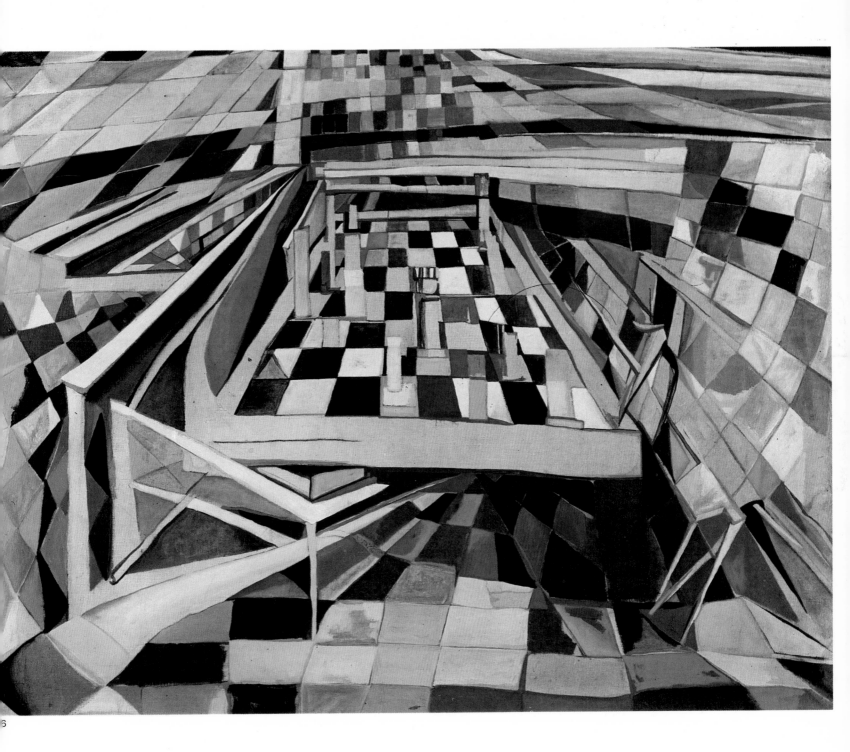

187. Library. 1949. Oil on canvas, 33×55 cm. Private collection, Lisbon.

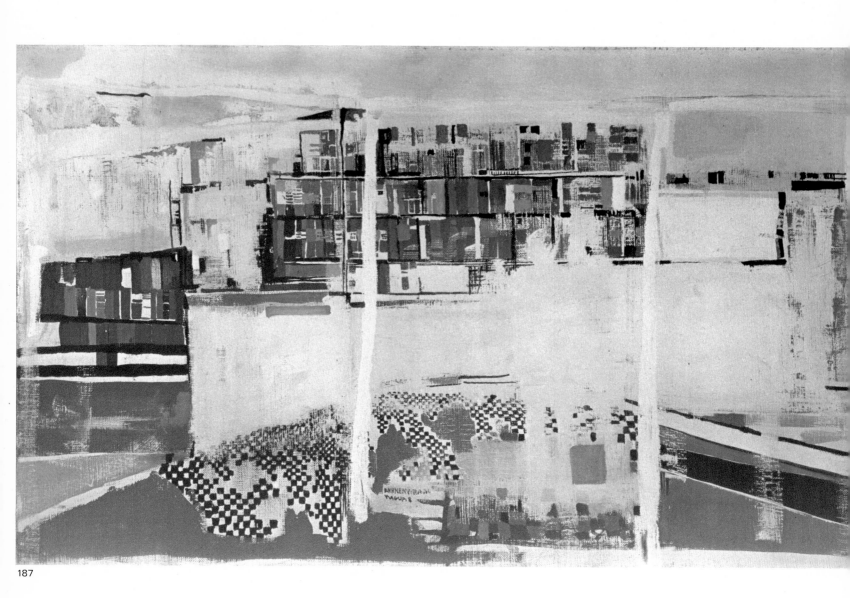

187

188. Interior of a Room. 1949. Oil on canvas mounted on fiberboard, 28×36 cm. Private collection, Paris.

189. Untitled. 1950. Gouache on cardboard, 27.5×17 cm. Collection Mme Haas, Paris.

190. Music. 1950. Gouache on canvas, 50×37.5 cm. Collection Dr. C. Bouvier, Geneva.

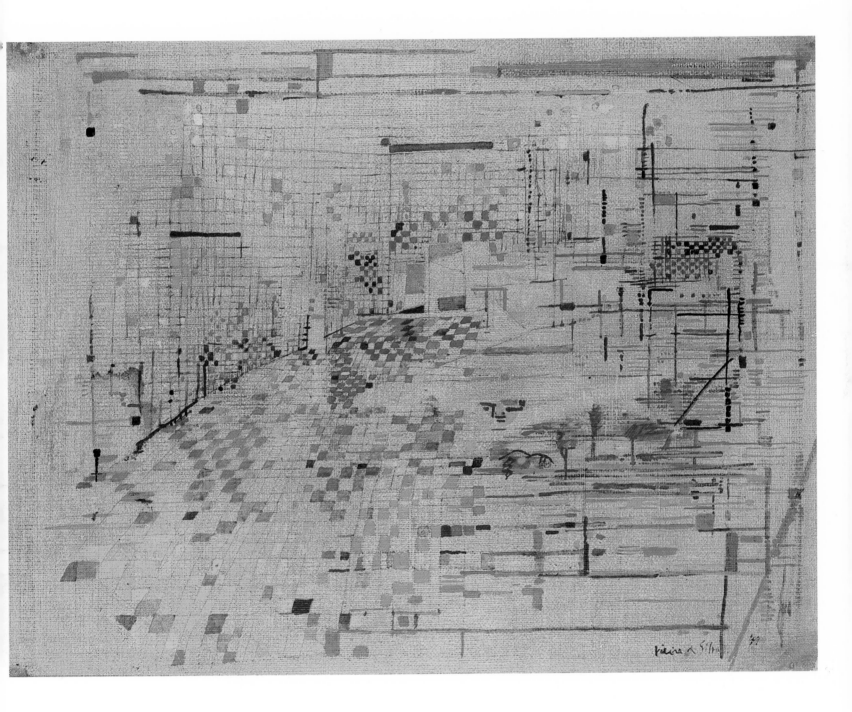

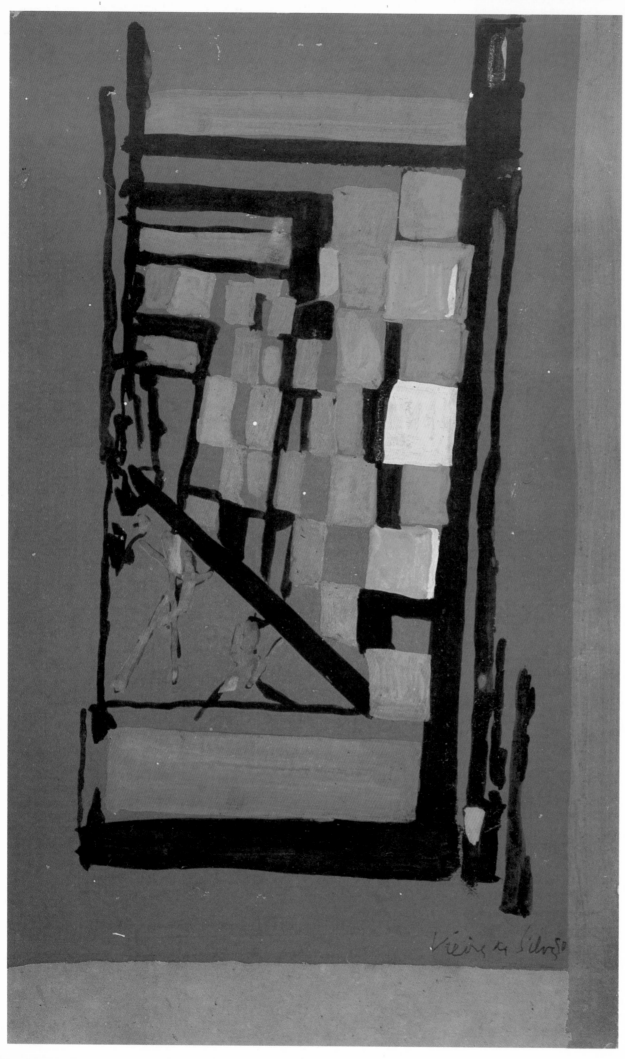

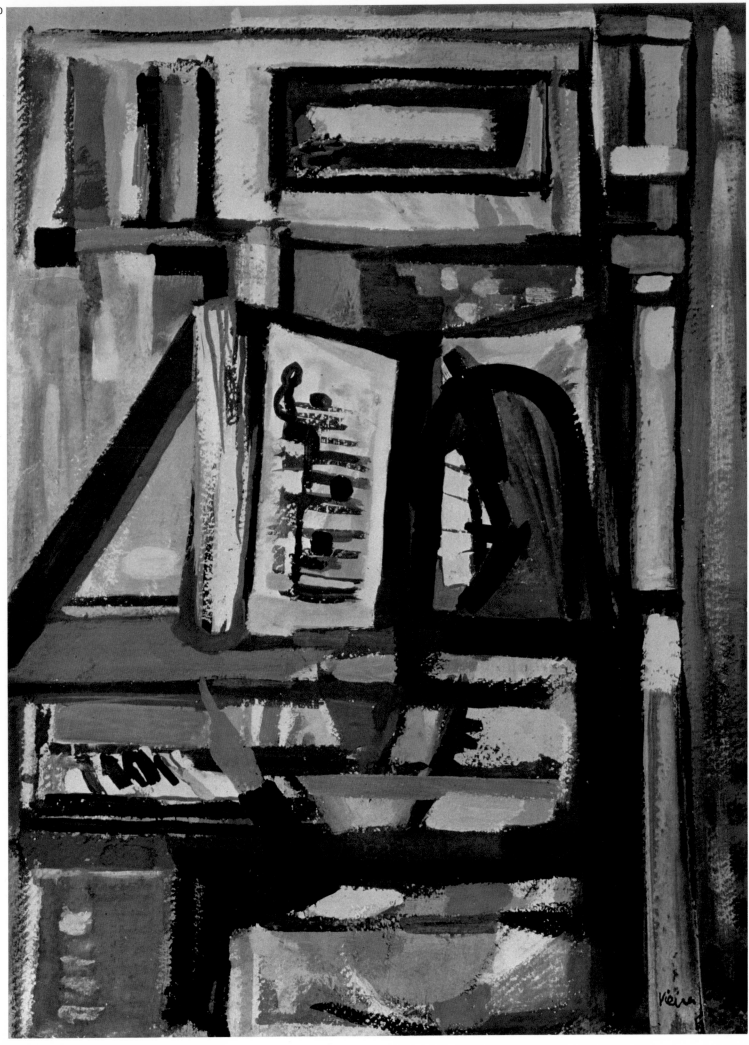

191. Untitled. 1950. Watercolor on paper, 14.5×13 cm.
 Collection René Char, Paris.

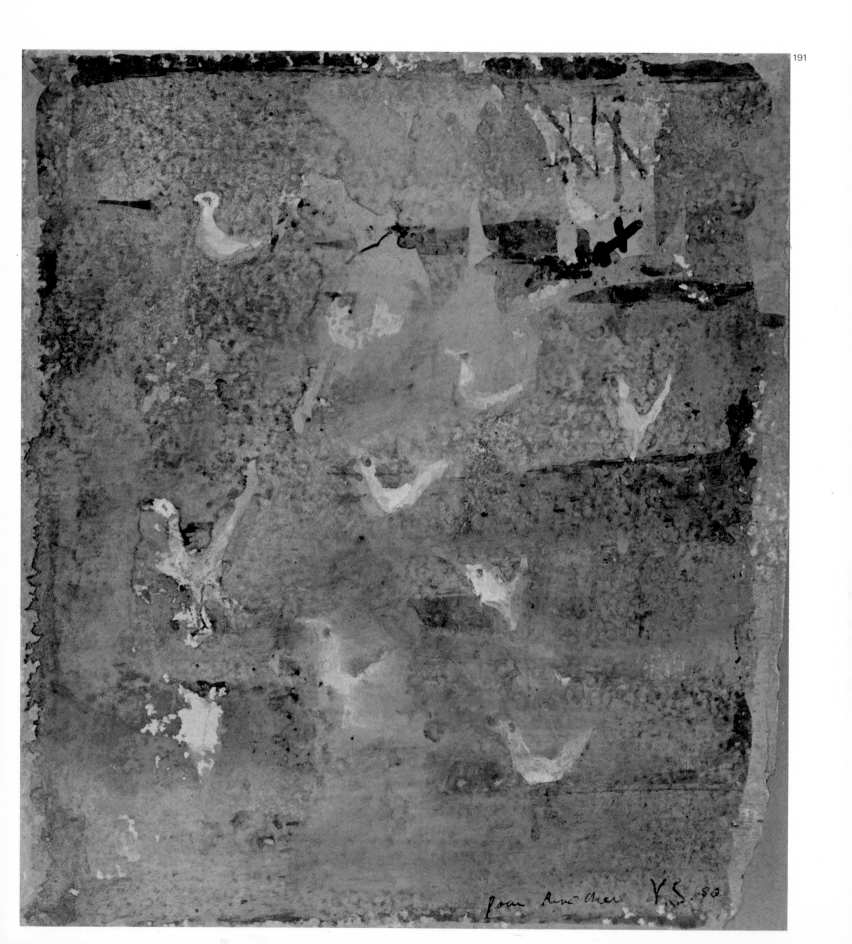

192. Arraial. 1950. Gouache on paper, 37 × 48 cm.
Private collection, Paris.

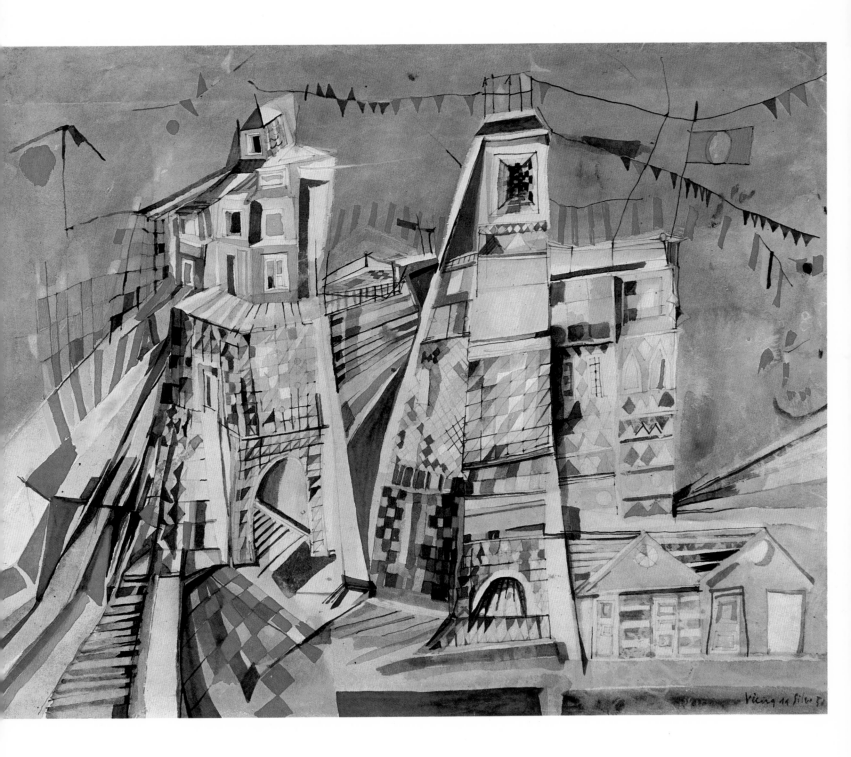

193. The Harvest. 1950. Oil on canvas, 96×130 cm.
Private collection, Zürich.

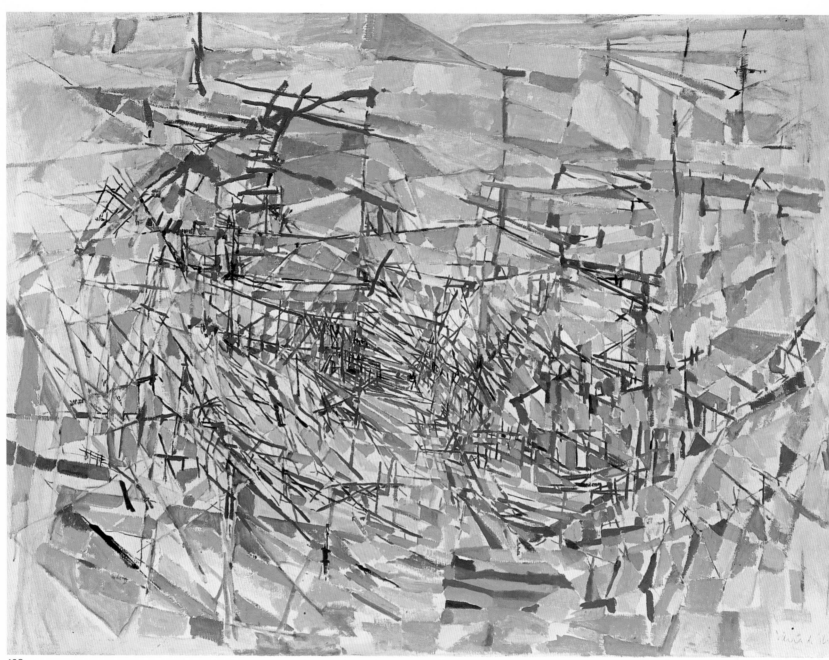

193

194. Gothic Chapel. 1951. Oil on canvas, 65×81 cm.
Collection Dr. C. F. Leuthardt, Basel.

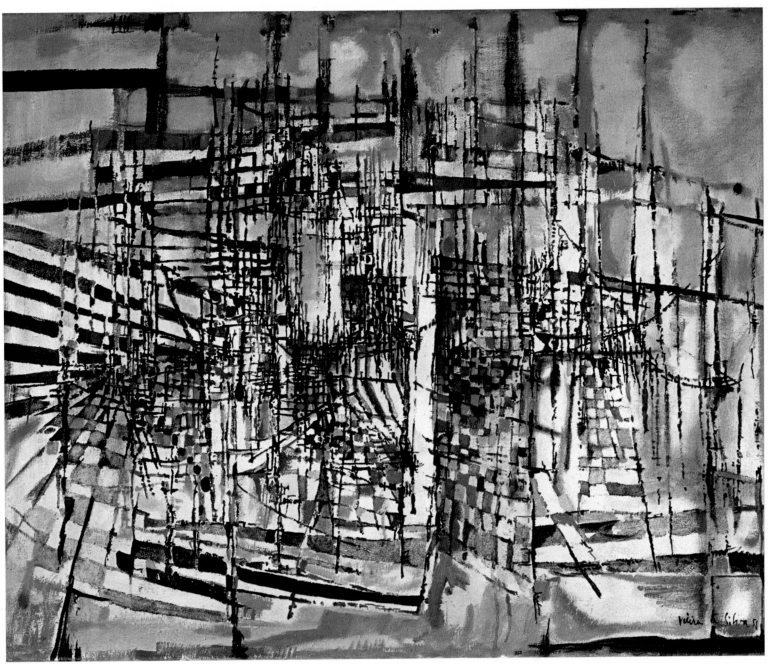

194

Come in, space

Come in, space, my guest. White, scarlet, or blue, depending on the hour. All those little doors from top to bottom of creation will be open on all the thresholds to welcome you. You will be free to make the checkered squares vibrate and glisten with reflections that move in the light. Scattered fragments, slight traces of the bleeding of colors on the snow, sharp lances of sunlight, lights and shadows rain down and blend with the oblique lines on the horizon. This creates a web of honeycomb cells whose surface I do not know, but whose weave and other side speak further to me.

I cross the entire city with ease. I climb frameworks of iron, gray and pale as steam. Here I am at the foot of a wall of feathers and wool. It sways and becomes a high plateau, gently inclined, tilted by the storm. Like a point launched outside a plane, I rise still further. I see the city that was or will be. From above it is nothing but crossed, interrupted lines, a checkerboard of barely shaded outlines, a plan of ruins, a plan of the future, such as the archaeologist sees with his eagle eye or the architect with his compass foot. All of a sudden I fall back. At the end of the streets, in the dim lunar light, I see the silhouette of the roofs, the towers, the chimneys.

But there is always space: the freedom of the clouds flows in my veins.

This world is a latticed world. A world traversed. Its thicknesses have crumbled and collapsed. Everything emerges from itself in the wonderment of the dream that sets you free. Everything communicates and opens: leaf, flower, shutter, rock, light signals, unequal durations suggesting a coded language.

What to say, except the haunting presence and tireless enigmas of reality? If we were suddenly to be born as adults, ignorant but with a fresh gaze, we would see only such a mirage, which would reach straight to the heart, awakening in us immediate and violent emotions, but their meaning would be unknown to us.

Here are gray and black intersecting lines, through which recede reds, pale or smoky areas, dark supports. A white expanse, barely blended in the blue, scorched in places, sometimes tinted with mauve or browned with bistre, breathes through this mesh, which contracts or expands as if the wind were shaking it in the equilibrium of the allotted space; it is in this way that such changing aspects of the earth on which we live, such

195. The Invisible Walker. 1951. Oil on canvas, 132×168 cm.
 Museum of Art, San Francisco.

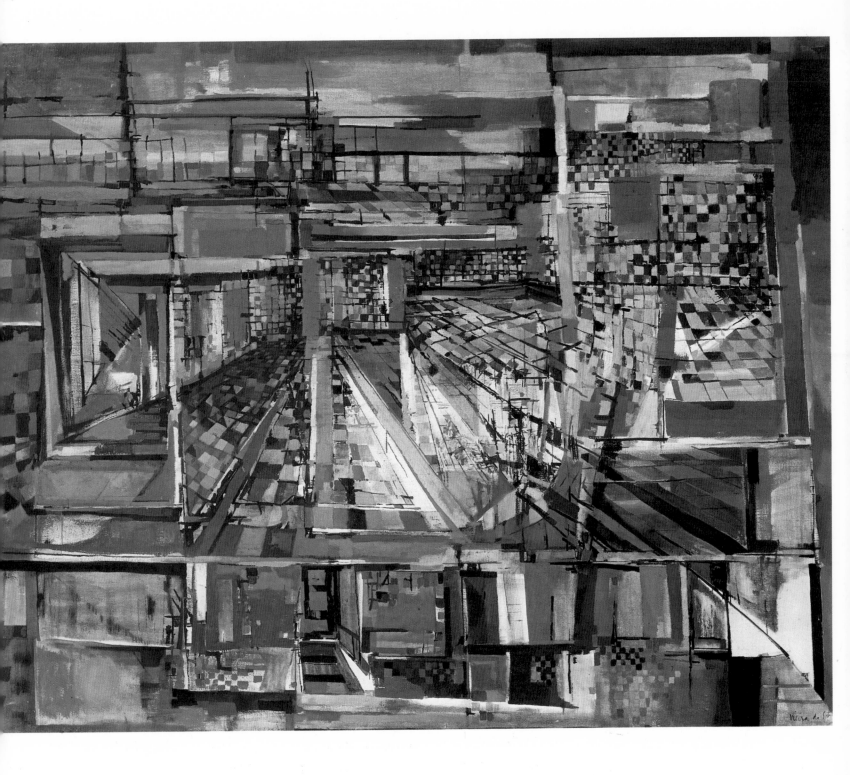

196. Gray Corot. 1950. Oil on canvas, 73×100 cm.
Private collection, Lisbon.

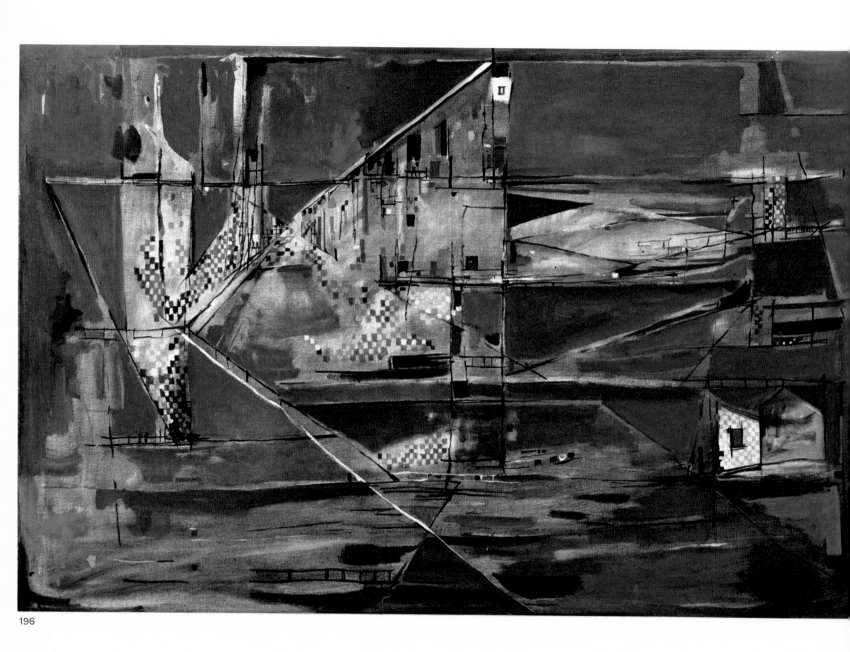

196

197. Winter. 1951. 81×100 cm. Private collection, Lisbon.

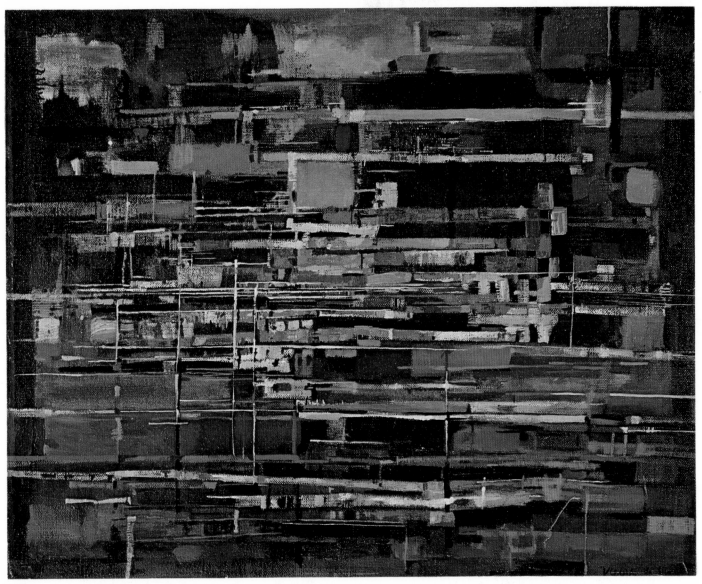

197

198. The Towers. 1953. Oil on canvas, 162×130 cm.
 Musée de Peinture et Sculpture, Grenoble.

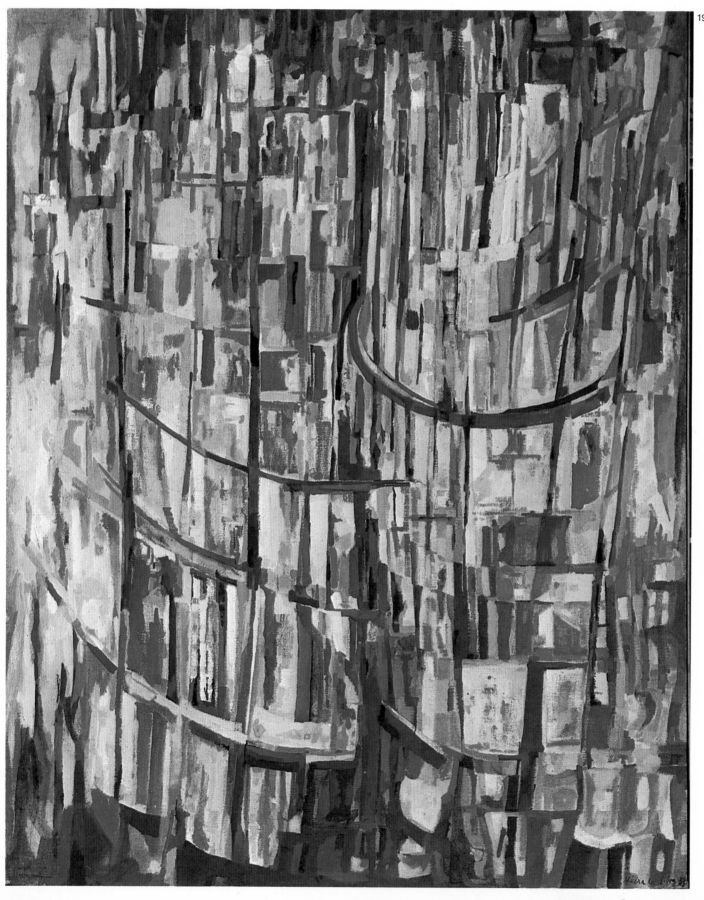

199. Paris at Night. 1951. Oil on canvas, 54×73 cm.
Private collection, Paris.

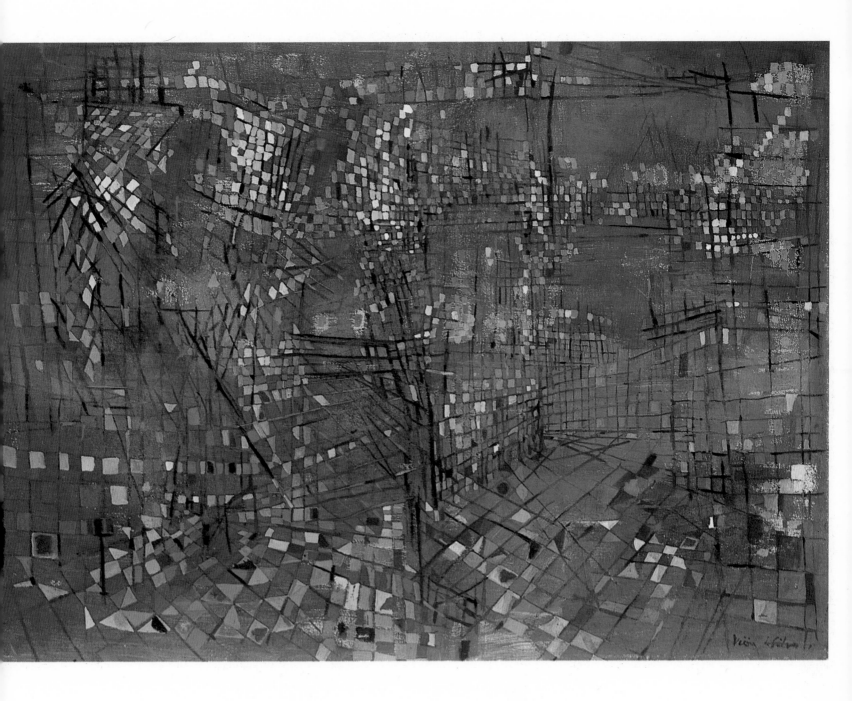

moments of truth, are metamorphosed in me.

The truth above all is Passage, this modulation of colored time, this train that glides and carries us along and settles us in its speed. Having started from the memory of things, which oblivion half devours, pondering that which changes outside as well as in ourselves, we see the things that burst, that scatter and whirl, rather than the ancient illusion of stability.

And yet, at this upper level, a new structure is elaborated, flexible and fine as a sword. It is born from the very motion that launches toward the horizon the rails, the suspension bridges, the endless trajectories, in a

high-pitched register, in the realm of the birds.

Henceforth I will live only in this unknown city, between yesterday and tomorrow, at the top of the scaffoldings, where the open air circulates, where the palms of the hands laid flat on things make them turn without effort, where the stones become as transparent and iridescent as soap bubbles, where heaviness gives way to delicacy, where one can conquer with the breath alone, with no other stratagem but pure patience attuned to the progress within.

Jean Tardieu
Les Portes de Toiles
Editions Gallimard

200. Composition. 1951. Oil on canvas, 70×140.5 cm.
Kunstmuseum, Basel.

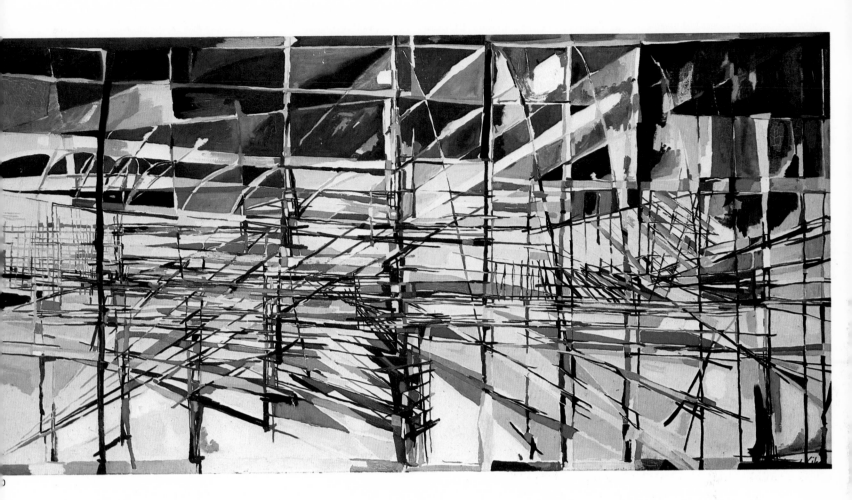

201. Et puis voilà. 1951. Gouache on paper, 24×16 cm.
 Private collection, Lisbon.

202. Et puis voilà. 1951. Gouache on paper, 26×17 cm.
 Private collection, Lisbon.

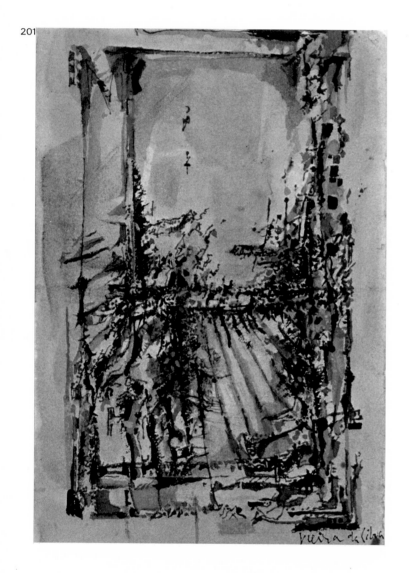

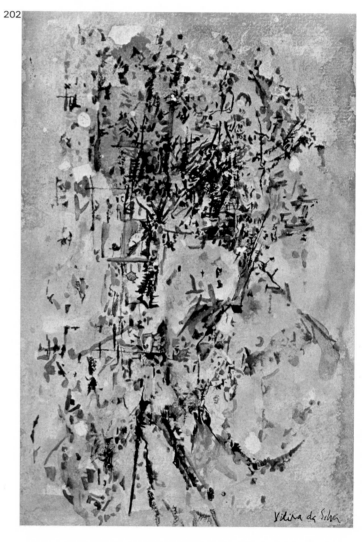

203. Flags. 1952. Oil on canvas, 24 × 40 cm.
Collection G. Desmouliez, Montpelier.

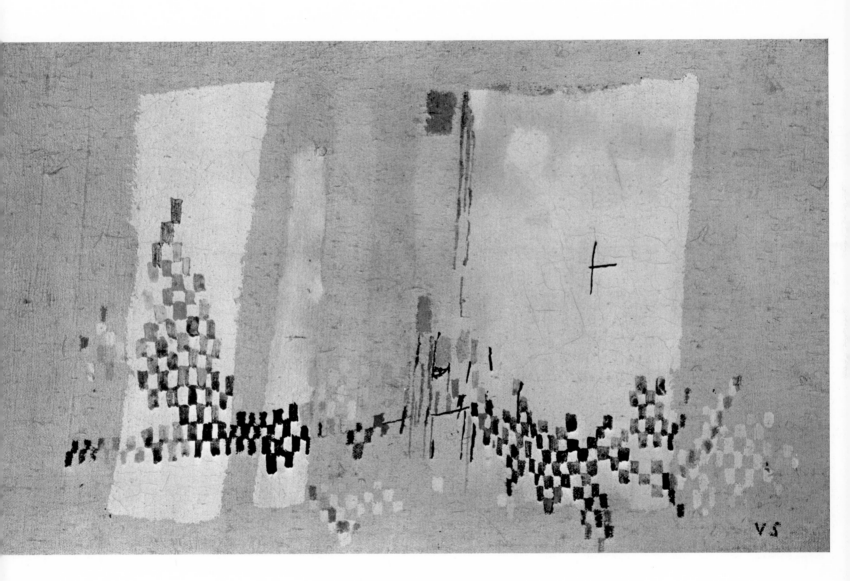

204. The Hotel Board. 1952. Tempera on plywood, 100×120 cm.
Private collection, Lisbon. Part of the décor for Arthur Adamov's play *La Parodie,* Théâtre Lancry.

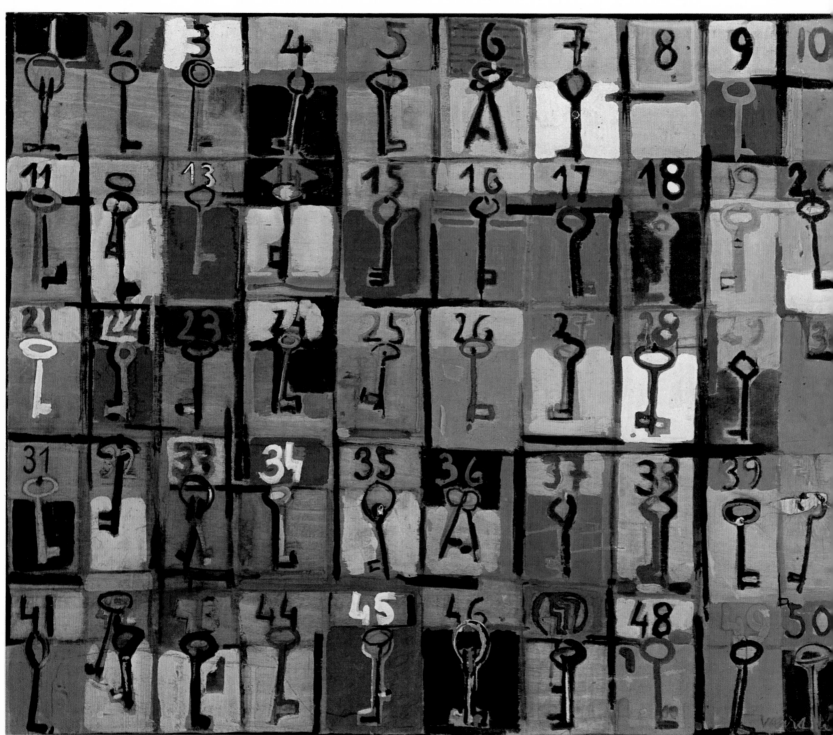

205. The Glass Towers. 1952. Oil on canvas, 60×73 cm.
Private collection, Lisbon.

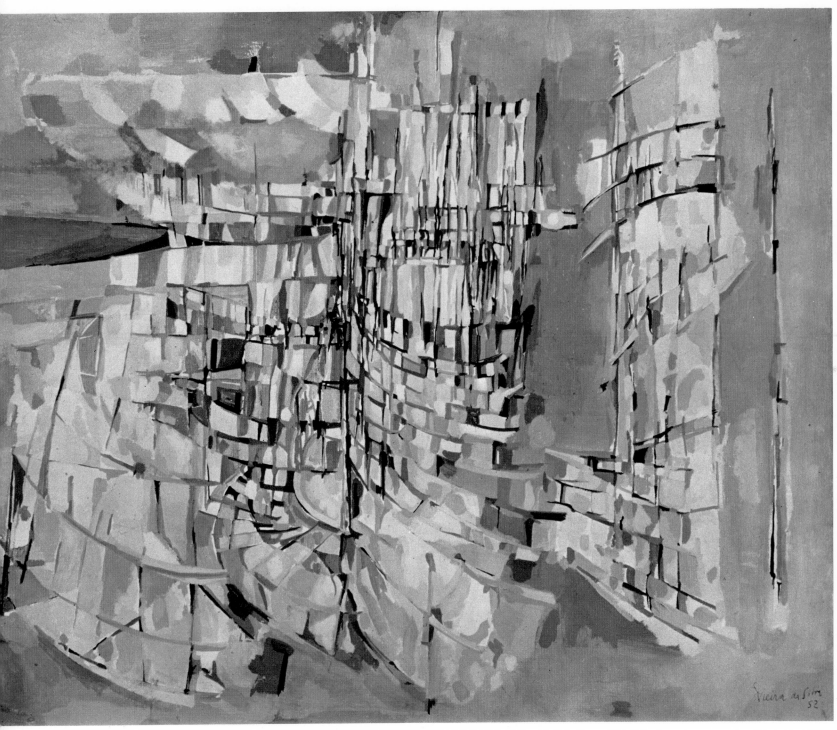

205

206. Urban Perspectives. 1952. Oil on canvas, 97×130 cm.
 Private collection, Lisbon.

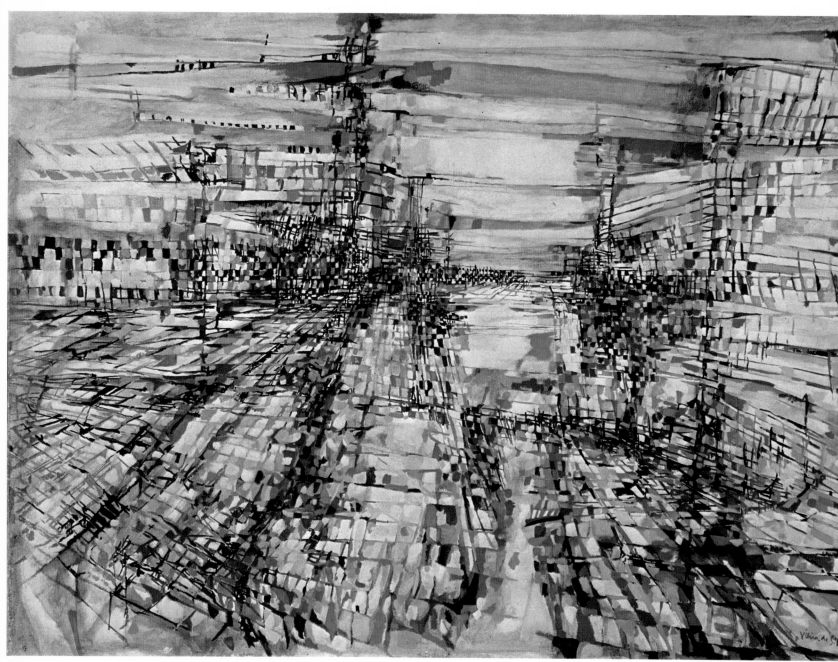

206

207. Rua das Chagas. 1952. Gouache on cardboard, 42×31 cm.
Private collection, Paris.

207

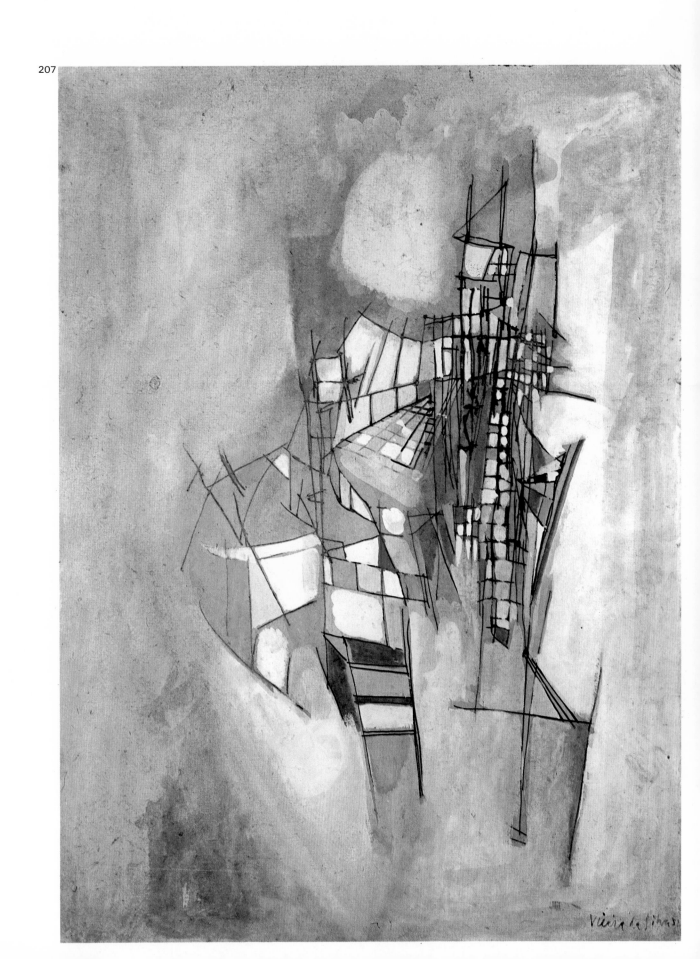

Style and cry

Little by little, by embroidering on her favorite theme, Vieira da Silva has created an irreplaceable art, a rare state of painting. There is something there that was never expressed until this day; a space without dimensions, simultaneously limited and limitless, a hallucinating mosaic each of whose elements is endowed with an inner power that immediately transcends its own matrix. Each spot of color possesses a charge of restrained dynamism, but this dynamism is expressed by the whole canvas.

The beauty of the work lies precisely in this channeled power, this bursting seen as it were in slow motion. A severe discipline, concealed by playful lightness, the apparent improvisation of lines and colors, determines the slightest stroke of this brush that is never overcome by temperament. Or rather, temperament, in Vieira da Silva, is temperance, order, orchestration.

What is surprising is that this principle, this art so firmly held in check, allows at the same time such an intense, mediumistic expression of the inner world. Rigor and freedom here make an exalting marriage.

The art of a Mondrian was pure style, that of Van Gogh pure cry. With Vieira da Silva, style and cry are simultaneous in each painting, closely intertwined in each moment of the painting.

This song consists of reserve and invention, of dry mathematics and a bursting forth. An inexplicable but irresistible enchantment is the result of this alchemy, this subtle fusion of causes.

I consider Vieira da Silva's painting a prodigy of the art of our time, something absolutely new. One moves there in concrete spaces whose every particle contains a mystery of infinity. Borders, borders, everywhere borders, but borders which do not confine anything, and which do not stop anyone from leaping over them: what goes beyond things is also within them and one has only to wait. Here is the concept I read in this painting. Someone was suffocating in narrow spaces and now he isn't suffocating any more, though the space is still there: inner lyricism has triumphed over all boundaries.

Here, then, is a painter who has opened her mind widely to all kinds of influences, thus nourishing her profound personality in order, finally, not to owe anything to anybody.

Once more I note that the forms of art can be used only once, and that there are no great disciples. Little followers do not interest me, however loud the noise they make.

Michel Seuphor
Preface to the catalogue of the exhibition at the
Galerie Pierre, Paris, 1949

Style et cri

Peu à peu, en brodant son thème familier, Vieira da Silva a créé un art irremplaçable, un état rare de la peinture. Quelque chose est là qui ne fut jamais exprimé à ce jour; un espace sans dimensions, à la fois limité et illimité, une hallucinante mosaïque dont chaque élément est doué d'une puissance intérieure qui transcende aussitôt sa propre gangue. Chaque tache de couleur possède une charge de dynamisme contenu mais dont la toile entière raconte la force.

La beauté de l'œuvre est précisément cette puissance canalisée, cet éclatement vu au ralenti en quelque sorte. Une discipline sévère, que cache le jeu léger, l'apparente improvisation des lignes et des couleurs, décide du moindre trait de ce pinceau qui jamais n'est dépassé par le tempérament. Ou plutôt, ce tempérament, chez Vieira da Silva, est tempérance, ordre, orchestration.

Ce qui surprend c'est que cette règle, cet art si fermement tenu en bride, permette en même temps une expression aussi intense, médiumnique, du monde intérieur. Rigueur et liberté font ici un exaltant mariage.

L'art d'un Mondrian était pur style, celui de Van Gogh pur cri. Chez Vieira da Silva le style et le cri sont simultanés dans chaque peinture, étroitement enchevêtrés dans chaque moment de la peinture.

Ce chant est fait de réserve et d'invention, de mathématiques sèches et de jaillissement. Un inexplicable mais irrésistible enchantement est le produit de cette alchimie, de cette subtile fusion des causes.

Je considère la peinture de Vieira da Silva comme un prodige de l'art de notre temps, quelque chose d'absolument inédit. On s'y promène dans des espaces concrets dont chaque parcelle a un mystère d'infini. Frontières, frontières, partout frontières, et qui ne délimitent rien, et qui n'arrêtent aucun bondissement: ce qui dépasse les choses est aussi au dedans d'elles et il n'y a qu'à attendre. Voilà le concept que je lis dans cette peinture. Quelqu'un étouffait dans des espaces étroits, et maintenant il n'étouffe plus quoique l'espace soit là toujours: le lyrisme intérieur a vaincu toutes les limites.

Voici donc un peintre qui ouvrit largement son esprit à toutes sortes d'influences, nourrissant ainsi sa personnalité profonde pour, finalement, ne devoir rien à personne.

Une fois de plus, je constate que les formes d'art ne servent qu'une fois et qu'il n'est pas de grand disciple. Les petits suiveurs ne m'intéressent pas, quelque grand bruit qu'ils fassent.

Michel SEUPHOR
Préface à l'exposition Galerie Pierre, Paris, 1949

208. Battle of Reds and Blues. 1953. Oil on canvas, 130×162 cm.
Private collection, Lisbon.

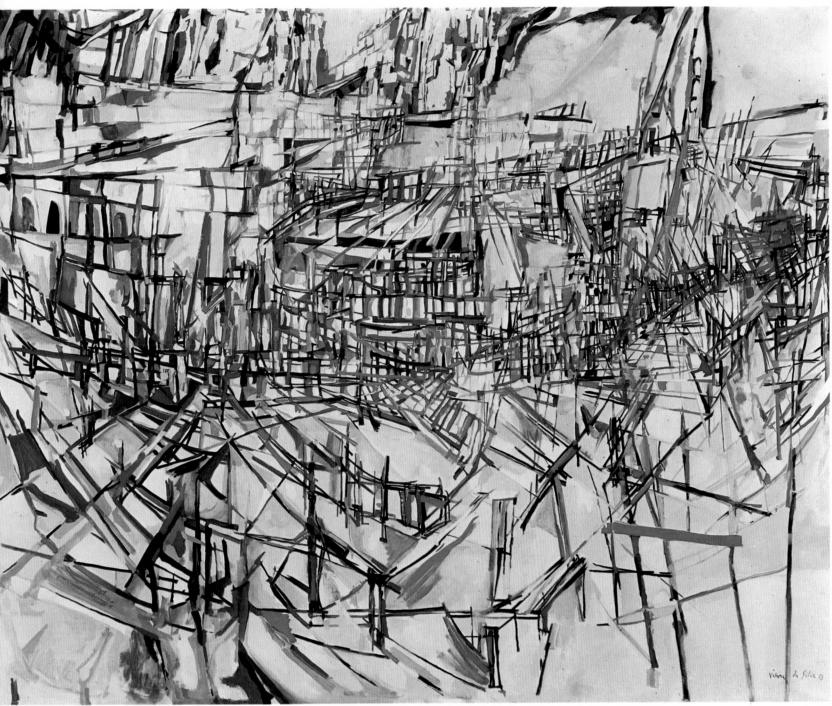

209. The Barrier. Paris, 1953. Oil on paper mounted on canvas, 73×100 cm. Private collection, Paris.

210. Bridges on the Thames. 1953(?). Oil on canvas, 46×55 cm. Private collection, Lisbon.

211. Australia. Paris, 1953. Gouache on paper, 28×37 cm. Private collection, Paris.

212. The Dike. 1953. Oil on canvas, 46×55 cm. Private collection, Paris.

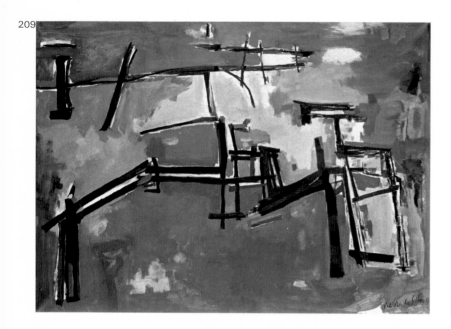

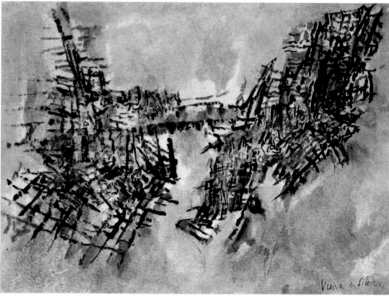

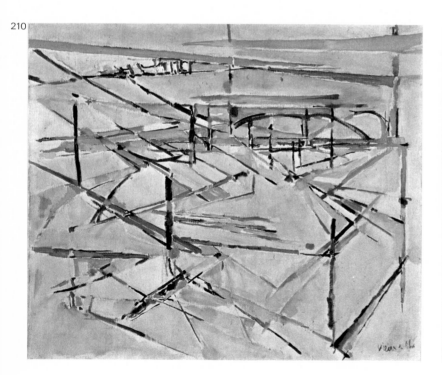

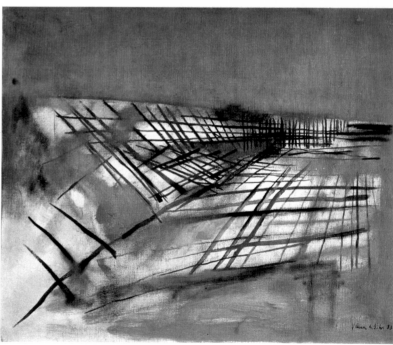

213. Clair de lune. 1953. Gouache on paper, 36×46 cm.
Private collection, Paris.

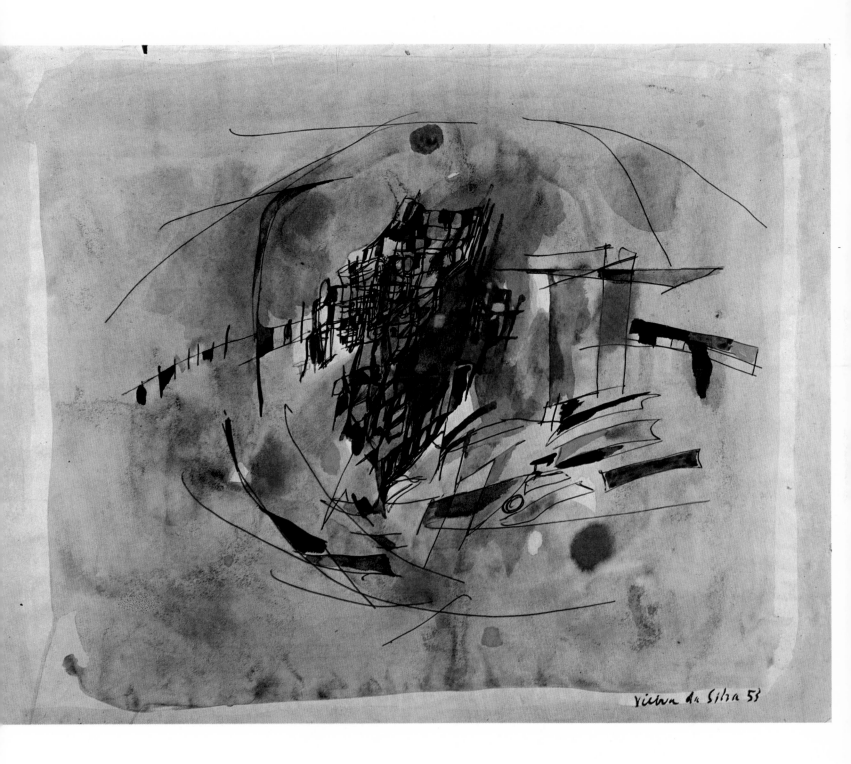

214. Biblioteca. 1953. Gouache on paper, 25×16 cm.
Collection Sophia de Mello Breyner Andersen, Lisbon.

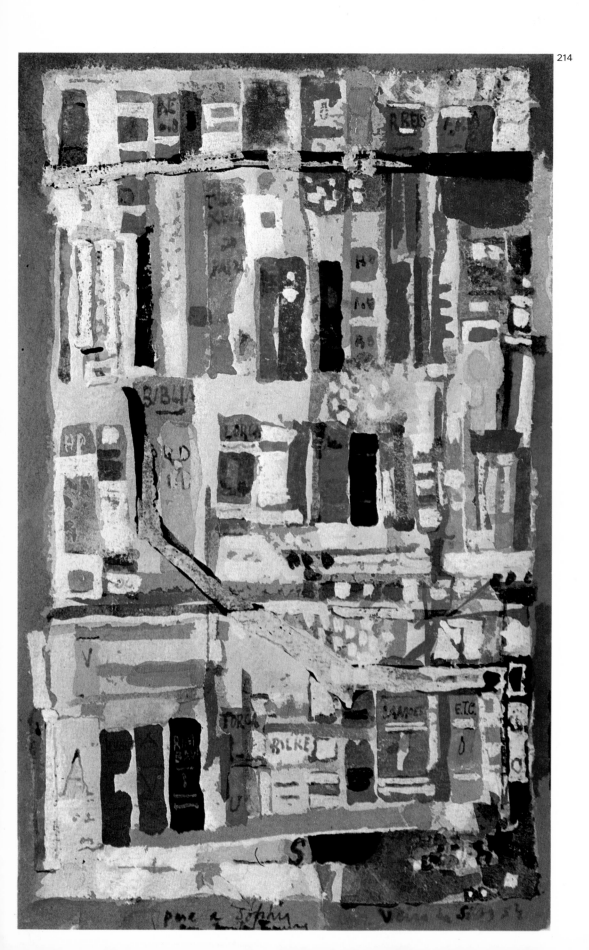

214

215. Rua. 1953. Gouache on cardboard, 39×31 cm.
Private collection, Paris.

216. Gouache. 1953. Gouache on paper, 24×31 cm.
Collection Dr. Manuel Vinhas, Estoril.

217. Untitled. 1953-54. Gouache and watercolor on paper, 36×43 cm.
Collection M. and Mme C. Gourlet, Saint-Benin (France).

215

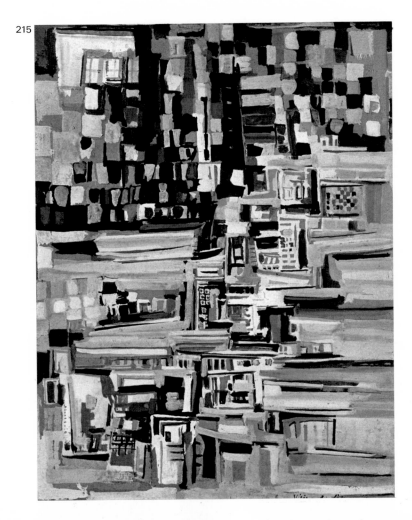

216

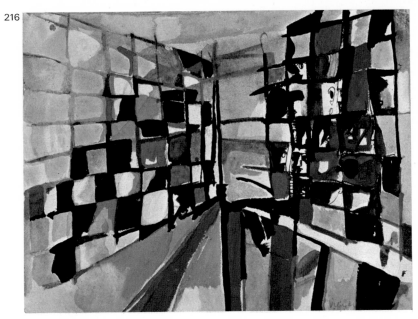

217

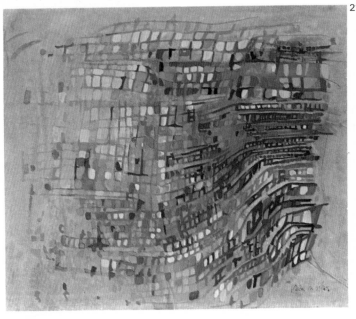

218. Sketch. 1953. Gouache on paper, 33×39 cm.
Private collection, Paris.
219. Sketch. 1953. Gouache on paper, 32×39 cm.
Private collection, Paris.
220. The Hanging City. 1952. Oil on canvas, 137×115 cm.
Musée Cantonal des Beaux-Arts, Lausanne.

218

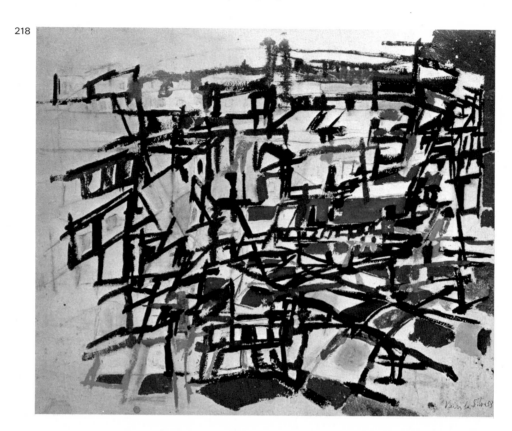

219

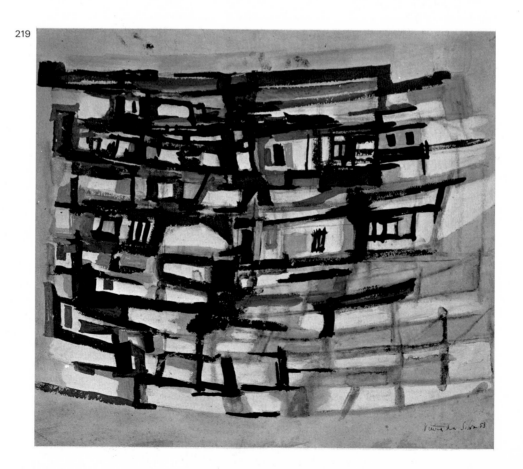

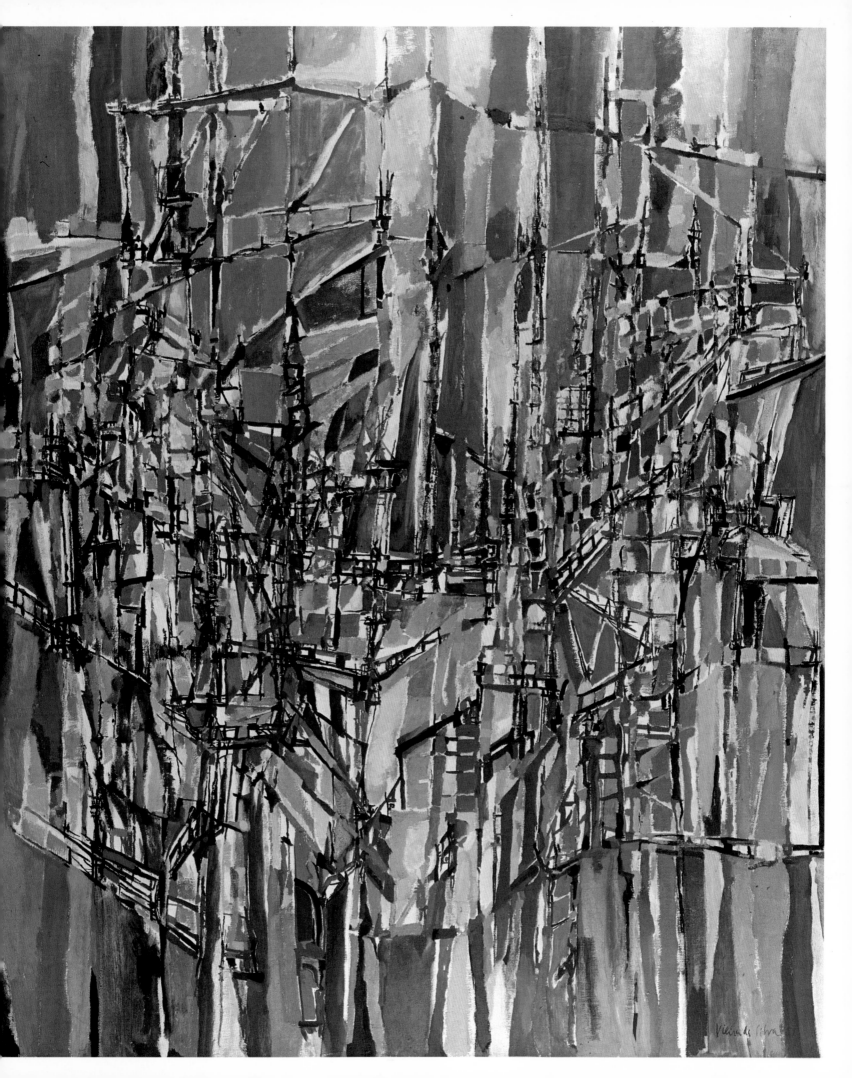

221. Et puis voilà. 1951. Gouache on paper, 22×17.5 cm.

221

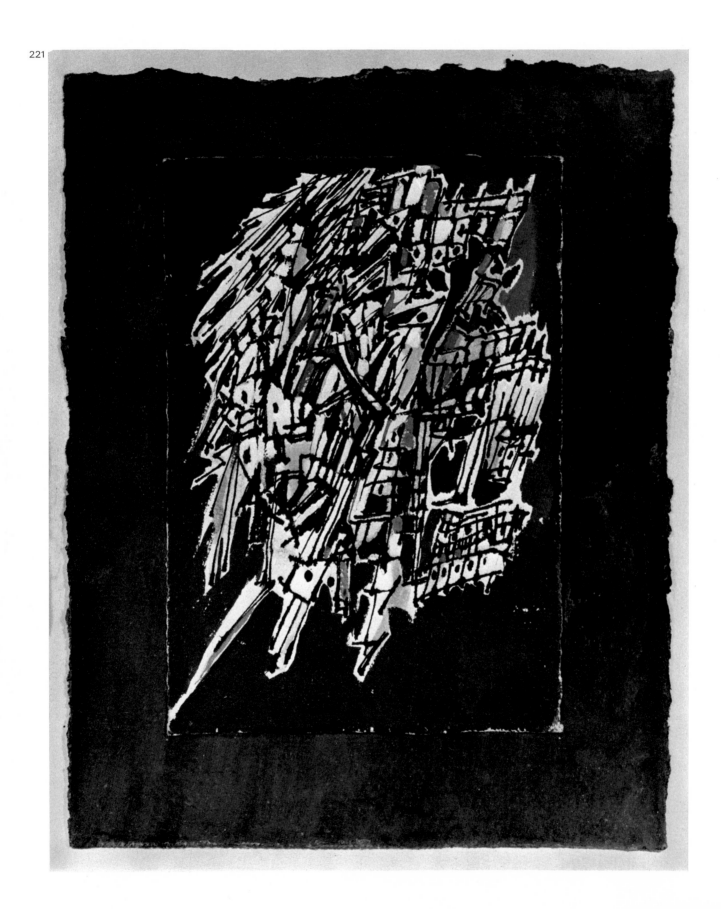

222. The City. 1953. Oil on canvas, 73 × 92 cm. Private collection, Lisbon.

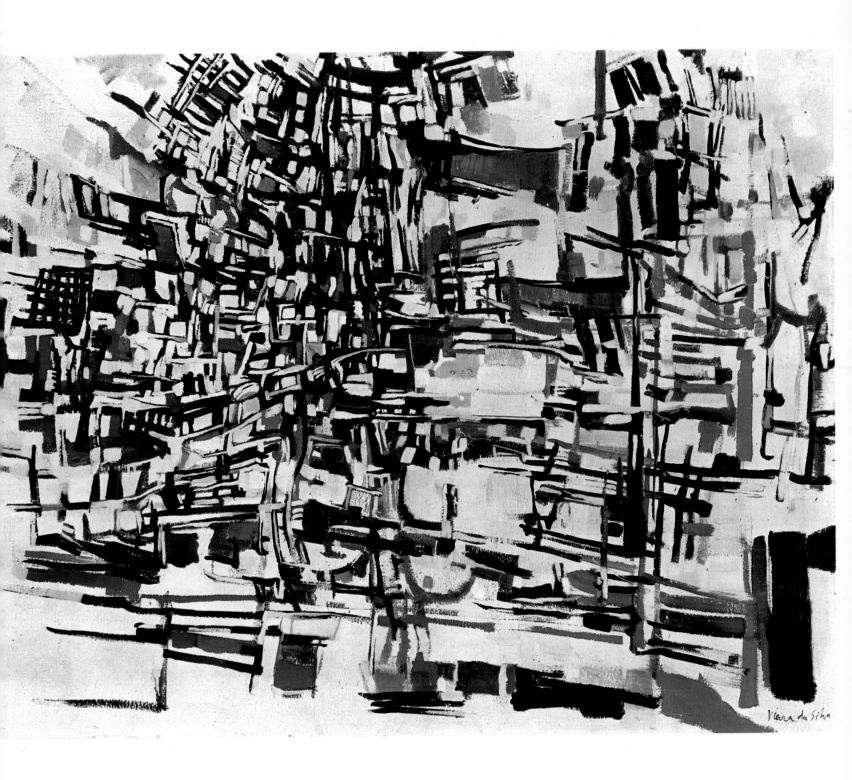

223. The Spider's Feast. 1953. Oil on canvas, 89×116 cm.
Private collection, Lisbon.

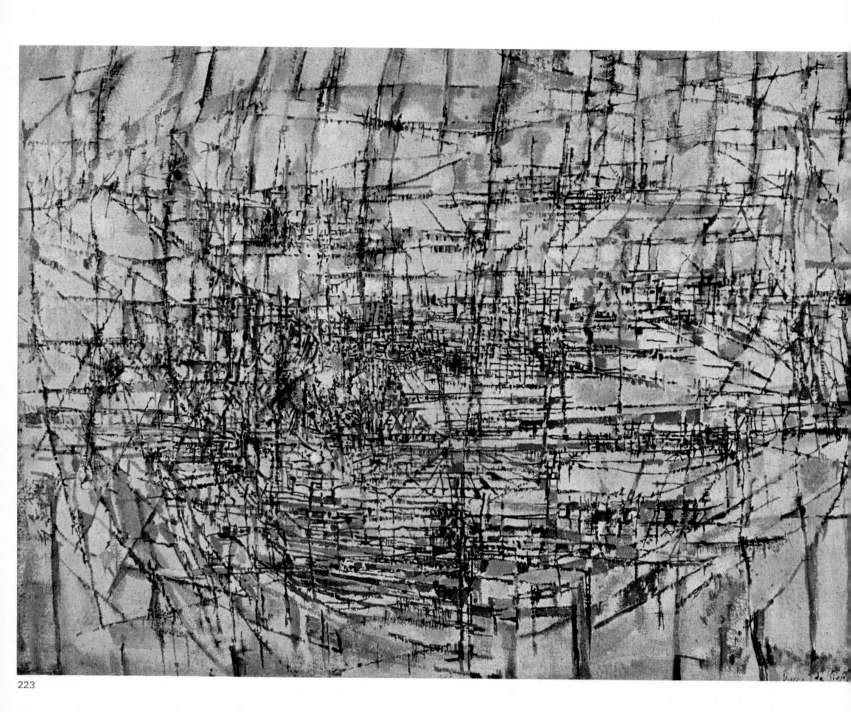

223

224. Les pistes. 1953. Oil on canvas, 89×116 cm.
 Private collection, Lisbon.

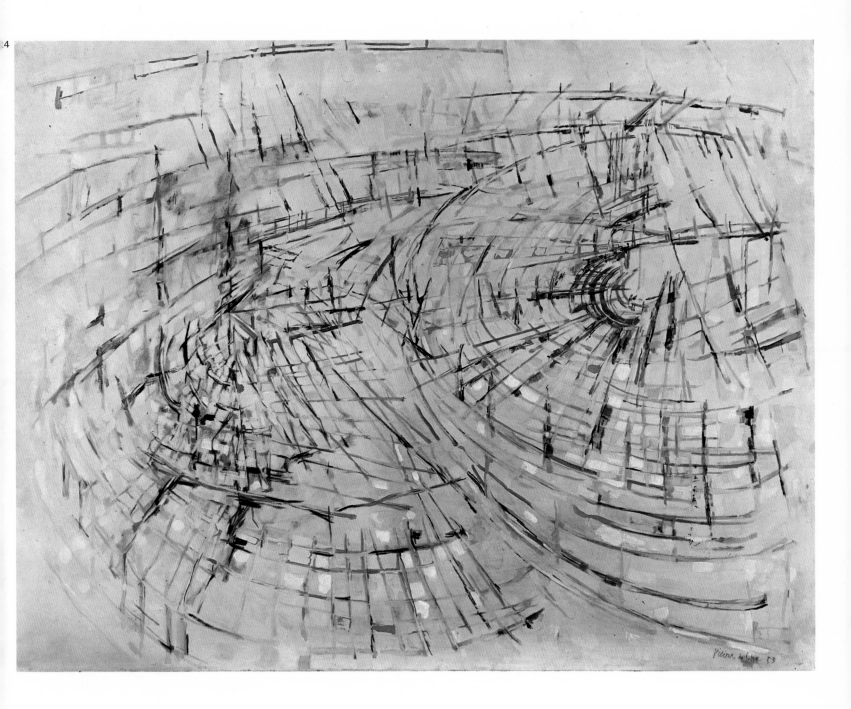

225. White Composition. 1953. Oil on canvas, 97×130 cm.
Kunstmuseum, Basel.

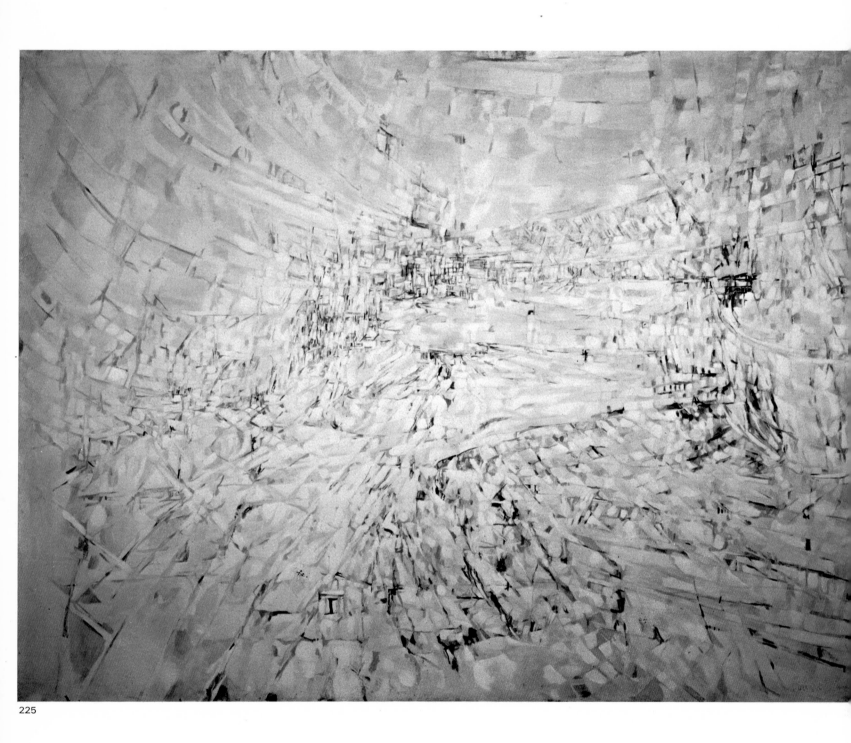

225

226. Brown and Black. 1954. Oil on canvas, 114×146 cm.
Collection Mme Silvia von Vincenz, Basel.

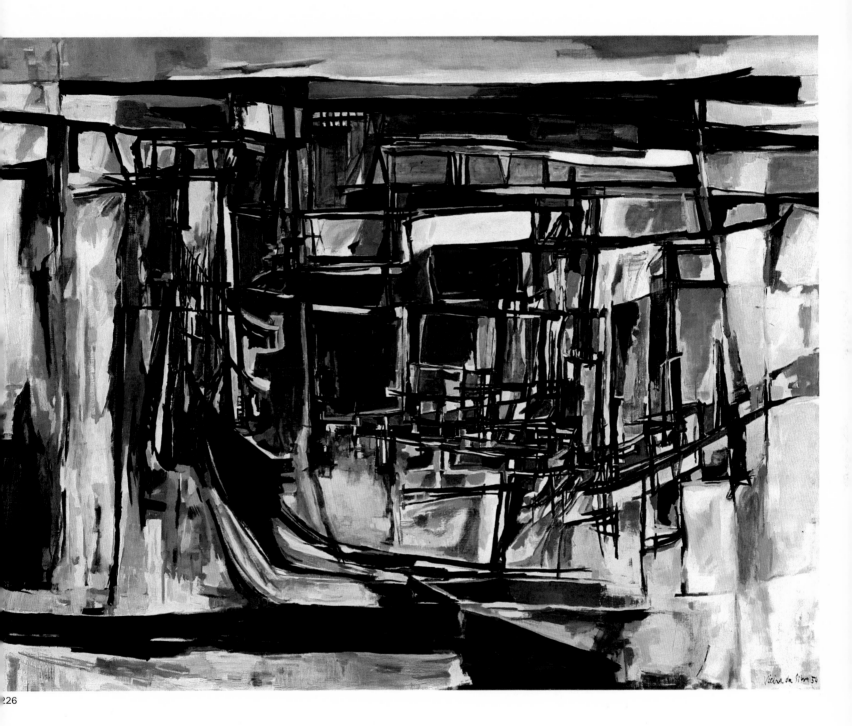

227. The Flooded Dikes (Holland Landscape). 1954. Oil on canvas, 73×100 cm.
Collection Marion Lefebre Burge, New York.

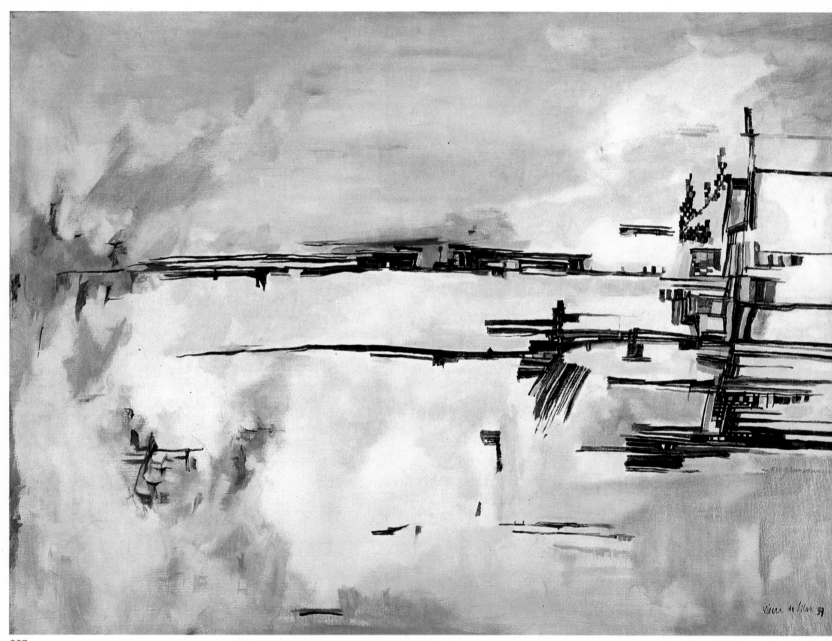

227

228. The Cataclysm. 1954. Oil on canvas, 97×130 cm.
Private collection. Lisbon.

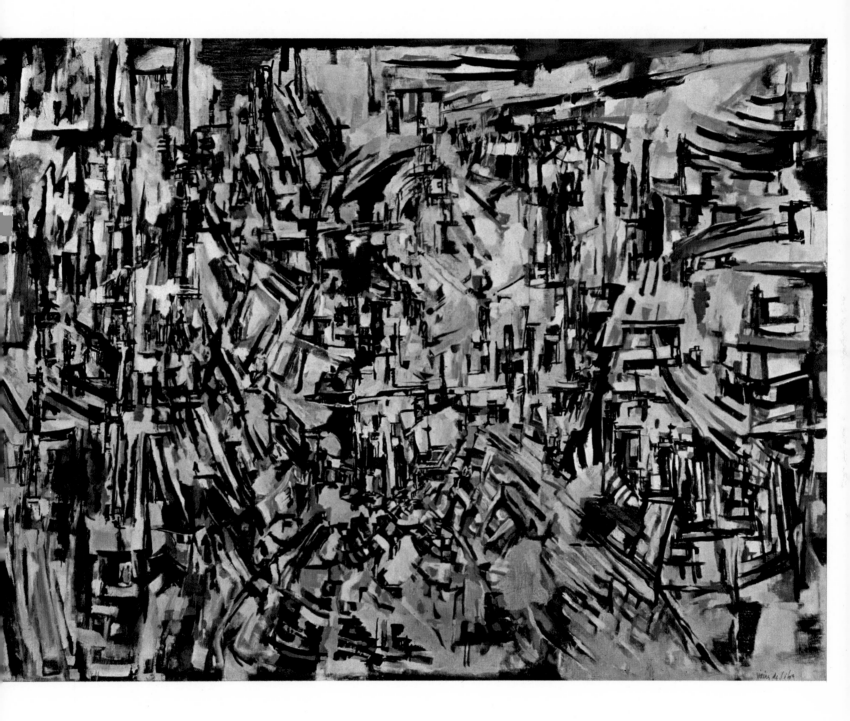

229

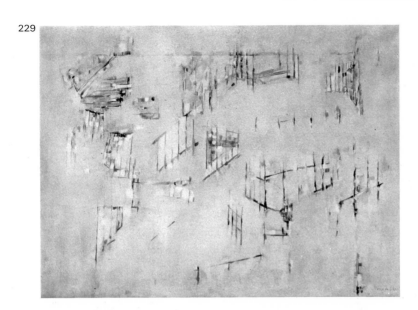

230

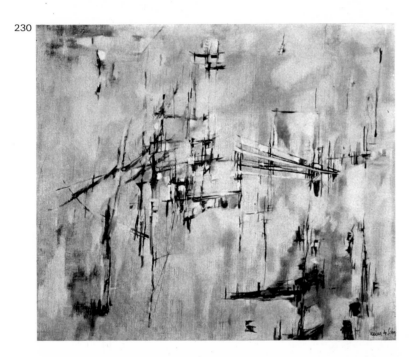

231

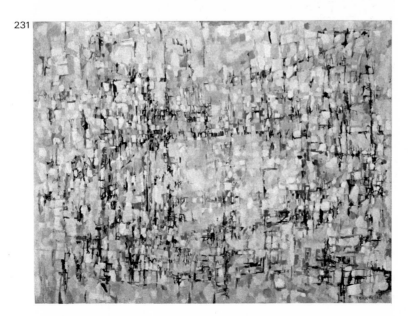

229. Children's Games. 1954. Oil on canvas, 89×116 cm. Private collection, Lisbon.

230. Suspension Bridge. 1954. Oil on canvas, 46×55 cm. Private collection, Lisbon.

231. Painting. 1953-54. Oil on canvas, 89×116 cm. Private collection, Lisbon.

232. The Flooded Station. 1956. Oil on canvas, 114×146 cm.
 Private collection, Paris.

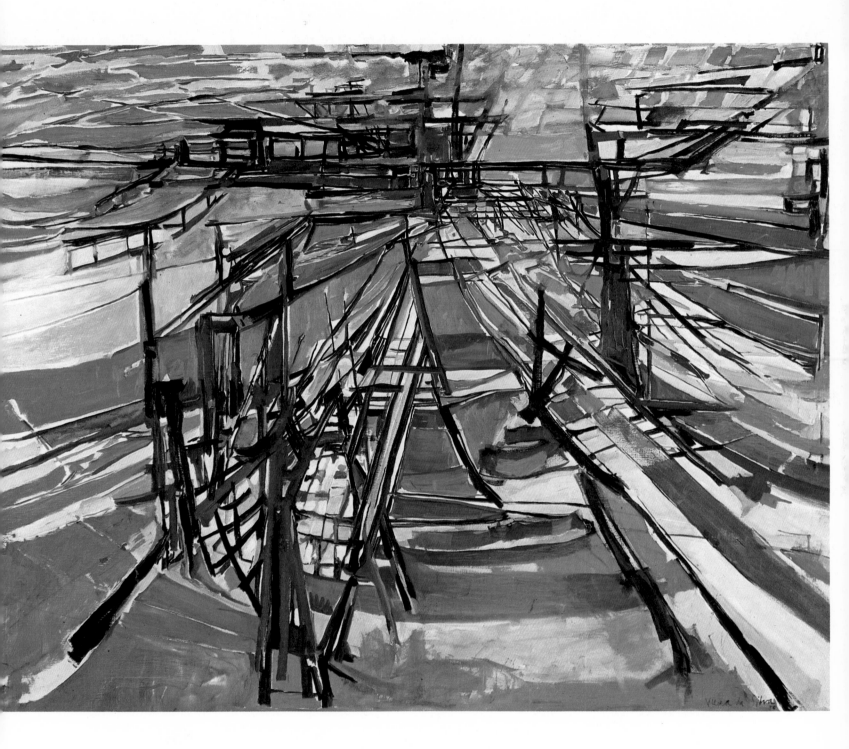

233. Blue Interior. 1954. Oil on canvas, 33×22 cm.
Private collection, Lisbon.

233

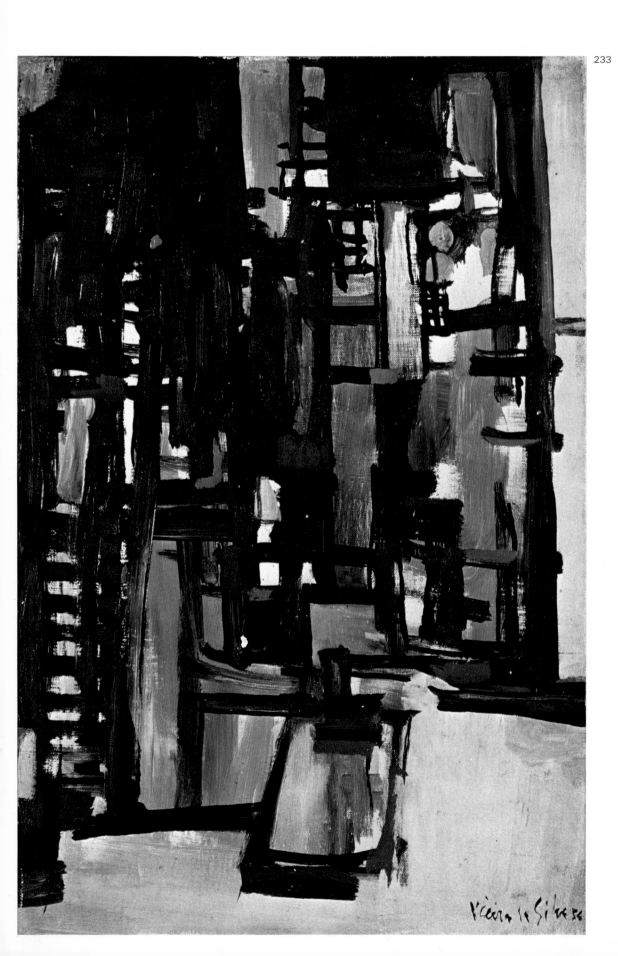

234. Dark Composition. 1953. Oil on canvas, 73×92 cm.
Private collection, Lisbon.

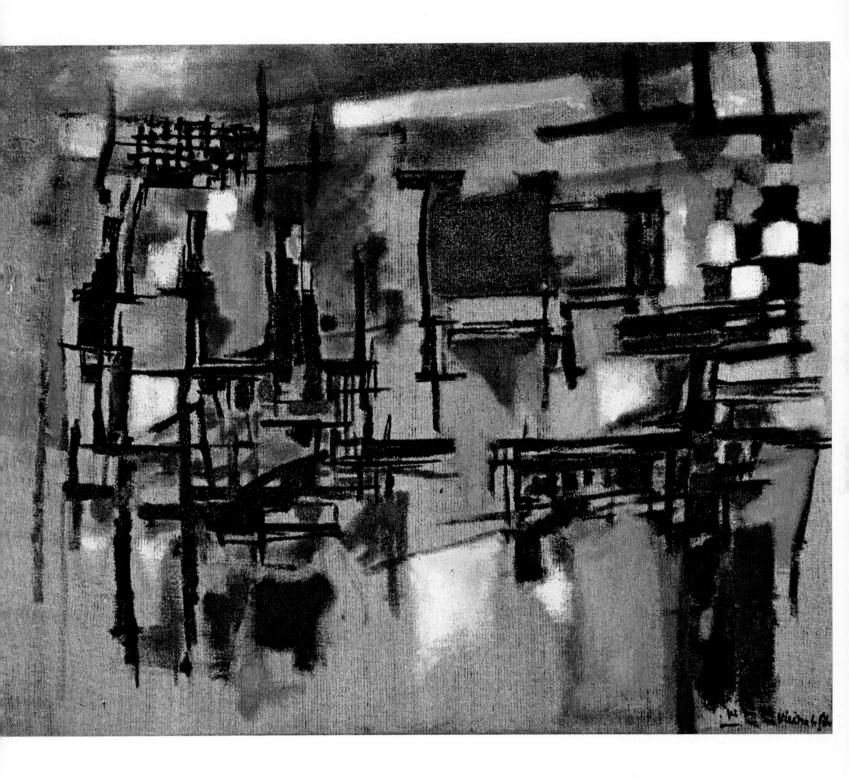

235. Rue de la Glacière. 1955. Oil on canvas, 73×116 cm.
Private collection, Lisbon.

236. Vertical Landscape (Hanging Gardens). 1955. Oil on canvas, 162×130 cm.
Musée National d'Art Moderne, Centre d'Art et de Culture Georges Pompidou, Paris.

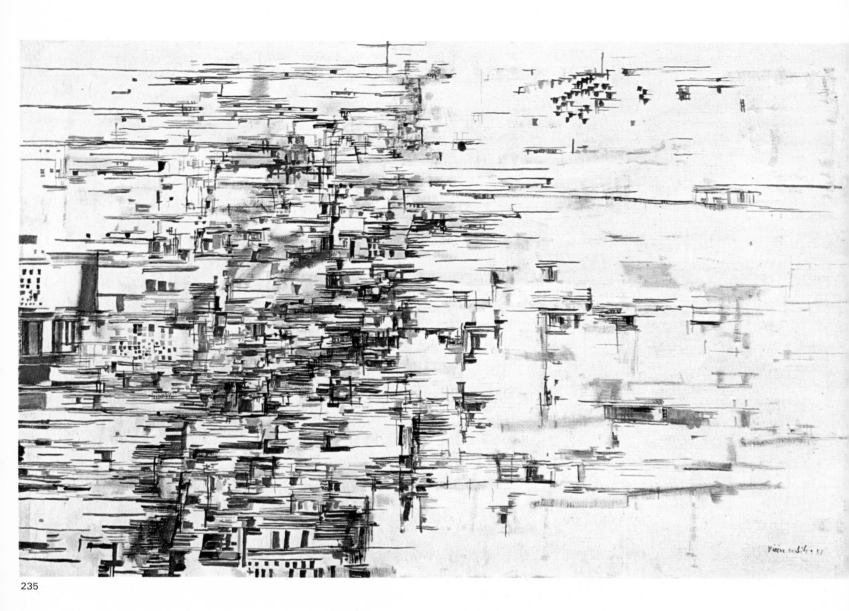

235

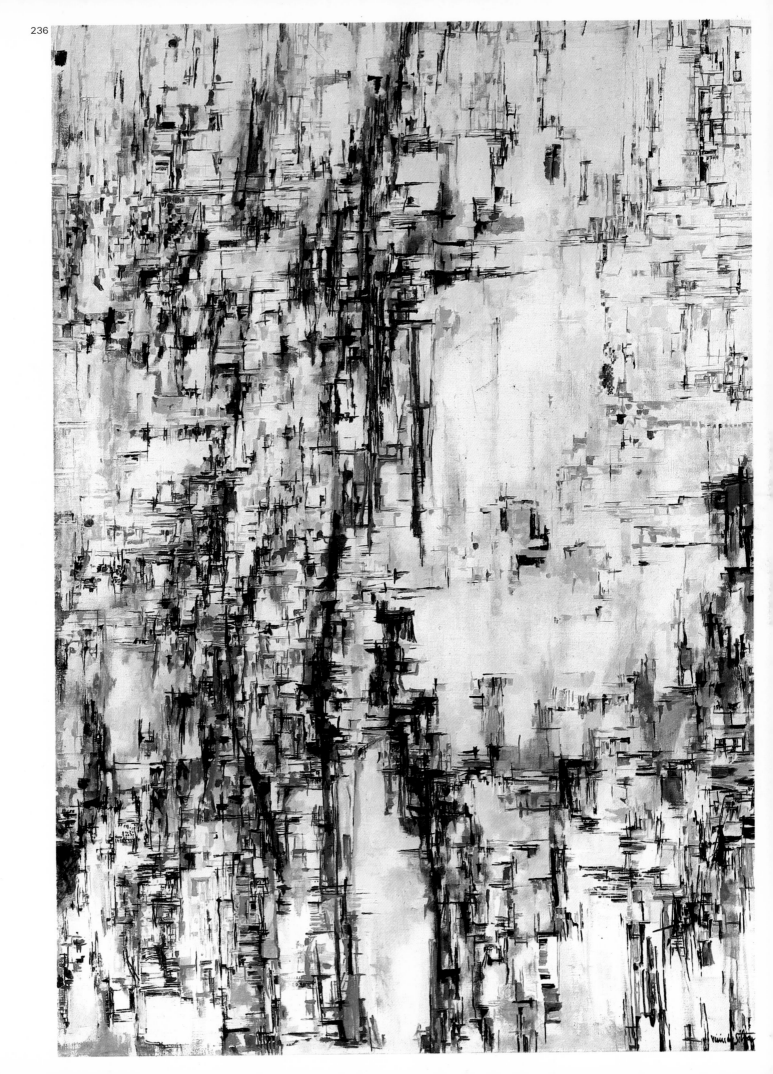

237. University of Basel. A lecture by Karl Jaspers.

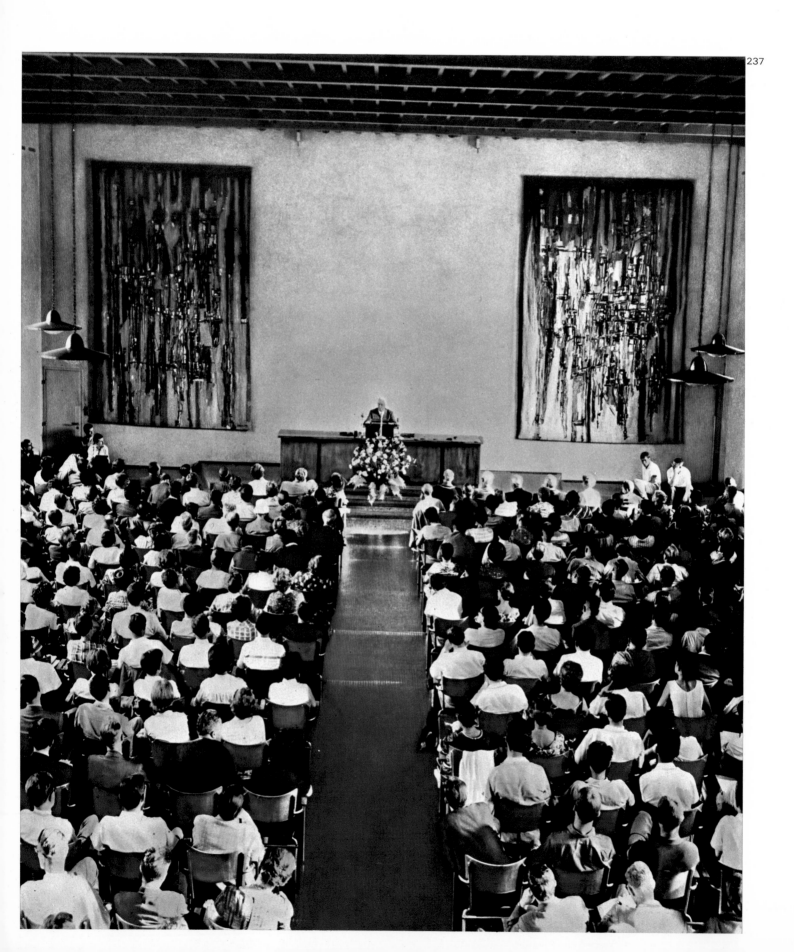

238. University of Basel. Tapestry, 518×342 cm.
239. University of Basel. Tapestry, 513×327 cm.

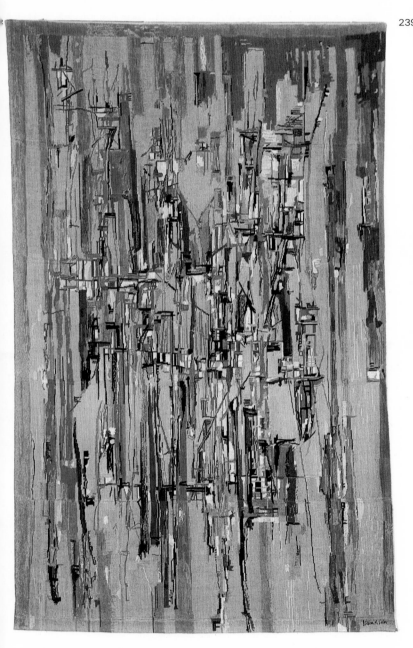

239

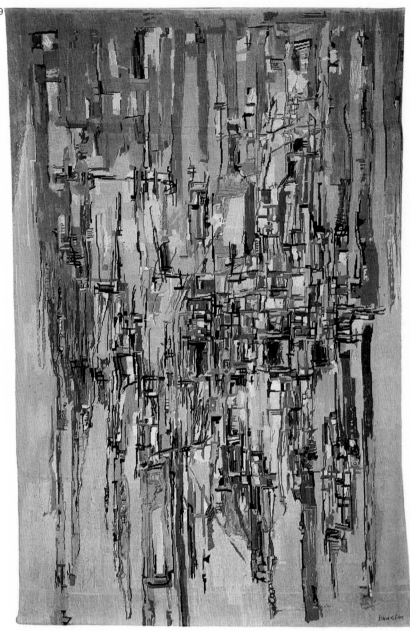

240. Grande Fugue. 1954. Oil on canvas, 81×130 cm.
 Städtische Kunsthalle, Mannheim.

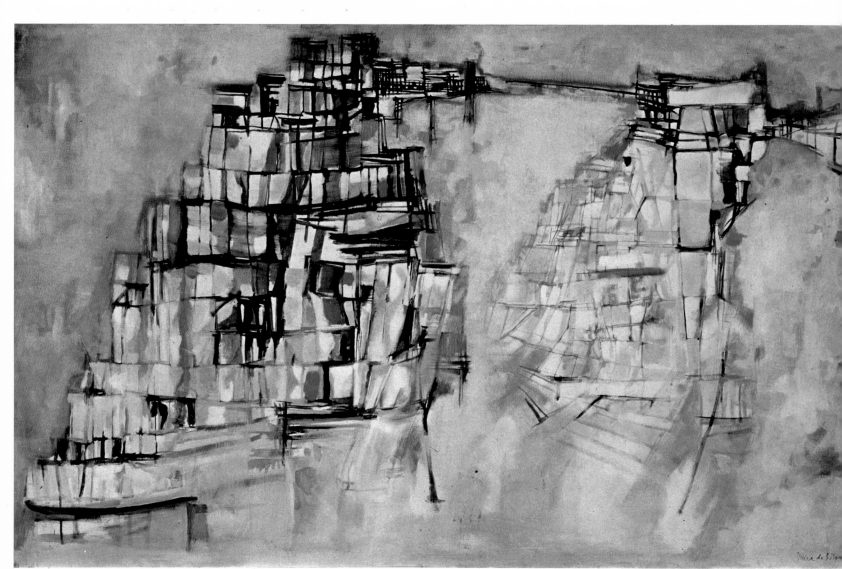

240

241. Library. Paris, 1955. Oil on canvas, 100×50 cm.
Fonds National d'Art Contemporain, Paris.

241
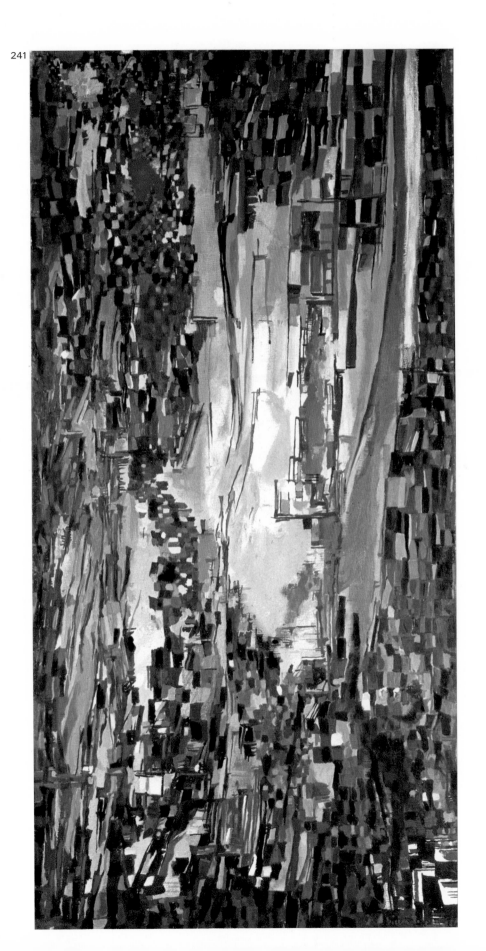

242. Elevated Subway. 1955. Oil on canvas, 160×220 cm.
 Kunstsammlungen Nordrhein-Westfalen, Düsseldorf.

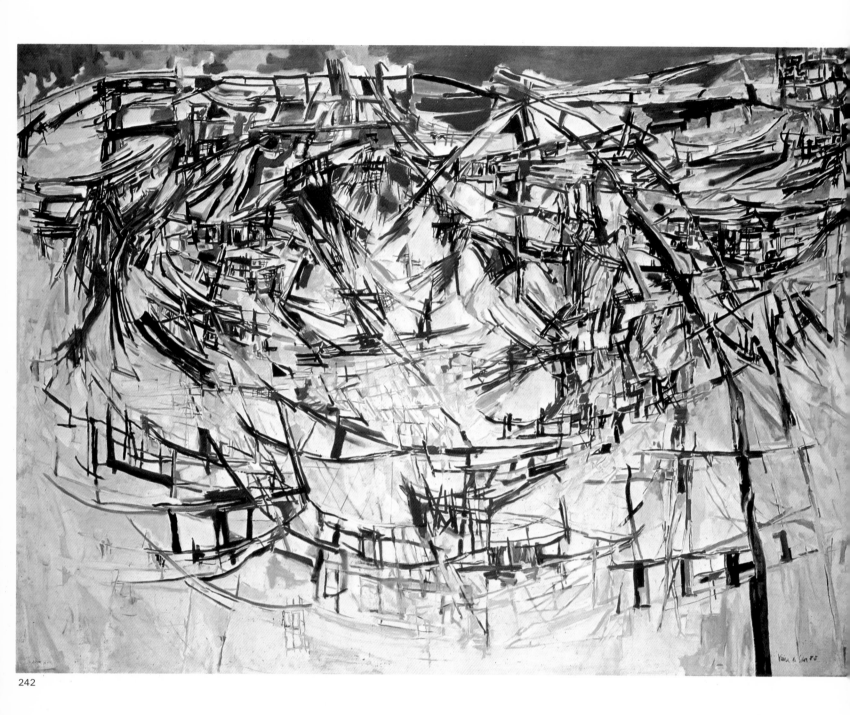

242

243. The Burned City. 1955. Oil on canvas, 130×81 cm.
Collection André Bernheim, Paris.

243

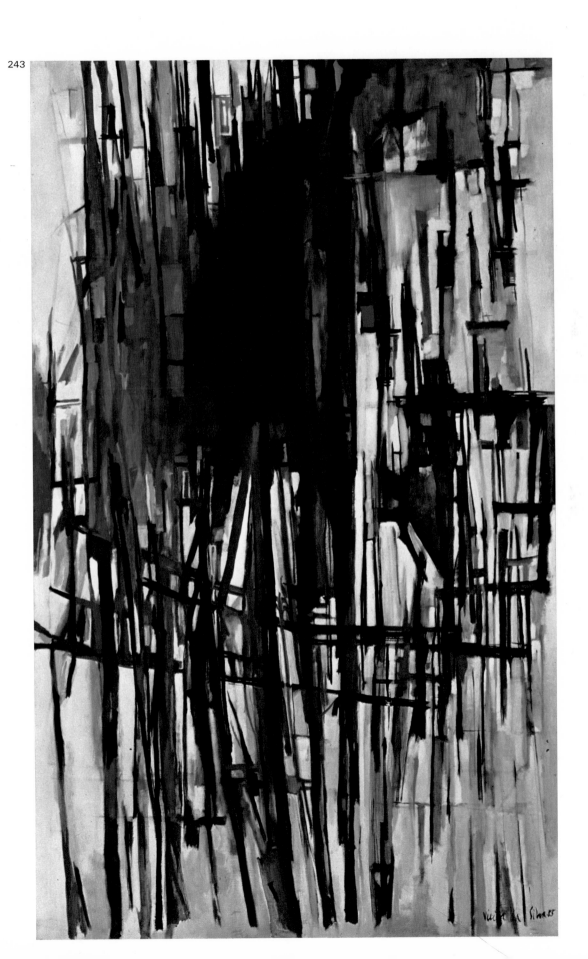

244. Csontvari. 1957. Oil on canvas, 81 × 100 cm.
Collection M. and Mme Etienne Hadju, Bagneux.

244

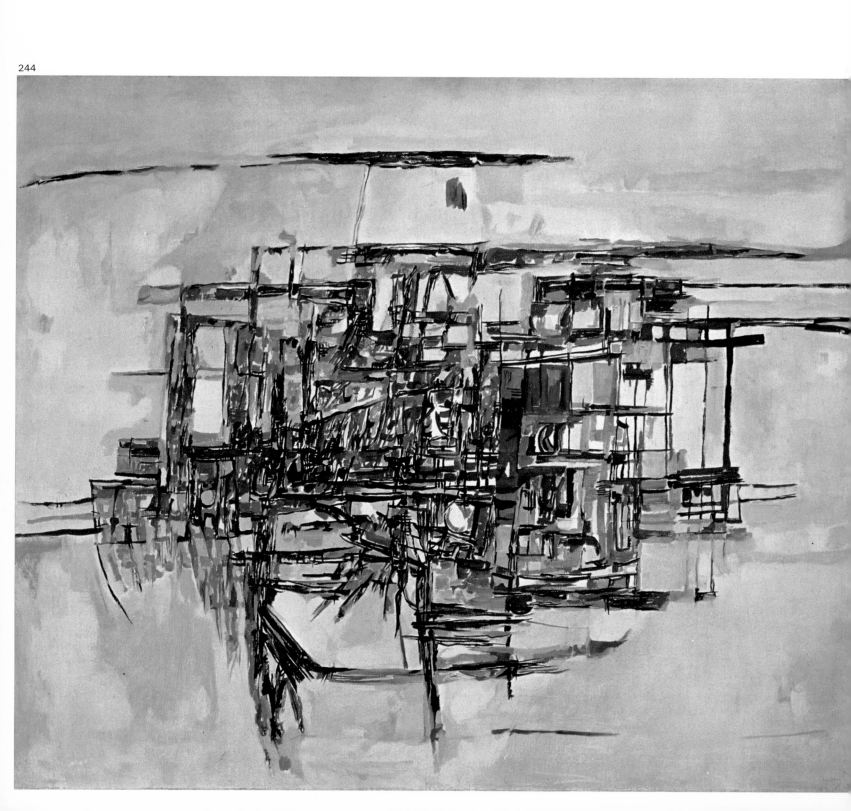

245. The City. 1955. Oil on canvas, 73×116 cm.
Private collection, Lausanne.

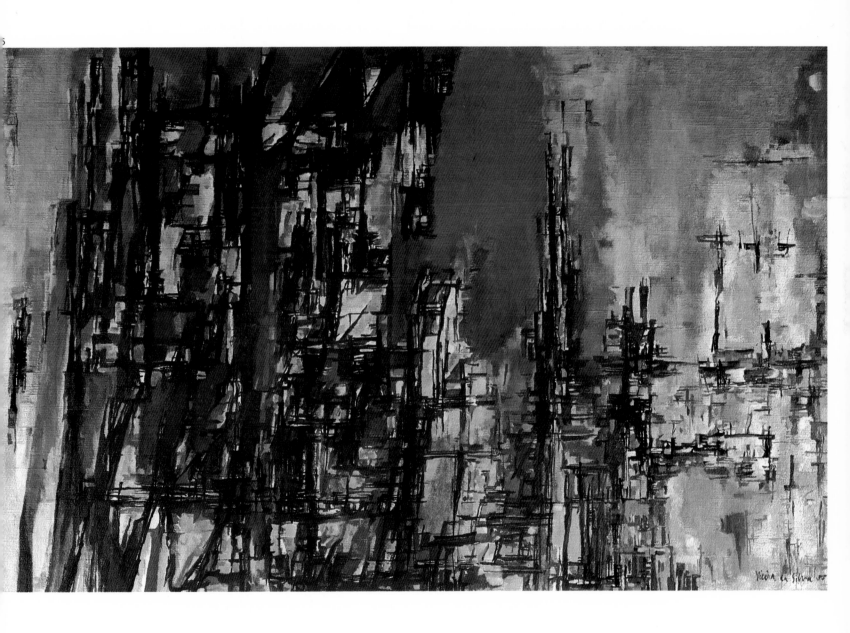

246. The Mine. Paris, 1956. Oil on canvas, 33×22 cm.
Private collection, Paris.

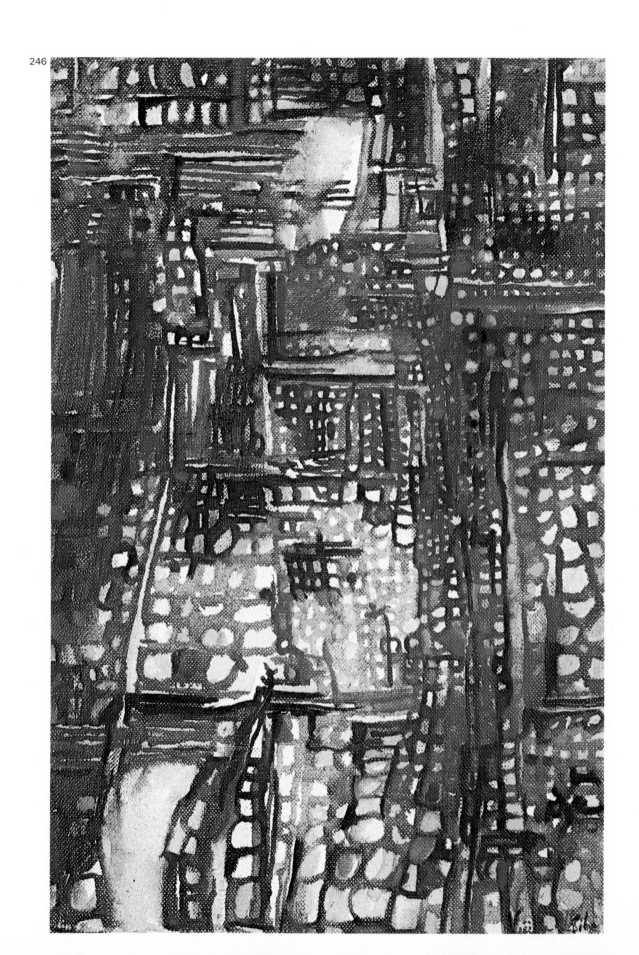

246

247. Workers' Quarter. 1956. Oil on canvas, 80×80 cm.
Private collection, Portugal.

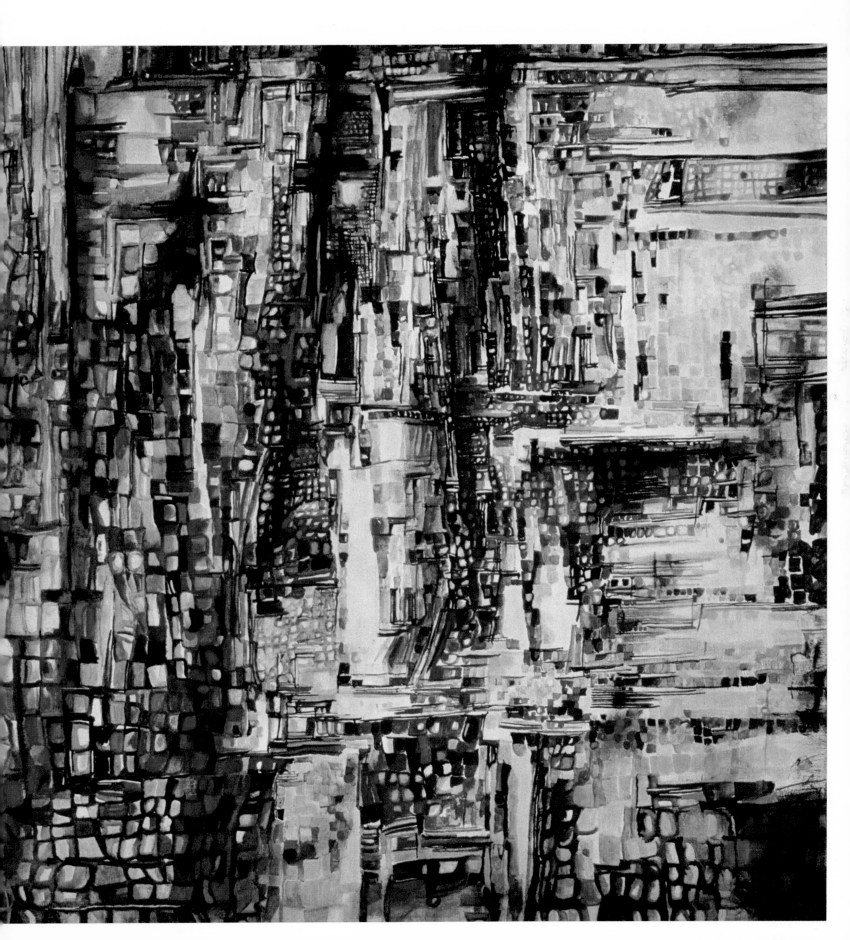

248. Contrasts. 1956. Oil on canvas, 60×120 cm.
Private collection, Lisbon.

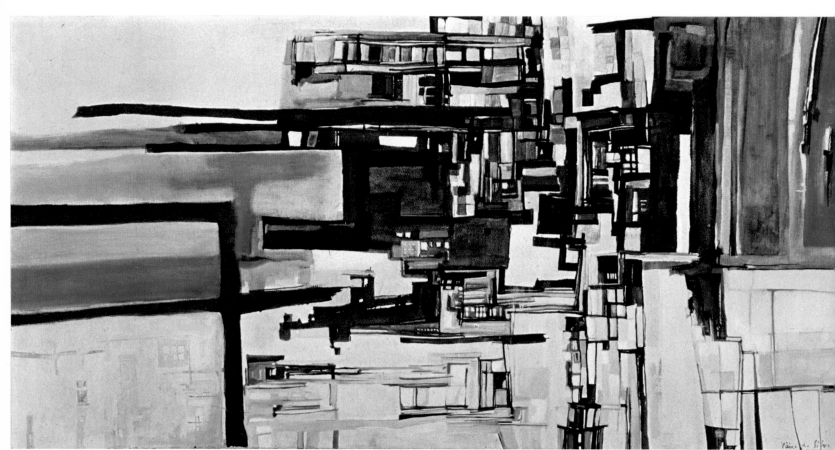

248

249. The Library. 1955. Oil on canvas, 81 × 100 cm.
Private collection, Paris.

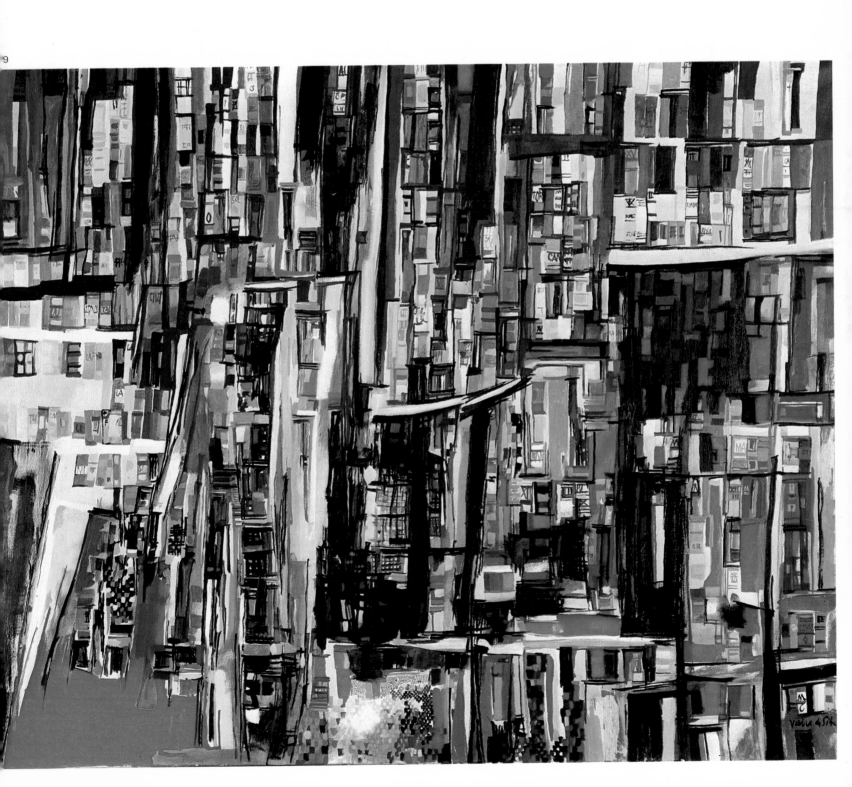

250. Gare Montparnasse. 1957. Oil on canvas, 81×100 cm.
Walker Art Center, Minneapolis.

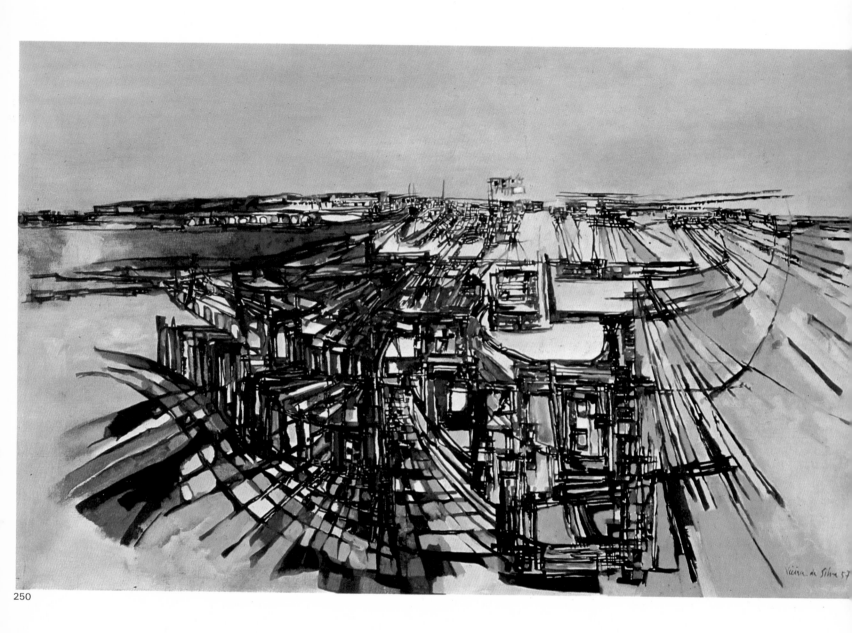

250

251. Tempest. 1957. Oil on canvas, 81 × 130 cm.
 Private collection, Lisbon.

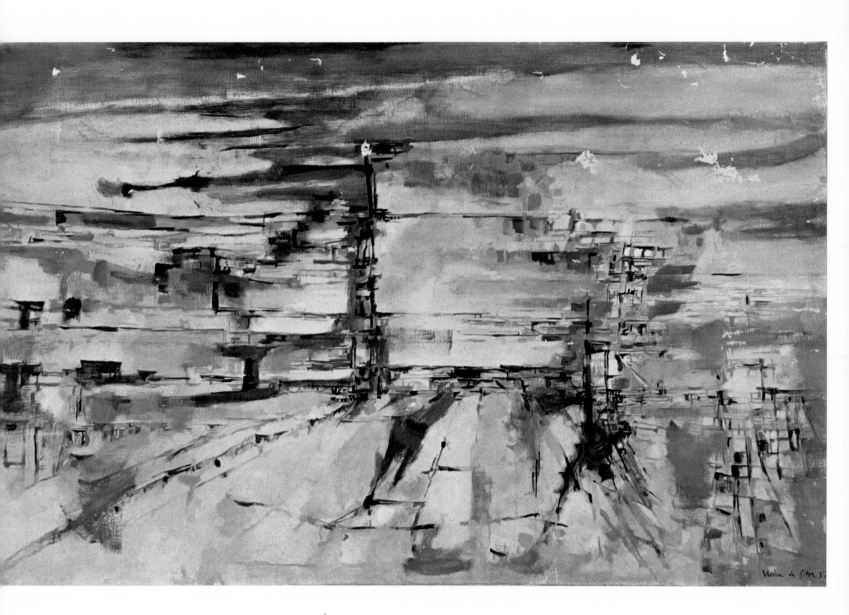

252. Large Constructions. 1956. Oil on canvas, 136×156 cm.
Private Collection, Paris.

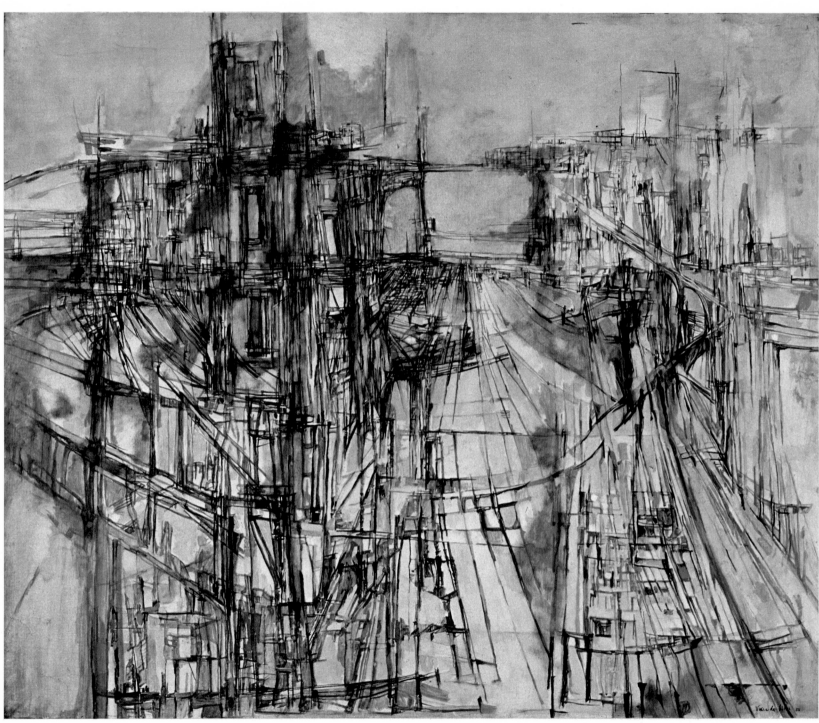

252

253. Outlines of the Storm. 1956. Oil on canvas, 81×100 cm.
 Private collection, Geneva.

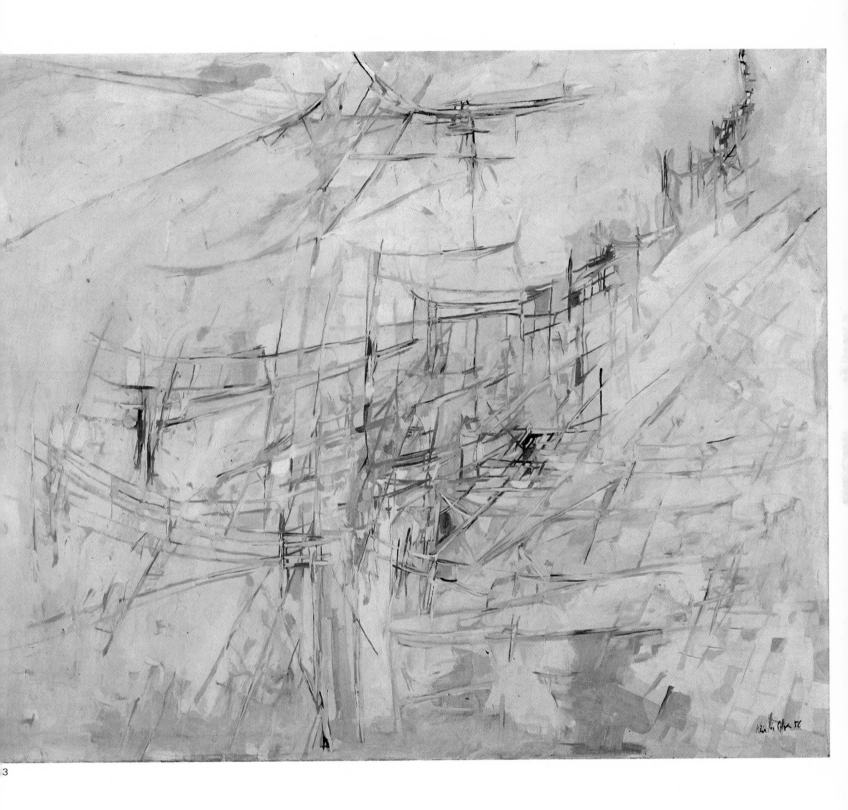

254. Knotted Landscape. 1957. Oil on canvas, 81×130 cm.
Private collection, Lisbon.

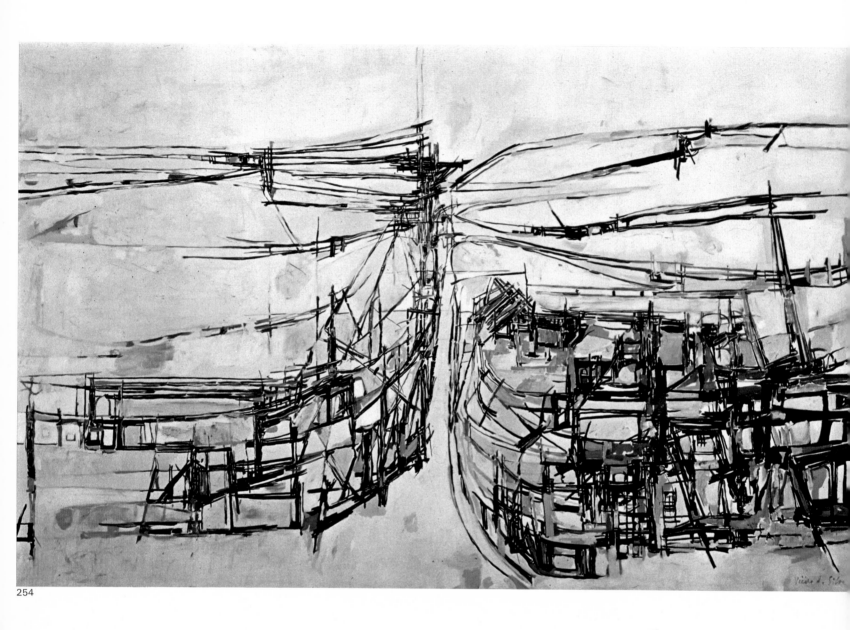

254

255. The Martyred City. 1957. Oil on canvas, 115×138 cm.
Private collection, Lisbon.

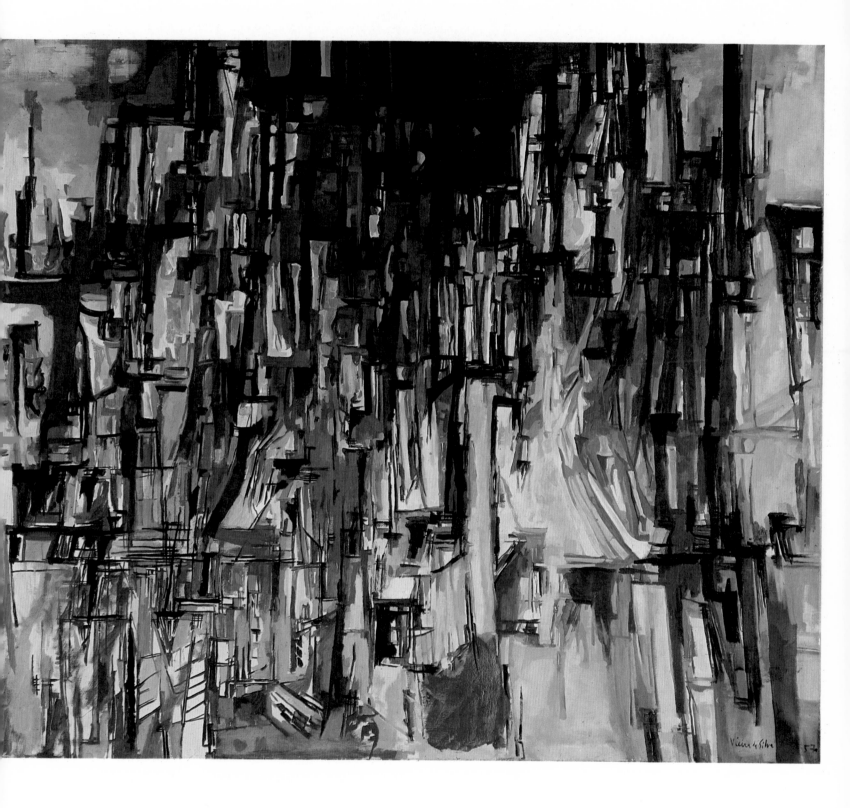

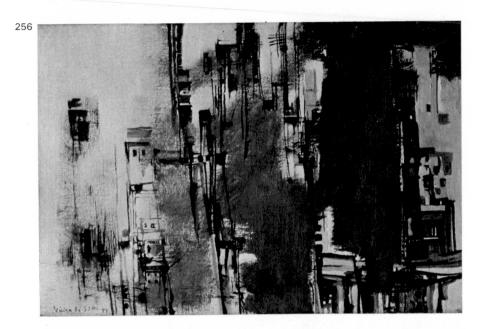

256

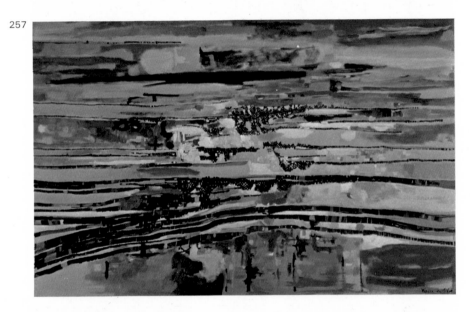

257

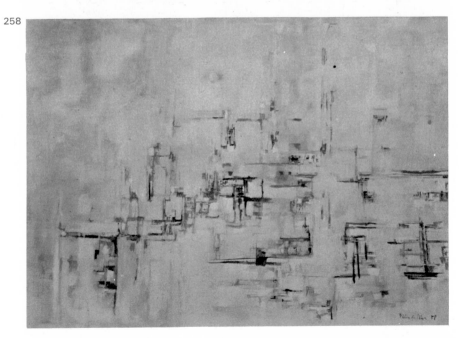

258

256. Future Urbanism. 1957. Oil on canvas, 27 × 41 cm. Private collection, Paris.

257. Sunset. 1957. Oil on canvas, 81 × 130 cm. Private collection, Lisbon.

258. The Gardens of Semiramis. 1958. Oil on canvas, 65 × 92 cm. Private collection, Lisbon.

259. Untitled. 1956-57. Tempera on paper, 67 × 67 cm. Private collection, Lisbon.

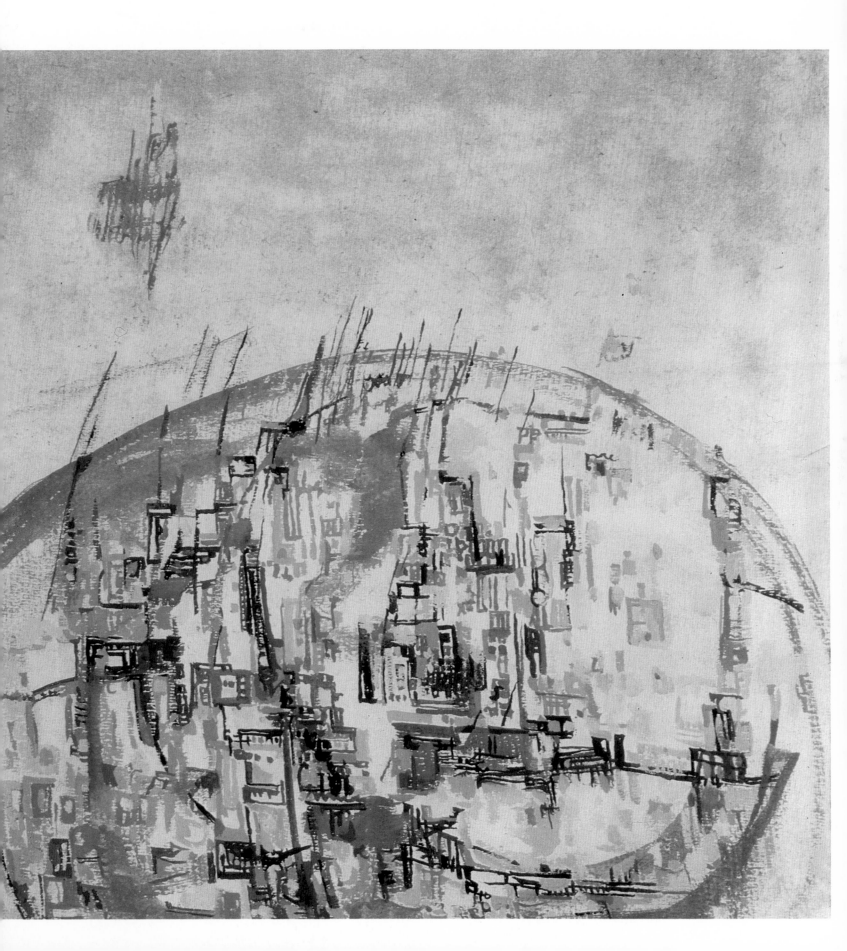

260. Old America. 1958. Oil on canvas, 33×22 cm.
Private collection, Paris.

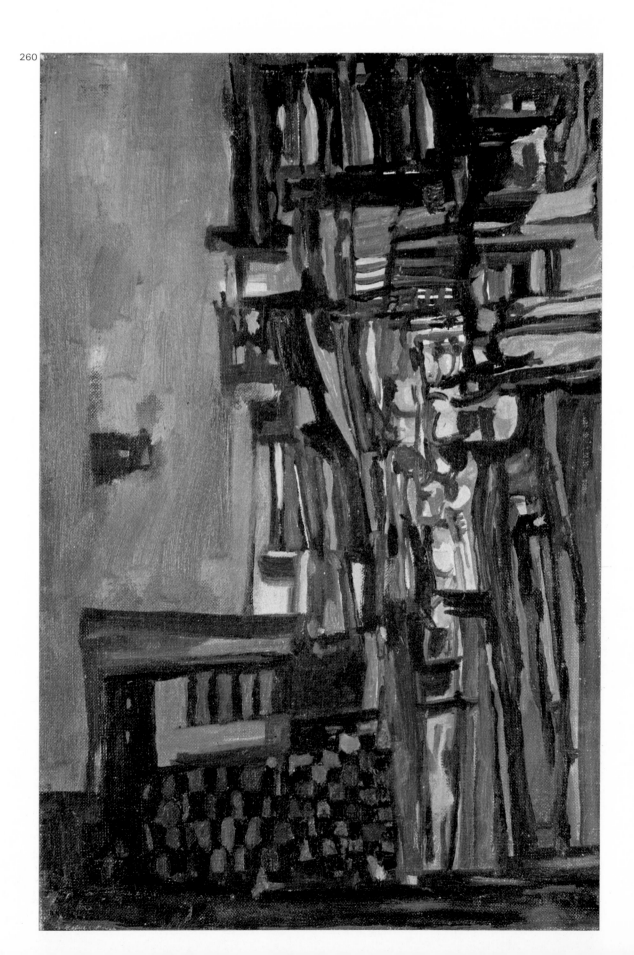

260

261. Collapsed Façades. 1957. Watercolor on paper, 68×56 cm.
Private collection, Lisbon.

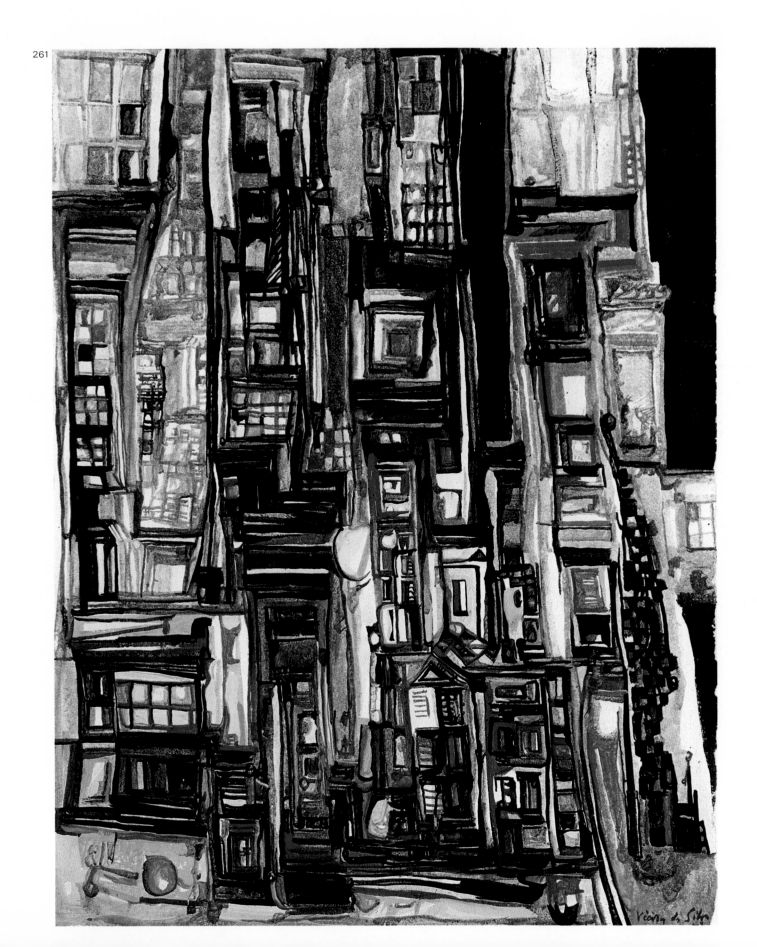

261

262. November. 1958. Oil on canvas, 114×146 cm.
 Private collection, Lisbon.

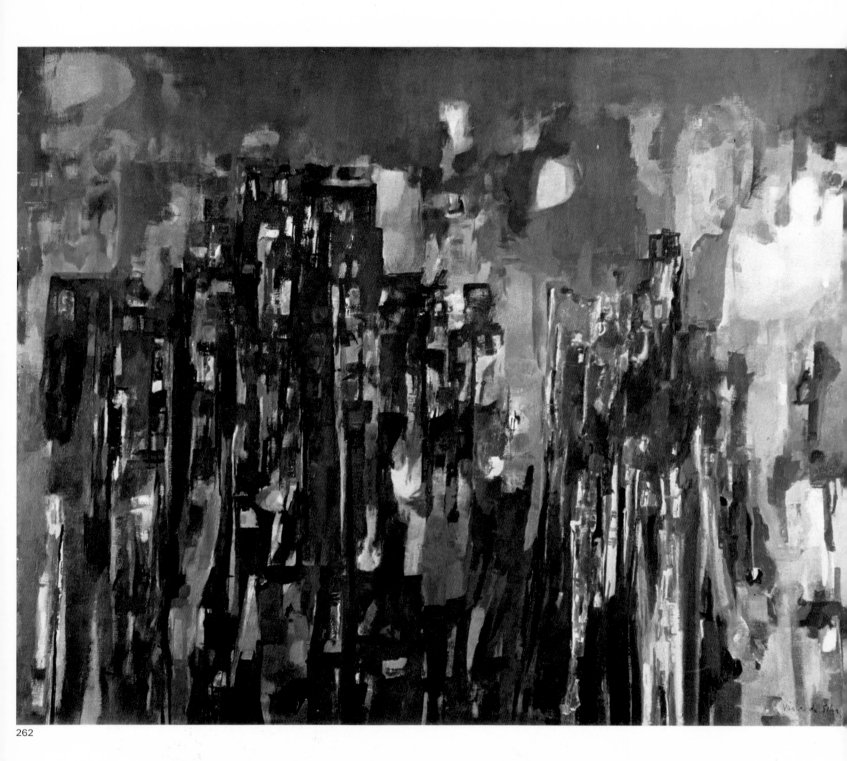

262

263. Canals in Holland. 1958. Oil on canvas, 137×114 cm.
 Private collection, Lisbon.

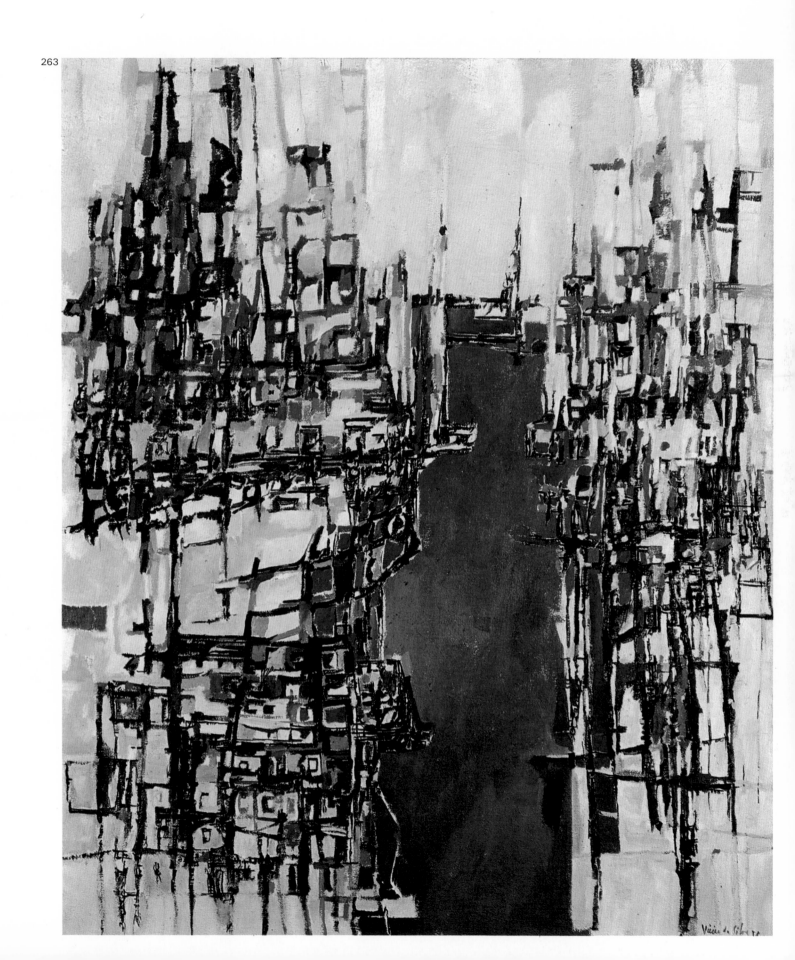

263

264. Periwinkle Blue. 1959. Oil on canvas, 81×100 cm.
Collection M. and Mme P. Berés, Paris.

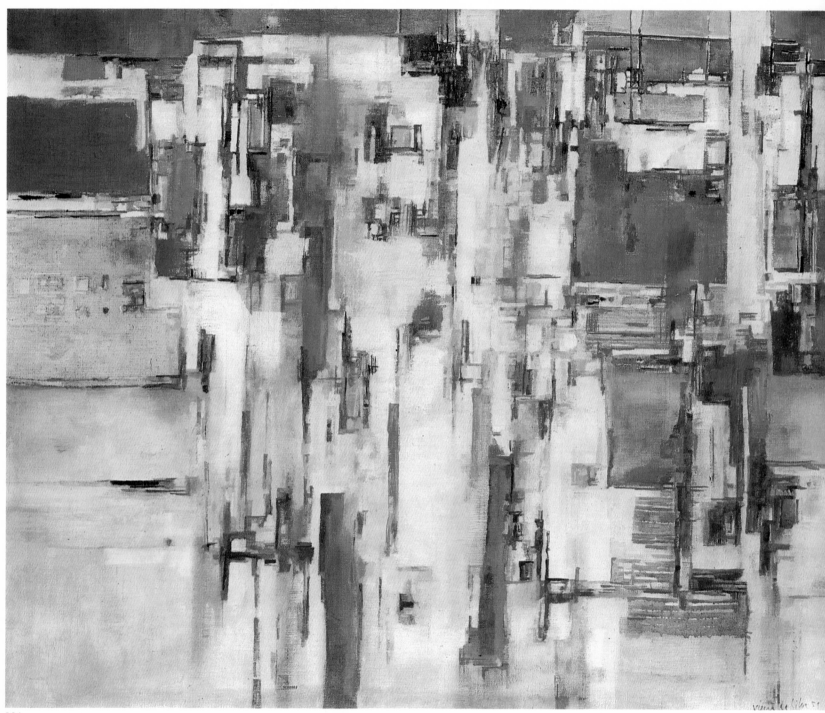

264

265. Fields of Sainte-Claire. 1958. Oil on canvas, 97×130 cm.
Private collection, Lisbon.

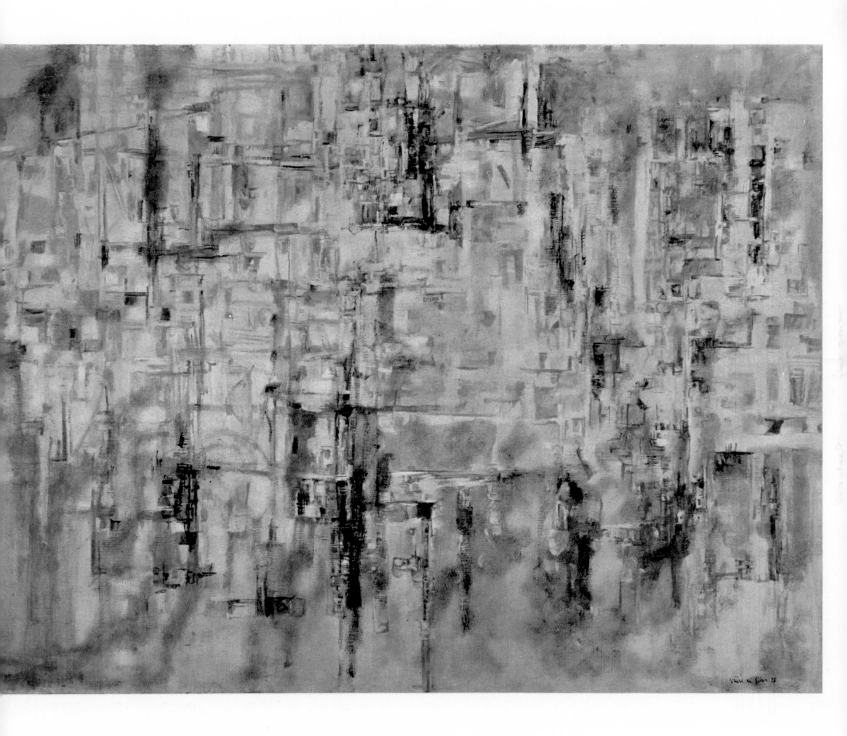

266. Flanders. 1960. Oil on canvas, 147×162 cm.
Cincinnati Art Museum. Cincinnati, Ohio.

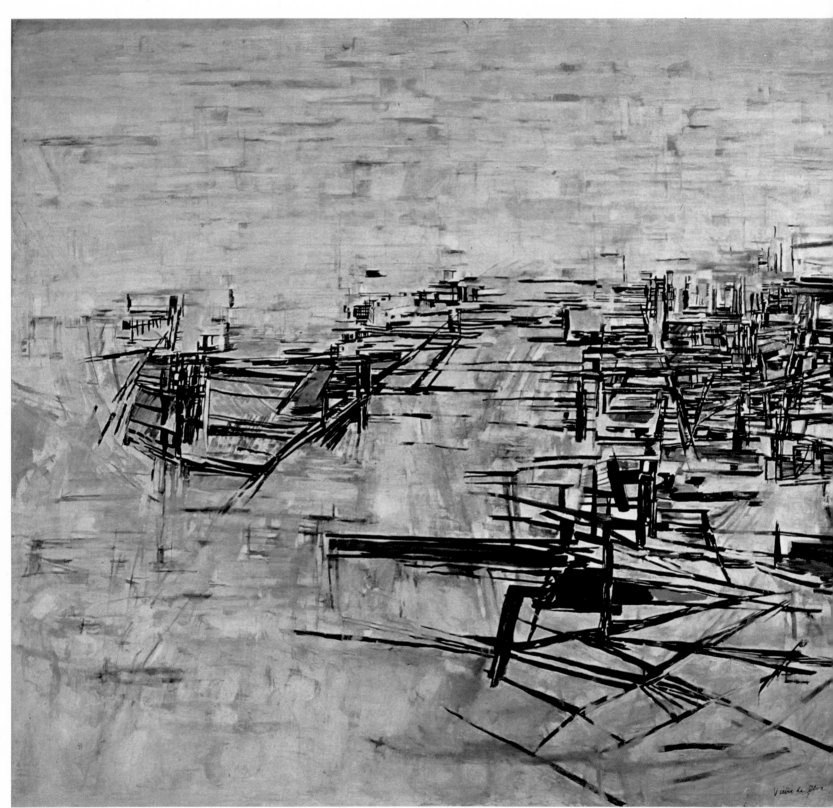

267. London. 1959. Oil on canvas, 162×146 cm.
Private collection, Paris.

267

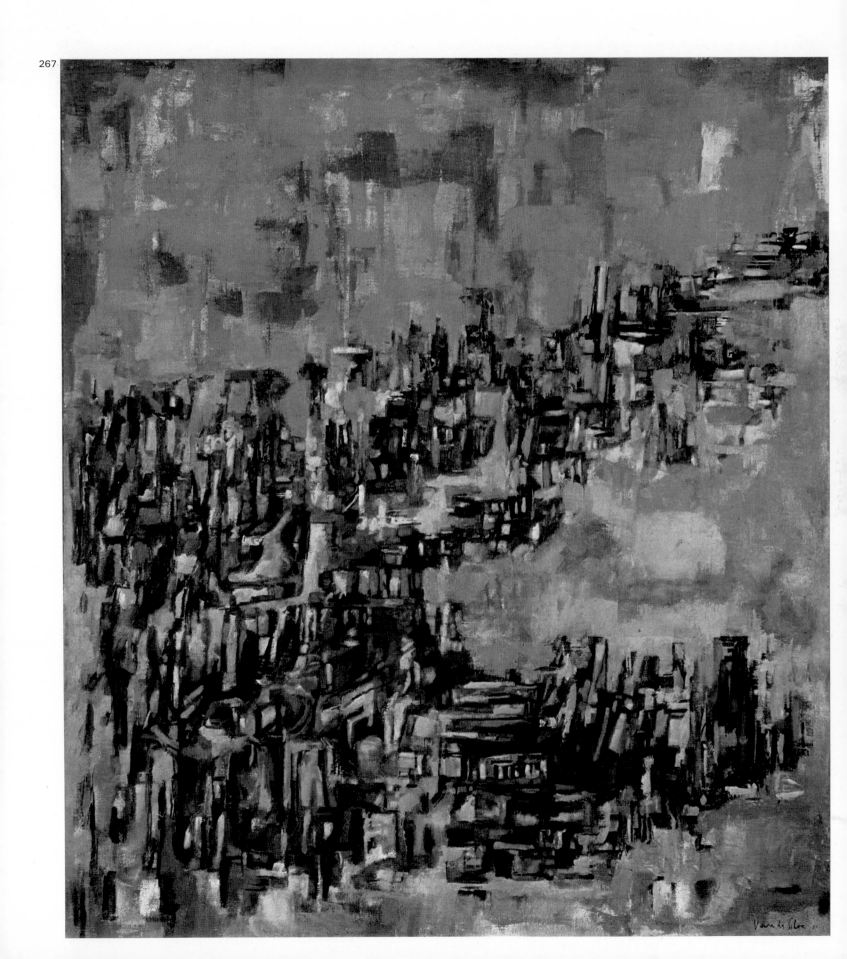

268. Chalk. 1958. Tempera on paper, 71 × 70 cm. Private collection, Paris.

268

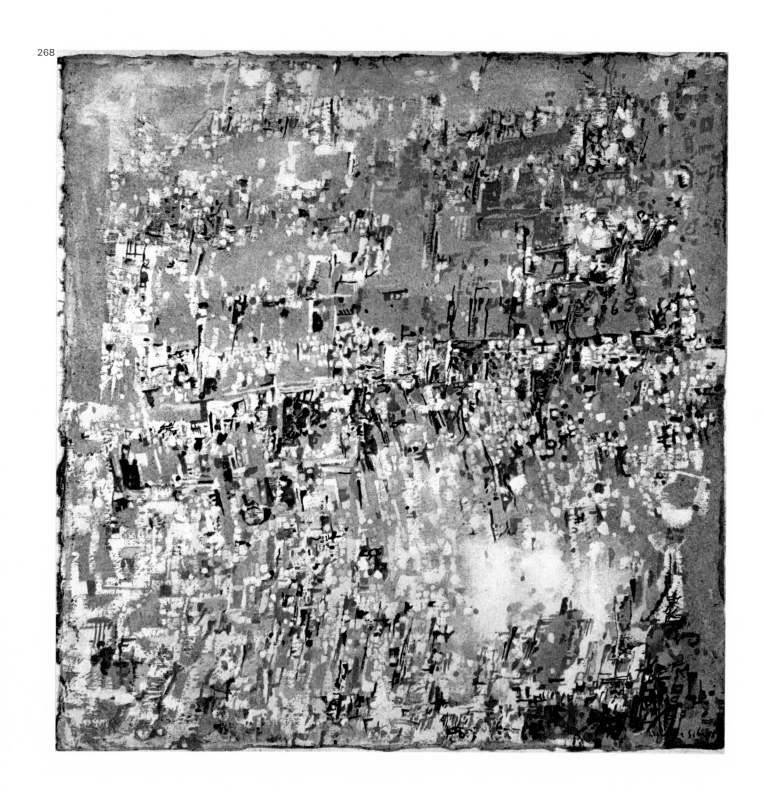

269. The Cascade. 1960. Oil on canvas, 81 × 100 cm.
Collection René Char, Paris.

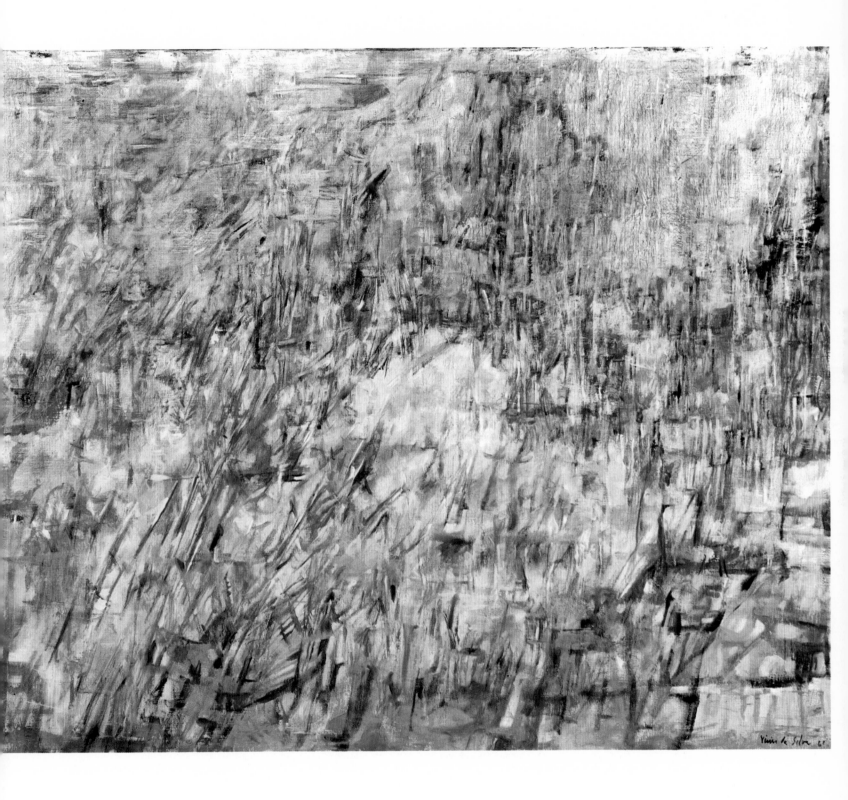

270. Summer. 1960. Oil on canvas, 81×100 cm.
 Musée National d'Art Moderne, Centre d'Art et de Culture Georges Pompidou, Paris.

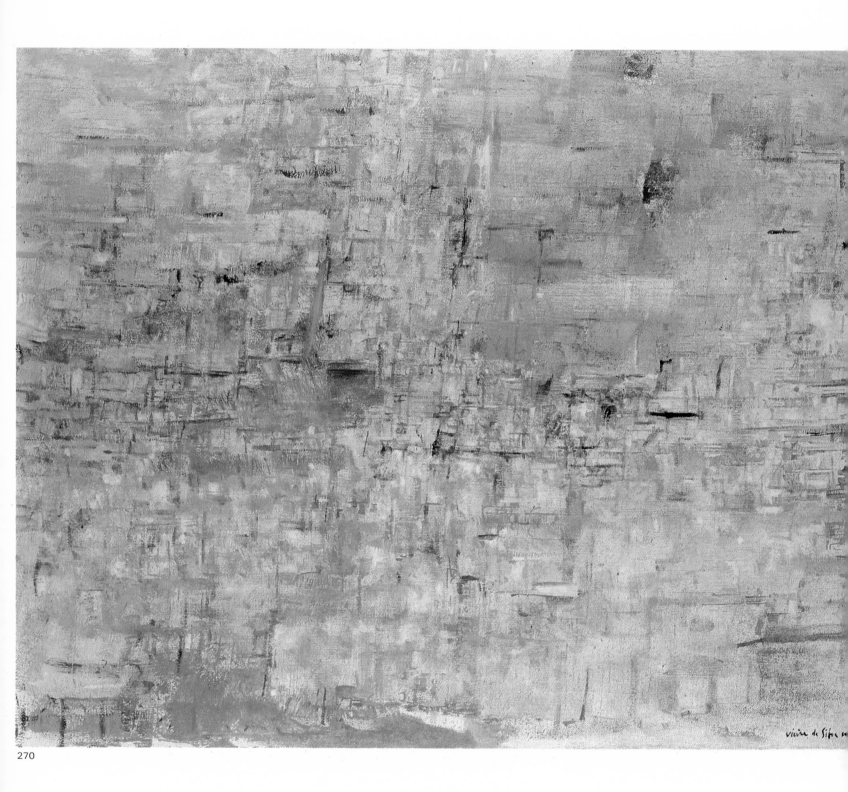

270

271. The Lost Path. 1960. Oil on canvas, 81×100 cm.
Private collection, New York.

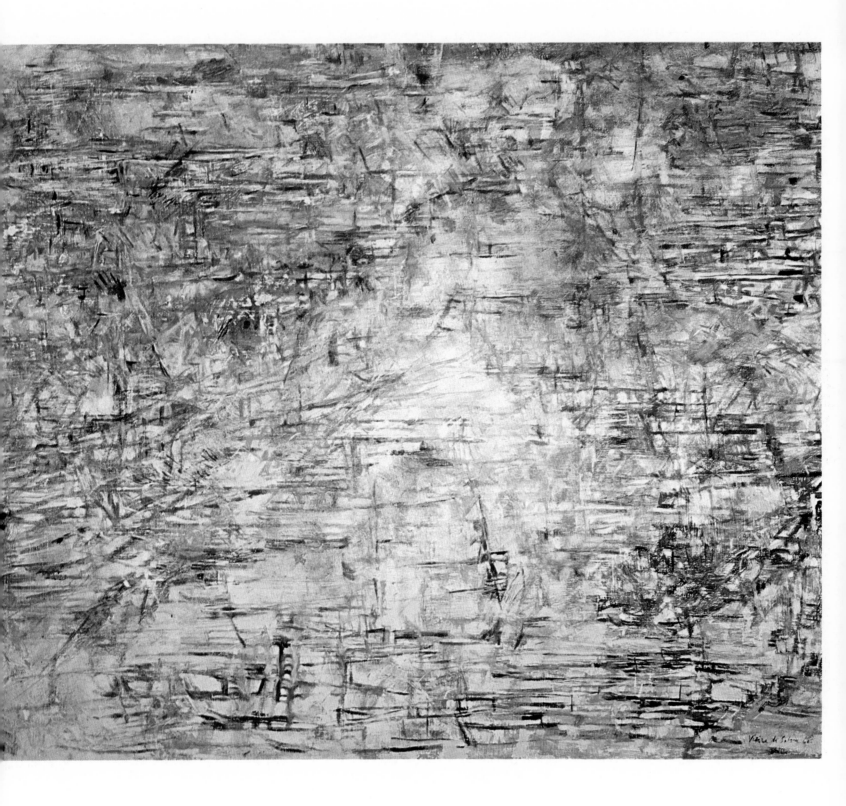

272. The Cycle of the Seasons. 1960. Oil on canvas, 81 × 100 cm.
Private collection, Paris.

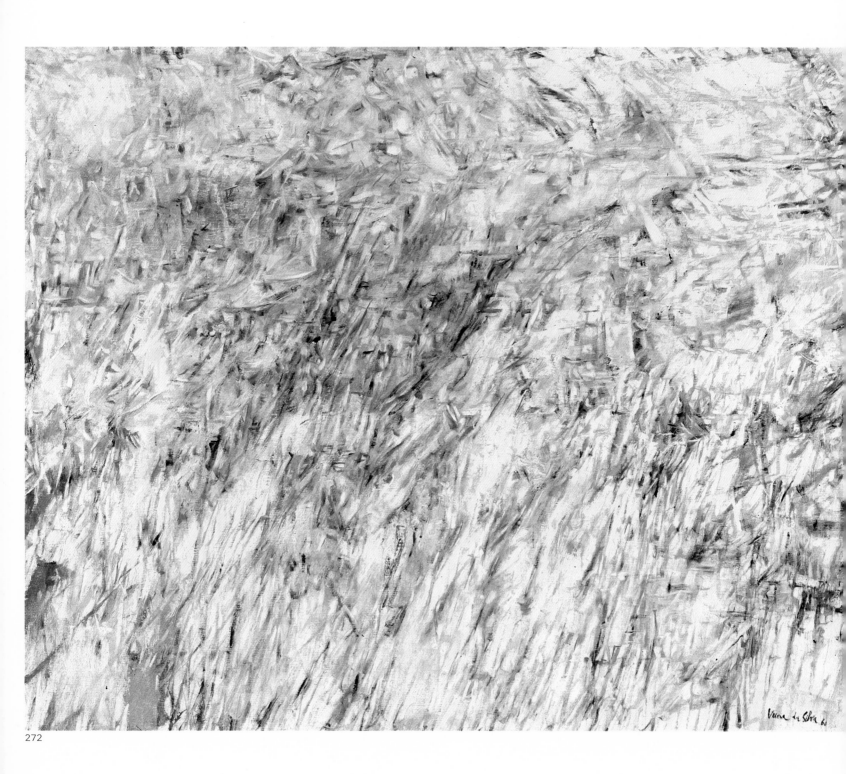

273. The Hill. 1960. Tempera on paper, 67×67 cm.
Private collection, Paris.

273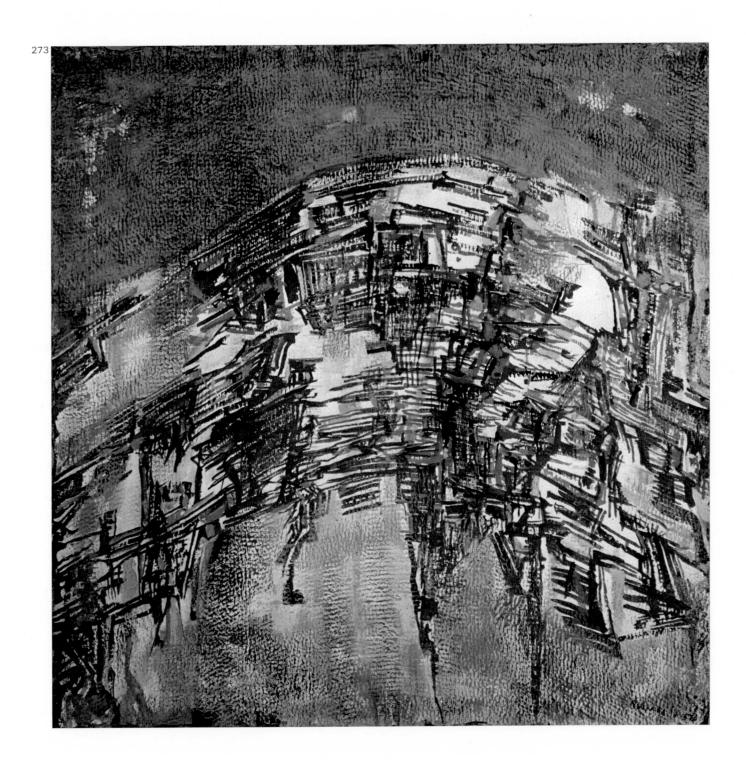

274. Glass and Steel. 1960. Oil on canvas, 116×73 cm.
Collection Mrs. Beatrice Glass, New York.

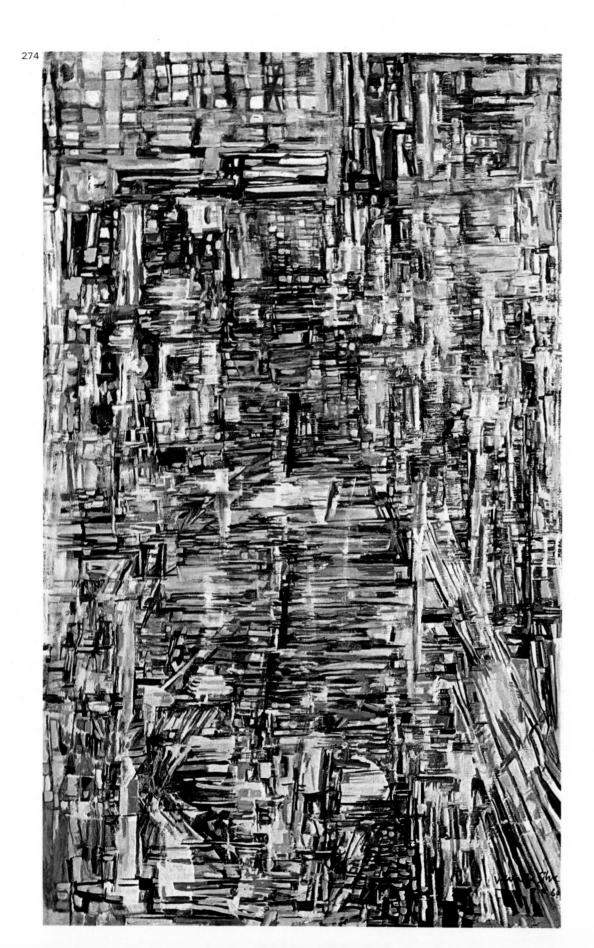

274

275. Le Bal. 1960. Oil on canvas, 147×162 cm.
Collection Mr. and Mrs. Edwin E. Hokin, Illinois.

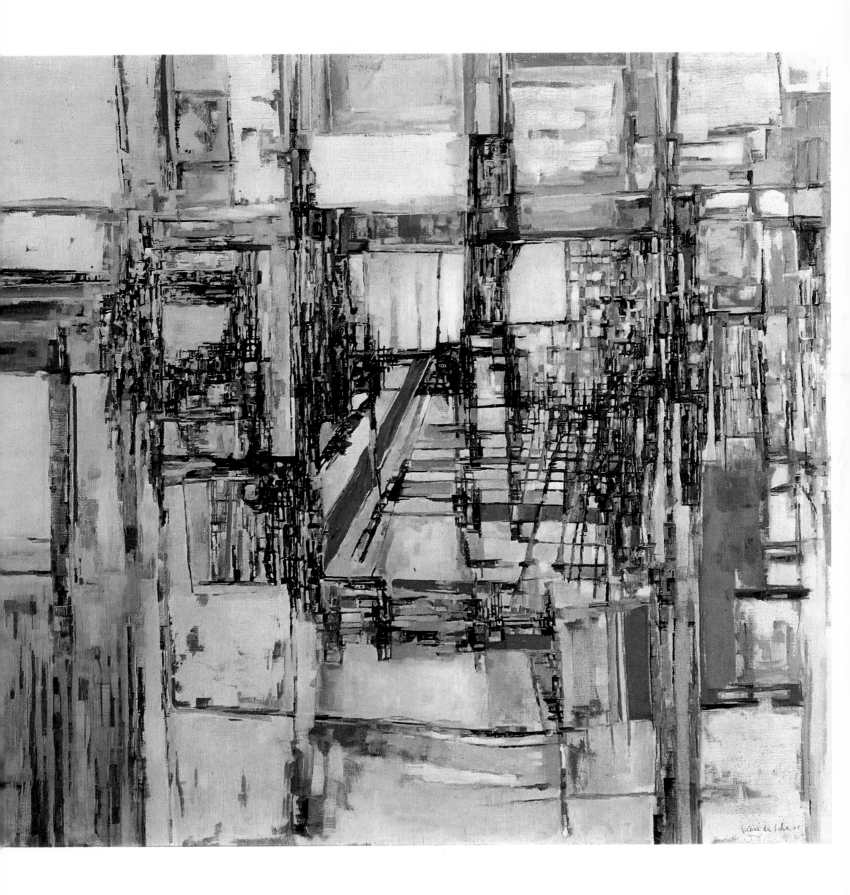

276. Strong City. 1960. Oil on canvas, 162×146 cm.
Private collection, Paris.

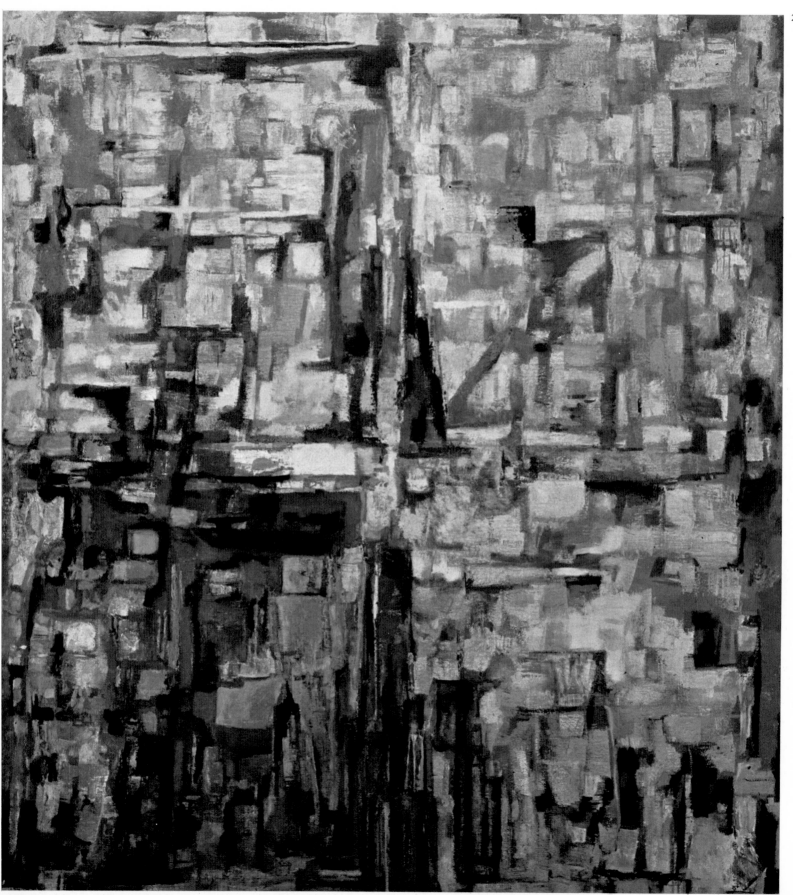

277. The Easels. 1960. Oil on canvas, 114×137 cm.
The Phillips Collection, Washington, D. C.

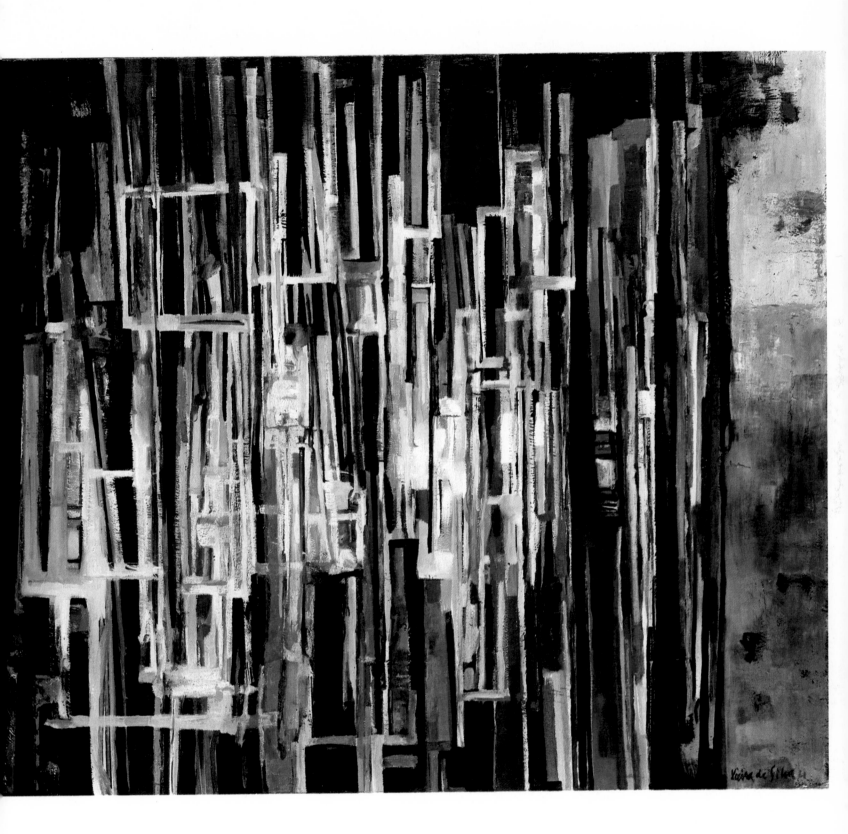

278. The Bridge. 1954-60. Oil on canvas, 73×116 cm.
Private collection, Lisbon.

279. Saint-Fargeau. 1961-65. Oil on canvas, 162×130 cm.
Private collection, Lisbon.

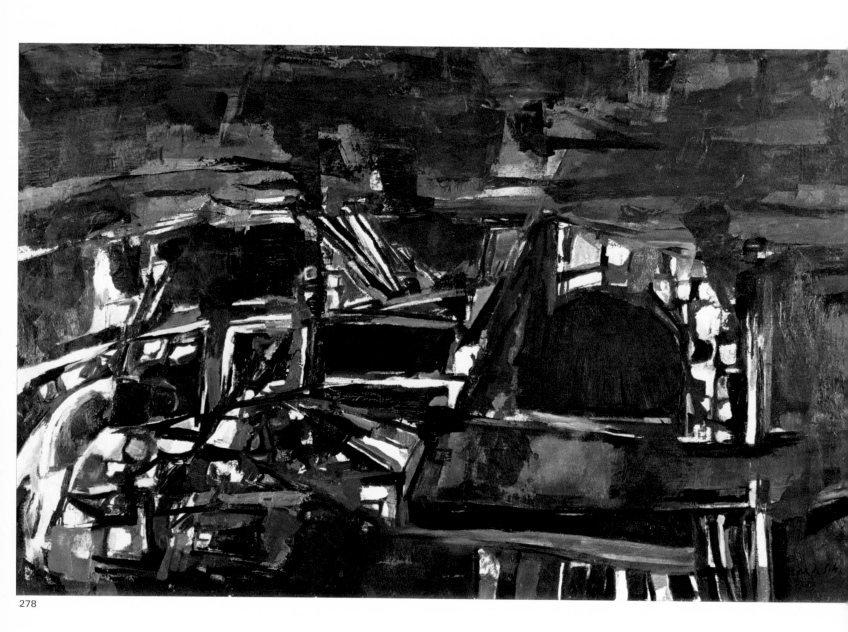

278

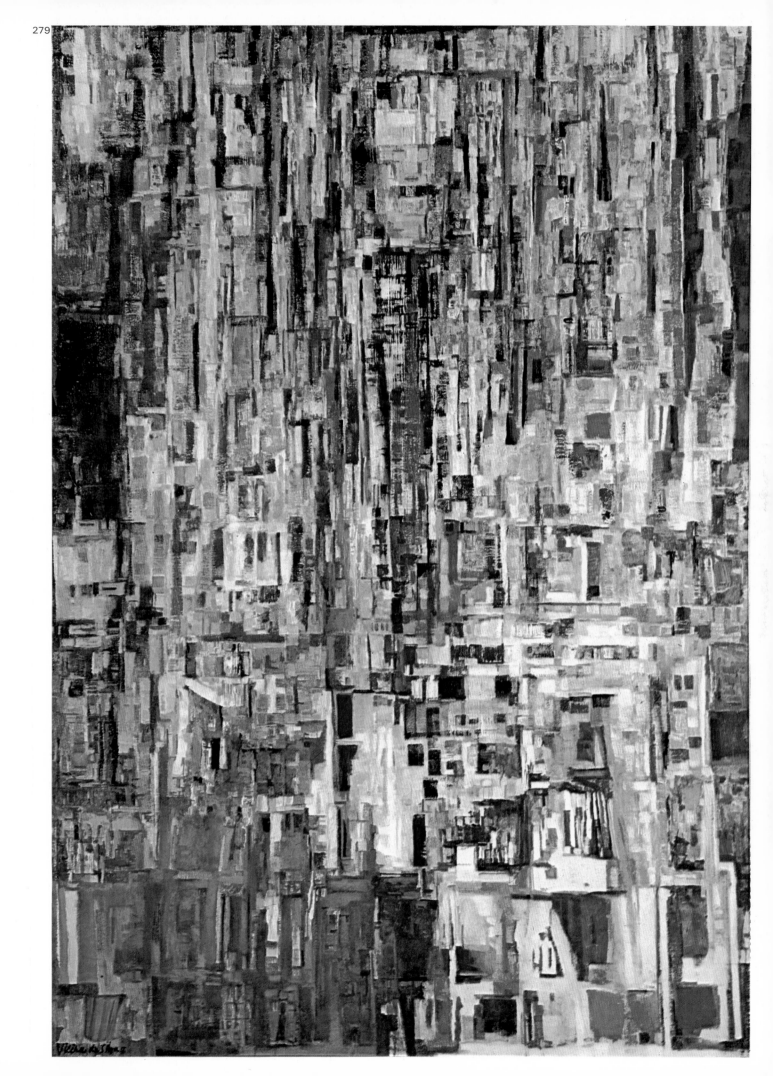

280. Impossible Enterprise. 1961-67. Oil on canvas, 162×162 cm.
 Musée National d'Art Moderne, Centre d'Art et de Culture Georges Pompidou, Paris.

280

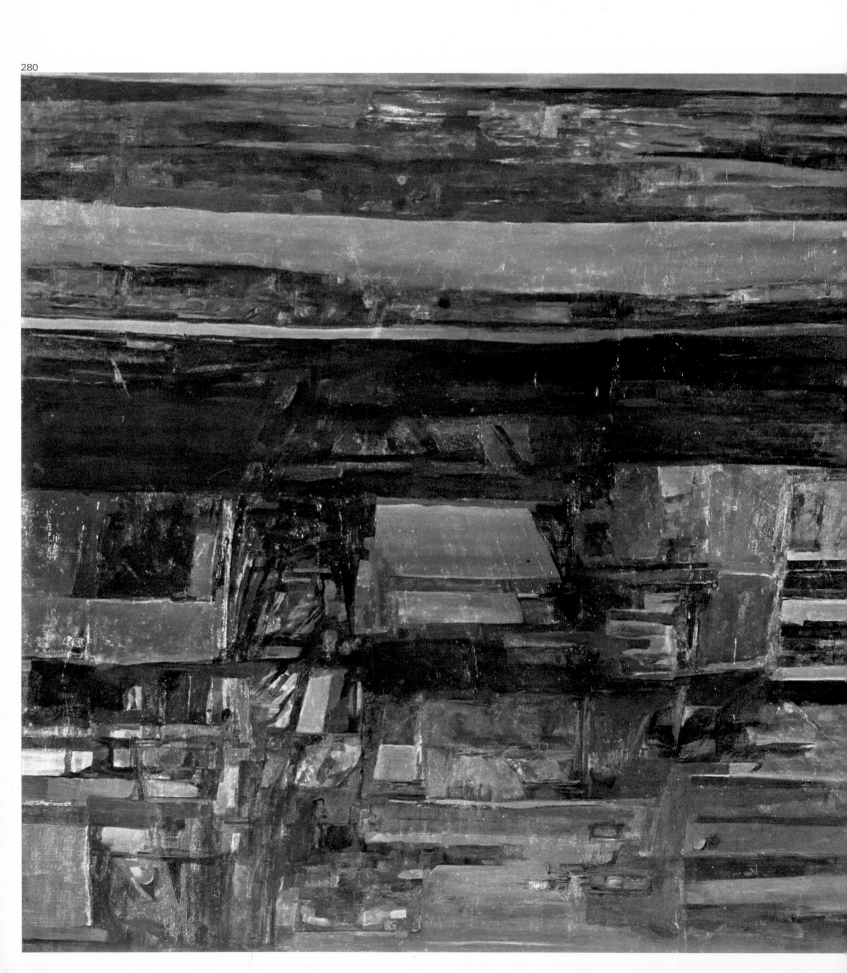

281. The Storm. 1961. Tempera on paper, 63×99 cm.
Private collection, Paris.

282. The Sea. 1962. Tempera on paper, 50×66 cm.
Collection Théodore Schempp, Paris.

283. Paris. 1961. Tempera on paper, 7.5×66 cm.
Private collection, Paris.

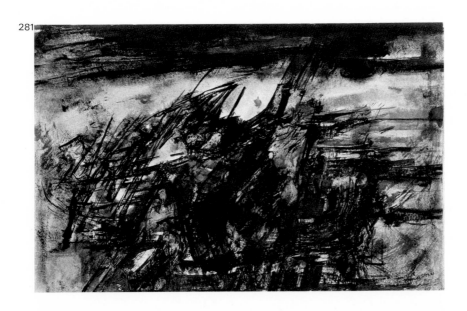

281

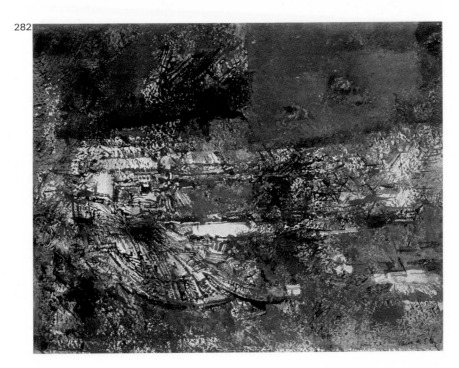

282

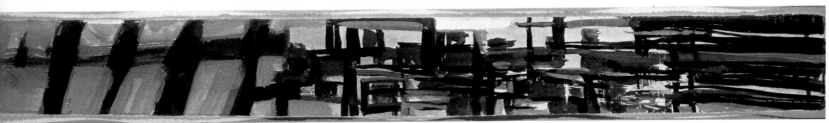

284. The Golden City (The Illuminated Port). 1956. Oil on canvas, 81×100 cm.
Musée des Beaux-Arts, Dijon. Donation Granville.

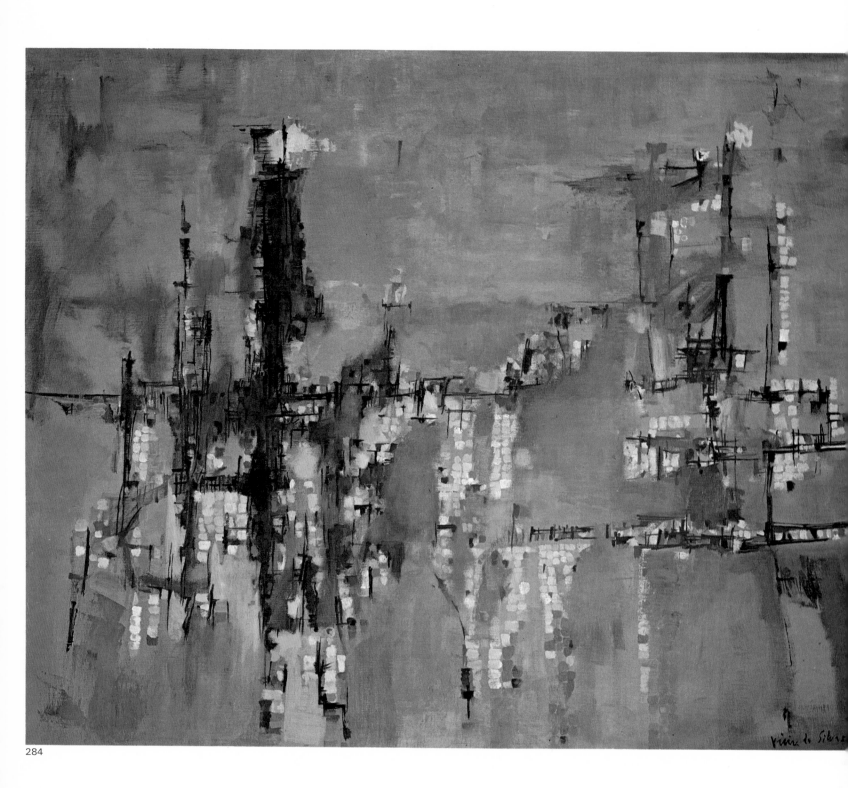

284

285. Nizhni Novgorod. 1961. Tempera on paper, 50×67 cm.
Collection Théodore Schempp, Paris.

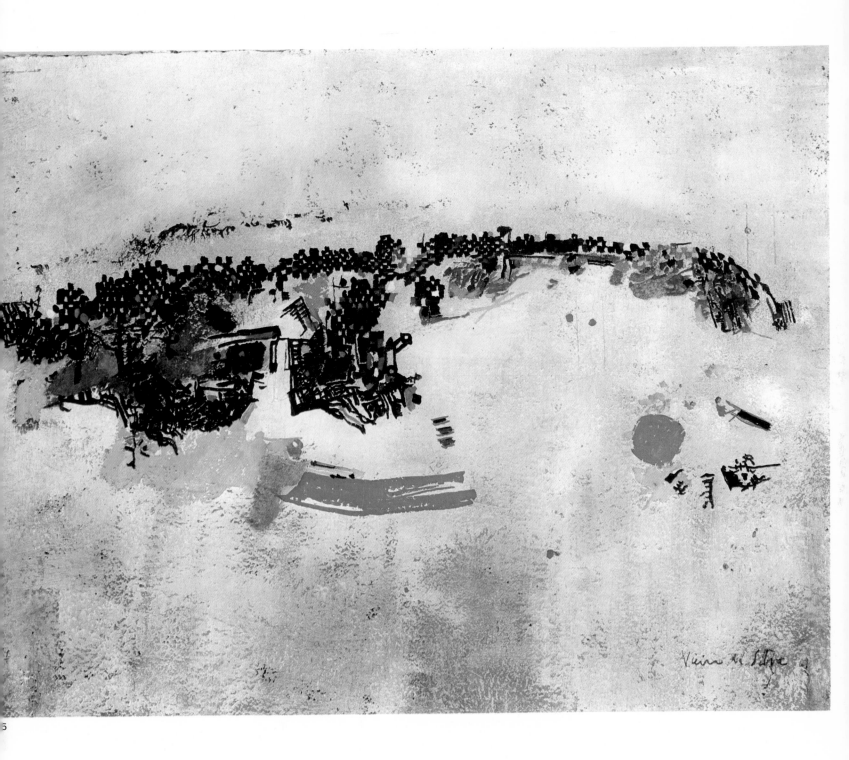

286. Painting. 1952. Oil on canvas, 27×16 cm. Private collection, Paris.

286

287. Oporto. 1962. Tempera on paper, 67×67 cm.
Collection Banco Portugués do Atlantico, Oporto.

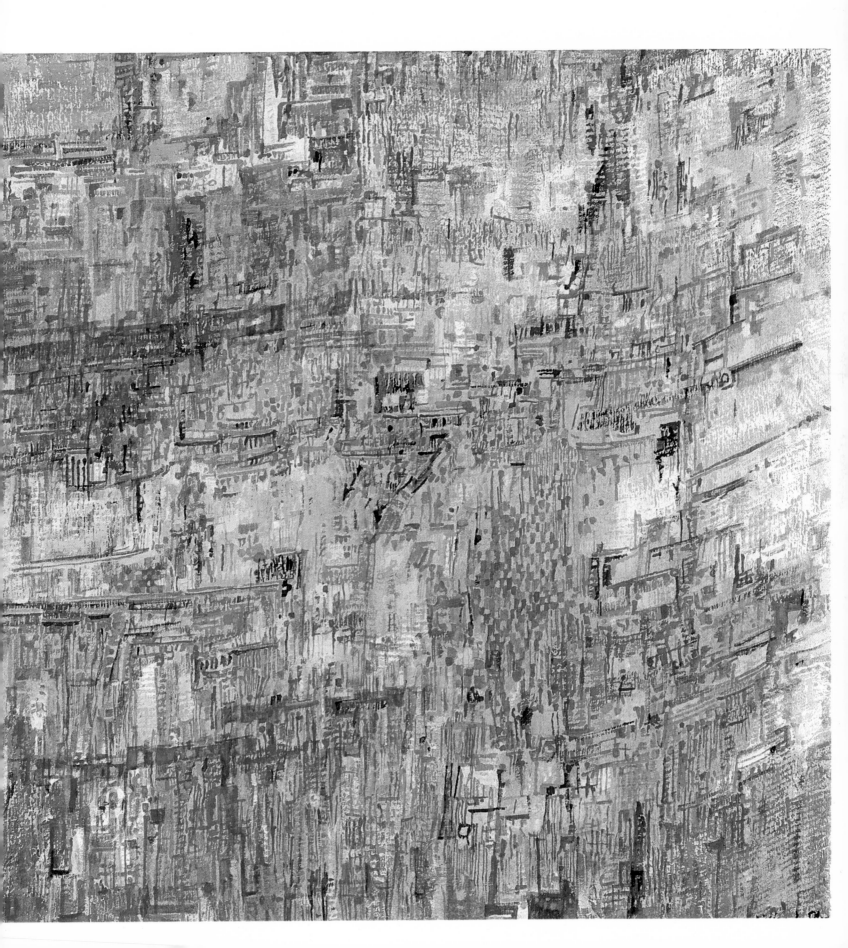

288. The Chessboard. 1962. Tempera on paper, 62×98 cm.
 Collection Dr. Jaeger, Paris.

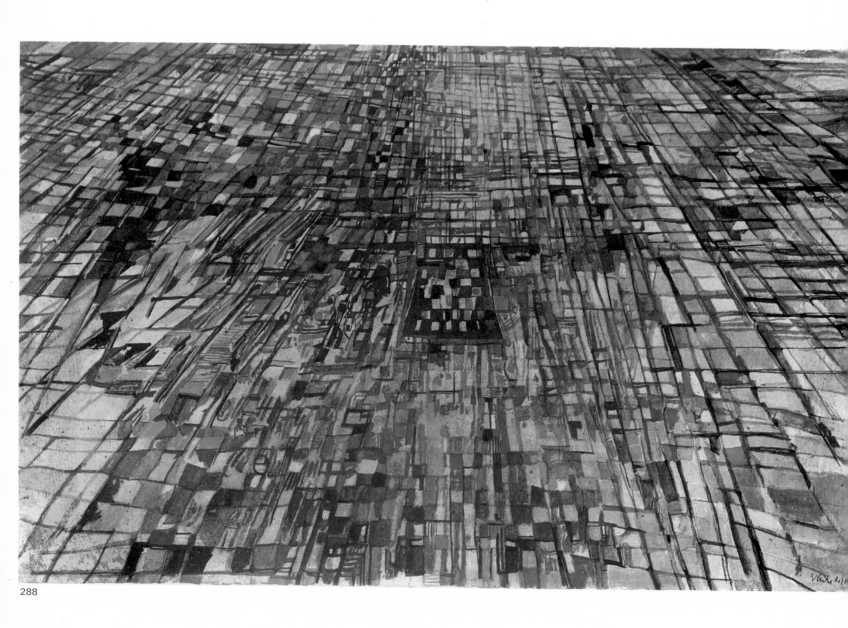

288

289. Au fur et à mesure. 1963. Oil on canvas, 195×130 cm.
Private collection, Lisbon.

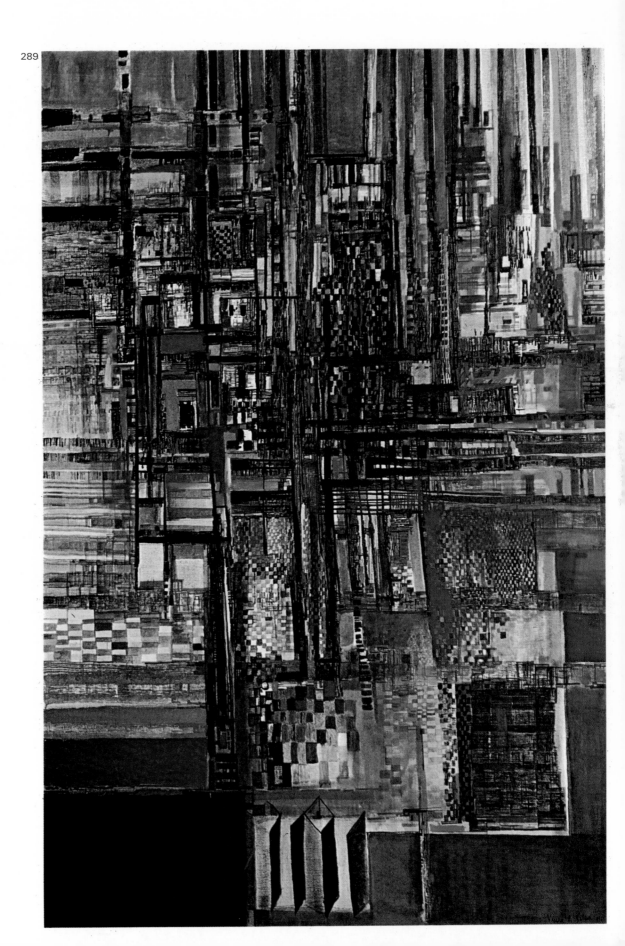

289

290. The Rosebush. 1963. Tempera on paper, 97×62 cm.
Private collection, Paris.

291. Dihedron. 1963. Oil on canvas and pasted papers. 195×130 cm.
Private collection, Paris.

290

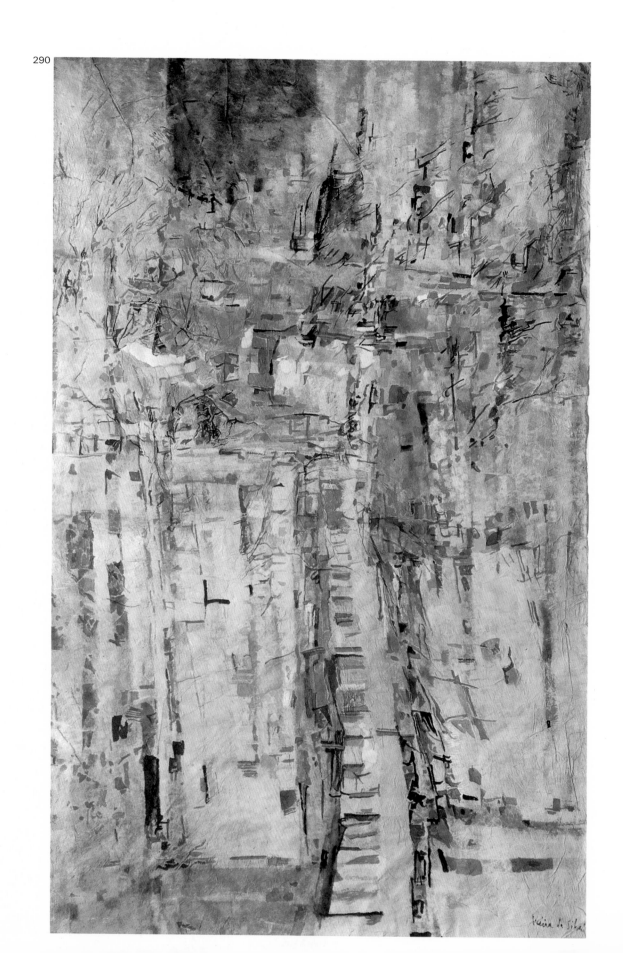

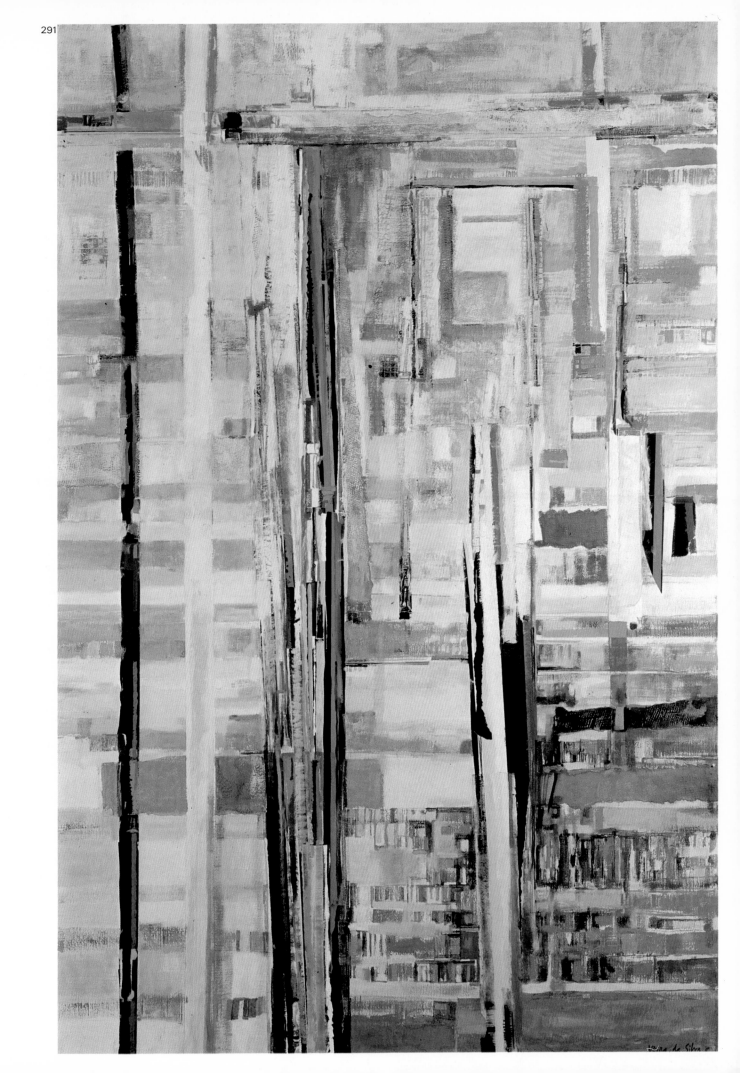

292. Kukan. Paris, 1963. Tempera on paper, 61 × 99.5 cm.
Private collection, Paris.

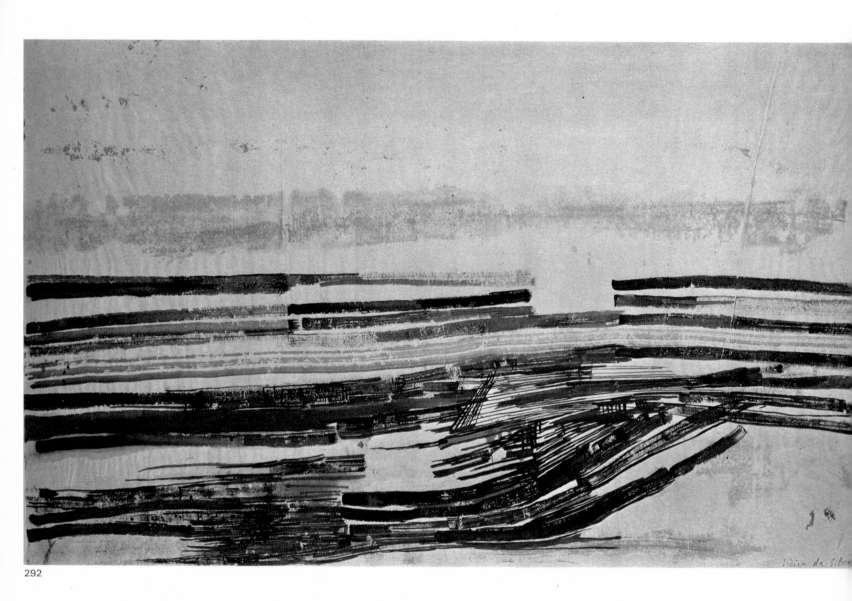

292

293. The Collector's Room. 1964. Tempera on paper, 68×68 cm.
Private collection, Lausanne.

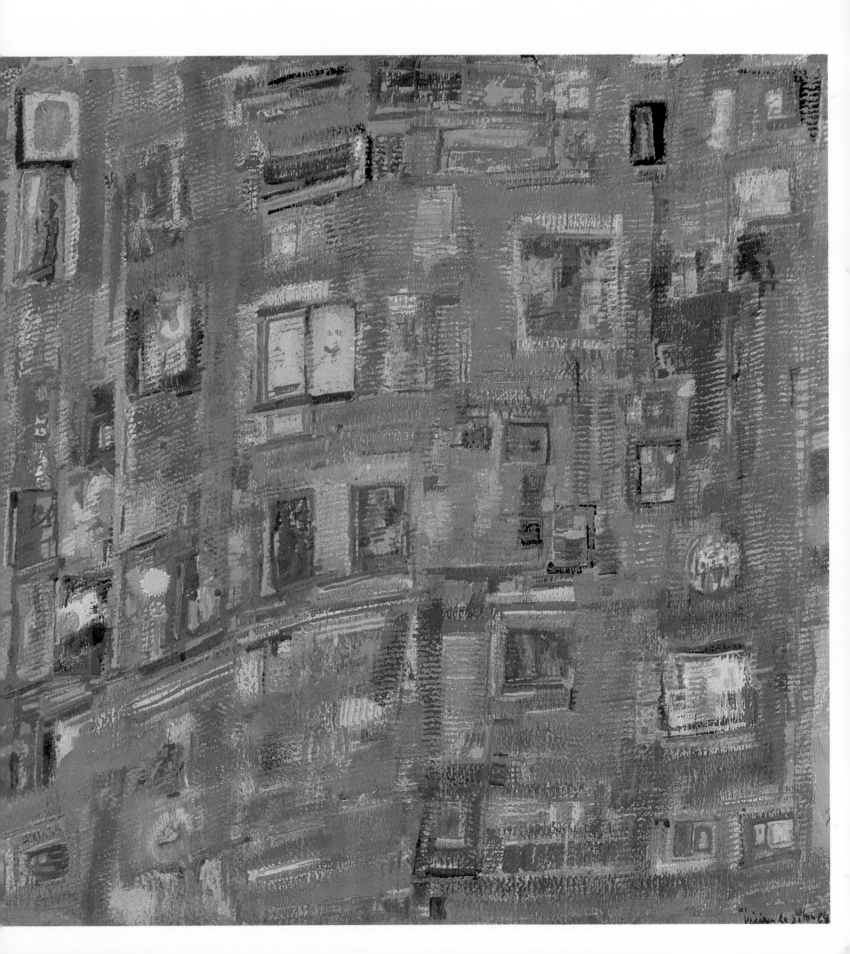

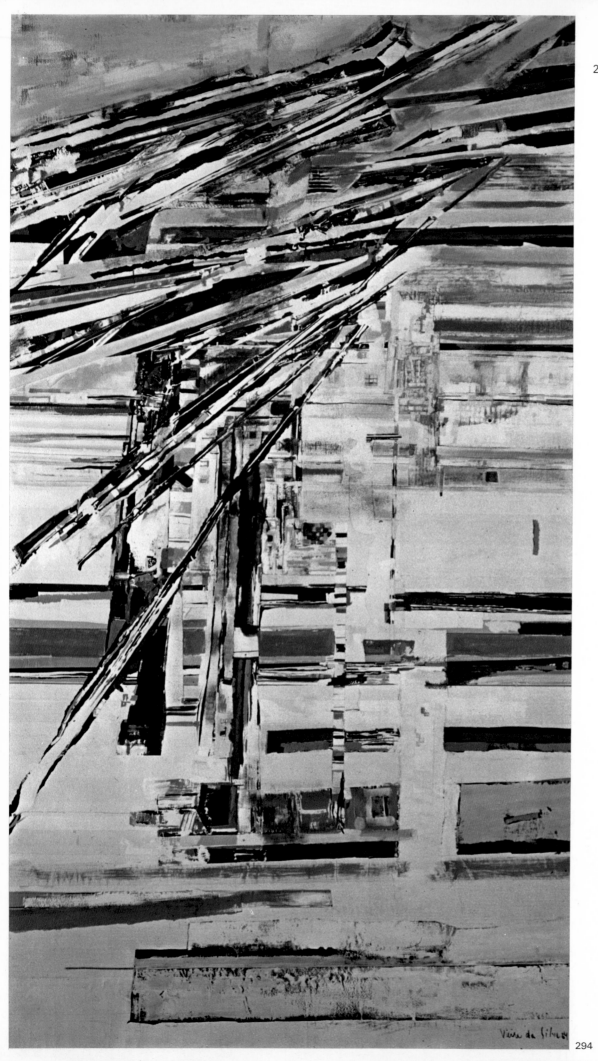

294. Le martinet. 1964. Tempera on
paper and pasted papers,
195×114 cm. Collection KM Cor-
poration, Jamaica.

295. Stele. 1964. Tempera on canvas, 195×114 cm.
Musée National d'Art Moderne, Centre d'Art et de Culture Georges Pompidou, Paris.

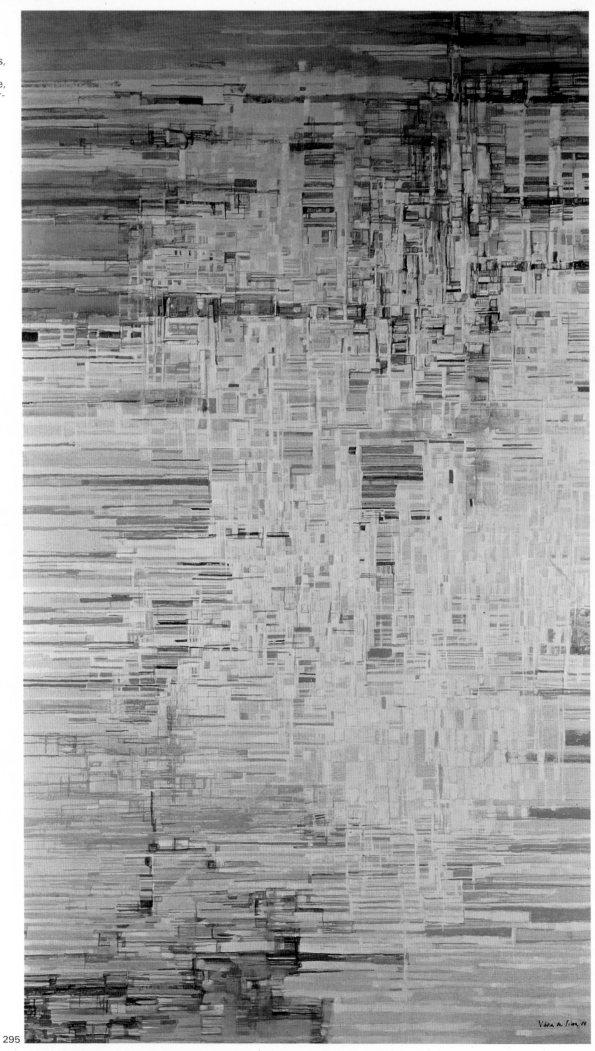

296. The House of Hercules. 1965. Oil on canvas, 81 × 100 cm.
 Private collection, Lisbon.

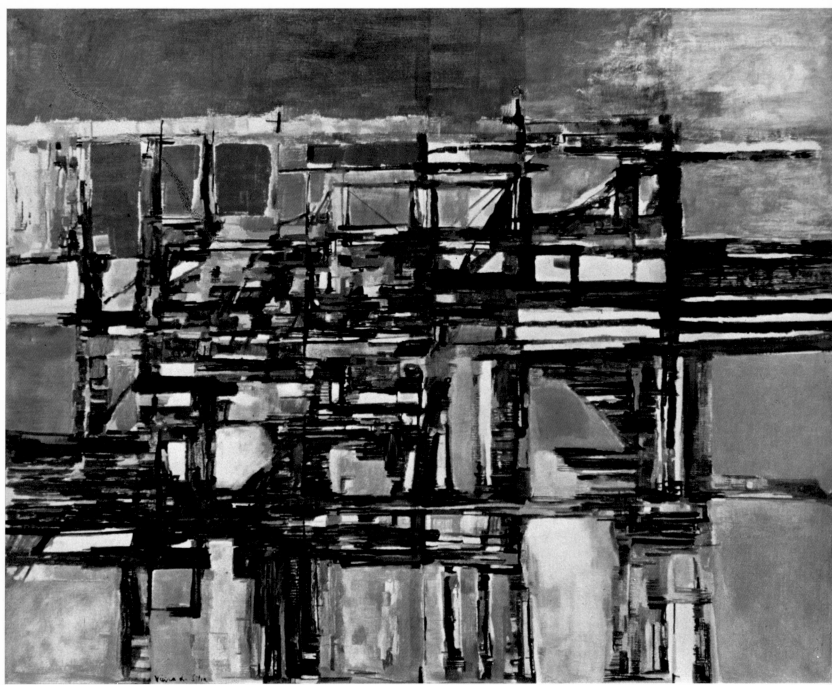

296

297. Nocturnal Interior. 1960-65. Oil on canvas, 114×146 cm.
Private collection, Paris.

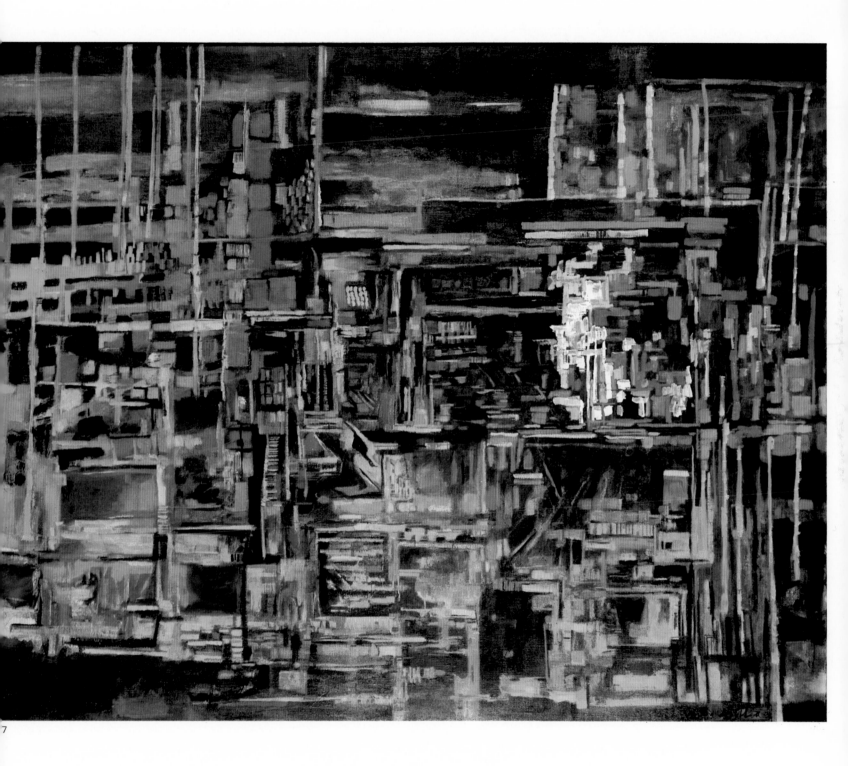

298. Parole II. Paris, 1965. Oil on canvas, 195×114 cm.
Private collection, U. S. A.

299. Les Fruits d'Or. 1965. Oil on canvas, 60×73 cm.
Collection Eugene McDermott, Dallas.

300. The Garden. 1960-65. Oil on canvas, 65×92 cm.
Private collection, Lisbon.

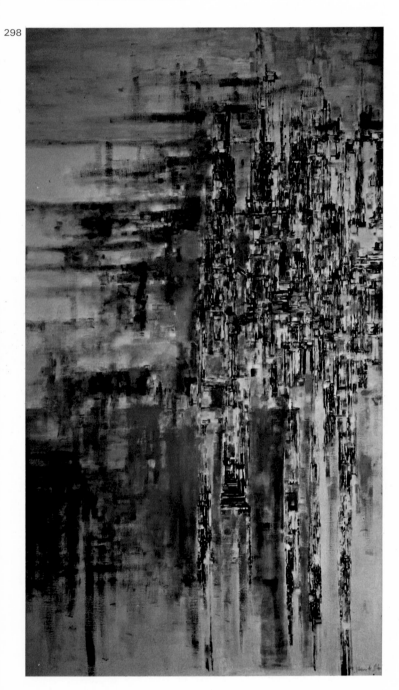

298

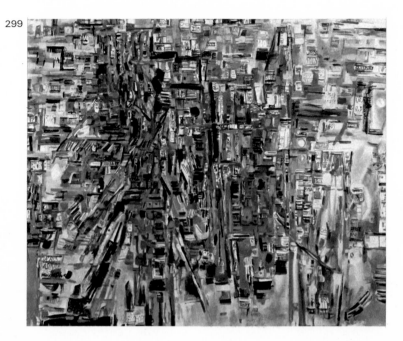

299

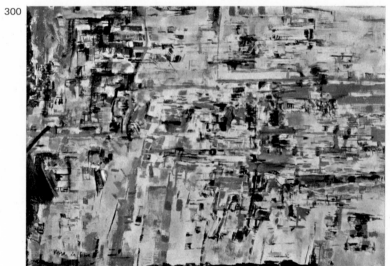

300

301. Arno. 1966. Oil on paper mounted on canvas, 81 × 100 cm.
Private collection, Paris.

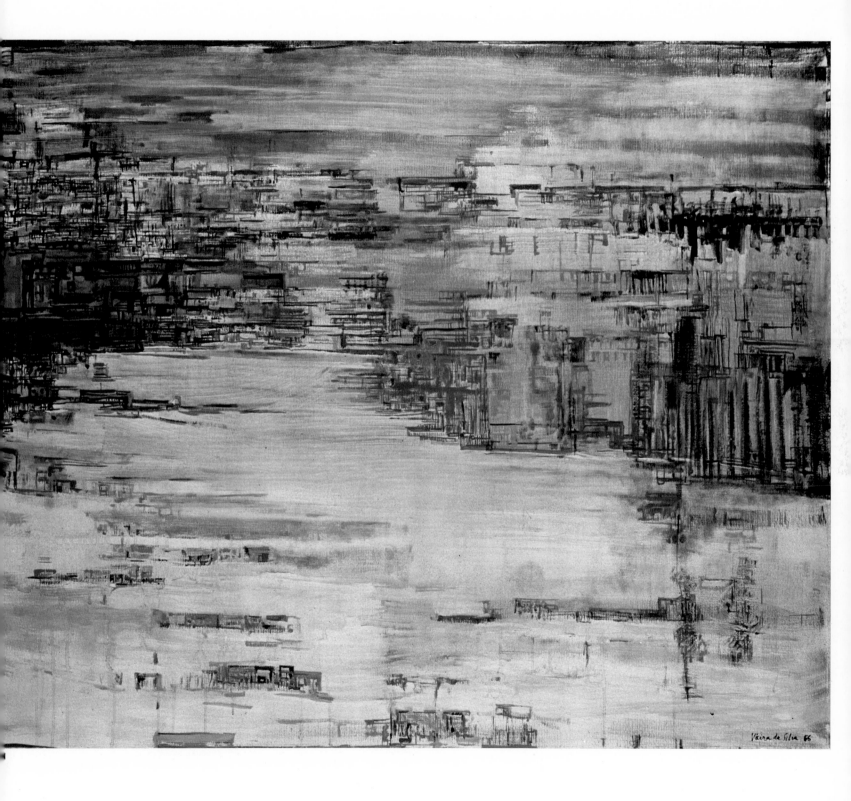

302. The Attic. 1965. Oil on canvas, 24×19 cm. Private collection, Paris.
303. The Library. 1966. Oil on canvas, 130×97 cm.
Private collection, Paris.

302
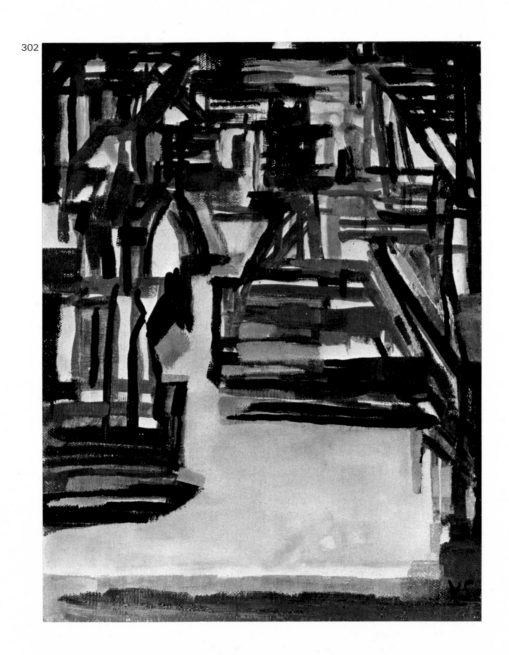

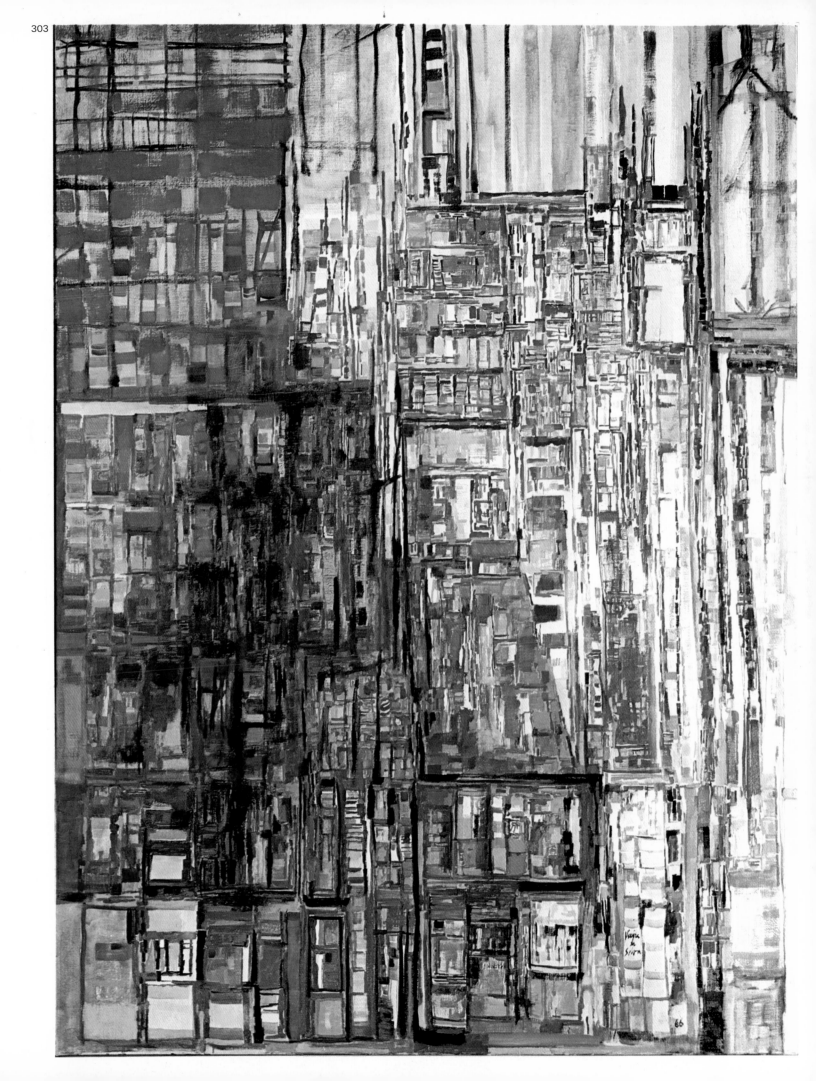

304. Contradictory Consequences. 1964-67. Oil on canvas, 195×97 cm.
Private collection, Liège.

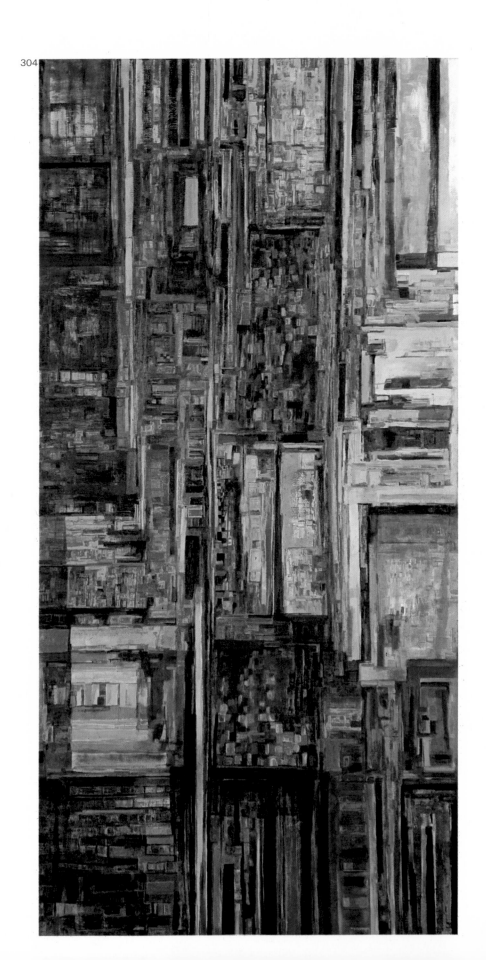

304

305. Equity. 1966. Oil on canvas, 97×195 cm.
Private collection, Liège.

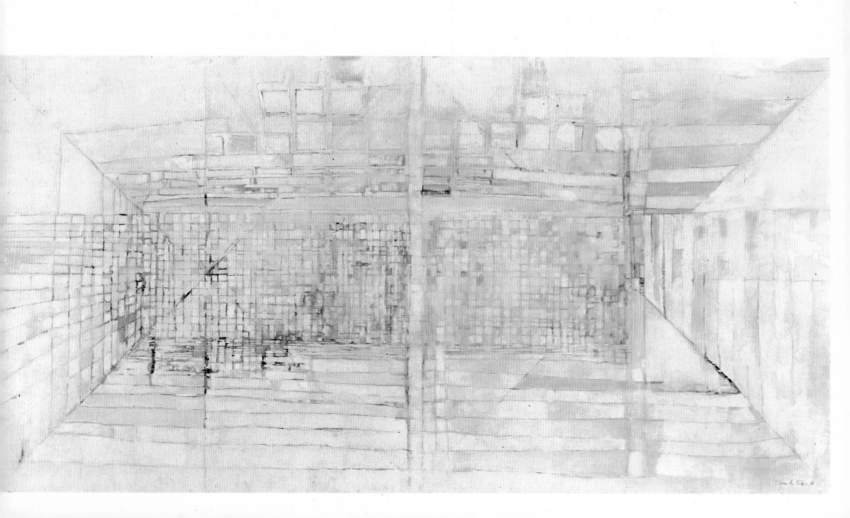

306. Rouen. 1966. Oil on canvas, 50×150 cm.
 Musée des Beaux-Arts, Rouen.

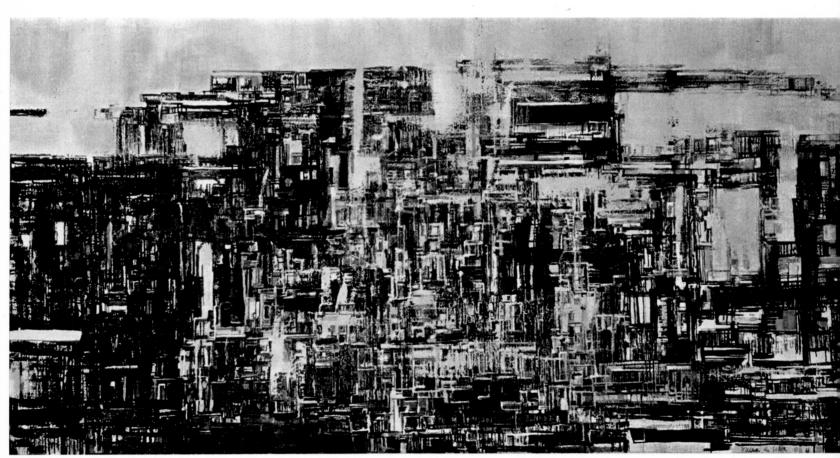

306

307. Rouen II. 1968. Oil on canvas, 27×41 cm.
Musée des Beaux-Arts, Rouen.

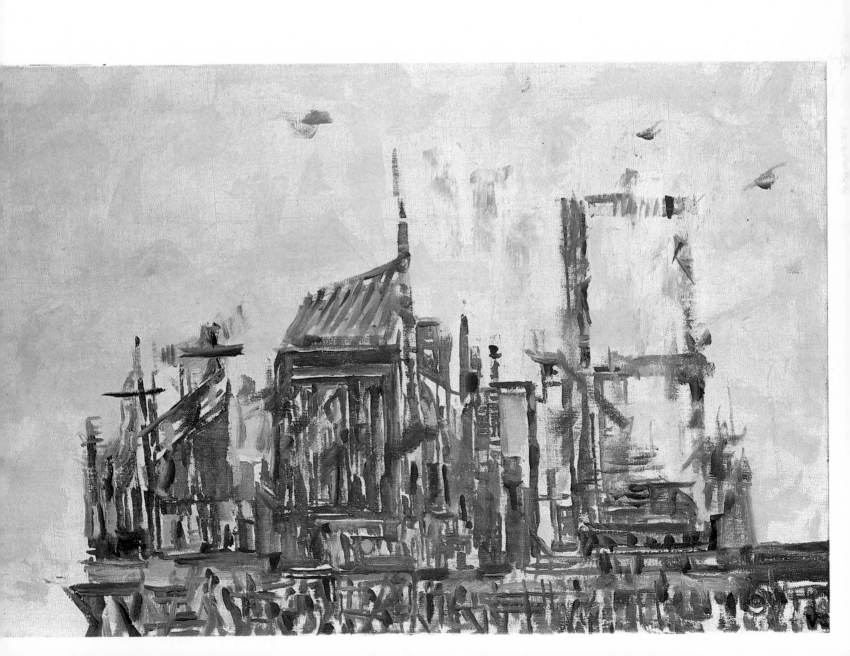

308. Le marteau sans maître. 1967. India ink on paper, 19×11 cm. Collection René Char.

309. The Parlor. 1967. Oil on canvas, 22×27 cm. Collection Maria do Rosario Oliveira, Paris.

310. Contested Propositions. 1966. Oil on canvas, 73×116 cm. Musée d'Art Moderne de la Ville de Paris.

311. May 68. 1968. Oil on canvas, 195×97 cm. Private collection, Lisbon.

308

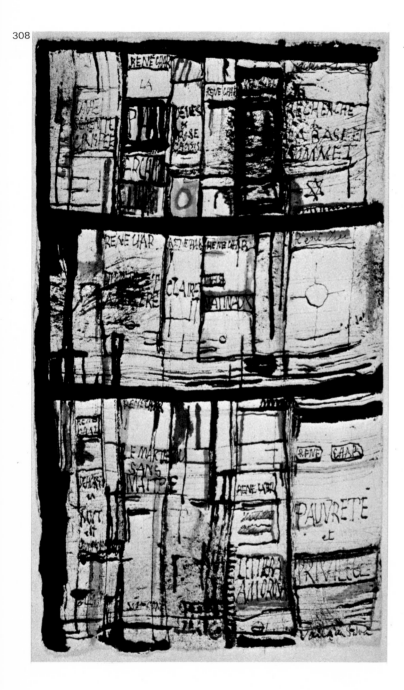

309

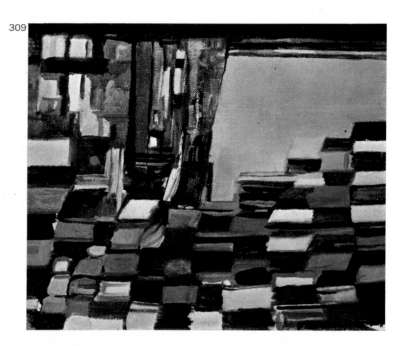

310

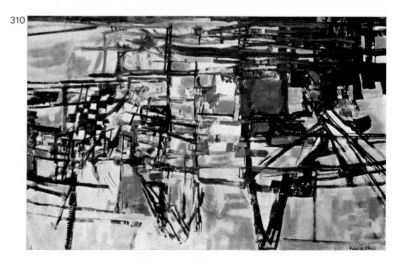

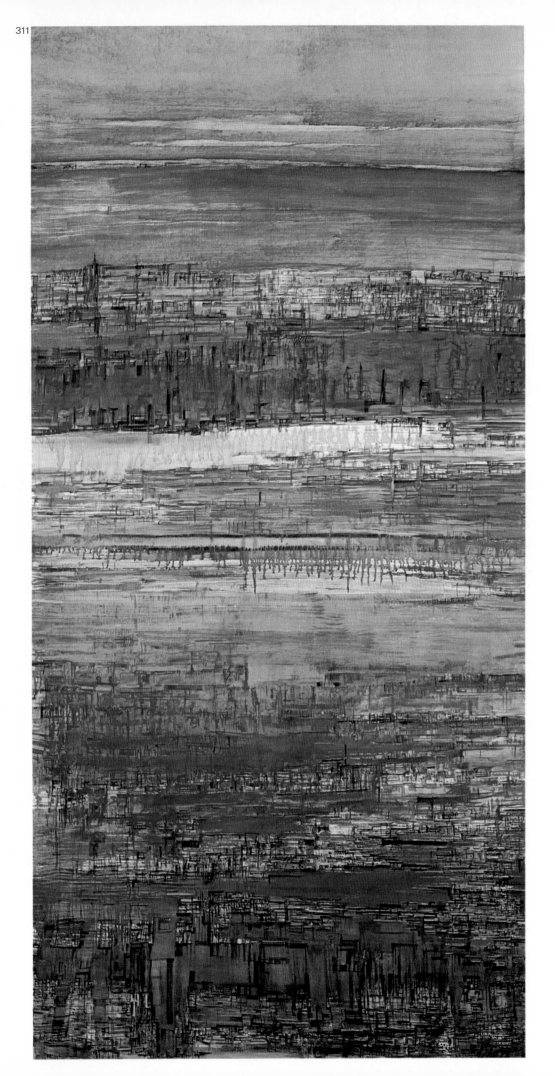

312. Memory. 1966-67. Oil on canvas, 114×146 cm.
Galerie Jeanne Bucher, Paris.

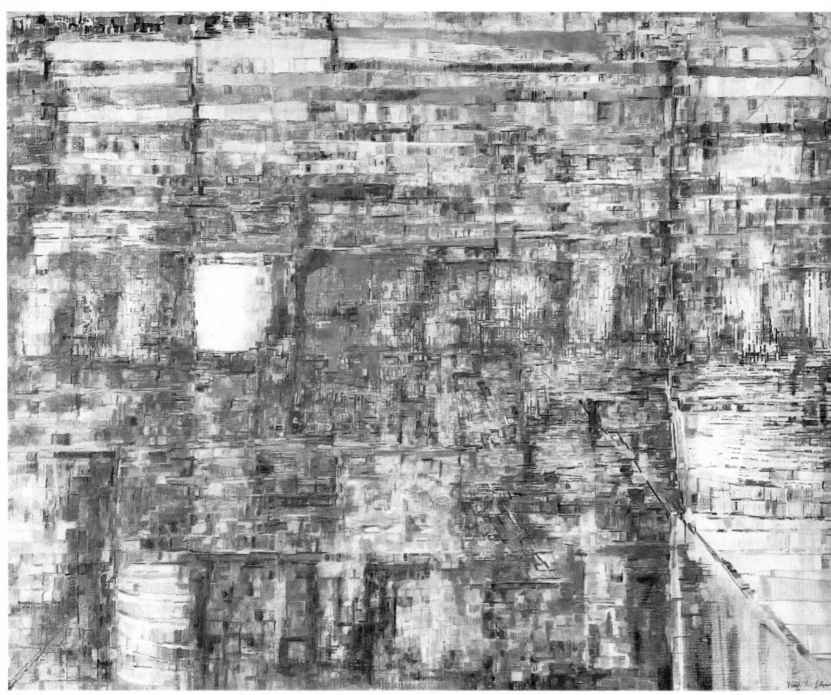

312

313. Little Theater of Greenery. 1972. Tempera on paper, 50.5×67 cm.
Galerie Jeanne Bucher, Paris.

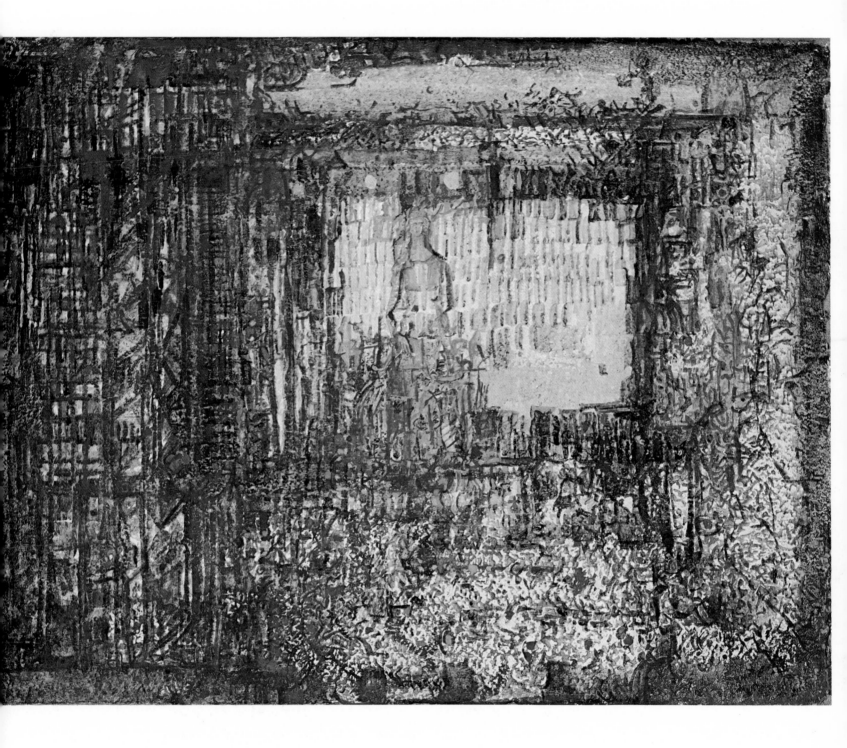

314. Illégalité des enchaînements. 1968. Oil on canvas, 81×130 cm.
Private collection, U.S.A.

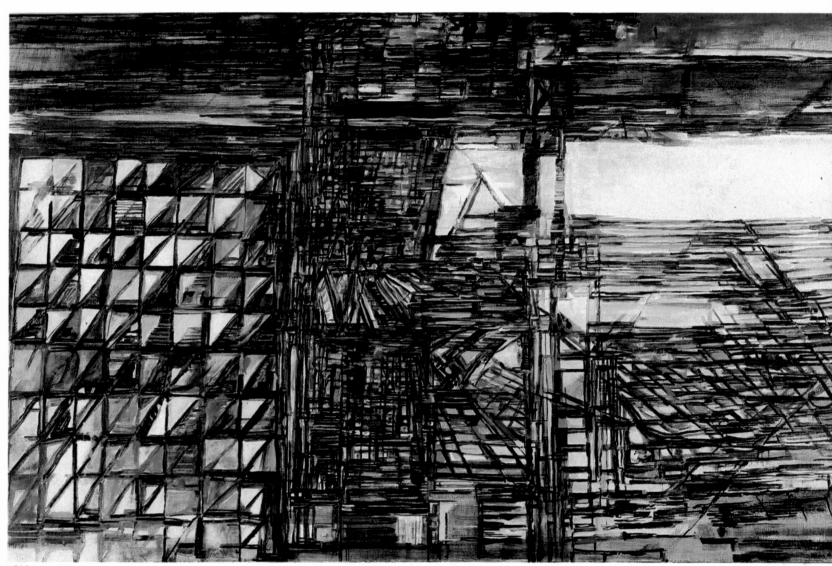

314

315. Sleep. 1969. Oil on canvas, 93×130 cm. Private collection, Paris.

315

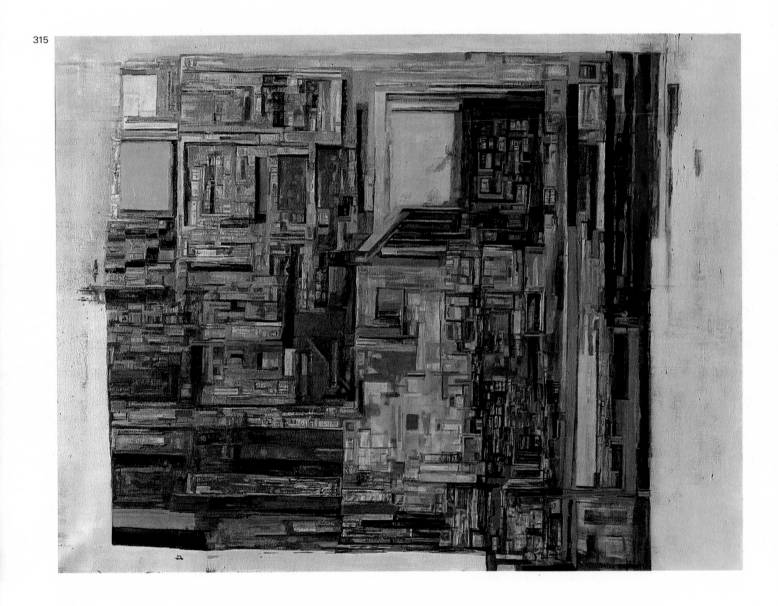

316. Le temps. 1969. Oil on canvas, 97×162 cm.
 Private collection, Lisbon.

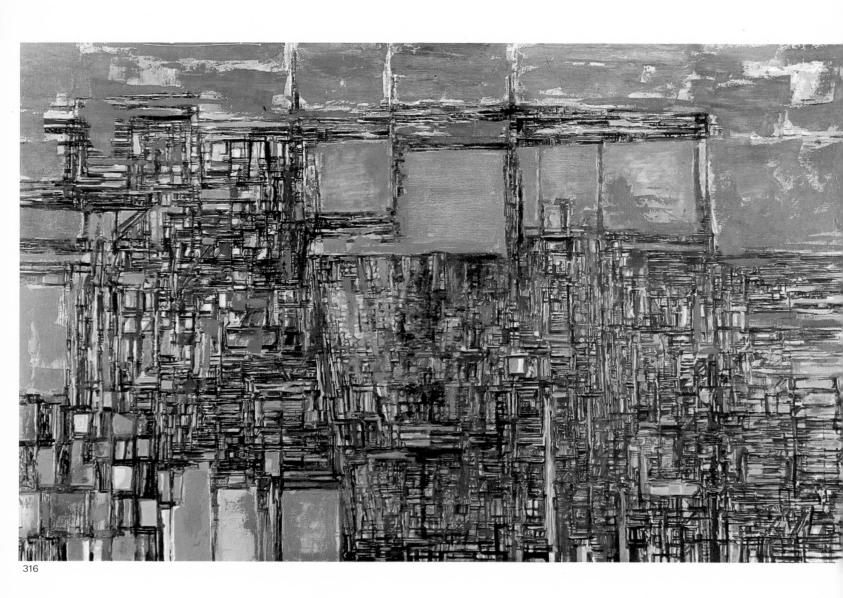

316

317. Rome. 1969. Oil on canvas, 97×130 cm. Private collection, Lisbon.

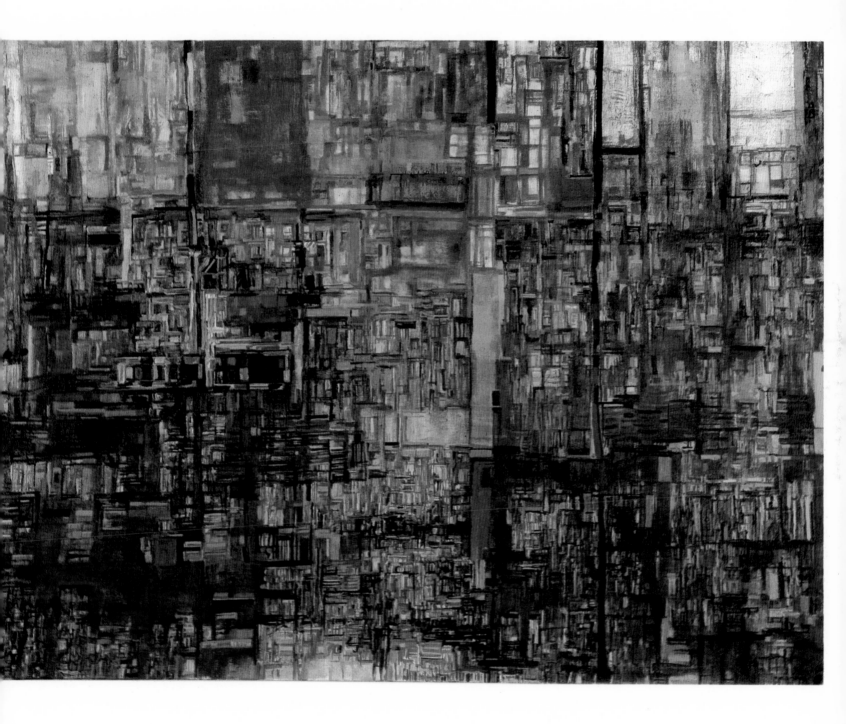

318. Málaga. 1969. Oil on canvas, 97×130 cm.
Private collection, Paris. Lausanne.

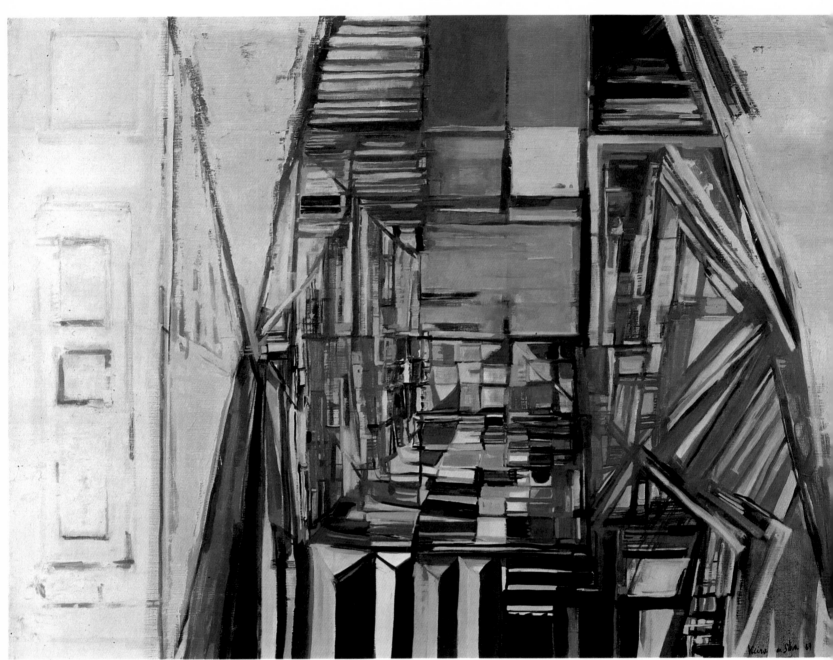

319. Les irrésolutions résolues XXVII. 1969. Charcoal on prepared canvas, 100×100 cm.
Private collection, Paris.

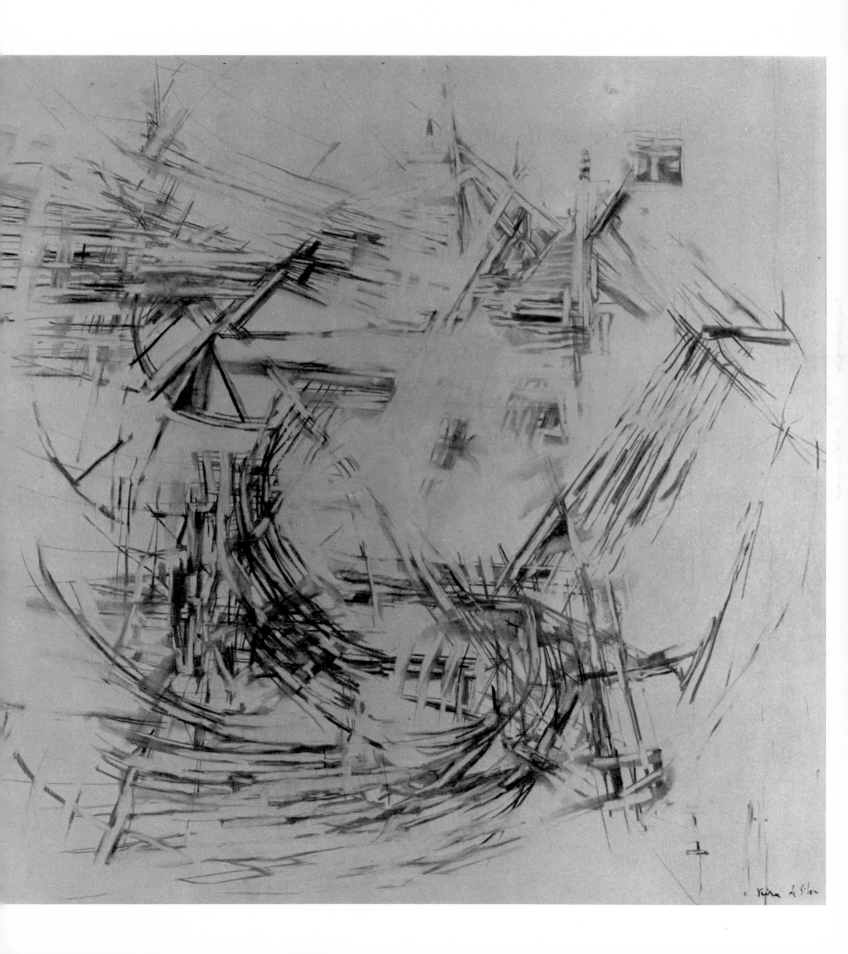

320. Les irrésolutions résolues XXIX. 1969. Charcoal and tempera on Japan paper. 76.5×57 cm.
Private collection, Paris.

320

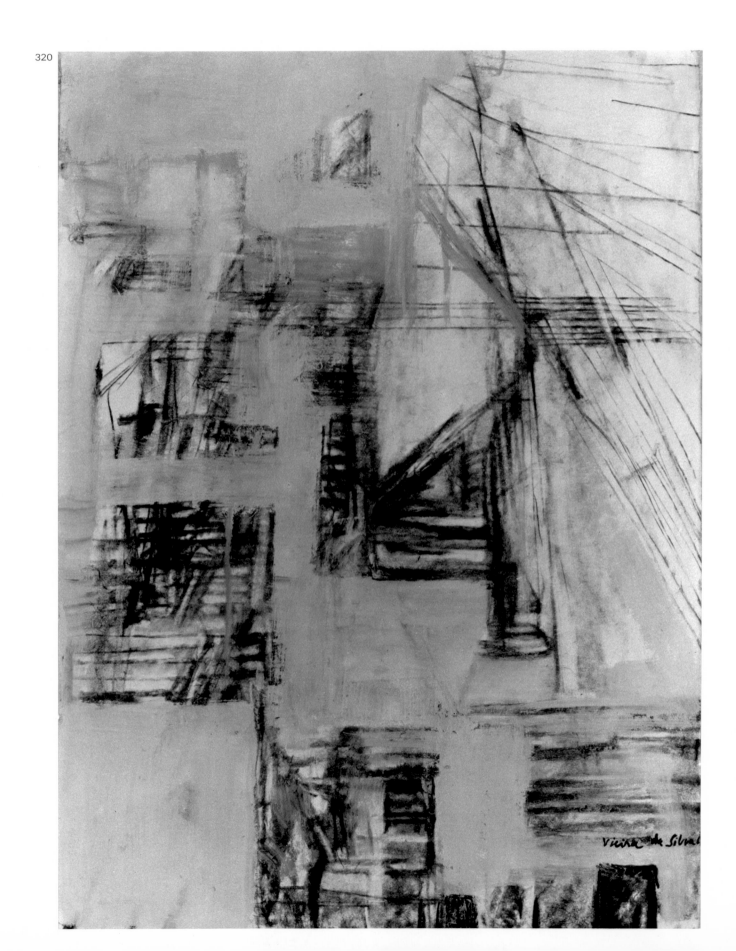

321. From Mars to the Moon. 1969. Oil on canvas, 195×97 cm.
Private collection, Lisbon.

321

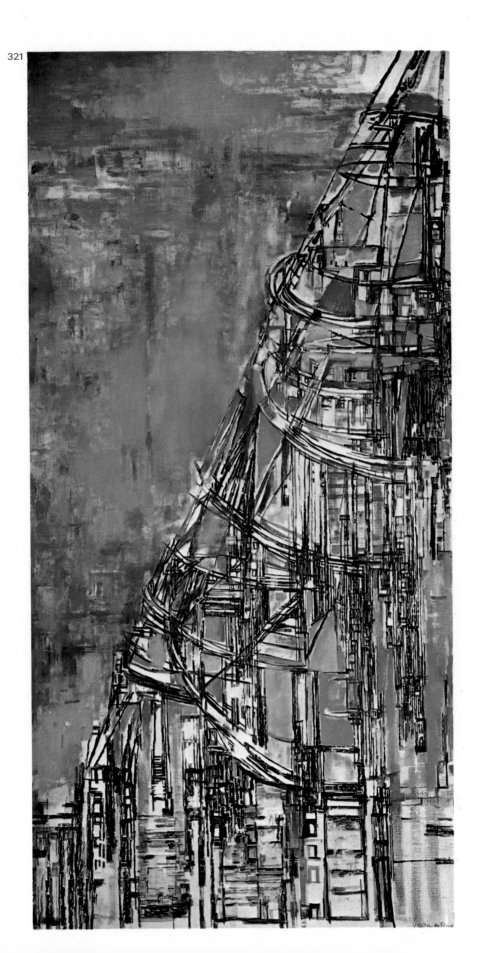

322. New Amsterdam I.
1970. Oil on canvas,
195×97 cm. Private
collection, Lisbon.

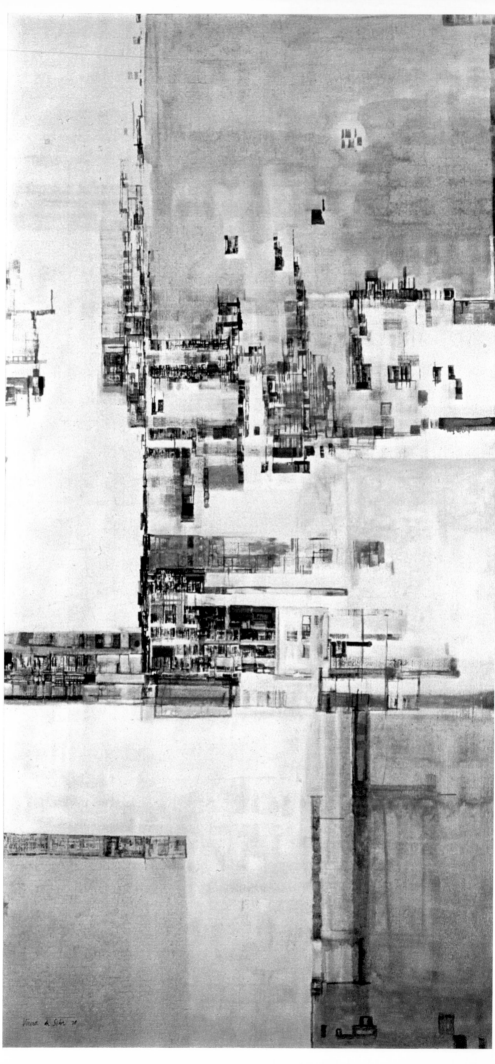

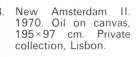

8. New Amsterdam II.
1970. Oil on canvas,
195×97 cm. Private
collection, Lisbon.

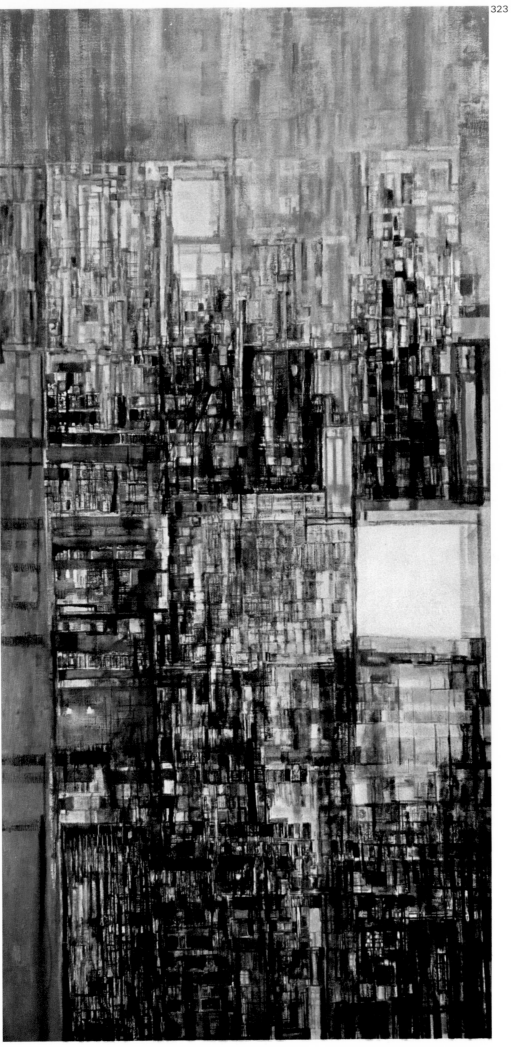

324. Window on Courtyard. 1970. Oil on canvas, 65×81 cm.
 Private collection, Switzerland.

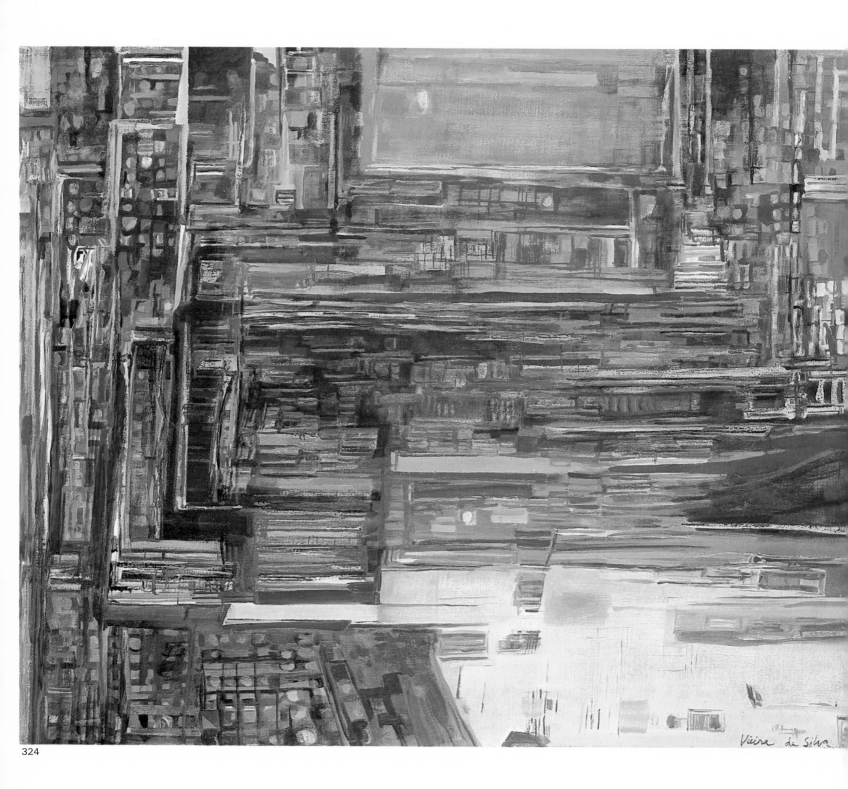

325. L'Evénement. 1962-73. Oil on canvas, 81×100 cm.
Private collection, Switzerland.

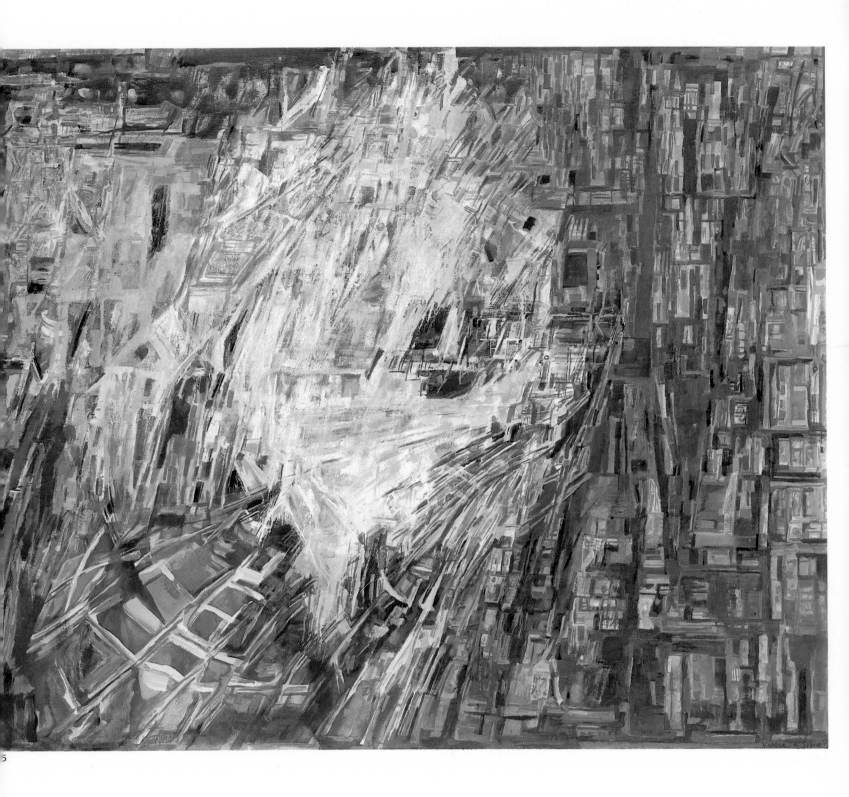

326. The Echo. 1971. Oil on canvas, 97×130 cm. Private collection, Lisbon.
327. Musical Instrument. 1971. Oil on canvas, 162×130 cm.
 Private collection, Switzerland.

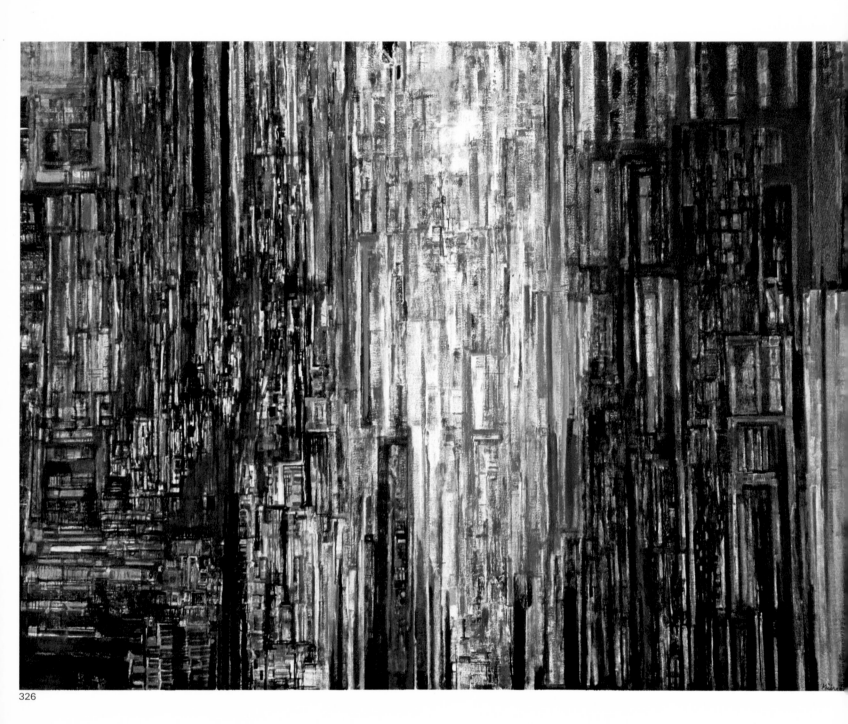

326

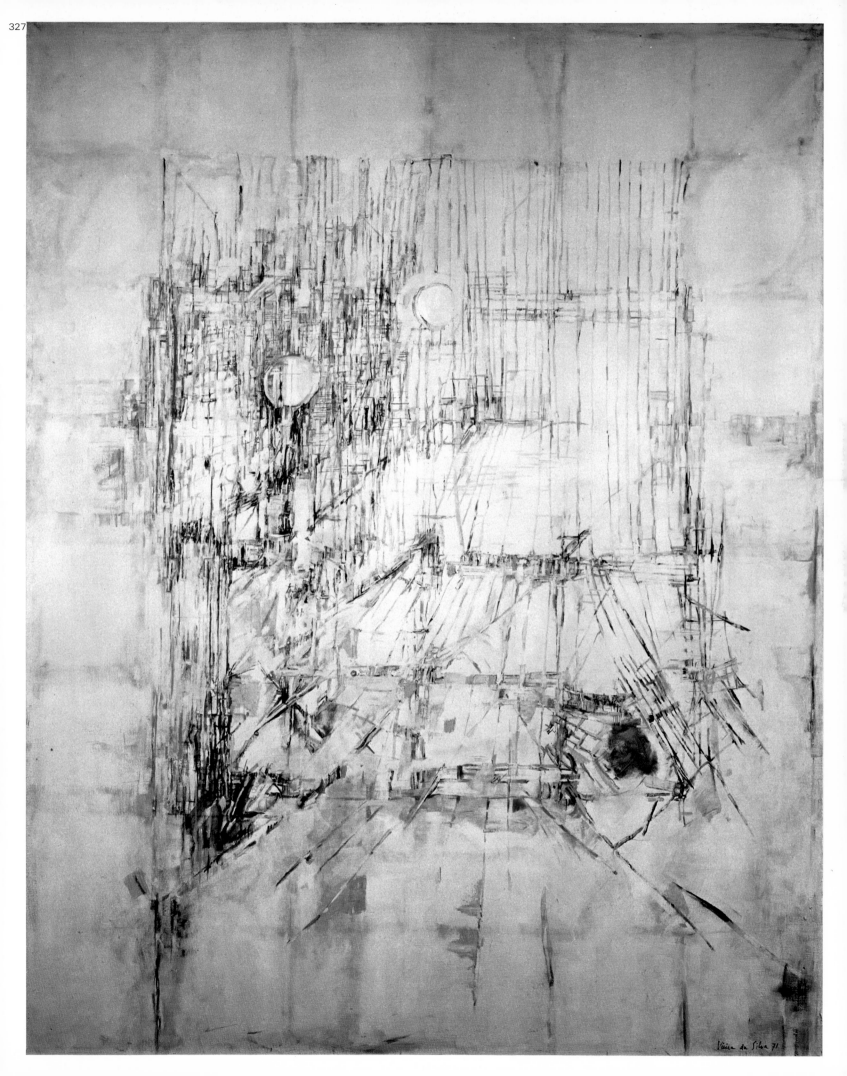

Vieira da Silva 71

328. The Esplanade. 1967. Oil on canvas, 97×195 cm.
Private collection, Lisbon.

329. Mul-ti-tude. 1972. Tempera on paper, 102×75 cm.
Private collection, Paris.

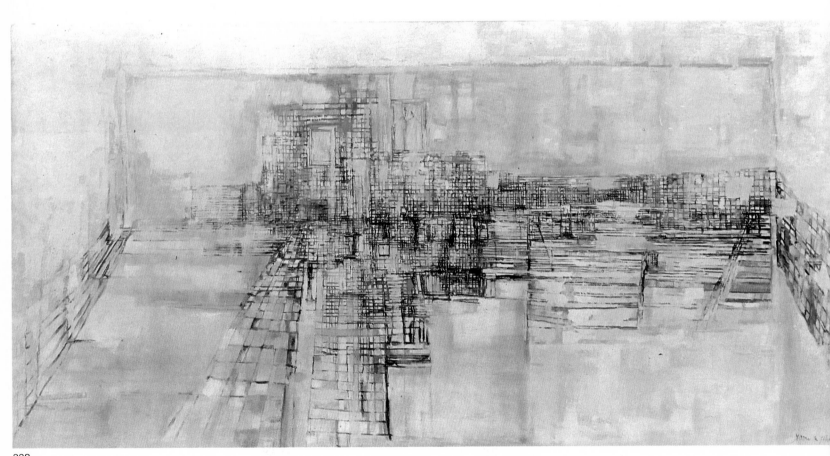

328

330. Terre de basse nuit. 1970. Oil on canvas, 160×90 cm. Private collection, Lisbon.
331. Grass. 1973. Oil on canvas, 100×81 cm. Private collection, Switzerland.
332. Theater of Life. 1973-74. Oil on canvas, 100×81 cm. Private collection, Paris.
333. The Three Windows. 1972-73. Oil on canvas, 130×97 cm. Private collection, Switzerland.

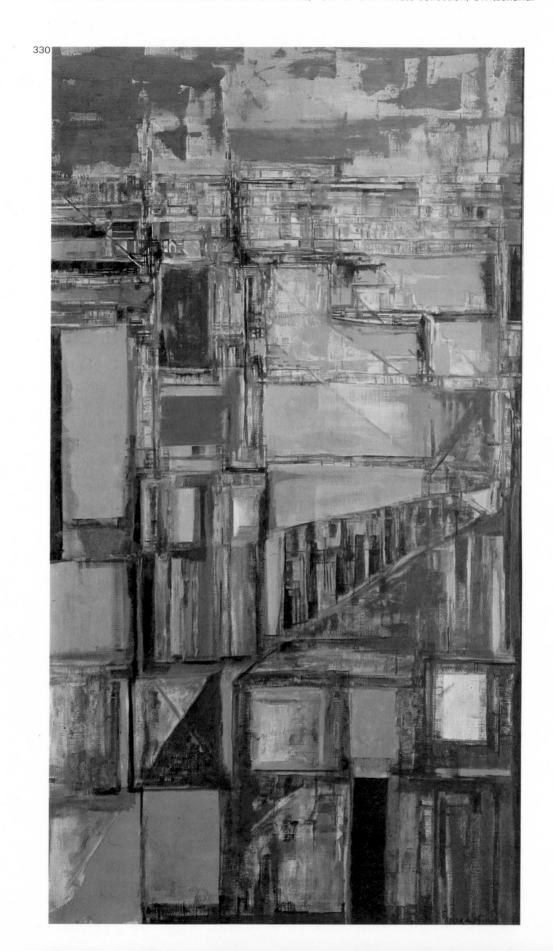

330

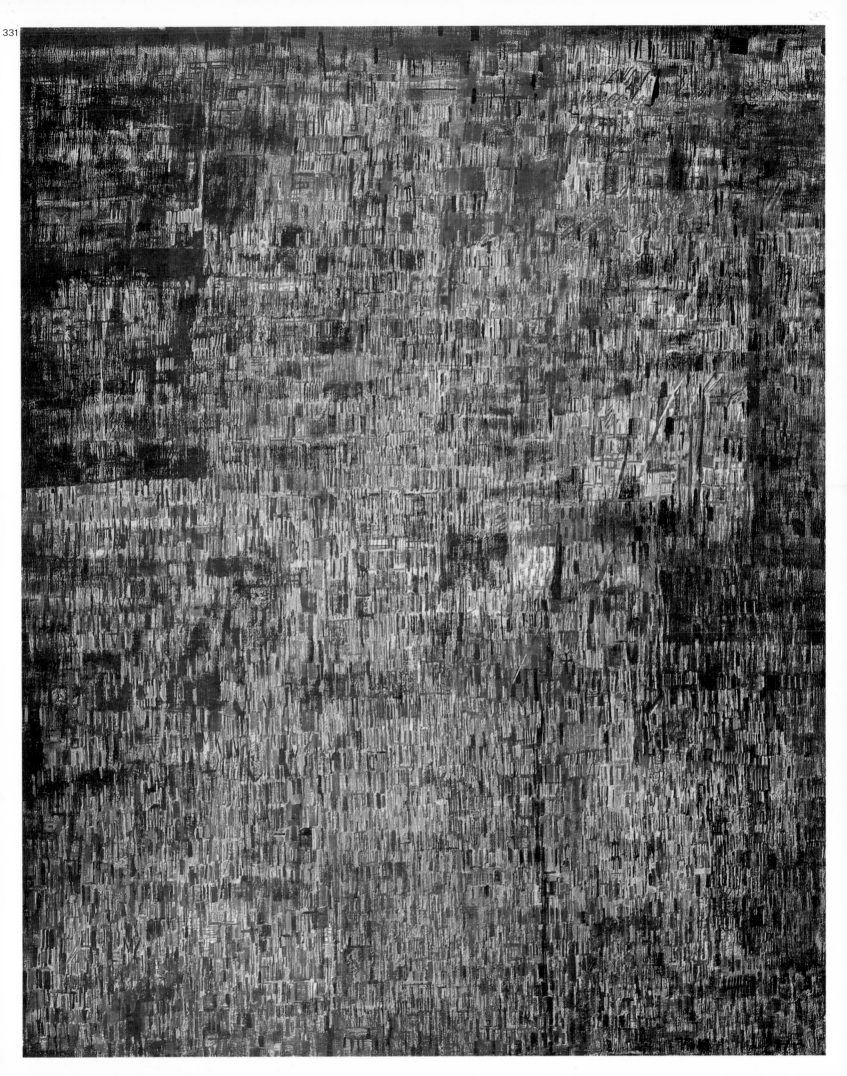

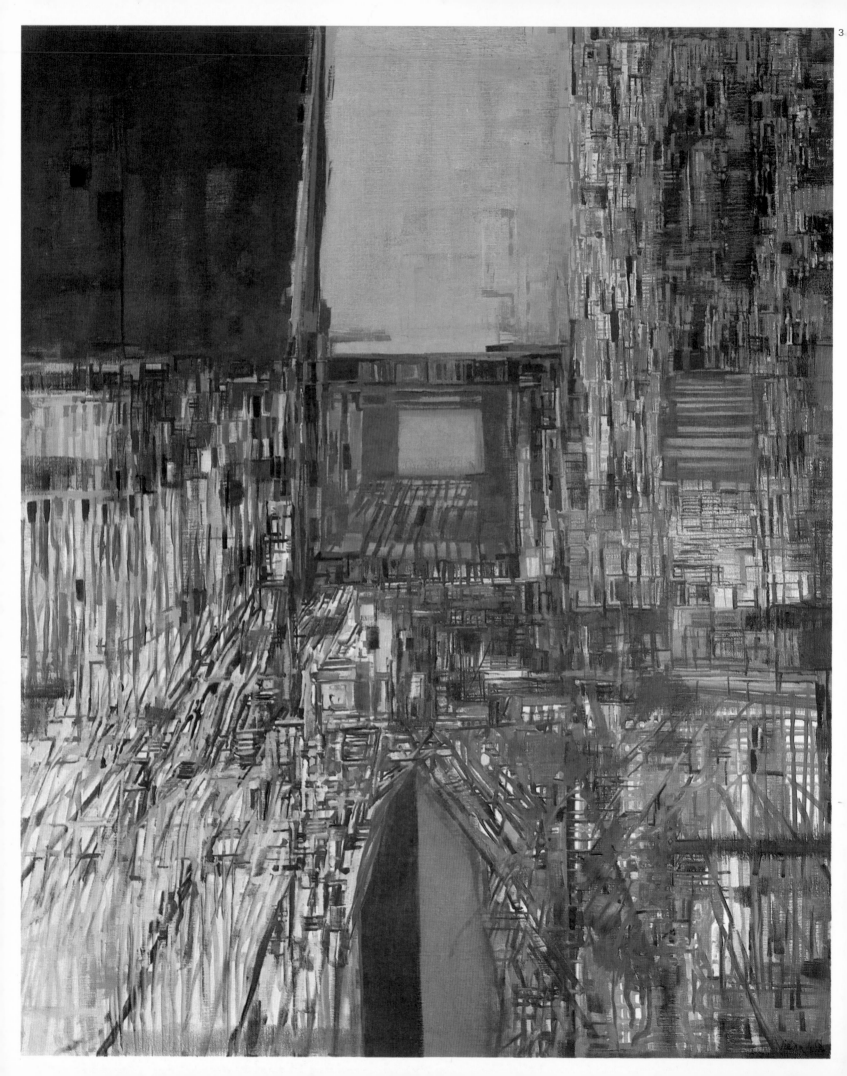

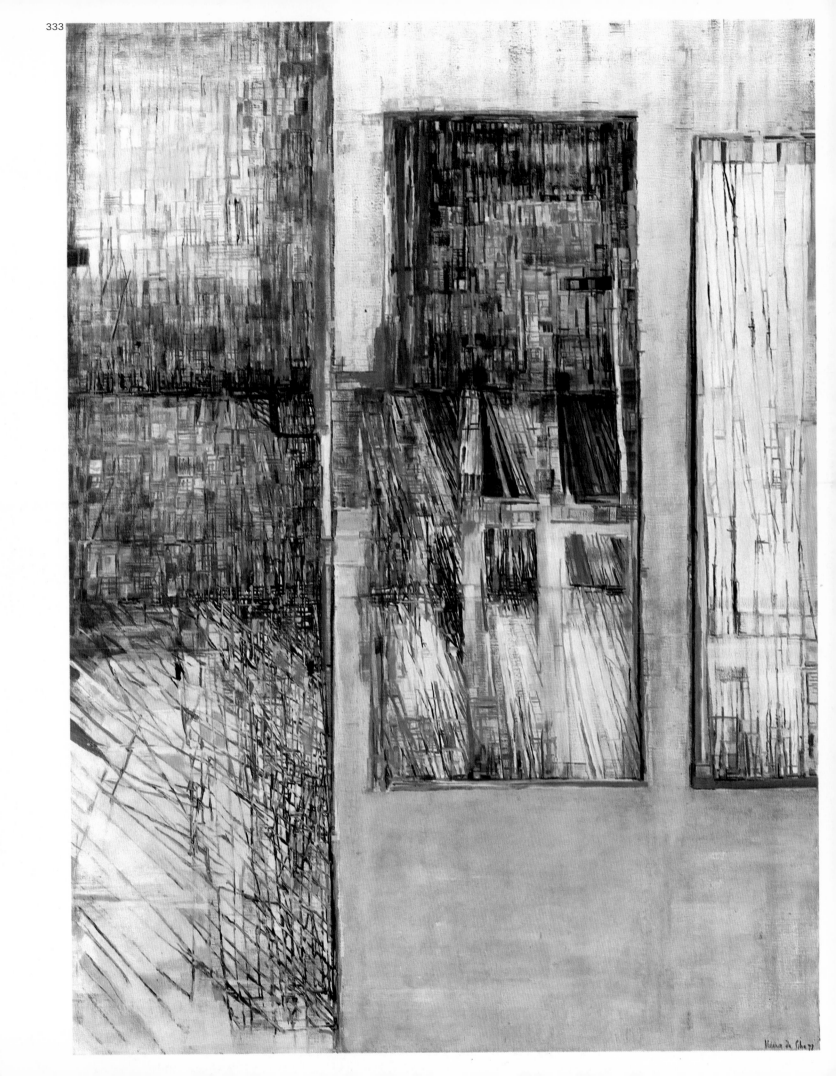

334.　The Square. 1973. Oil on canvas, 100×100 cm. Musée des Beaux-Arts, Rheims.

334

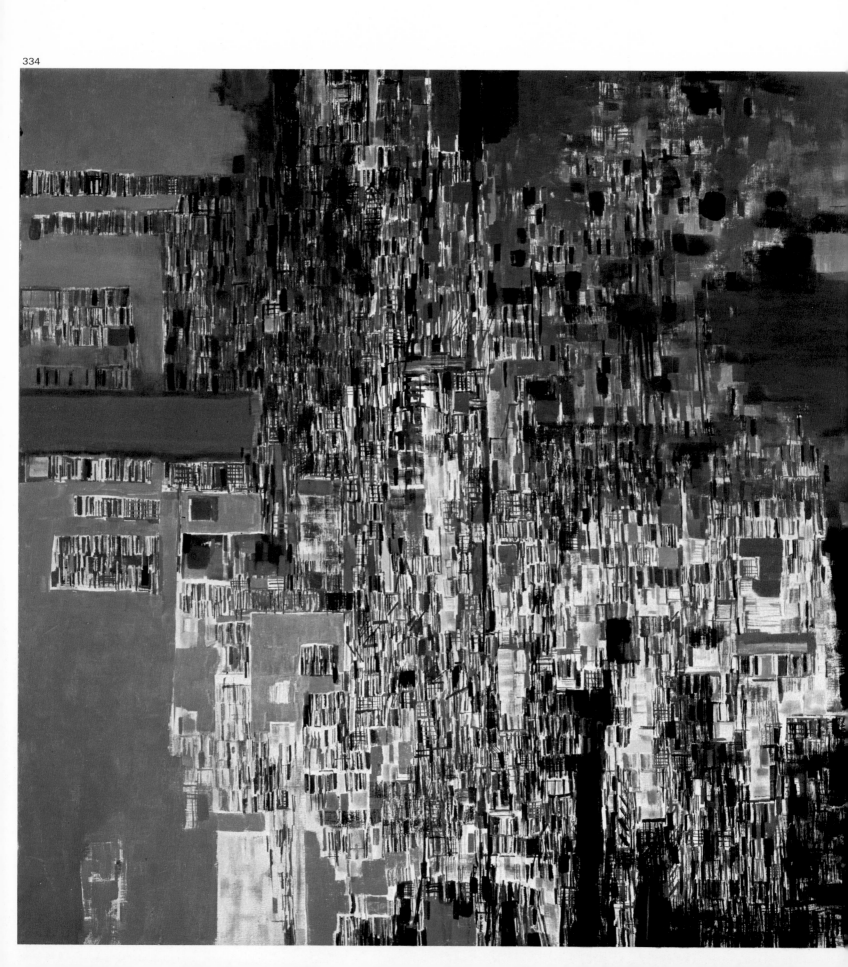

335. The Library. 1974. Oil on canvas, 130×97 cm. Galerie Jeanne Bucher, Paris.

335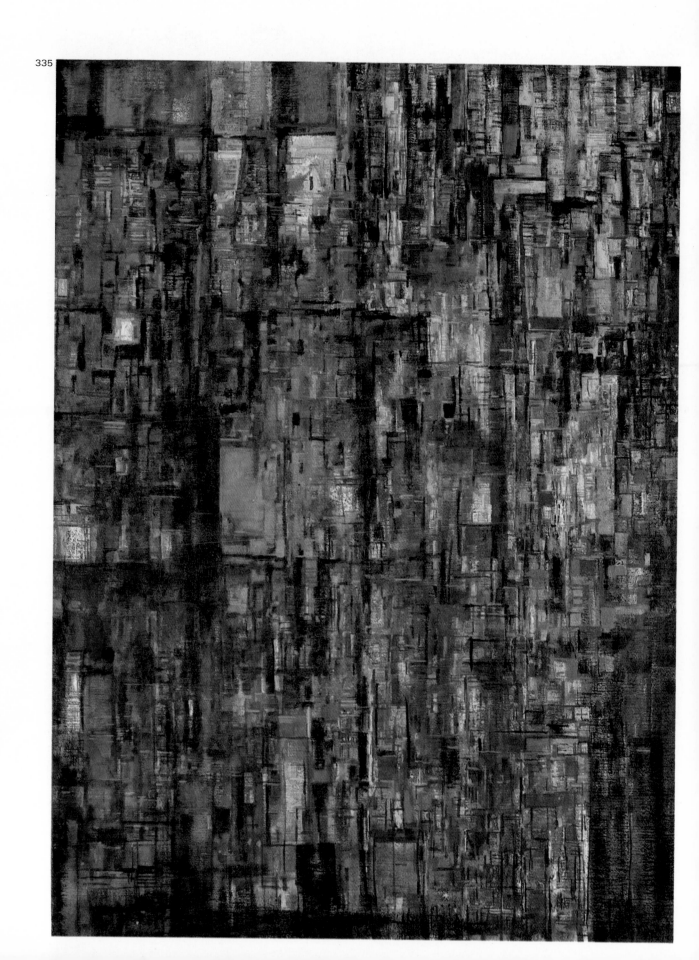

336. "Irrésolutions résolues". 1969.
Charcoal on canvas, 124.5×26 cm.
Galerie Jeanne Bucher, Paris.

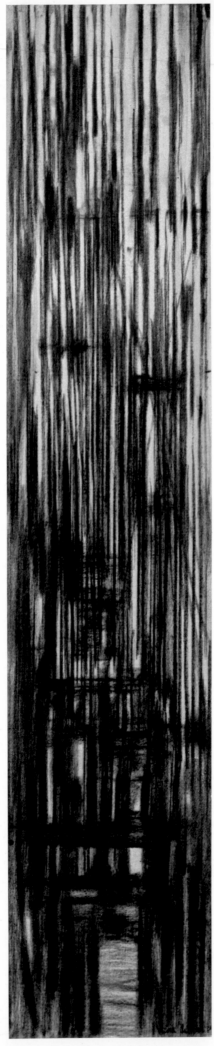

337. Freedom. 1973. Oil on paper
mounted on canvas, 150×50 cm.
Private collection, Paris.

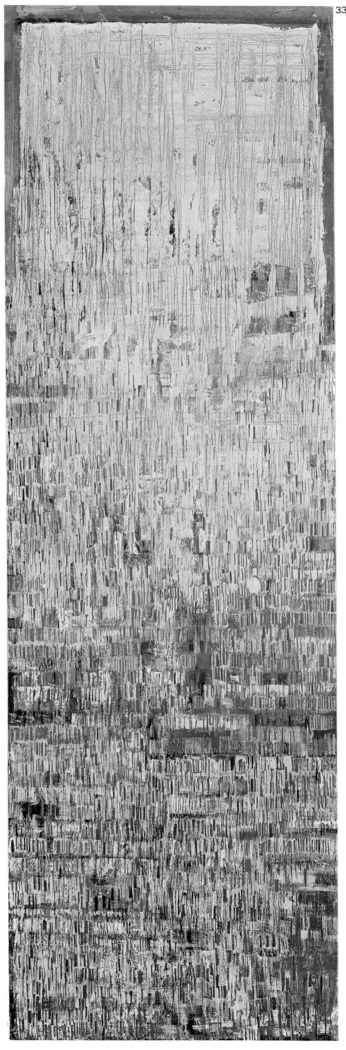

338. Wedding. 1971. Tempera, 53×120 cm. Collection Galerie Alice Pauli.

338

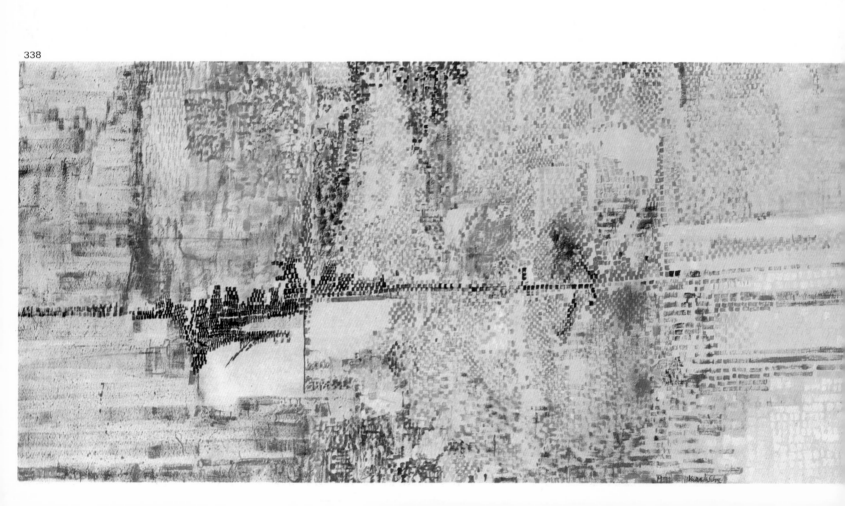

339. Urbi et Orbi. 1963-72. Tempera and oil on canvas, 300×401 cm.
Musée des Beaux-Arts, Dijon. Donation Granville.

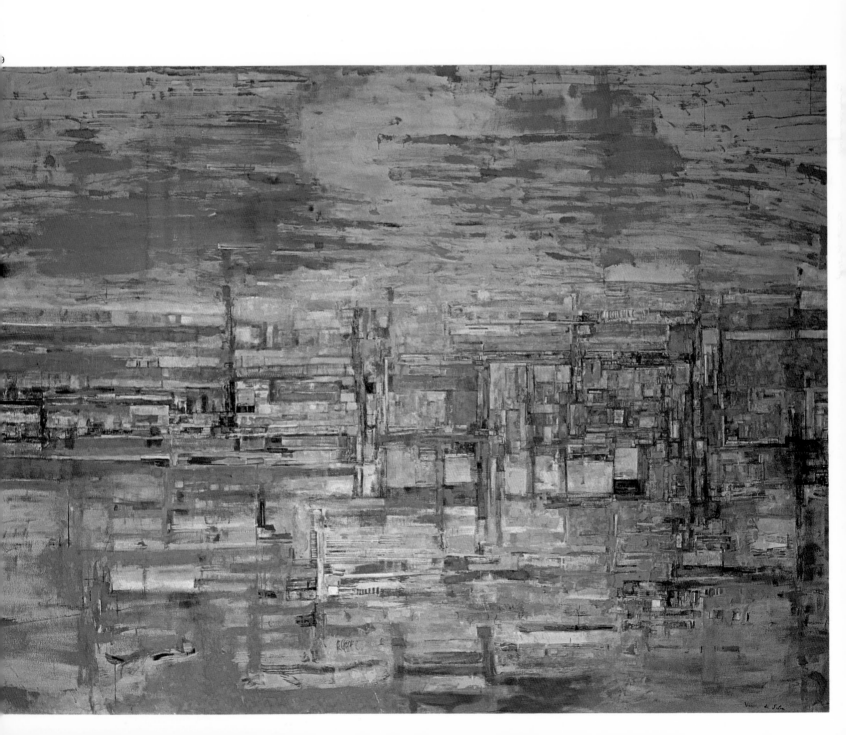

340. Maze. 1975. Oil on canvas, 116×81 cm. Private collection, Paris.

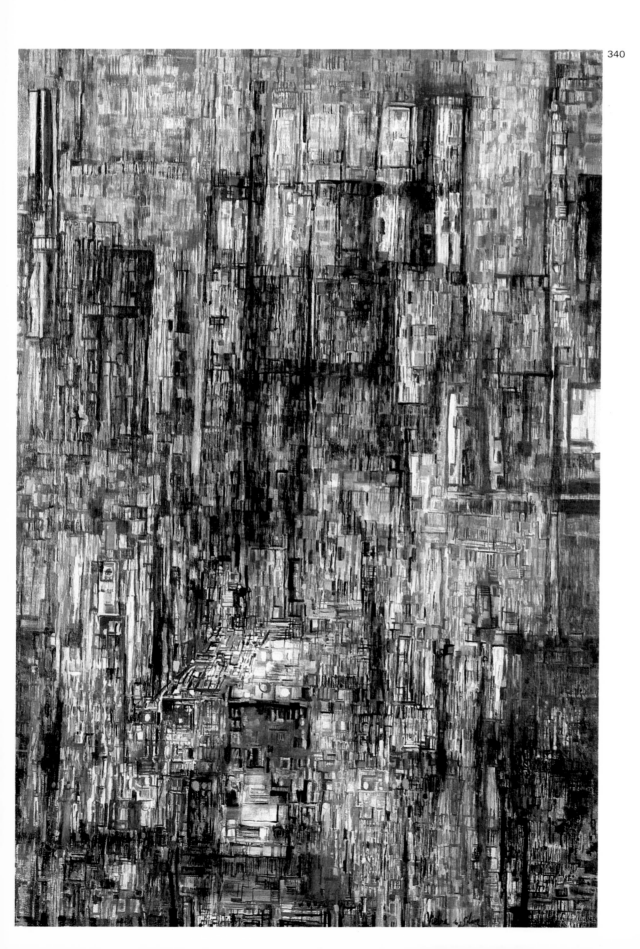

341. The Thirteen Doors. 1972. Tempera on Chinese paper, 50×121 cm.
Private collection, Paris.

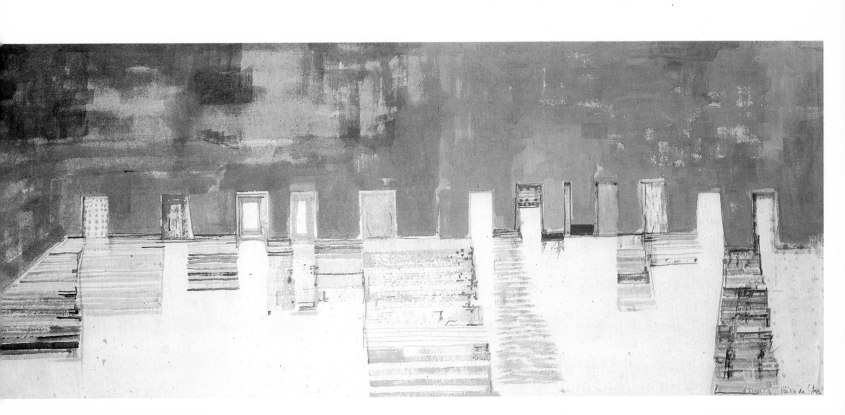

342. Landscape of Ruum. 1973. Oil on paper mounted on canvas, 80×100 cm.
 Private collection, Switzerland.

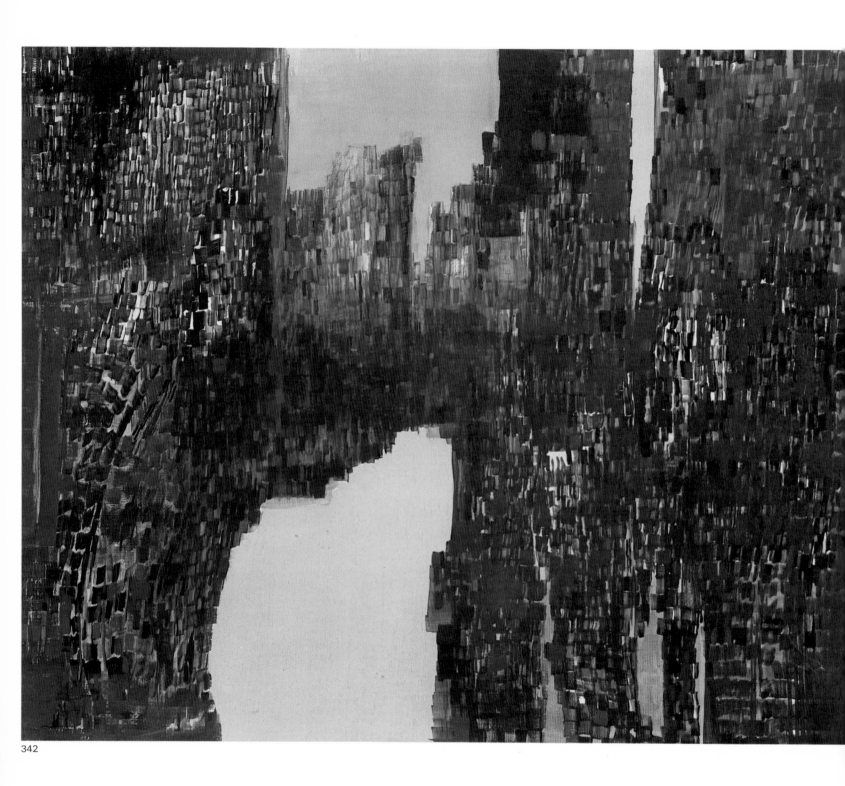

342

343. The Black Indies. 1974. Oil on canvas, 60×120 cm.
Private collection, Paris.

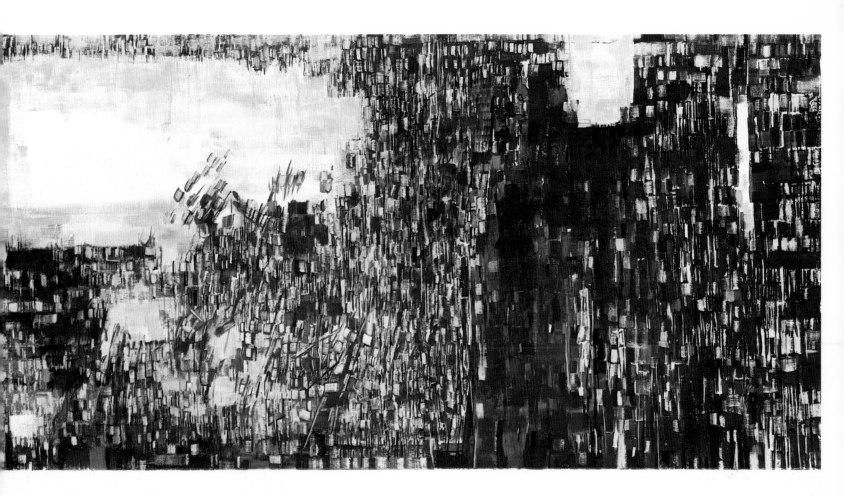

344. Baptistery I. 1974. Tempera on paper, 57.5×42 cm.
Private collection, Paris.

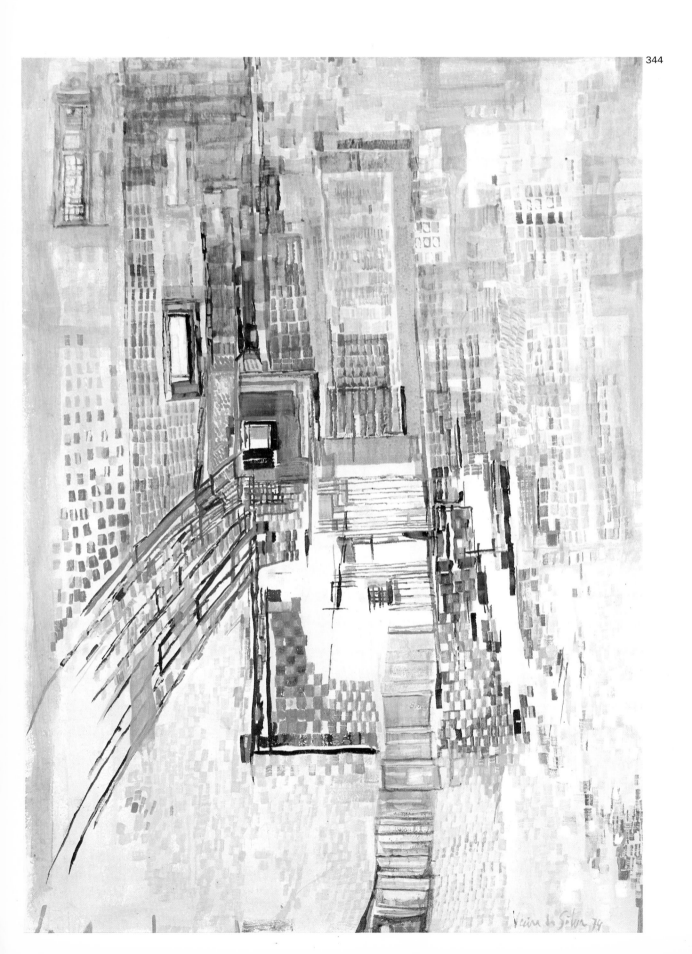

345. Baptistery II. 1974. Tempera on paper, 65×51 cm.
Private collection, Paris.

345

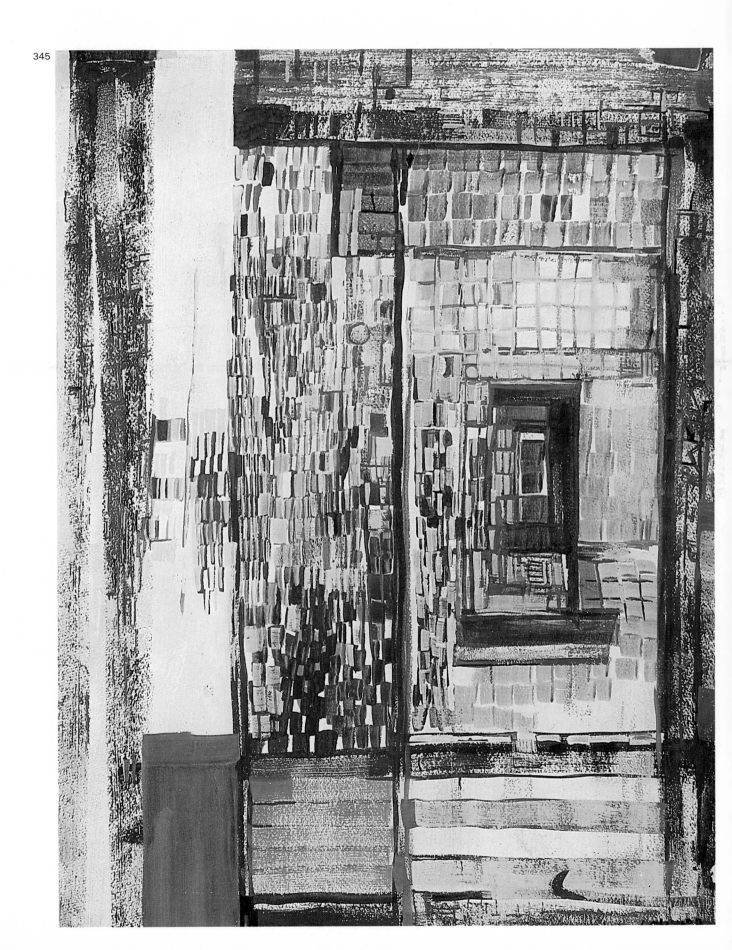

346. Baptistery III. 1974. Tempera on paper, 63×54 cm.
Private collection, Paris.

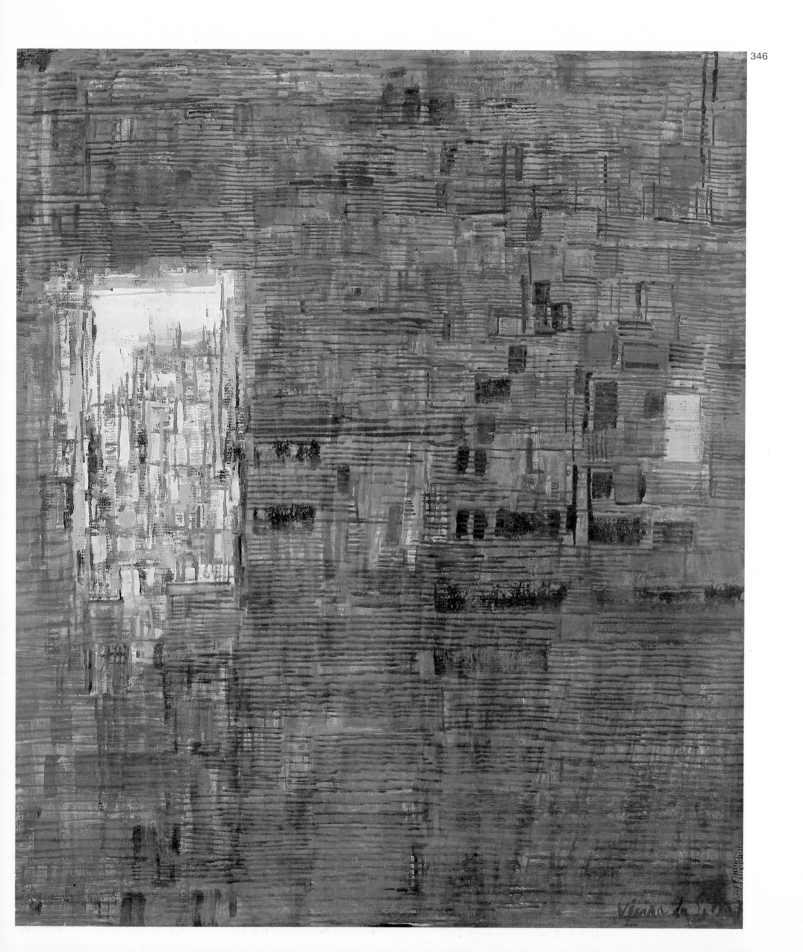

347. Composition in Three Parts. 1976. Tempera on paper, 81×57 cm.
Private collection, Paris.

347

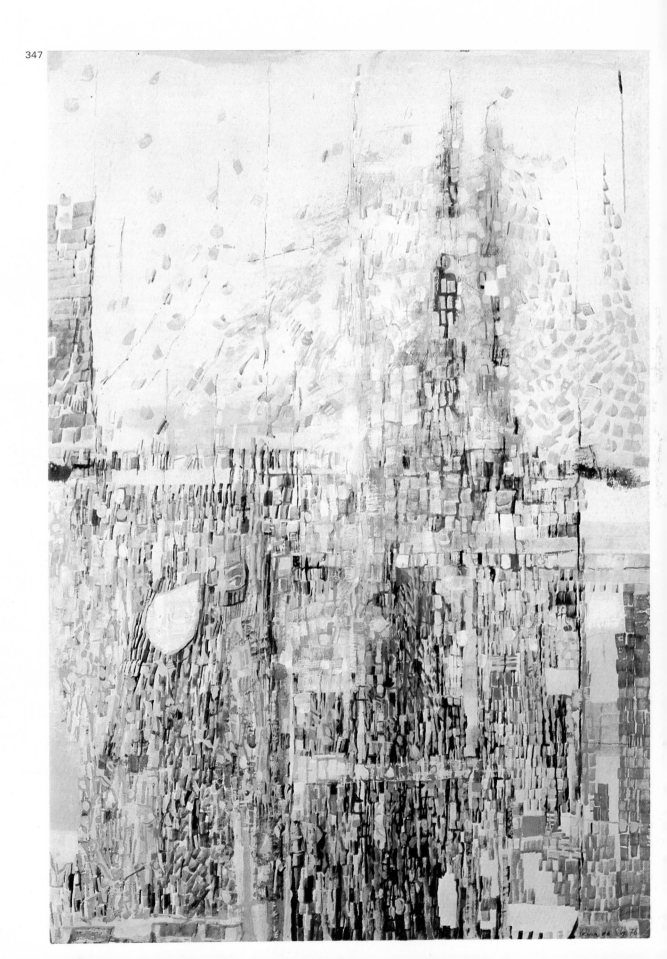

348. The Good Neighborhoods. 1973. Tempera on Chinese paper, 57.5×121 cm.
349. Portioned Hillock. 1974. Oil on canvas, 100×81 cm. Private collection, Switzerland.

348

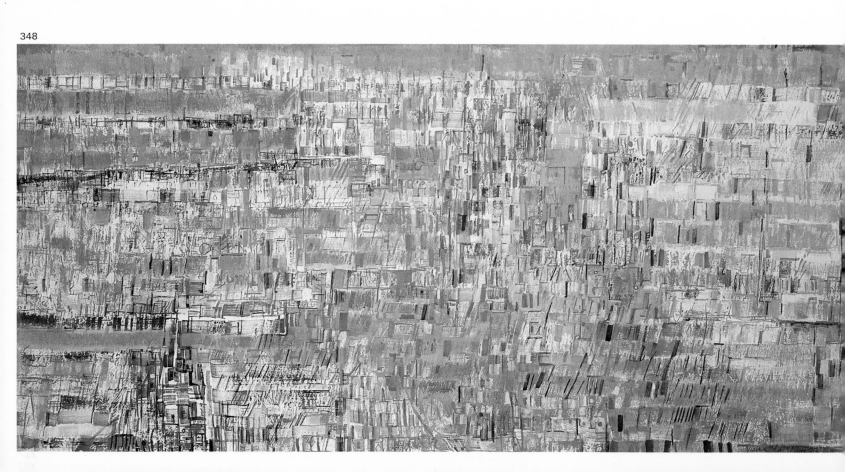

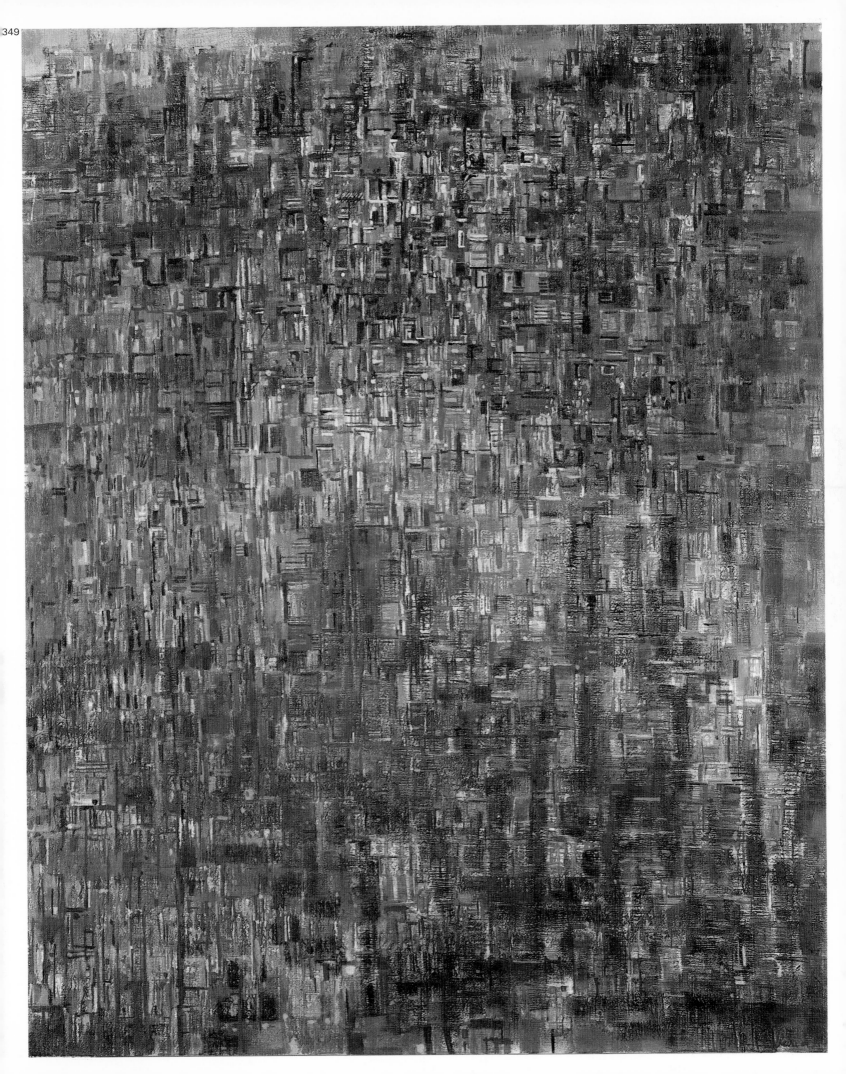

350. Allégresse. 1976. Tempera on paper, 57×121 cm.
Private collection, Paris.

351. Tempera. 1977. Tempera on Kraft paper, 152×52 cm.
Private collection, Paris.

350

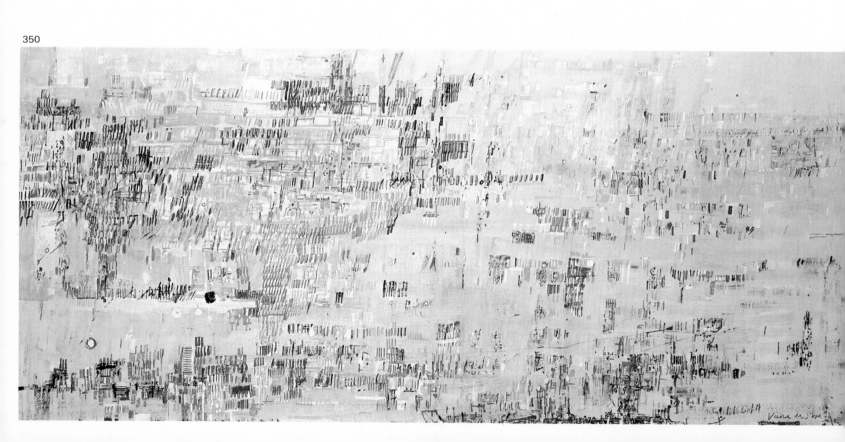

Stained glass
Saint-Jacques in Rheims

When Joan of Arc had Charles VII crowned in the basilica of Saint-Remi in Rheims, not far from there stood the church of Saint-Jacques. Today it is a monument that in its diversity of styles has nevertheless found a fortunate harmony. Indeed it offers in itself a summing up of architectural development from the thirteenth to the sixteenth century, from Gothic to the Renaissance.

Joseph Sima was at first to take over the whole of the stained glass. But being in poor health at the time, and alarmed by the importance of the work, he ended by yielding to the wishes of the master glassmaker Charles Marq and sent word to Vieira da Silva, asking if she would agree to share the task with him.

Vieira da Silva, though certainly mystical, was very far from the Church and had never worked for it. This insistent request left her at first perplexed.

Divided between her apprehensions and the attraction of the proposal, and frightened by the responsibilities involved, she accepted out of admiration for Sima's work, which she had known for a long time. But it had taken a long struggle with

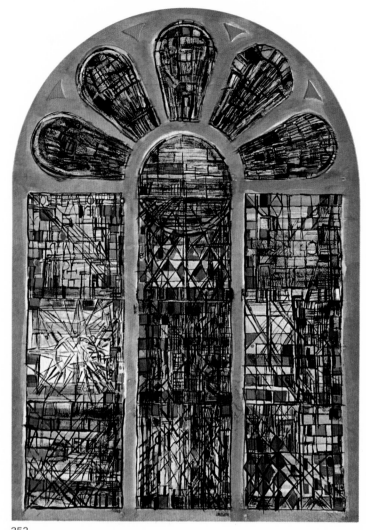

352

herself to overcome her hesitations and anxiety.

In 1963, she executed a first window. The experiment left her dissatisfied but allowed her to meet Brigitte Simon and Charles Marq in their Rheims workshop. The warmth of the welcome she received, the perspicacity and conviction that both of them showed for the work, were to

352 to 354. Designs for the south chapel of the church of Saint-Jacques, Rheims.

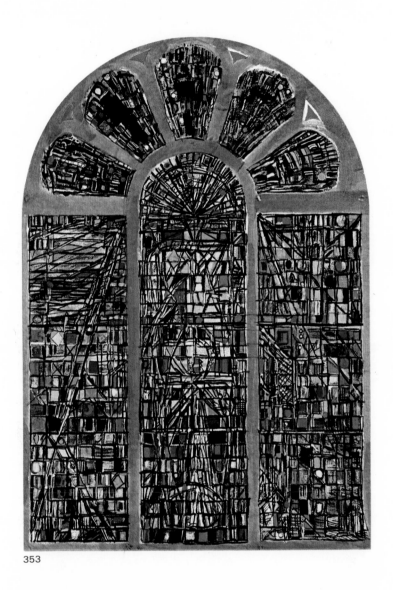

353

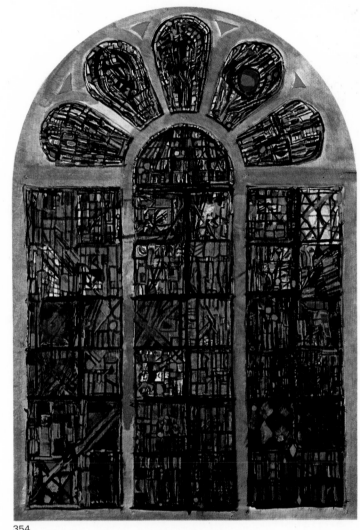

354

count heavily in her decision, when in 1966 she finally agreed to accept the commission. Brigitte and Charles constituted a very strong element of security for her. She knew she could rely on their affectionate understanding; she also knew that since both were painters, they would survive difficulties and anxieties in harmony. But also Vieira da Silva already loved the house, those studios with walls

covered with photographs, post-cards, souvenirs, with shelves loaded with porcelain and glassware, where music poured out easily in those vast spaces and tall structures. A peace favorable to reflection and concentration reigned there.

There is nothing to indicate it precisely, but certain hidden aspects suggest that this was once the map

355. Rheims. Church of Saint-Jacques. East chapel. Apse.

room in the tower of a tall manor house built at the end of the last century. Leaning out of the window, one would not be surprised to see cliffs and the forest in the foggy distance.

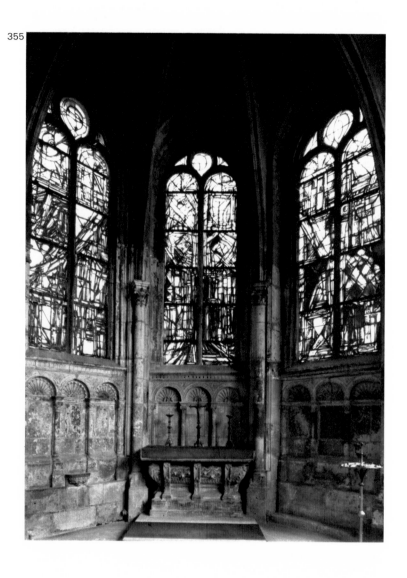

355

Having garnered the precious information that the stained-glass windows of the Renaissance were traditionally silver and gold, it was this scale that Vieira da Silva wanted to maintain. Silver for the north, gold for the south, while seeking to rediscover in the modulations of light the equivalent color variations of these two metals. The colors appear as precious stones, encased carbuncles: agate, opal, ruby, emerald, sapphire, and rock crystal are caught in the shifting brightness. Still in the same spirit, she has contrived intermediate passages: gray and light brown dotted with yellows, blues, reds, and greens to the northeast, then to the southeast with reds, umbers, and burnt sienna, again with a play of reds, yellows, various blues, and a few very occasional greens. These two groups of windows, the first to

be installed, are the first fruits of the cold and warm glimmers of light from north and south. The sun's progress around the fourteen windows of the choir has determined the placing of the dominant colors and the theme has naturally followed it. The revolution of the sun accompanied the itinerary of the pilgrims, the long grave march rising in exaltation from stage to stage and reaching its zenith

in Compostela, before the crowned Saint James facing the Atlantic.

On the technical level, Charles Marq obviously wanted Vieira da Silva to use the old methods for working the glass. Such was also the artist's wish. Grisaille (iron oxide mixed with crushed glass vitrifies in the fire to become an immutable enamel) makes it possible to revise the whole composition before firing, and even to alter it considerably one last time. The color arrangement having been decided on, and the cutting of the panes accomplished, it seemed necessary to both of them to perfect the unity of the elements among themselves and to unify the parts. Finally, this grisaille gives the glass a density that the artist seeks in her various modes of expression, and by offering free rein to her imagination, it has allowed her to invent with her brush an infinity of signs and modulations. For instance, the light no longer traverses the glass directly. The distribution of the grisaille restrains its dazzle, spreads it, filters it. It acts as a fine sieve for the light. But also the intervention of the hand needed to warm the material appeared to them as the mysterious point of fusion for their intentions and decisions.

356. Rheims. Church of Saint-Jacques. West chapel. Apse.
357. Rheims. Church of Saint-Jacques. North chapel. Right window (no. 11).
358. Rheims. Church of Saint-Jacques. North chapel. West apse.
359. Rheims. Church of Saint-Jacques. North chapel (detail).
360. Rheims. Church of Saint-Jacques. South chapel (detail).
361. Rheims. Church of Saint-Jacques. South chapel (detail).

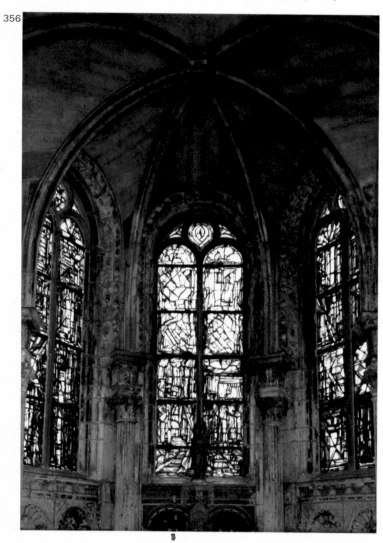

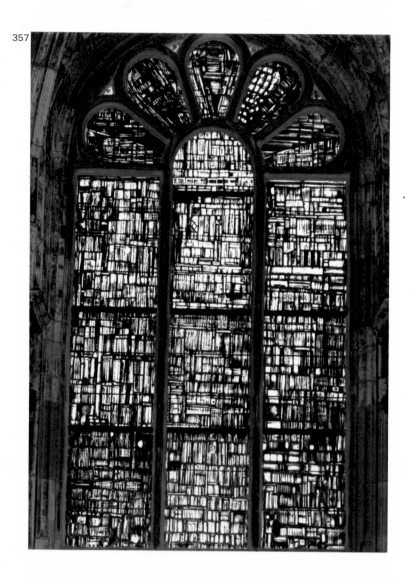

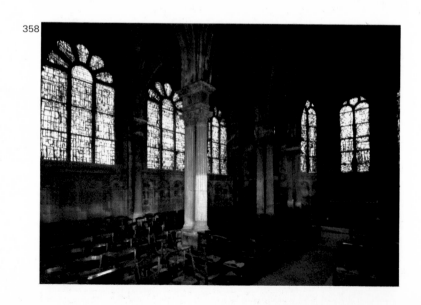

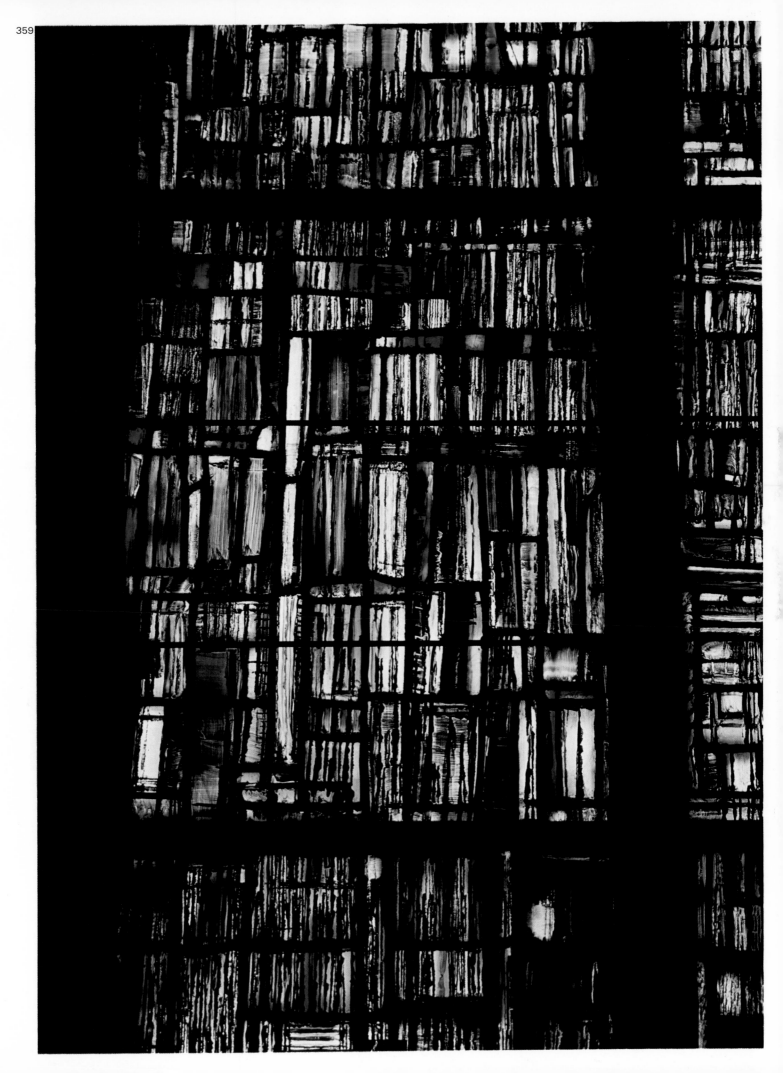

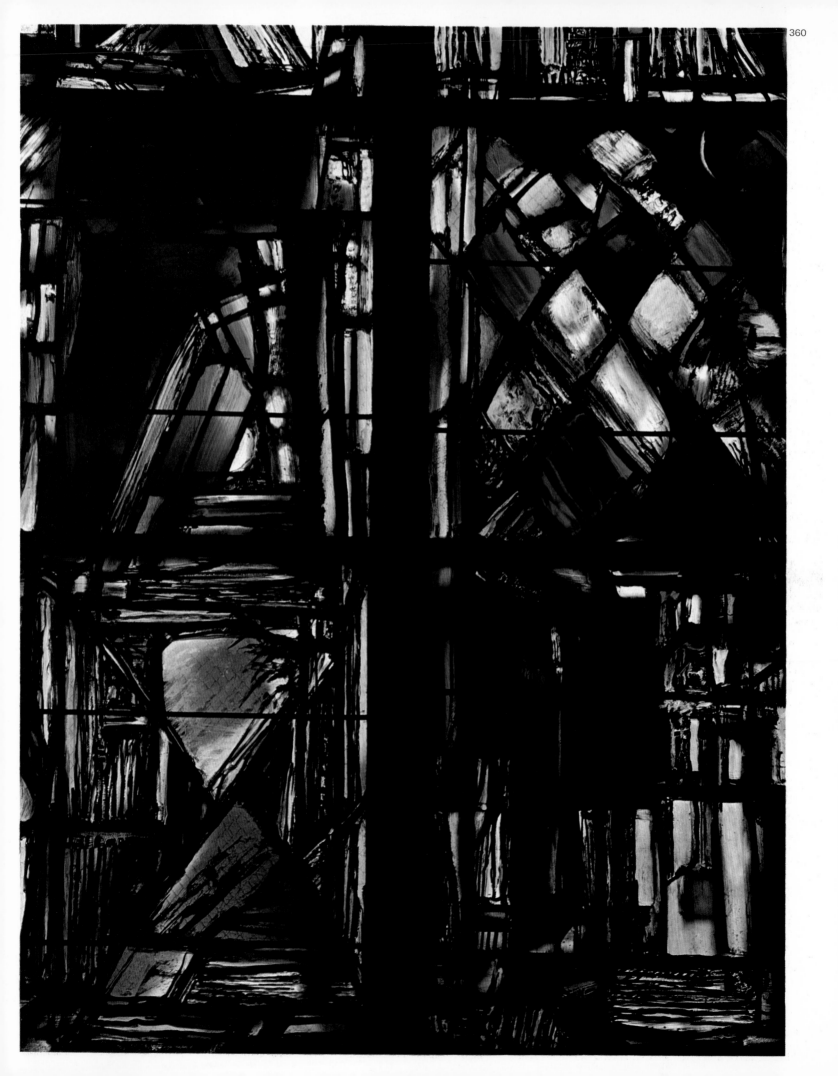

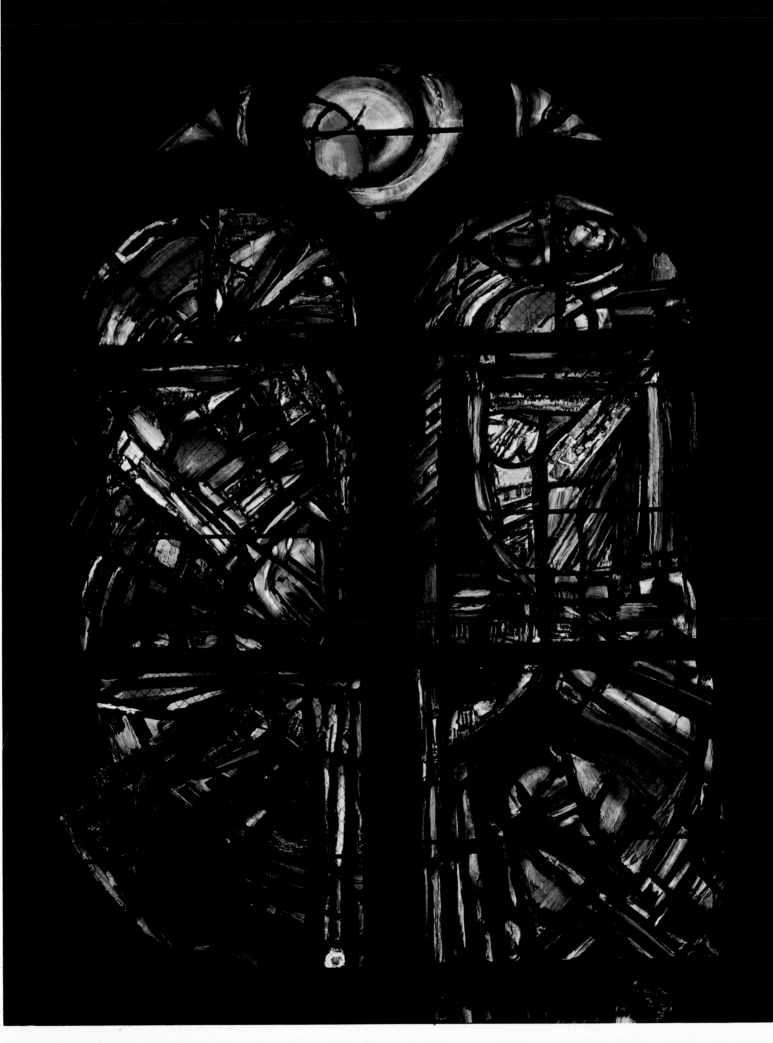

CHRONOLOGY

1908 June 16, birth of Maria Helena, only child of Marcos and Maria Graça Vieira da Silva.

1908-10 Travels with her parents in England, France and Switzerland.

1911 February 14, her father dies in Leysin (Switzerland).

1913 Visit to London and to Hastings, where she attends a memorable performance of *A Midsummer Night's Dream* at the theater built over the water at the end of the pier. Having heard a good deal of music, she studies the piano.

1917 In Lisbon, attends performances of the Ballets Russes.

1919-27 Studies drawing with Emilia Santos Braga, then painting with Armando Lucena, professor at the School of Fine Arts in Lisbon. Also practises sculpture in 1924. Becomes interested in anatomy and, as a Fine Arts student, takes courses in the subject at the School of Medicine.

1928 Having long considered the idea, goes to Paris to work, and enrolls at the Académie de la Grande-Chaumière to study sculpture with Bourdelle. The Bonnard exhibition held at the Galerie Bernheim Jeune is a revelation for her. Visits Italy, becomes enthusiastic about Sienese painting.

1929 Studies sculpture with Despiau at the Académie Scandinave. Gives up sculpture for good. Works in painting with Dufresne, Waroquier, and Friesz. In the evenings, practises engraving in Hayter's studio. She creates fabric designs in a studio in the Rue des Petits-Champs. Attends Fernand Léger's school and takes courses with Bissière. Does abstract designs for rugs. Dolly Chareau buys two of her designs.
During this period Vieira da Silva lives at the Hôtel Médical.

1930 Marriage to the Hungarian painter Arpad Szenes. The couple move to the Villa des Camélias.

1931 Vieira da Silva and Arpad Szenes attend the gatherings of the "Amis du monde." There they meet several artists who have since become their close friends.

1932 Meets Jeanne Bucher, whose gallery at the time was in the Rue du Cherche-Midi. Thanks to her, Vieira da Silva discovers the work of Torres-García, which she finds on display in the window of Pierre Loeb's gallery. Takes courses with Bissière at the Académie Ranson.

1933 Jeanne Bucher organizes her first individual exhibition, at which she shows *KÔ et KÔ,* a children's book with text by Pierre Gueguen and pochoir illustrations by Vieira da Silva, the preparatory notes, and finally a few paintings — not to mention a Christmas tree decorated with cut-out figures by the artist.

1934 For the first time one of her works is bought. The buyer is the painter Campigli, at the Hôtel Drouot.

1935 Antonio Pedro, writer, painter and stage director, organizes her first exhibition in Lisbon, at the UP gallery. Seeking solitude in order to devote herself to her work, Vieira da Silva leaves Paris to settle temporarily in Portugal.

1936 In January, Vieira da Silva and Arpad Szenes exhibit abstract paintings in their Lisbon studio. The newspaper *Paris Soir* begins publication of her drawings to illustrate *Madame la Grammaire* by Pierre Gueguen. Returns to Paris at the beginning of October.

1937 In January, exhibits again at the Galerie Jeanne Bucher, now located on Boulevard du Montparnasse. She and Arpad Szenes execute copies of Braque and Matisse for Madame Cuttoli. Julian Trevelyan is her second purchaser. Hilla Rebay acquires one of her paintings for the Guggenheim Collection.

1938 The couple leave the Villa des Camélias and move to Boulevard Saint-Jacques.

1939 Because of political events, Vieira da Silva and Arpad Szenes decide to go to live in Portugal. They entrust the care of their works and studio to Jeanne Bucher. Arrival in Lisbon in September.

1940 Vieira da Silva wins a prize for the decoration of a cutler's window. In June the couple embark for Brazil and settle in Rio de Janeiro. She quickly makes contact with Brazilian writers and poets, in particular Murilo Mendes and Cecilia Meireles.

1942 No less rapidly, their studio becomes a center where young artists meet: Martin Gonçalves, Ruben Navarra, Carlos Scliar, etc. Vieira da Silva and Arpad Szenes exercise a strong influence on them.
The Museum of Fine Arts of Rio de Janeiro exhibits her works.

1943 For the National School of Agronomy, "Kilometer 44," she executes the decoration of the dining-room in ceramic tiles.

1944 Arpad Szenes advises a few young artists, the circle rapidly expands, and he then decides to open a studio, which under his energetic direction soon becomes a very active center.
Vieira da Silva exhibits at the Askanasy gallery in Rio de Janeiro.

1946 She is invited with her husband by Kubitschek, then governor of the State of Minas Gerais, to exhibit her works at the municipal palace of Belo Horizonte. They spend several weeks in this city.
The Marian Willard Gallery presents her first individual exhibition in New York, organized by Jeanne Bucher.

1947 In March, Vieira returns to France. In the month of June, she exhibits at the Galerie Jeanne Bucher. At the end of the year, Pierre Loeb comes to visit her studio and immediately

becomes interested in her work. December and January, visit to Lisbon.

1948 The French State buys *The Chess Game* (1948).

1949 Individual exhibition at the Galerie Pierre, Paris. Guy Weelen, then a young critic and organizer of exhibitions for various foreign museums, asks permission to visit her studio. He is deeply moved by her work and by that of Arpad Szenes, which he is able to see a few months later. Pierre Descargues publishes the first booklet devoted to her painting (Les Presses Littéraires de France, Paris).

1950 Individual exhibition at the Galerie Blanche in Stockholm. Exhibition of gouaches with Reichel at La Hune gallery-bookstore, Paris.

1951 The State acquires *The Library* (1949), which now hangs in the Musée National d'Art Moderne, Paris. Individual exhibition at the Galerie Pierre, Paris.
Exhibition at the Galerie Jeanne Bucher of a group of gouaches assembled on the occasion of the publication of *Et puis voilà* (published by Jeanne Bucher, Paris), stories told to her doll by Marie-Catherine Bazaine when she was five years old.

1952 Individual exhibition at the Galerie Dupont in Lille, France.

1952-53 Individual exhibition at the Redfern Gallery, London.

1953 Individual exhibition at the Cadby Birch Gallery, New York. Acquisition prize at the São Paulo Biennale.

1954 The Kunsthalle in Basel displays her work, along with paintings by Bissière, Schiess, and Ubac, and sculptures by Germaine Richier.
First prize in the competition for tapestries for the University of Basel. She has worked several years on the execution of life-size cartoons. They are executed under the direction of Marthe Guggenbull.
So as to be able to devote herself to painting without having to be bothered by the concerns of everyday life, she asks Guy Weelen, who has become a friend to her and her husband, to act as a link between them and the world. But he also indexes her work for the purpose of establishing the catalogue, classifies and arranges the archives, writes the biography, compiles the bibliography, and takes charge of the technical organization, calendar, conception and hanging of future exhibitions.

1955 Third Prize at the Caracas Biennale.
Exhibition, with Germaine Richier, at the Stedelijk Museum, Amsterdam. Individual exhibition at the Galerie Pierre, Paris.
Executes a series of silkscreen prints in the studio of René Bertholo and Maria Lourdes.
The purchasing group of the Amis des Musées offers the painting *L'Ecluse glacée* (The Frozen Weir, 1953) to the Musée des Beaux-Arts in Lille.

1956 By a decree issued on May 15, Vieira da Silva and Arpad Szenes are granted French citizenship.
The Saidenberg Gallery in New York and the Gallery of Modern Art in Basel hold exhibitions of her works. The French State acquires *Hanging Gardens* (1955), which hangs in the Musée National d'Art Moderne, Paris. .
She buys a site in the 14th arrondissement. The architect G. Johannet designs her studio and builds her house.
René de Solier publishes a book on her work (Musée de Poche, Paris).

1957 Exhibition in Geneva (Galerie du Perron), then in London, at the Hanover Gallery.
Her mother moves to Paris for good.
The Musée de Peinture et Sculpture in Grenoble, France, buys *The Towers* (1953).
Exhibits at the Portico Gallery, Lisbon.

1958 The Kestner Gesellschaft in Hanover (Germany) holds her first retrospective, later shown at the Kunsthalle in Bremen, and at the Kunst und Museumverein of Wuppertal: 91 works appear in the catalogue.
Mention in the Guggenheim Museum Annual Prize.
Fourth Prize, Carnegie Institute, Pittsburgh.
Visit to Portugal in autumn. Goes to southern Spain. José Augusto França publishes the first monograph in Portugal (Artis, Lisbon).

1959 Works on engravings for *L'Inclémence Lointaine*, poems by René Char.

1960 Exhibition at the Galerie Jeanne Bucher, Paris. In March she is named Chevalier of the Order of Arts and Letters. The tapestries for the University of Basel are displayed with public ceremonies.
Publication of twelve color plates with a text by Guy Weelen (F. Hazan, Paris).

1961 *L'Inclémence Lointaine* is published in Paris by Pierre Berès. This book contains 25 engravings. Roland Balay and Theodor Schempp exhibit her works at the Knoedler Gallery in New York. The exhibition is later presented at the Phillips Art Gallery in Washington, D.C.
First visit to New York.
The State buys *Summer or Gray Composition* (1960), for the Musée National d'Art Moderne, Paris.

1962 In January, Vieira da Silva is made a Commander of the Order of Arts and Letters.
The Kunsthalle in Mannheim holds an exhibition of her works. On this occasion, she visits Heidelberg. International Grand Prize in painting, São Paulo Biennale. January, trip to Spain.

1963 The Galerie Jeanne Bucher in Paris, Knoedler's in New York, and the Phillips Art Gallery in Washington, D.C. exhibit her temperas. The Gravura Gallery in Lisbon shows *L'Inclémence Lointaine*. The Bezalel Museum (Jerusalem) exhibits *L'Inclémence Lointaine*, along with lithographs and silkscreen prints. At the suggestion of Jacques Lassaigne, she executes her first stained-glass window at

the Atelier Jacques Simon in Rheims. It is bought by the State. Grand Prix National des Arts, Paris.

1964 February 7, death of her mother.
The Musée de Peinture et de Sculpture in Grenoble and the Museo Civico in Turin hold retrospectives of her work. These two exhibitions contain 67 and 145 works, respectively.
Visits Italy.

1965 Exhibition at the Albert Loeb Gallery, New York. The Musée Saint-Pierre in Lyons acquires *The Veranda* (1948) and *Paris* (tempera, 1961).
Stele, a large tempera on canvas painted during her mother's illness, is exhibited at the Musée National d'Art Moderne, Paris.

1966 Individual exhibition at Knoedler's in New York. Second trip to the United States. The Academy of Amateurs of Music in Lisbon holds an exhibition of works by her in Portuguese collections.
The Musée des Beaux-Arts in Rouen acquires *Rouen* (1966). Receives commission for stained-glass windows for the church of Saint-Jacques in Rheims. Begins working on models.

1967 One-man show at the Galerie Jeanne Bucher, Paris. Joint exhibition with the sculptor Etienne Martin at the Château de Ratilly, France.
A first tapestry is woven from her designs by the Gobelins, a second by the workshop of the Beauvais factory. The State buys *The Library* (1955).

1968 The Cabinet des Estampes of the Bibliothèque Nationale acquires two engravings from *L'Inclémence Lointaine.* The Musée d'Art Moderne de la Ville de Paris acquires *Contested Propositions* (1966), and the State, *Impossible Enterprise* (1961-67).
The Calouste Gulbenkian Foundation, Lisbon, acquires *Les Degrés* (1964), *Landgrave* (1966), and *L'Aire du Vent* (1966).
At the urging of Guy Fino, the Manufactura de Tapeçarias de Portalegre (Portugal) undertakes the execution of a number of tapestries.
The stained-glass windows executed in collaboration with Charles Marq, Atelier J. Simon, are installed in the church of Saint-Jacques, south chapel, east wall. Visit to Venice. One-man show at the Comédie de la Loire, Tours.

1969 Installation of stained-glass windows in the church of Saint-Jacques, north chapel, east wall. The Musée Cantini (Marseilles) acquires *The Satellite* (1955). The State buys the models for the stained-glass windows of the church of Saint-Jacques in Rheims.

1969-70 Retrospectives at the Musée National d'Art Moderne, Paris; the Boymans-van Beuningen Museum, Rotterdam; the Kunstnernes Hus, Oslo; the Kunsthalle, Basel; and the Calouste Gulbenkian Foundation, Lisbon. These five exhibitions contain 87, 78, 85, 76 and 202 works, respectively.

On this occasion the Galerie Jeanne Bucher, Paris, holds an important exhibition, "Les Irrésolutions Résolues," consisting of large charcoal drawings, and the Galerie Jacob, Paris, a group of gouaches, 1945-67.

1970 The São Mamede, 111, and Judith da Cruz galleries in Lisbon and the Zen in Porto present an exhibition of her works. She is appointed a member of the National Academy of Fine Arts, Portugal.

1971 The Musée Fabre, Montpelier, organizes an important retrospective exhibition of her work, including a selection of prints: 90 paintings and temperas, 45 prints. The perfect technique of Claude Manesse encourages her to execute a series of lithographs. Along with recent temperas, they are exhibited at the Galerie Jeanne Bucher, Paris, on the occasion of the publication of Dora Vallier's study (Editions Weber). This book was to be followed by another volume devoted to the catalogue raisonné.
The Pinton workshops, Aubusson, weave a tapestry, *Bibliothèque,* designed for the hall of the Faculty of Letters, University of Bordeaux.
Charles Marq receives new designs for the stained-glass windows of the church of Saint-Jacques: three north windows, north chapel. They will be installed in 1975.
The Musée des Beaux-Arts in Rheims acquires a tempera, *Les Thermes.*

1972 The Musée des Beaux-Arts in Rouen and the Musée Thomas-Henry in Cherbourg hold exhibitions of the engraved work; the Galerie Michel Vokaer in Brussels and the Galerie Véga in Liège show a group of lithographs. The museum of Unterlinden Colmar devotes its annual show to her. *Le Banquet* (The Symposium) by Plato, in a new translation by M. P. Boutang, is illustrated with nineteen drawings (published by Hermann, Paris).
Is elected an honorary member of the Mark Twain Society in the United States.

1973 The Musée d'Art et d'Histoire, Orleans, holds a retrospective of her work that includes *L'Inclémence Lointaine.* The cultural center of this city exhibits a selection of prints. The Rizzoli Center in Milan exhibits a group of her paintings. The lithograph *Atlantide* is added to those already published. A series of lithographs, silkscreen prints, engravings, etc., enters the Bibliothèque Nationale, Paris. Guy Weelen publishes a new monograph (F. Hazan, Paris).

1974 Her graphic work is exhibited by the Quadrum Gallery, Lisbon, and at Monique Delcourt's gallery in Valenciennes, France. A large exhibition of paintings — 1970 to 1974 — is organized by the Galerie Artel in Geneva. The Musée des Beaux-Arts in Dijon presents "Deux Volets de la Donation Granville: J. F. Millet et Vieira da Silva." The artist offers a very large painting, *Urbi et Orbi* (1963-72), to the Donation Granville, Musée des Beaux-Arts, Dijon. She executes several lithographs, including *Love Letter* and *Transylvania.* Thirty drawings accompany *Récits Abrégés,* poems by Jean Guichard-Meili (Galanis Editeur, Paris), a work that wins the Prix Max Jacob. The magazine *Argile,*

No. 4 (Maeght, Paris) publishes a series of eight drawings in homage to the great Portuguese poet Fernando Pessoa. She executes five portraits of André Malraux in "sugar-process" aquatint, including one with the burin. One of them is designed for the de luxe edition of *Malraux, celui qui vient,* a series of interviews with André Malraux and José Bergamín, text by Guy Suarès (Stock Editeur, Paris). The Musée des Beaux-Arts of Rouen acquires *Rouen II.*

1975 Together with Arpad Szenes, she exhibits paintings and engravings in the setting of the 12th International Music Festival of Royan. The Nova Gallery in Stockholm exhibits a series of recent temperas. The Pinton Workshops weave for the French State a second version of *Bibliothèque,* in which the range of color has been completely changed. At the request of the poet Sophia Mello Breyner Andersen, she designs two posters to commemorate the "25th of April 1974," which are published by the Calouste Gulbenkian Foundation, Lisbon.

1976 Publication of *Sept Portraits de René Char,* accompanied by a text: "Chère voisine, multiple et une....", to celebrate the long artistic friendship between the painter and the poet. This album, surrounded by older and recent works, is displayed at the Galerie Jeanne Bucher, Paris. Having executed the last three models for the south windows, south chapel of Saint-Jacques in Rheims, she makes several visits to this city to put the last touches to the glass. The windows are installed for the Christmas holidays. With Arpad Szenes, she makes an important donation of drawings to the Musée National d'Art Moderne, Centre Georges Pompidou, Paris. They are presented to it along with paintings and tapestries belonging to the State. The Maison des Arts et Loisirs of Sochaux, the Museums of Metz, and the Musée d'Etat of Luxemburg organize a retrospective of her work; 77 and 50 works appear in the catalogues; the Kutter Gallery in Luxemburg exhibits her recent tempera paintings. Acquisition by the Musée d'Unterlinden (Colmar) of the painting *The Theater of Gérard Philipe* (1975), by the Musée des Beaux-Arts in Rheims of the canvas *Le Carré* (1973), of a gouache by the Société L'Art Contemporain of Dunkirk, a tempera, *Charmilles* (1975) by the Metz museums, and *The Angel* (1976), another tempera, by the Musée d'Etat of Luxemburg. She presents *Portrait of Arpad* (1936) to the Musée d'Art Moderne de la Ville de Paris.

1977 The Musée d'Art Moderne de la Ville de Paris organizes the first retrospective exhibition devoted to the paintings in tempera; it is also presented in Lisbon by the Calouste Gulbenkian Foundation. These two exhibitions consist of 88 and 84 works, from 1929 to the present year.
Arts et Métiers Graphiques, Paris, publishes the catalogue of the graphic work compiled by Guy Weelen. The Galerie in Nimes exhibits a selection of illustrated books, engravings and aquatints, along with prints. Antoine Terrasse devotes a volume in the series "Carnets de Dessins" (Henry Screpel, Paris) to her drawings and tempera paintings.
The Portuguese government confers on her the Grand Cross of Sant'Iago da Espada.
For the Société des Amis du Musée d'Art Moderne de la Ville de Paris and various publishers, she executes a series of 15 lithographs at the Imprimerie Artistique Bellini, Paris.

BIBLIOGRAPHY

1931 KAHN: *Mercure de France.* Paris, December 15.

1933 GEORGE, WALDEMAR: *Art et Décoration.* Paris, December.

1935 PETERDY, GABOR: "A Modern Müvészet, Térhúditása Anglia es Amerika felé." *Magyar Hirlap.* March 17.

ANTONIO, PEDRO: "Maria Helena Vieira da Silva et Arpad Szenes." *Fradique.* June 27-July 11.

ANTONIO, PEDRO: "Oito frases de introito." Preface to the catalogue of an exhibition, UP Gallery. Lisbon.

1936 SIMÕES, JOÃO GASPAR: "Introdução a Pintura abstrata de Maria Helena Vieira da Silva et Arpad Szenes." Lisbon. *Diário de Lisboa.* January.

1937 LHOTE, ANDRÉ: "La Peinture: Salon des Surindépendants." Paris. *Le Soir.* November 27.

1938 COURTHION, PIERRE: "Fantaisie sur trois peintres." Paris. *XX^e Siècle,* No. 3, July-September.

SIMÕES, JOÃO GASPAR: "Introducao a Pintura abstrata de Maria Helena Vieira da Silva et Arpad Szenes." Lisbon. *Novos Rumos.*

1939 COURTHION, PIERRE. "Chronique du jour: Plaisir de peindre." Paris. *XX^e Siècle,* Nos. 5-6, February-March.

1941 NAVARRA, RUBÉN: "Notícia de una pintora Luso-Brasileira." Rio de Janeiro. *Diário de Notícias.* August 24.

1942 J. DE B.: "A senhora de Maria Helena Vieira da Silva e sua Pintura." Lisbon. *O Jornal.* January 6.

MENDES, MURILO: Catalogue preface, exhibition by Maria Helena Vieira da Silva. Rio de Janeiro. National Museum of Fine Arts. July.

BANDEIRA, MANUEL: "Artes Plásticas." Rio de Janeiro. *A Manhã.* July 10.

NAVARRA, RUBÉN: "Maria Helena, Pintora de Lisboa e Paris." Rio de Janeiro. *Diário de Notícias.* July 12.

1943 TORRES-GARCÍA, JOAQUÍN: "La pintura de Maria Helena Vieira da Silva." Montevideo. *Alfar.* January 31.

MEIRELES, CECILIA: *Sosségo.* Rio de Janeiro, July 14.

1944 SZENES, ARPAD: "Estudos sobre a Arte." Rio de Janeiro. *Revista Leitura,* No. 19, June.

FERRAZ, GERALDO: "Maria Helena na Galeria Askanasy." Rio de Janeiro. *O Jornal.* July 14.

MENDES, MURILO: Rio de Janeiro. *A Manhã.* December 10.

MEIRELES, CECILIA: "Un passeio prodigioso." Rio de Janeiro. December 13.

CARDOSO, LUCIO: "Maria Helena." Rio de Janeiro. *O Jornal.* December 16.

NAVARRA, RUBÉN: "Vieira da Silva e a Escola de Paris." Rio de Janeiro. *Diário de Notícias.* December 17.

CAMPFIORITO, QUIRINO: "Maria Helena." Rio de Janeiro. December 19.

1945 LINS DO REGO, JOSÉ: "A pintora Maria Helena." Rio de Janeiro. *A Manhã.* February 3.

MENDES, MURILO: *Mundo Enigma.* Porto Alegre. Livraria do Globo.

CARDOSO, LUCIO: "Saudação a Dois Pintores." Rio de Janeiro. *O Jornal.* January 6.

1946 ANONYMOUS: "Review and Previews: Young Portuguese Explores Space and Time." New York. *Art News,* XLV, No. 3, May.

DEVREE, HOWARD: "Among the New Exhibitions." New York. *New York Times.* April 14.

BURROWS, CARLYLE: *New York Herald Tribune.* New York. April 21.

GUEHENNO, JEAN: "Fragment d'un journal de voyage en Amérique du sud. Pensées du soir à Rio de Janeiro." Paris. *Le Figaro Littéraire.* June 8.

NICOLUSSI, HAYDÉE: "Retorno de Arpad Szenes." Rio de Janeiro. *O Jornal.* July 14.

1947 BERKOWITZ, MARC: "The Arts: Farewell to Maria Helena." Rio de Janeiro. *Brasil Herald.* February 27.

SIMÕES, JOÃO GASPAR: "Vive em Paris una grande Pintora Portuguesa." Lisbon, *Artes e Letras.* December 31.

TREVELYAN, JULIAN: *World Review.* Special New Year Number. London. Halton.

1949 SEUPHOR, MICHEL: Catalogue preface, Vieira da Silva exhibition. Paris. Galerie Pierre, June-July.

LASSAIGNE, JACQUES: "La saison des Prix." Paris. *La Bataille.* July 14.

ALVARD, JULIEN: "Vieira da Silva." Paris. *Art d'Aujourd'hui,* No. 2, July-August.

GREGORIAN, ÉD.: "Notas de um Turista sem pressa. Vieira da Silva." Rio de Janeiro. *A Manhã.* August 7.

ESTIENNE, CHARLES: "Bilan d'une année de peinture—Irregulier." Paris. *Combat.* September 21.

SEUPHOR, MICHEL: "Promenade autour de Vieira da Silva." Paris. *Cahiers d'Art,* No. 2.

1950 ESTIENNE, CHARLES: "Préface Exposition de gouaches Vieira da Silva et Reichel." Paris. Galerie La Hune, March-May.

GINDERTAËL, ROGER VAN: "Vieira da Silva, Reichel." Paris. *Art d'Aujourd'hui,* No. 9, April.

AGAY, C.: "L'artiste et son Modèle." Paris. *Art d'Aujourd'hui,* No. 10, May-June.

DESCARGUES, PIERRE: "Paintings in Paris." New York. *Magazine of Art,* May.

GAUGUIN, POLA: "Fransk Kunst par Charlottenborg." Copenhagen. *Ekstrabladet.* September 13.

REWALD, JOHN: "Farven Ikke DoD." Copenhagen. *Ekstrabladet.* September 13.

1951 SIMÕES, JOÃO GASPAR: "Maria Helena Vieira da Silva, una pintora portuguesa que todo o mondo culto conhece e os portugueses ignoram, esta em Lisboa e falamos de arte Moderna." Lisbon. *Diário Popular,* April 25.

WESCHER, HERTA: "Pariser Künstvereinnen." Basel. *Inspire,* No. 31, November.

FRANÇA, JOSÉ-AUGUSTO: *Retrato de Vieira da Silva.* Lisbon. *Da Poesia Plástica.* Cadernos de Poesia.

1952 FEIZO E EDDY, M.: "De Paris." Lisbon. *Eva,* No. 960, January.

TEXEIRA, MARIA DE LURDES: "Da paisagem luxuriante do silvestre ao atelier sarteano do Boulevard St.-Jacques. Vida, Romance e Arte de Maria Helena Vieira da Silva." São Paulo. *Folha da Manhã.* July 20.

CESARINY, MÁRIO: "Maria Helena Vieira da Silva, pintora de renome universal e quase uma desconhecida no nosso pais." Lisbon. *Cartaz*, July.

CESARINY, MÁRIO: "Carta aberta a pintora Vieira da Silva." Lisbon. *Cartaz*, September.

MEIRELES, CECILIA: "Maria Helena." São Paulo. *Jornal de São Paulo*. December 21.

1953 RUDLINGER, ARNOLD: Catalogue preface, exhibition by Vieira da Silva, Ph. Martin, H. Marshall. Berne, Kunsthalle, February-March.

FRANÇA, JOSÉ-AUGUSTO: "Nota sobre Maria Helena Vieira da Silva." Oporto. *O Commércio do Porto*. May 26.

A. DE G.: "30 minutos com a Pintora Maria Helena Vieira da Silva." *Ler*, No. 15, June.

ALVES DAS NEVES, J.: "Vieira da Silva." Lisbon. *O Mundo Ilustrado*, June.

GINDERTAËL, ROGER VAN: L'Art abstrait. Nouvelle situation. Premier Bilan de l'Art Actuel (1937-1953). Paris. *Soleil Noir*, Nos. 3-4.

DESCARGUES, PIERRE: L'Art abstrait, nouvelle situation, les frontaliers. Premier Bilan de l'Art Actuel (1937-1953). Paris. *Soleil Noir*, Nos. 3-4.

1954 SWEENEY, JAMES JOHNSON: "The Young Guard Painters in Paris." New York. *Harper's Bazaar*, No. 2907, February.

K. L. L.: "Vieira da Silva, Obsessions of Space." New York. *Art News*, March.

GUEGUEN, PIERRE: Catalogue preface, exhibition by Vieira da Silva, Bissière, Schiess, Ubac, G. Richier. Basel, Kunsthalle, June-July.

BERGER, MAX: "Germaine Richier, Vieira da Silva à Bâle." Paris. *Preuves*, August.

1955 PLESSIX, F. DU: "Neuf femmes peintres qui peignent comme des hommes." Paris. *Nouveau Femina*. February 11.

WENTINCK, CHARLES: "Germaine Richier en Vieira da Silva Sted. Museum, Dubbele exposite." Amsterdam. *Zuterdag*. February 12.

FRANÇA, JOSÉ-AUGUSTO: "Lembrança de Maria Helena Vieira da Silva." São Paulo. *O Estado de São Paulo*. August 14.

GINDERTAËL, ROGER VAN: "L'Expérience Poétique." Brussels. *Les Beaux-Arts*. November 25.

SIBERT, CLAUDE HÉLÈNE: "Vieira da Silva." Paris. *Cimaise*, 3rd series, No. 2, December.

SOLIER, RENÉ DE: "Vieira da Silva." Paris. *Nouvelle Revue Française*, No. 36, December.

CHAR, RENÉ: "Sept Merci pour Vieira da Silva." Paris. *Cahiers d'Art*.

DIONÍSIO, MÁRIO: "A Paleta e o Mundo." Lisbon. *Europa-América*.

1956 SIMÕES, JOÃO GASPAR: "Uma notavel mulher portuguesa." Porto. *Jornal de Notícias*. January 15.

GRENIER, JEAN: "Vieira da Silva." Paris. *L'Œil*, No. 14, February.

BERGER, RENÉ: Catalogue preface, Vieira da Silva Exhibition. Geneva. Galerie du Perron, February-March.

THARRATS, J. J.: "Vieira da Silva." *Revista*. May 13.

GUEGUEN, PIERRE: "Vieira da Silva." Paris. *XX^e Siècle*, nouvelle série, No. 7, June.

ANONYMOUS: "A Pintora Vieira da Silva fala-nos sua arte misteriosa." Lisbon. *Diário de Notícias*. September 27.

M. W.: "Kunst in Basel. Vieira da Silva. Bilder aus den Letzten zehn Jahren." Basel. *Weltwoche*. November 9.

ANONYMOUS: "Basler Ausstellungen." Basel. *National Zeitung*. November 14.

ANONYMOUS: "Basler Ausstellungen. Vieira da Silva." Basel. *Basler Nachrichten*. November 20.

SELLÉS PAES: "Pintura de Vieira da Silva em Lisboa." Lisbon. *Diário Ilustrado*. December 23.

PAMPLONA, FERNANDO DE: "Pinturas de Vieira da Silva na Galeria Pórtico." Lisbon. *Diário da Manhã*. December 29.

SELLÉS PAES: "Maria Helena Vieira da Silva." Lisbon. *Panorama*, December.

WEELEN, GUY: "Problème du Mouvement dans l'Art Contemporain." Brussels. *Synthèse*, no. 124.

BRION, MARCEL: *Art Abstrait*. Paris. Albin Michel.

GORE, FREDERICK: *Abstract Art*. London. Methuen & Co.

1957 OLIVEIRA, MÁRIO DE: "A Exposição de Vieira da Silva na Galeria Pórtico." Lisbon. *Diário Popular*. January 3.

A. P. F.: "Considerações sobre uma mostra de Arte de Vieira da Silva, a pintora nascida em Portugale mais conhecida em Paris que Lisboa." Lisbon. *Diário de Lisboa*, January.

CESARINY, MÁRIO: "Passagem do meteoro Vieira da Silva." Lisbon. *Diário Ilustrado*. August 13.

LAKE, CARLTON: "Art from Paris in London." Boston. *Christian Science Monitor*. October 19.

TAILLANDIER, YVON: "Parmi les peintres dont on parle le plus, une femme: Vieira da Silva." Paris. *Connaissance des Arts*, No. 70, December.

DORIVAL, BERNARD: *Les peintres du XX^e siècle*. Paris. Tisné.

SEUPHOR, MICHEL: *Dictionnaire de la peinture abstraite*. Paris. Hazan.

1958 SELLÉS PAES: "Para a comprensão de Vieira da Silva." Lisbon. *Rumo*, No. 12, February.

DIONISIO, MÁRIO: "Visita a Vieira da Silva." Lisbon. *Gazeta Musical e de todas as artes*, 2nd series, No. 82, February 2.

JOUFFROY, ALAIN: "L'Ecole de Paris était une aventure. Aujourd'hui c'est un centre d'apprentissage. Elle ne survivra pas sans une nouvelle révolution picturale." Paris. *Arts*. February 26-March 4.

TANNEGUY DE QUENETAIN: "L'Art Abstrait: mystification ou révolution?" Paris. *Réalités*, No. 147, April.

M. E. C.: "Eine Malerin der Schule von Paris. Zur kollektiv. Ausstellung Vieira da Silva, in Stadtischen Museum." Wuppertal. *General Anzeiger der Stadt Wuppertal*. June 7.

CHEVALIER, DENYS: "Vieira da Silva." Paris. *Ishtar*, June.

MACEDO, DIOGO: "Um caso de excepção." Lisbon. *Occidente*, Vol. LV, No. 243, July.

BERNDT, HANS: "Filigran wundersamer Kristalle. Raumbilder der Portugiesin Vieira da Silva in der Bremer Kunsthalle." Bremen. *Weser Kurier Bremen*. August 12.

SCHMALENBACH, WERNER: Catalogue preface, Vieira da Silva Retrospective Exhibition. Kestner Gesellschaft, Hanover.

GONZÁLEZ, REGOJO: "Uma noção de Espaço em Vieira da Silva." Revista de Associação, Academica de Coimbra. *Via Latina*, No. 77.

LIMBOUR, GEORGES: "La Nueva Escuela Pictórica de Paris." Paris. *Cuadernos,* No. 28.

MELLO BREYNER ANDERSEN, SOPHIA: "Vieira da Silva." Brussels. *Synthèse,* Nos. 145-46.

GUEDES, FERNANDO: "La peinture au Portugal." Brussels. *Synthèse,* Nos. 145-46.

GIAMPIERO, GIANNI: *Arte Astratta.* Milan. Della Conchiglia.

CESARINY, MÁRIO: *A Grafiaranha Maior. Alguns mitos maiores, alguns mitos menores. Essais de découverte.* Lisbon. Coll. A Antologia.

BERGER, RENÉ: *Découverte de la peinture.* Lausanne. La Guilde du Livre.

1959 SIMÕES, JOÃO GASPAR: "A Andaluzia nos olhos de uma grande pintora." Porto. *Jornal de Notícias.* January 4.

SELLES PAES: "Vieira da Silva, a Pintora portuguesa de Paris." Lisbon. *Mundo.* January 22.

FERRIER, JEAN-LOUIS: "Le Salon de Mai." Paris. *Les Temps Modernes,* July.

WEELEN, GUY: *Vieira da Silva.* Turin. Catalogue 6th France-Italy Exhibition.

MICHELSON, ANNETTE: "Vieira da Silva." New York. *Arts,* Paris-New York. Year Book, No. 3.

RAGON, MICHEL: *Peinture Actuelle.* Paris. Fayard.

MENDES, MURILO: *Poesias.* Rio de Janeiro. Libreria José Olympio.

GRENIER, JEAN: *Peinture Actuelle.* Paris, Gallimard.

PAMPLONA, FERNANDO DE: *Dicionário de Pintores e Escultores,* vol. 4. Lisbon.

1960 FRANÇA, JOSÉ-AUGUSTO: "Les expositions à Paris: Vieira da Silva." Paris. *Aujourd'hui, Art et Architecture,* No. 29, December.

RAOUL DUVAL, J.: "Œuvres récentes de Vieira da Silva." Paris. *L'Œil,* No. 63, March.

WEELEN, GUY: "Vieira da Silva ou fil des jours (fragments)." Lausanne. *Pour l'Art,* No. 71, May-June.

TASSART, MAURICE: "Promenade concrète dans l'art abstrait." Paris. *Parisien Libéré,* November 3.

GEORGE, WALDEMAR: "Les espaces imaginaires de Vieira da Silva." Paris. *Combat.* November 17.

ELGAR, FRANK: "Exposition Vieira da Silva." Paris. *Carrefour.* November 30.

ANONYMOUS: "Vieira da Silva." Paris. *Les Lettres Françaises,* November.

CHAR, RENÉ: Catalogue preface, Vieira da Silva Exhibition. Paris. Galerie Jeanne Bucher, November-December.

GINDERTAËL, ROGER VAN: "Vieira da Silva." Brussels. *Les Beaux-Arts.* December 2.

GUICHARD-MEILI, JEAN: "Dialogue avec le sensible." Paris. *Témoignage Chrétien.* December 2.

TAVARES RODRIGUES, URBANO: "Paris em fins de 1960. Notas sobre arte e sobre a Rua." Lourenço Marques. *Notícias.* December 4.

ANONYMOUS: "Les Arts, onde du Rêve. Vieira da Silva." Paris. *Figaro.* December 6.

DAHAN, BERNARD: "Les maîtres de la peinture: Vieira da Silva." Oran. *Echo-Soir.* December 9.

ANONYMOUS: "Vieira da Silva." Paris. *Combat.* December 10.

LASSAIGNE, JACQUES: "Vieira da Silva." New York. *Pensée Française,* No. 12, December.

TOULMAN, MOUSSIA: "Vieira da Silva." Paris. AMIF, No. 90, Year IX, December.

PINGAUD, BERNARD: "Parler avec les peintres." Aix-en-Provence. *L'Arc.* Spring.

ANONYMOUS: *Kunst und Naturform.* Basel. Basilius Press.

THWAITES, JOHN ANTONY: *Ich Hasse die moderne Kunst.* Frankfort. Ullsteid.

TARDIEU, JEAN: *De la peinture abstraite.* Lausanne. Mermod.

PONENTE, NELLO. *Peinture moderne: Tendances contemporaines.* Geneva. Skira.

LANGUI, EMILE. *50 ans d'Art Moderne.* Cologne. Dumont-Schauberg.

HAFTMANN, WERNER: *Painting in the Twentieth Century.* New York. Praeger. Munich. Prestel Verlag.

CHARBONNIER, GEORGES: *Monologue du peintre.* Paris. Juillard.

1961 FRANÇA, JOSÉ-AUGUSTO: "Presença de Vieira da Silva." São Paulo. *O Estado de São Paulo.* January 14.

BENOIT, P. A.: "Vieira da Silva." Paris. *Sens Plastique,* No. XXIII, January.

BOUDAILLE, GEORGES: "Les expositions à Paris. Vieira da Silva." Paris. *Cimaise,* No. 51, January-February.

WEELEN, GUY: "Vieira da Silva." Madrid. *Goya,* No. 40, January-February.

SOLIER, RENÉ DE: "Peinture et mouvement." Paris. N.R.F., No. 98, Gallimard, February.

ANONYMOUS: "Les Galeries: Vieira da Silva." Paris. *Jardin des Arts,* No. 75, February.

FRANÇA, JOSÉ-AUGUSTO: "Presença e Actualidade de Vieira da Silva." Lisbon. *Colóquio,* February.

JOOS, EGON A.: "Vieira da Silva, Gemälde in der Kunsthalle, Zusammen Klang von Einfühlung und abstraktion." Mannheim. *Allgemeine Zeitung.* March 27.

ANONYMOUS: "Romanischer Formsinn, Austellung Vieira da Silva in der Kunsthalle." Baden. *Badische Volkszeitung.* March 29.

DANNECKER, H.: "Malerische Durchdringung des Raumes: Geldbilder von Vieira da Silva in der Mannheimer Kunsthalle." Mannheim. *Mannheimer Morgen.* March 29.

W. ST.: "Poesie der Ungegens Rändlichkeit (Gemälde von Vieira da Silva in der Kunsthalle Mannheim)." Mannheim. *Rhein-Neckar Zeitung.* March 30.

MELLO BREYNER ANDERSEN, SOPHIA: "Vieira da Silva." Lisbon. *Almanaque,* March-April.

SCHMIDT, D.: "Vieira da Silva in der Mannheimer Kunsthalle." Frankfort. Frankfurter Allgemeine Zeitung. April 5.

U.S.E.: "Maria Helena Vieira da Silva in der Stadtischen Kunsthalle Mannheim." Stuttgart. *Stuttgarter Nachrichten.* April 7.

WEBER, W.: "Ihre Bilder Bannen der Raum, Die Portugiesin Vieira da Silva stellt in Mannheim aus." Sarrebrück. *Saarbrücker Zeitung.* April 7.

FRANÇA, JOSÉ-AUGUSTO: "Vieira da Silva." Paris. *Méditations,* No. 2, May.

WATT, ALEXANDRE: "Visages d'artistes: Vieira da Silva." London. *Studio,* No. 817, May.

CANADAY, JOHN: "Bienal Prize Goes to Vieira da Silva." New York. *New York Times.* September 14.

ANONYMOUS: "Bursting Bienal." New York. *Time* magazine, LXXVIII, No. 12. September 22.

BAROTTE, RENÉ: "Triomphe d'un grand peintre français: Vieira da Silva." Paris. *Paris-Presse l'Intransigeant.* September 26.

RAGON, MICHEL: "Lauréates de la Biennale de São Paulo: Vieira da Silva et Penalba. Une double fascination magique." Paris. *Arts.* September 27.

CONIL-LACOSTE, MICHEL: "Dans l'atelier de Vieira da Silva, Grand Prix de la Biennale de São Paulo." Paris. *Le Monde.* September 29.

DRAGON, JEAN: "Vieira da Silva Grand Prix de la Biennale de São Paulo." Nice. *Nice-Matin.* October 5.

FRANÇA, JOSÉ-AUGUSTO: "Homenagen a Vieira da Silva." Lisbon. *Jornal de Letras e Artes.* October 11.

PINTO ALVES, CARLOS DE: "Pintura e Realidade." São Paulo. *Diário de São Paulo.* October 22.

WEELEN, GUY: Biographical notes for the exhibition catalogue. New York. Knoedler Gallery, October.

ROBERTS, COLETTE: "Vieira da Silva à New York." New York. *France-Amérique.* October 22.

THWAITES, JOHN ANTONY: *Deutsche Zeitung.* November 14.

GARRIC, DANIEL: "A São Paulo, cinquante pays, mille quatre cents peintres, cinquante mille œuvres: une automystification." Paris. *Le Figaro Littéraire.* November 25.

VALLIER, DORA: *Gravures de Vieira da Silva pour "L'Inclémence Lointaine,"* poèmes de René Char. Paris. Art de France, No. 1. P. Berès.

CHAR, RENÉ: "Neuf Merci pour Vieira da Silva." Paris. *L'Inclémence Lointaine.* P. Berès.

DIEHL, GASTON: *La peinture moderne dans le monde.* Paris. Flammarion.

DORIVAL, BERNARD: *Ecole de Paris au Musée d'Art Moderne.* Paris. Somogy.

LACERDA, ALBERTO DE: *Homenagem a Maria Helena Vieira da Silva.* "Palacio" Poems. Lisbon. Delfos.

READ, HERBERT: *Histoire de la peinture.* Paris. Somogy.

RICARD-SAVANNE: *Les femmes célèbres,* Vol. II. Paris. Mazenod.

1962 SELLÉS PAES: "Nem com penas...nem sem elas." Lisbon. *Diário de Notícias.* January 4.

BERGER, RENÉ: "Vieira da Silva et l'intuition de l'espace." Paris. *XXᵉ Siècle.* Nouvelle série, No. 19, February.

MONNIER, JACQUES: "Vieira da Silva (notes)." Lausanne. *Pour l'Art,* No. 83, March-April.

BONNEFOI, GENEVIÈVE: "Petite musique pour Vieira da Silva." Lausanne. *Pour l'Art,* No. 83, March-April.

CESARINY, MÁRIO: "Da Pintora de Vieira da Silva" (with comparative translation of the poem "Les Ponts" by Rimbaud). Lisbon. *Letras e Artes,* July.

DO CANTO, VIOLANTE: "Encontro com Vieira da Silva." Lisbon. *Tavola Redonda,* No. 15, July.

MICHENER, JAMES A.: "The Prize in Painting." Zürich. *Art International,* Year VI, No. 10. December 20.

KOCHNITZKY, LEON: "Maria Helena Vieira da Silva." Brussels. *Quadrum,* No. 12.

SEUPHOR, MICHEL: *Peinture abstraite, sa genèse, son expansion.* Paris. Flammarion.

BERL, EMMANUEL: *Cent ans d'histoire de France.* Paris. Arthaud.

1963 WEELEN, GUY: "A Pintura de Vieira da Silva." Lisbon. *Letras e Artes.* January 2.

ANONYMOUS: "Notulas de Comentário a Vieira da Silva." Azores, Portugal. *Diário Insular.* January 17.

GONÇALVES, R. M.: "Vieira da Silva." Lisbon. *Jornal de Letras e Artes.* March 6.

WEELEN, GUY: *Vieira da Silva: Serigraphs, Lithographs, Engravings.* Preface, catalogue for the exhibition at the Bezalel National Museum, Jerusalem, March-April.

PERNES, F.: "Gravuras de Vieira da Silva." Lisbon. *Colóquio,* No. 23, April.

RAGON, MICHEL: "Les Miroirs de l'âme." Paris. *Arts.* June 5.

BOUDAILLE, GEORGES: "Les Temperas de Vieira da Silva: Les sons et les couleurs prisonniers d'une structure." Paris. *Les Lettres Françaises.* June 6.

Le Piéton de Paris: "New York, Mamie." *France Observateur.* June 6.

BAROTTE, RENÉ: "Technique secrète de Vieira da Silva." *Paris-Presse l'Intransigeant.* June 8.

CONIL-LACOSTE, MICHEL: "Vieira da Silva à la Tempera." Paris. *Le Monde.* June 14.

ELGAR, FRANK: "Les expositions: Vieira da Silva." Paris. *Carrefour.* June 19.

CHABRUN, JEAN-FRANÇOIS: "Vieira da Silva, aider à vivre, aider à voir." Paris. *L'Express.* June 20.

GINDERTAËL, ROGER VAN: "A la Galerie Jeanne Bucher, les grandes Temperas de Vieira da Silva." Brussels. *Les Beaux-Arts.* June 21.

REY, JEAN-DOMINIQUE: "Les expositions: Vieira da Silva." Paris. *Jardin des Arts,* No. 15, June.

VALLIER, DORA: "Vieira da Silva." *Chefs d'œuvre de l'art,* No. 15, June.

DAMASE, JACQUES: "Vieira da Silva et les barricades mystérieuses." Paris. *Maison et Jardin,* No. 94, June.

TAVARES RODRIGUES, URBANO: *Dos frescos da Tassili a Vassily Kandinsky e a Vieira da Silva. De Florença a Nova Iorque.* Lisbon.

FRANÇA, JOSÉ-AUGUSTO: "Retrato de Vieira da Silva." *O Estado de São Paulo.* June 29.

COGNIAT, RAYMOND: "Les mondes suggérés." Paris. *Le Figaro.* July 4.

FRANÇA, JOSÉ-AUGUSTO: "Retrato de Vieira da Silva." *O Comercio do Porto.* July 9.

FRANCILLON, CLARISSE: "Rencontre avec Vieira da Silva." Lausanne. *Gazette de Lausanne.* August 3.

CASTILHO, GUILHERME DE: "A Linha da amizada na pintura de Vieira da Silva." Lisbon. *Artes e Letras,* No. 97, August.

BONNEFOI, GENEVIÈVE: "Les miroirs brouillés de Vieira da Silva." Paris. *Les Lettres Nouvelles.* Nouvelle série, No. 39, October.

GETLEIN, FRANK: "Fashions in Art Are Mixed Blessings." Washington, D.C. *The Sunday Star.* December 1.

BERGER, RENÉ: *Connaissance de la peinture.* Lausanne. Centre National des Arts. Vol. VII (Espace, Perspective, Vision). Novorop.

1964 BRAUN, ARMAND D.: "Vieira da Silva: Le propos d'une exposition." Strasbourg. *Le Pavé,* January.

ANONYMOUS: Adresse: Vieira da Silva Bauernhaus Irgendiwo. Film und Frau. Hamburg. *Architektur und Kultiviertes Wohnen,* No. 8, January.

TOULMAN, MOUSSIA: "Arts et Couleurs, Femmes peintres: Vieira da Silva." Paris. *AMIF,* XIII, No. 122, February.

LEM, F. H.: "Vieira da Silva l'Enchanteresse." Paris. *Défense de l'Occident,* Year XII, new series, No. 39, March.

FRANÇA, JOSÉ-AUGUSTO: "Portrait de Vieira da Silva." Paris. *Aujourd'hui, Art et Architecture,* No. 45, March.

P. H. L.: "La peinture, ça se découvre lentement, nous confie Vieira da Silva." Lausanne. *Feuille d'Avis de Lausanne.* April 26.

BRUMAGNE, M. M.: "Le peintre Vieira da Silva expose ses œuvres à la Galerie Pauli." *Tribune de Lausanne.* May 3.

GRAZ, LIESL: "Around the Galleries: Portuguese Abstracts." Geneva. *Weekly Tribune,* Vol. 7, No. 18. May 8.

KUENZI, ANDRÉ: "Vieira da Silva." Lausanne. *Gazette de Lausanne.* May 9, 10.

MONNIER, JACQUES: "Vieira da Silva." Lausanne. *Nouvelle Revue.* May 15.

DE ASIS VILLELA, NETO: "Vieira da Silva a simplicidade das cosas consumadas." São Paulo. *Diário de São Paulo.* May 16.

P. H. L.: "A travers les expositions: Vieira da Silva ou les mystères de l'inexprimable." *Feuille d'Avis de Lausanne.* May 21.

LOEWER: "Vieira da Silva: Géométrie et Sortilège." La-Chaux-de-Fonds. *L'Impérial.* May 21.

ANONYMOUS: "Vieira da Silva au Musée de Grenoble: La révélation d'une peinture capitale." Lyons. *Le Progrès.* June 26.

GALI, CHRISTIAN: "Un événement: la rétrospective de Vieira da Silva au Musée de Grenoble. Un peintre qui domine toutes les écoles et oriente l'avenir." Lyons. *Le Progrès.* July 4.

REY, JEAN-DOMINIQUE: "Que voir cet été dans les Musées de province." Paris. *Jardin des Arts,* No. 116, July-August.

LASSAIGNE, JACQUES: Catalogue preface, Vieira da Silva retrospective exhibition. Musée de Peinture et de Sculpture, Grenoble. Published in *Les Lettres françaises,* August 6-19.

DÉROUDILLE, R.: "Huis-clos de Vieira da Silva au Musée de Grenoble." Grenoble. *Le Dauphiné Libéré.* August 23.

RAGON, MICHEL: "Vieira da Silva." Paris. *Jardin des Arts,* No. 118, September.

CARLUCCIO, LUIGI: Catalogue preface, Vieira da Silva retrospective. Turin, Museo Civico, Galleria d'Arte Moderna di Torino, October-November.

CARLUCCIO, LUIGI: "I labirinti di Vieira da Silva." Turin. *Gazzetta del Popolo.* October 27.

DRAGONE, ANGELO: "Mostre d'arte: Vieira da Silva alla Galleria Moderna." Turin. October 29.

PEROCCO, GUIDO: "La fanatica prospettiva rivive in Vieira da Silva." Venice. *Il Gazzettino Venezia.* November 11.

VALESCHI, MARCO: "Esemplarità di Torino." Milan. *Tempo,* XXVI, No. 47. November 18.

LACERDA, ALBERTO DE: "Notas para un retrato." Lisbon. *Diário Popular.* November 26.

MELLO MREYNER ANDERSEN, SOPHIA: "Um 'falar visivel'." Lisbon. *Diário Popular.* November 26.

RUBEN, A.: "O Mundo imenso ela abri pela cor." Lisbon. *Diário Popular.* November 26.

SIMÕES, JOÃO GASPAR: "Una sensibilidade artistica genuinamente portuguesa." Lisbon. *Diário Popular.* November 26.

SIMÕES, JOÃO GASPAR: " 'E natural que a poesia me tivesse formado o espirito'." Lisbon. *Diário Popular.* November 26.

VENTUROLI, MARCELLO: "Vieira da Silva a Torino." Rome. *Le Ore.* November 26.

MENDES, MURILO: "Maria Helena Vieira da Silva da Antologica Poetica' do Circulo de Poesia." Lisbon. November 26.

SELLÉS, PAES: "Francis Smith e Vieira da Silva." *Diário da Manhã.* December 17.

KARLEN, ANNE-MARIE: *Miroir et Mémoire du premier Salon International des Galeries Pilotes.* Lausanne. Musée Cantonal des Beaux-Arts.

GALI, CHRISTIAN: "Vieira da Silva, Musée de Grenoble. Parenté avec René Char." Grenoble. *Parler.* Summer.

PASONI, ALDO: "Vieira da Silva." Turin. *Augusta Taurinorum,* IV, 4th trimester.

WEELEN, GUY: *Vieira da Silva.* Paris. Les peintres contemporains. Mazenod.

SCHMIDT, GEORG: *Musée des Beaux-Arts.* Basel. (150 paintings, 12th-20th century.) Baloise-Holding.

MONNIER, JACQUES: *Visées.* Lausanne. Spès.

MENDES, MURILO: *Antologia Poetica.* Lisbon. Livraria Morais.

FRANÇA, JOSÉ-AUGUSTO: "Vieira da Silva." *Dicionário da Pintura Universal,* Vol. II. Lisbon. Estudios Cor.

ANONYMOUS: *International Directory of Contemporary Art.* Milan. Metro.

1965 LOURENÇO, EDUARDO: "Itinerário de Vieira da Silva ou da poesia como Espaço." Lisbon. *O Tempo e o Modo,* February.

HOLMBOEBANG, ERNA: "Mennkesket er Blit en slags." Copenhagen. *Kuantited Morgenbladet.* June 27.

LEVÊQUE, JEAN-JACQUES: "La maison parisienne de Vieira da Silva et Arpad Szenes, deux ateliers et une salle de séjour aménagés avec tendresse." Paris. *Galerie des Arts,* July-September.

ANONYMOUS: "O Mundo essencial de Vieira da Silva." São Paulo. Semana Portuguesa São Paulo. August 28.

SCHNEIDER, PIERRE: "Au Louvre avec Vieira da Silva." *Preuves,* No. 175, September.

KUENY, GABRIELLE: "Exposition d'été, 1964, Vieira da Silva." Grenoble. *Bulletin du Musée de Grenoble,* No. 1, October.

GOLDAINE, LOUIS and ASTIER, PIERRE: *Ces peintres vous parlent.* Coll. l'Oeil du Temps. Du Temps.

1966 ROBERTS, COLETTE: "Vieira da Silva." New York. *France-Amérique.* March 31.

RUSSELL, JOHN: "An Artist in the Family: Vieira da Silva." New York. *Art in America,* April-May.

ANONYMOUS: "Les meilleurs peintres vivants classés d'après les préférences d'un Panel de Connaisseurs." Paris. *Connaissance des Arts,* June.

GARNIER, FRANÇOIS: "La vie d'artiste qu'est ce que c'est? Dix femmes répondent." Paris. *Antoinette,* August.

MIÈGE, DENISE and LEVÊQUE, JEAN-JACQUES: "Trois questions clefs pour tester la santé de l'art actuel." Paris. *Beaux-Arts,* September.

ANONYMOUS: "Gloria Portuguesa, a Maria Helena Vieira da Silva, a França atribuiu, ihe grande Prémio Nacional das Artes." Lisbon. *O Seculo.* November 30.

COGNIAT, RAYMOND: "Vieira da Silva et le grand Prix National des Arts." Paris. *Le Figaro.* December 1.

LEVÊQUE, JEAN-JACQUES: "Prix National des Arts: Vieira da Silva." Paris. *Arts et Loisirs.* December 7.

MAZARS, PIERRE: "De toutes les couleurs. Triomphe de DADA. Vieira da Silva Prix National des Arts." Paris. *Le Figaro Littéraire.* December 8.

WEELEN, GUY: "Marie Hélène Vieira da Silva: Prix National des Arts." Paris. *Les Lettres Françaises.* December 8. Translation for *Seara Nova,* No. 1455. Lisbon, January 1967.

DIONÍSIO, MÁRIO: "Lopes Graça et Vieira da Silva." Vida Literaria e Artistica. Suplemento Semanal, No. 436. Lisbon. *Diário de Lisboa.* December 8.

MARQUES, ALFREDO: "O portuguesismo de Vieira da Silva." Lisbon. *Diário Popular.* December 15.

1967 FRANÇA, JOSÉ-AUGUSTO: "Vieira da Silva conversando." Lisbon. *Diário de Lisboa.* January 11.

ALVARO, EGIDIO: "Vieira da Silva: Artistas — Escândalo — Consciências." Lisbon. *Artes e Letras,* XII, No. 626. *Diário de Notícias.* March 2.

WEELEN, GUY: "L'Univers mystérieux de Vieira da Silva." Paris. *La Nouvelle Critique,* No. 7 (188), new series, October.

CONIL-LACOSTE, MICHEL: "Le Mûrissoir de Vieira da Silva." Paris. *Le Monde.* November 17. Translation published Lisbon, supplement of *Diário de Lisboa,* No. 486. November 23.

DUPARC, CHRISTIANE: "L'Ombre de Klee." *Nouvel Observateur.* November 22-28.

BOUDAILLE, GEORGES: "Vieira da Silva: Fascination de l'espace." Paris. *Les Lettres Françaises,* No. 1210. November 29-December 5.

HAHN, OTTO: "Vieira da Silva sort de Purgatoire." Paris. *L'Express.* December 4-10.

BAROTTE, RENÉ: "Le jour où une araignée collabora avec Vieira da Silva." Paris. *Paris-Presse l'Intransigeant.* December 12.

LEVÊQUE, JEAN-JACQUES: "Vieira da Silva ou l'œil de mouche." Paris. *Galerie des Arts,* No. 48, November.

BONNEFOI, GENEVIÈVE: "En Gros Plan, ce mois: Vieira da Silva explore patiemment espace et temps." Paris. *Connaissance des Arts,* December.

GUNTHER, OTTO: *Maria Helena Vieira da Silva: Le métro aérien.* Brunswick. Georg Westermann Verlag.

PICON, GAETON: Catalogue preface, Vieira da Silva exhibition. Paris. Galerie Jeanne Bucher. November 1967-January 1968.

VALLIER, DORA: *L'Art abstrait.* Paris. Le Livre de Poche.

1968 GLENY, CHRISTINE: "Kunst-Brief in den Galerien von Paris." Stuttgart. *Christ und Welt.* January 5.

TOULMAN, MOUSSIA: "Vieira da Silva." Paris. *AMIF,* January.

PÓMAR, JULIO: "Vieira da Silva, ou a maturidade." *Colóquio,* No. 47, January.

GUICHARD-MEILI, JEAN: "Vieira da Silva." Paris. *Art et Création,* No. 1, January-February.

DUBREUIL, EUGÉNIE: "Deux grandes dames de la peinture." Paris. *Droit et liberté,* No. 270, February.

TRUAN, FRANÇOIS: "Vieira da Silva ou la désobéissance." Geneva. *Supplément de la Tribune de Géneve.* March 6.

RIJKE, WILHELMA DE: "Da Silva, Sense of Infinite Space." Montreal. *The Montreal Star.* March 23.

ALCORTA, GLORIA: "Encuentro con Vieira da Silva." Buenos Aires. *La Prensa.* May 26.

SELLÉS PAES: "Pintura de Mulheres." Lisbon. *Revista T.V.* September.

DAHAN, BERNARD: "Vie Culturelle Arts." Paris. *Tendances,* No. 56, December.

LIMA DE FREITAS: "La grande Pintora, Vieira da Silva." Lisbon. *Eva,* No. 1153. Christmas number.

1969 SUARÈS, GUY: "Vieira da Silva ou le Philtre d'Amour." Catalogue preface, Vieira da Silva exhibition. Tours. Comédie de la Loire. February.

GUEDES, FERNANDO: "Galeria Fundação." Lisbon. *Colóquio,* No. 53, April.

BRONZE, FRANCISCO: "Pintores Portugueses na Galeria Gulbenkian." Lisbon. *Vida Mundial.* May 2.

AZEVEDO, MANUELA DE: "Vinte e seis obras de pintura de Columbano à Vieira da Silva." Lisbon. *Diário de Notícias.* June 15.

LEVÊQUE, JEAN-JACQUES: "Vieira da Silva, une nouvelle approche de la réalité." Paris. *Galerie des Arts.* September 15.

CUTLER, CAROL: "Art in Paris: Vieira da Silva in Retrospective." Paris. *Herald Tribune.* September 20.

HAHN, OTTO: "Vieira da Silva à fleur de peau." Paris. *L'Express,* No. 950. September 22.

BAROTTE, RENÉ: "Maria Helena Vieira da Silva peintre de la ville future." Paris. *Paris-Presse l'Intransigeant.* September 23.

FREUND, ANDREAS: "Vieira da Silva Works on View at Paris Modern Art Museum." *The New York Times.* September 25.

WARNOD, JEANINE: "L'invitation au voyage de Vieira da Silva." Paris. *Le Figaro.* September 26.

COGNIAT, RAYMOND: "Signes de notre temps." *Le Figaro.* September 26.

LEVÊQUE, JEAN-JACQUES: "Au Musée d'Art Moderne Vieira da Silva: Un nouveau langage." Paris. *Le Nouveau Journal.* September 27.

ANONYMOUS: "Vieira da Silva et Etienne Martin." Paris. *Zodiaque,* No. 81, August.

P. D.: "Vieira da Silva: La Lenteur." *Tribune de Lausanne.* September 28.

CRESPELLE, JEAN-PAUL: "Une Portugaise de Paris." Paris. *Journal du Dimanche.* September 28.

CABANNE, PIERRE: "Vieira da Silva Architecte de l'Espace." Paris. *Combat.* September 29.

DERVAL, JOËL: "D'un musée à l'autre." Paris. *Combat.* September 29.

FERMIGIER, ANDRÉ: "La poésie des Capitales." Paris. *Le Nouvel Observateur,* No. 255. September 29.

TARDIEU, JEAN: "Figures et non-figures." "Les Passerelles de Babylone," poem dedicated to Vieira da Silva. *N.R.F.,* No. 201, September.

SAUCET, JEAN: "Les lumières de Da Silva." Paris. *Les Grands Musées,* September.

LEYMARIE, JEAN: Catalogue introduction, Vieira da Silva retrospective exhibition. Paris. Musée National d'Art Moderne. September-November.

ESTEBAN, CLAUDE: "La Conscience et l'Etoilement." Catalogue preface, Vieira da Silva retrospective exhibition. Paris. Musée National d'Art Moderne. September-November.

BOUDAILLE, GEORGES: "Au Musée d'Art Moderne: L'Univers de Vieira da Silva." Paris. *Les Lettres Françaises,* October 1.

DITTIÈRE, MONIQUE: "Le Journal des Arts. Aux frontières 'de l'imaginaire Vieira da Silva." Paris. *L'Aurore.* October 1.

GASSIOT-TALABOT, GÉRALD: "Le Labyrinthe de Vieira da Silva." Paris. *Quinzaine Littéraire.* October 1.

ROLLIN, JEAN: "Au Musée National d'Art Moderne: A la rencontre de Vieira da Silva." Paris. *L'Humanité.* October 3.

ANONYMOUS: "Le mystère da Silva." *Gazette de Lausanne.* October 4.

VIDIL, J. L.: "Peinture élémentaire." *Réforme.* October 4.

MARX, CLAUDE-ROGER: "Vieira da Silva la Berthe Morisot du post-cubisme." Paris. *Le Figaro Littéraire.* October 6.

FRANCK, ANDREAS: "Entfaltung gemalter räumlicher energien: Vieira da Silva im Nationalmuseum moderner Kunst in Paris." Baden. *Badische Keuste Nachrichten.* October 6.

STROZENBERG, ARMANDO: "Arte-Vida. Sintese de Vieira da Silva." Rio de Janeiro. *Jornal do Brasil.* October 7.

ELGAR, FRANK: "Les architectures imaginaires de Vieira da Silva." Paris. *Carrefour.* October 8.

GUICHARD-MEILI, JEAN: "Vieira da Silva ou le vertige apprivoisé." Paris. *Témoignage Chrétien.* October 9.

ALVARO, EGIDIO: "Homenagem a Vieira da Silva." Lisbon. *Artes e Letras,* No. 765. October 9.

FOUCHET, MAX-POL: "90 Tableaux au Musée d'Art Moderne consacrent une femme peintre dont chaque toile raconte un rêve: Vieira da Silva." Paris. *Paris-Match,* No. 1066. October 11.

BAROTTE, RENÉ: "Vieira da Silva qui bâtit des villes de rêve." Bordeaux. *Sud-Ouest.* October 11.

GONÇALVES, R. M.: "Vieira da Silva." Lisbon. *A Capital.* October 15.

CONIL-LACOSTE, MICHEL: "L'Espace échafaudé de Vieira da Silva." Paris. Le *Monde.* October 16.

ANONYMOUS: "Un art, une ambiance." Paris. *Télé Médecine.* October 19.

FURHANGE, MAGUY: "Mystère, subtilité, poésie: Vieira da Silva." Nice. *Nice-Matin.* October 19.

BOUDAILLE, GEORGES: "Du Vietnam à La Hune." Paris. *Les Lettres Françaises.* October 22.

SAINT-AIGNAN, B.: "Les Expositions." Paris. *L'Amateur d'Art.* October 23.

BESSA LUIS, AGUSTINA: "O Passeante invisivel." Lisbon. *Diário Popular.* October 23.

COGNIAT, RAYMOND: "Illusions de Réalité." Paris. *Le Figaro.* October 23.

CLAIR, JEAN: "Vieira da Silva: Génèse et structure." Paris. *Gazette Médicale de France,* No. 26. October 25.

FRESTE, GÉRARD: "Maria Helena Vieira da Silva peint sans sujet et sans savoir où elle va, sinon à la gloire." Clermont-Ferrand. *La Montagne.* October 26.

FRIEDMANN, M. H. R.: "De l'humour aux labyrinthes des songes." Marseilles. *Le Méridional.* October 26.

BONNEFOI, GENEVIÈVE: "L'Espace et ses mirages." Paris. *Connaissance des Arts,* No. 212, October.

BAROTTE, RENÉ: "Au Musée National d'Art Moderne. Triomphe d'un grand peintre: Vieira da Silva." Paris. *Plaisir de France,* October.

GONÇALVES, R. M.: "Vieira da Silva, grande artista Portuguesa." Lisbon. *Turismo de Portugal,* October.

BUTOR, MICHEL: "RESSAC." Poem, catalogue preface, Vieira da Silva exhibition, "Les Irrésolutions résolues." Paris. Galerie Jeanne Bucher. October-November.

LEENHARDT, JACQUES: "Vieira da Silva ou la hantise des villes." Geneva. *Journal de Genève.* November 1.

MORNAND, PIERRE: "Vieira da Silva." Paris. *La Revue Moderne.* November 1.

"GENÊT": "Letter from Paris." New York. *The New Yorker.* November 1.

M. D.: "Vieira da Silva a nossa pintora universal de Paris." Oporto. *O Primeiro de Janeiro.* November 12.

BAROTTE, RENÉ: "Vieira da Silva bâtit des villes de rêves." Marseilles. *Provençal Dimanche.* November 16.

ENNESCH, CARMEN: "Musée d'Art Moderne, Vieira da Silva." Toulouse. *La Dépêche du Midi.* November 20.

SIMÕES, JOÃO GASPAR: "Em Paris com Vieira da Silva ao telefone." Oporto. *O Primeiro de Janeiro.* November 20.

SERS, PHILIPPE: "Vieira da Silva." *L'Art Vivant,* No. 5.

GAILLARD, FRANÇOISE: "Vieira da Silva au Musée d'Art Moderne." Paris. *Nouvelle Revue Pédagogique,* No. 3, November.

CHARMET, RAYMOND: "Les archives de l'art." Paris. *Archives Diplomatiques et Consulaires,* November.

LEM, F. H.: "Vieira da Silva Rétrospectives." Paris. *Défense de l'Occident,* November.

MEHU, ANNE-ROSE: "Vieira da Silva. Musée d'Art Moderne." Lyons. *L'Illustré Protestant,* November.

CONLON, BARNETT D.: "Report from Paris." New York. *Pictures on Exhibit,* November.

MARX, CLAUDE-ROGER: "Le mois à Paris — Arts. A la Royal Academy. Vieira da Silva au Musée d'Art Moderne." Paris. *Revue de Paris,* November.

TOULMAN, MOUSSIA: "Rétrospective de Vieira da Silva." Paris. *AMIF,* No. 180, November.

GUICHARD-MEILI, JEAN: "Vieira da Silva: Le un et l'infini." Paris. *Nouvelle Revue Française.* December 1.

ROCHA, NUNO: "Maria Helena Vieira da Silva: 'Para mim, viver é pintar.'" Lisbon. *Diário Popular.* December 5.

WELLING, DOLF: "Dynamisch zuimtevesef in Het werk van Vieira da Silva." Rotterdam. *Rotterdamsch Nieuwsblad.* December 30. Idem: in *Haugsche Courant.* Rotterdam, January 7, 1970.

SCHMIDT, BERTAS: "Geen logica maar intuïtie." Holland. *Het vrije volk.* December 31.

BAYARD, JEAN-PIERRE: "De l'absurde." *L'Ingénieur Constructeur,* December.

REY, JEAN-DOMINIQUE: "Vieira da Silva." *Jardin des Arts,* No. 81, December.

WEELEN, GUY: "Vieira da Silva ou les structures mouvantes et superposées." Paris. *La Revue du Louvre et des Musées de France,* 19th year, No. 45.

WEELEN, GUY: "Vieira da Silva: Silhouette." Paris. *Culture Française,* No. 3. Autumn.

GASSIOT-TALABOT, GÉRALD: "Paris." *Opus International,* Nos. 13-14.

BOUDAILLE, GEORGES: "Scrioare din Paris Expozitii: Vieira da Silva." Bucharest. *Arta,* No. 12.

RAGON, MICHEL: *Vingt-cinq ans d'art vivant.* Paris. Castermann.

LASSAIGNE, JACQUES: *Vieira da Silva. Pictori pe care i-am cunoscut.* Bucharest. Meridiane.

LASSAIGNE, JACQUES: *La nuova pittura a Parigi dopo il 1945.* L'Arte Moderna, No. 101, Vol. XII. Milan. Fratelli Fabbri.

PONTUAL, ROBERTO: *Dicionário das Artes Plásticas no Brasil.* Rio de Janeiro. Civilização Brasileira.

FUTERMAN: "Vieira da Silva." Paris. *Droit et liberté,* No. 288, December 1969-January 1970.

1970 PENDERS, W.: "Onbekende Vieira da Silva in Boymans." Holland. *Het Vaderland.* January 3.

DOELMAN, C.: "Vieira da Silva: Schildert met en Vliegnoog." Rotterdam. *Nieuwe Rotterdamsche Courant.* January 10.

LAAN, ADRI: "Vieira da Silva: Parijse school interugblik." Holland. *Dë Gelderlander.* January 13. Idem: *Arnhems Dagblad.* January 13.

BEEK, MARIUS VAN: "Spiegelpaleizen van Vieira da Silva." Holland. *De Tijd.* January 14.

LEERINK, HANS: "Maria Helena Vieira da Silva: Geboeid door het perspectivisch effect." Amsterdam. *Elsevier.* January 17.

CARDOSO, J. RAFAEL: "Vieira da Silva: Breve nota sobre 'Les irrésolutions résolues'." Lisbon. *Jornal do Comércio.* January 17-18.

GONÇALVES, R. M.: "Vieira da Silva: Grande artista portuguesa." Lisbon, *A voz.* January 29.

BOYER, PHILIPPE: "Pour un espace différent." Paris. *Esprit,* January.

BERIT, ODLAND: "En Samtale med Vieira da Silva." Oslo. *Aftenposten.* February 10.

CARDOSO, J. RAFAEL: "Breve apontamento sobre a pintura de Vieira da Silva." Lisbon. *República.* February 17.

ANONYMOUS: "Frankrikes Hoyestbetalte Malerine Stiller uti Oslo." Oslo. *Morgenposten.* February 24.

ANONYMOUS: "34 ar med Vieira da Silva." Oslo. *V.G.* February 25.

ANONYMOUS: "Vieira da Silva i Kunstnernes Hus." Oslo. *Morgenbladet.* February 25.

ANONYMOUS: "Ukens Gallerinde-Bred Vieira da Silva Monstring." Oslo. *Aftenposten.* February 26.

DRWESKI, ALICIA: "Paris, Musée d'Art Moderne: Vieira da Silva." London. *Art and Artists,* February.

GONÇALVES, ENRICO: "Exposição retrospectiva de Vieira da Silva." Funchal. *Comércio do Funchal,* February.

JOHSEN, SOREN STEEN: "Kunst og Kunstnere Vieira da Silva." Oslo. *Aftenposten.* March 4.

MICHELET, JOHAN FR.: "Et nytt syn pa virkeligheten." Oslo. *V.G.* March 4.

DURBAN, ARNE: "Kjent Paris. Malerinne i Kunstnernes Hus." Oslo. *Morgenposten.* March 5.

PARMANN, OISTEN: "Vieira da Silva." Oslo. *Morgenbladet.* March 6.

KYLLINGSTADE, STALE: "Maria Helena Vieira da Silva i Kunstnernes hus." Oslo. *Nationen.* March 7.

CARDOSO, J. RAFAEL: "Vieira da Silva." Lisbon. *Semana Médica.* March 8.

BEIRES, J. SARMENTO DE: "No Morro de Santa Teresa." Lisbon. *Diário Popular.* March 8.

BRUN, HANS-JAKOB: "Apenbaring." Oslo. *Dagbladet.* March 9.

WOLL, GERD: "Vieira da Silva i Kunstnernes Hus." Oslo. *Arbeiderbladet.* March 19.

ETH: "Transparente Räume. Vernissage in der Basler Kunsthalle." Basel. *National-Zeitung.* March 20.

J. E.: "Vieira da Silva in der Kunsthalle." Basel. *Basler Volksblatt.* March 20.

ANONYMOUS: "Vieira da Silva in der Kunsthalle." Basel. *Basler Nachrichten.* March 21.

J.E.: "Entwaffnen der Raster zur Ausstellung Vieira da Silva in der Kunsthalle." Basel. *Basler Volksblatt.* March 23.

F.W.R.: "Ausstellungen Vieira da Silva in der Kunsthalle." Basel. *Basler Woche.* March 24.

R. S.: "Verchachtelung des Räumes M. H. Vieira da Silva in der Kunsthalle." Basel. *Abend-Zeitung.* March 25.

ANONYMOUS: "Heiter sie die Kunst. Vieira da Silva in der Basler Kunsthalle." Basel. *Basler Nachrichten.* March 27.

E. M. L.: "Vieira da Silva der unischtbare Spazierganger." Wiesbaden. *Wiesbadener Kurier.* March 30.

SEELMANN EGGEBERT, ULRICH: "Das lebenswerk von Maria Helena Vieira da Silva in der Kunsthalle." Basel. *Kulturbericht aus Baden und der Pafalz.* April 19.

ANONYMOUS: "Pole Moderner Kunst: Vieira da Silva und Ipousteguy in der Basler Kunsthalle." Basel. *Aarganer Tagblatt.* April 19.

ANONYMOUS: "Vieira da Silva." Basel. *Die Tat.* April 19.

BRONZE, FRANCISCO, GONÇALVES, R. M., and PERNES, FERNANDO: "A nova crítica portuguesa e Vieira da Silva." Lisbon. *Colóquio,* No. 58, April.

LOURENÇO, EDUARDO: "Vieira da Silva uma poetisa do espaço." Lisbon. *Colóquio,* No. 58, April.

TAVARES, SALETTE: "A Semántica do abstracto em Vieira da Silva." Lisbon. *Colóquio,* No. 58, April.

FRANÇA, JOSÉ-AUGUSTO: "Vieira da Silva e a cultura portuguesa." Lisbon. *Colóquio,* No. 58, April.

GALY-CARLES, HENRY: "Vieira da Silva. Période de 1931-1951: Analyse, évolution." *Colóquio,* No. 58, April.

WEELEN, GUY: "Vieira da Silva et la peinture de l'après-guerre." Lisbon. *Colóquio,* No. 58, April.

SAMPAYO, NUNO: "Quatro livros sobre Vieira da Silva." Lisbon. *Colóquio,* No. 58, April.

CARDOSO, J. RAFAEL: "'Les Irrésolutions Résolues' uma notavel exposição de Vieira da Silva ao Manuel Cargaleiro." Portugal. *Almada,* April.

THOMMEN, ELSBETH: "Kunst und Kunstlichkeit: Die Ausstellungen Vieira da Silva und Ipousteguy in der Basler Kunsthalle." Basel. *National-Zeitung,* May 2-3.

R. M. P.: "Exposition Vieira da Silva à Bâle." Lausanne. *Feuille d'avis.* May 5.

H. K.: "Vieira da Silva und Ipousteguy." *Vaterland,* No. 109. May 13.

BUSCHKIEL, JURGEN: "Magische Räume: Vieira da Silva. Gemälde in der Kunsthalle Basel." Stuttgart. *Stuttgarter.* May 14.

I. S.: *Iszraelitisches Wochenblat.* Zürich. May 15.

ANONYMOUS: "Vieira da Silva." Lisbon. *Alleluia,* No. 197, May.

WEELEN, GUY: "Chez Vieira da Silva." *Jardin des Arts,* No. 186, May.

GRAN, H.: "Gjensyn med Vieira da Silva." Oslo. *Kunst-Kultur,* May.

CARDOSO, J. RAFAEL: "De Paris: Vieira da Silva apontamento breve para um perfil da artista." Lisbon. *República.* June 12.

ANONYMOUS: "Vieira da Silva a mais celebre mulher Pintora." Lisbon. *Flama,* No. 1163, June 19.

CONIL-LACOSTE, MICHEL: "Vieira da Silva um espaço povoado de andaimes." Lisbon. *Diário de Lisboa.* June 25.

MARQUES, ALFREDO: Uma grande lição de pintura: A retrospectiva de Vieira da Silva." Lisbon. *Diário Popular.* June 25.

REIS, JOSÉ: "O Mito de Vieira da Silva." Lisbon. *Diário da Manhã.* June 28.

ROCHA DE SOUSA, NUNO: "Vieira da Silva." Lisbon. *Notícias.* June 29.

CARDOSO, J. RAFAEL: "Da pintura de Vieira da Silva." *Jornal de Letras,* June.

JAEGER, JEAN-FRANÇOIS: "Vieira da Silva à Lisbonne." Lisbon. *Colóquio,* No. 59, June.

GUEDES, FERNANDO: "Anatomia de exposiçao Vieira da Silva na fundaçao Gulbenkian." Lisbon. *Colóquio,* No. 59, June.

OLIVEIRA, MÁRIO DE: "Coerência Pictórica de Vieira da Silva." Lisbon. *Artes e Letras,* No. 804. July 2.

GRADE, FERNANDO: "Em exposição na Fundação Gulbenkian: Vieira da Silva et a autra." Lisbon. *O Século Ilustrado,* No. 1696. July 4.

GONÇALVES, R. M.: "Vieira da Silva a grande Pintora a conquistou o público de Lisboa." Lisbon. *A Capital* (Sunday supplement). July 5.

SIMÕES, JOÃO GASPAR: "Preconceitos e cultura média." Lisbon. *Primeiro de Janeiro.* July 8.

OLIVEIRA, MÁRIO DE: "Vieira da Silva e o seu espaço." Lisbon. *Artes e Letras,* No. 805. July 9.

PINTO, JORGE: "Artes plásticas: Maria Helena Vieira da Silva." Lisbon. *República.* July 15.

PERNES, FERNANDO: "Vieira da Silva Pintora de Portugal e de Paris." Lisbon. *Vida Mundial,* No. 1623. July 17.

OLIVEIRA, MÁRIO DE: "Vieira da Silva e o seu sentimento cromático." Lisbon. *Diário de Notícias.* July 30.

A. C.: "Vieira da Silva." Lisbon. *Esfera.* August 6.

SASPORTES, JOSÉ: "Vieira da Silva fechada entre quatro paredes pelos críticos portugueses." Lisbon. *Diário Popular.* August 13.

CASTRO MEIRELES, R. DE: "Ainda Vieira da Silva." Lisbon. *Voz Portugalense.* August 15.

GONÇALVES, ENRICO: "Interrogação dos limites." Funchal (Portugal). *Comércio do Funchal.* August 16.

ROCHA DE SOUSA, NUNO: "Promoção da Arte Moderna?" Lisbon. *Diário de Lisboa.* August 20.

FRANÇA, JOSÉ-AUGUSTA: "Vieira da Silva a mesa redonda." Lisbon. *Diário de Lisboa.* August 20.

ROSA ARAUJO, MATILDE: "Os Rostros no Rio." Lisbon. *A Capital.* August 26.

SÁ, JOÃO DE: "Rescaldo de uma exposiçao memorável." Lisbon. *Notícias.* September 12.

MARQUES, ALFREDO: "Vieira da Silva compreendida em Portugal." Lisbon. *Diário Popular.* September 22.

I. R. A.: *Menina e Moça,* No. 261. Lisbon, September.

ANONYMOUS: "Vieira da Silva foi pintora em Portugal." Lisbon. *A Capital.* October 4.

SARDOEIRA, ILIDIO: "Sobre Vieira da Silva." Oporto. *Comércio do Porto.* October 10 and 27.

PERRUCHOT, HENRI: "Les femmes artistes." *Jardin des arts,* No. 191, October.

GONÇALVES, R. M.: "Vieira da Silva grande artista Portuguesa." Rio de Janeiro. *Turismo de Portugal,* October.

GONÇALVES, R. M.: "O Vieira da Silva." Lisbon. *A Capital.* December 31.

MARQUES, ALFREDO: "A Retrospectiva de Vieira da Silva foi a maior acontecimento artistico do Ano." Lisbon. *Diário Popular.* December 31.

SOLIER, RENÉ DE: "Vieira da Silva." Montreal (Canada). *Vie des Arts,* No. 57.

CHÂTELET, ALBERT: *Cent chefs-d'œuvre du Musée de Lille.* Musée de Lille.

LIMA MONTEIRO FREIRE THEMUDO, MARILIA ALDA DE: "Um mensagem da Pintora Vieira da Silva." *Revue Labor.*

1971 VALDEMAR, ANTONIO: "Lisboa na criação artistica de Vieira da Silva." Lisbon. *O Primeiro de Janeiro.* April 21.

SHIREY, DAVID: "Cuevas Displays His Mastery of Line." New York. *The New York Times.* May 8.

GUICHARD-MEILI, JEAN: "Poème pour Vieira da Silva." *Métamorphoses,* Nos. XV-XVI. O. Ibrahimoff. May.

C. Z. O.: "Gallery Previews in New York: Vieira da Silva." New York. *Pictures on Exhibit,* May-June.

REWALD, JOHN: "Vieira da Silva: Paintings 1967-1971." Catalogue preface, exhibition at the Knoedler Gallery, New York, May-June. Published in French, translation by Alice Rewald, exhibition catalogue, Galerie Artel, 1974.

DESMOULIEZ, GEORGES: Preface to exhibition catalogue: Vieira da Silva. Montpelier. Musée Fabre, July-September. Preface reprinted in *Midi-Libre,* Montpelier. "Au Musée Fabre à Montpellier. Vieira da Silva ou les enchantements d'une grande magicienne."

VERUNE, G.: "Le monde étrange et angoissé de Vieira da Silva." Montpelier. *Midi-Libre.* July 31.

A. R.: "Les peintures de Vieira da Silva un art mis au tombeau." Marseilles. *La Marseillaise.* August 3.

BECRIAUX, ROGER: "À Montpellier: Une double exposition de Vieira da Silva." *Le Monde.* August 25.

VALLIER, DORA: "La peinture de Vieira da Silva: Chemins d'approche." Paris. *N.R.F.,* August.

CHARMET, RAYMOND: "Les expositions: Vieira da Silva." Paris. *Le Nouveau Journal.* December 18.

BOUDAILLE, GEORGES: "Décembre à Paris." Paris. *Les Lettres Françaises.* December 22.

MARCHAND, SABINE: "Rue de Seine, au 53: Vieira da Silva." *Le Figaro.* December 30.

DESCARGUES, PIERRE: "Vieira da Silva à la Galerie Jeanne Bucher." Paris. *Plaisir de France,* December.

PERNES, FERNANDO: Catalogue preface, Vieira da Silva exhibition. Galeria Zen. Oporto (Portugal).

CESARINY, MÁRIO: 19 projectos de premio Aldonso Ortigão, seguidos de Poemas de Londres (Ode a outros e a Maria Helena Vieira da Silva). Lisbon. Quadrante. Coleção Poesia.

SCHNEIDER, PIERRE: *Louvre Dialogues.* New York. Atheneum.

ESCHAPASSE, MAURICE: "Vieira da Silva." *Grande Encyclopédie Larousse.* Paris.

1972 BARON, JEANINE: "Musées, Galeries, les Expositions: Vieira da Silva." *La Croix.* January 1.

BOSQUET, ALAIN: "Irremplaçable Vieira da Silva." Paris. *Combat.* January 17.

COGNIAT, RAYMOND: "Sur les chemins du succès." Paris. *Le Figaro.* January 24.

LEVÊQUE, JEAN-JACQUES: "Les fabuleux labyrinthes de Vieira da Silva." Paris. *La Galerie,* January.

COLLARD, JACQUES: "Vieira da Silva, 'première' bruxelloise." Brussels. *Pourquoi pas?,* No. 2778. February 24.

CASO, PAUL: "Vieira da Silva, quand le style et le cri sont simultanés." Brussels. *Le Soir.* March 15.

WEELEN, GUY: Preface to exhibition catalogue, *Œuvres Graphiques.* Galerie Michel Vokaer. Brussels. March-April.

SOLIER, RENÉ DE: "Vieira da Silva." *Art International,* Vol. XVI/4. Lugano (Switzerland), April.

BARON, JEANINE: "La peinture de Vieira da Silva: Chemins d'approche." *La Croix.* August 14.

CHATELET, ALBERT: Catalogue preface, Vieira da Silva exhibition. Colmar (France). Musée d'Unterlinden. June-October.

AYMART, J. M.: "Vieira da Silva" France. *La Nouvelle République.* November 7.

OLIVEIRA, MÁRIO DE: "3 Ensaios — Vieira da Silva e a sua Pintura." Braga (Portugal). Pax.

1973 SAINT-MICHEL, LÉONARD: "L'art et la vie: De Platon a Vieira da Silva." Bourges (France). *Le Berry Républicain.* March 3.

J. M.: "Peintures de Vieira da Silva au Musée Historique." Orleans. *République du Centre.* May 18.

PICTON, JOËL: "Vieira da Silva un mystère, au fond, très quotidien." Orleans. *République du Centre.* June 6.

MÉGRET, FRÉDÉRIC: "Vieira da Silva et son œil à facettes." Paris. *Le Figaro.* August 14.

TARDIEU, JEAN: *Les Portes de Toiles.* Paris. 1969. Gallimard. Translated by Ramos Rosa Antonio *Extra/A Capital.* Sexta Feira. November 23.

PUEL, GASTON: "L'aire des poussières." *Métamorphoses,* No. 21-22. O. Ibrahimoff.

1974 MARCHAND, SABINE: "Vieira da Silva: 'Un tableau n'est jamais terminé'." Paris. *Le Figaro.* April 23.

DÉROUDILLE, RENÉ: "Hommage à Vieira da Silva. Galerie Artel." Grenoble. *Le Dauphiné Libéré.* April 30.

BORD, DOMINIQUE: "Les expositions à Genève: La sombre passion de Vieira da Silva." Geneva. *Tribune de Genève.* May 1.

PEPPIAT, MICHAEL: "Art in Europe: Watching Evolution of Vieira da Silva." Paris. *International Herald Tribune.* May 7.

GRANVILLE, PIERRE: "Vieira da Silva sur les rives du Léman." Paris. *Le Monde.* May 9.

JAUNIN, FRANÇOISE: "A voir à la Galerie Artel à Genève: Vingt toiles de Vieira da Silva." Lausanne. *Tribune de Lausanne.* May 14.

PEPPIAT, MICHAEL: "Vieira da Silva." *Financial Times.* May 21.

SUARÈS, GUY: "Tribune critique: Vieira da Silva." Paris. *Le Quotidien de Paris.* June 4.

KOHLER, ARNOLD: "Vieira da Silva ou le dialogue: Formes et Couleurs." Basel. *Coopération.* June 6.

PARINAUD, ANDRÉ: "Vieira da Silva: 'Peindre, c'est marier le regard intérieur au regard extérieur'." Paris. *La Galerie,* June.

ANONYMOUS: "Vieira da Silva, Marie Hélène." Paris. *Les Muses.* Hachette.

1975 PLAZY, GILLES: "La nouvelle vie du Musée de Dijon." Paris. *Le Quotidien de Paris.* January 20.

SYDHOFF, BEATE: "RUM Av Ljus. Maria Helena Vieira da Silva. Franska Institutet." Stockholm. *Svenska Dagbladet.* February 1.

P. D.: "Liens du Regard. Galerie Jacob, 28 Rue Jacob. 6° jusqu'au 15 avril." Paris. *Le Pharmacien de France,* No. 6, March.

PARET, PIERRE: "Peinture: Les constructions d'Arpad Szenes et Vieira da Silva." Bordeaux. *Sud-Ouest.* March 24.

GRANATH, OLLE: "Storstäder och Stenubbar." Stockholm. *D. N.* June 2.

BOURNIQUEL, CAMILLE: Librairie du Mois: "J. Guichard-Meili. Récits Abrégés, dessins de Vieira da Silva." Paris. *Esprit,* June.

TERRASSE, ANTOINE: "Marie Hélène Vieira da Silva. *N.R.F.* Gallimard, No. 276, December.

LINNEBACH, GABY: "Das aktuelle interview aus Paris: Fünf Minuten mit Vieira da Silva." Germany. *Style,* 1st trimester.

MAILLARD, ROBERT: "Vieira da Silva." *Dictionnaire Universel de la Peinture.* Paris. Le Robert.

1976 MICHEL, JACQUES: "Florilège contemporain du Musée National d'Art Moderne." Paris. *Le Monde.* February 13.

DUNOYER, JEAN-MARIE: "Le creux de la vague." Paris. *Le Monde.* February 14.

PELY, ANNICK: "Le legs Szenes da Silva au Musée d'Art Moderne." Paris. *Le Quotidien de Paris.* February 23.

AGUILAR, NELSON: "Vieira da Silva no Brasil." Lisbon. *Colóquio,* No. 27, April.

PARINAUD, ANDRÉ: "L'Aventure de l'Art Moderne. Vieira da Silva et Arpad Szenes, un couple devant la création." Paris. *Galerie des Arts,* April.

LEVÊQUE, JEAN-JACQUES: "TILT. Peindre son Char." Paris. *Le Quotidien de Paris.* May 13.

LEVÊQUE, JEAN-JACQUES: "ART. Vieira da Silva: Sept portraits de René Char. Cette peinture qui vous regarde..." Paris. *Les Nouvelles Littéraires.* May 13.

MAZARS, PIERRE: "Arts. L'œil aux aguets. Les rayons de miel de Vieira da Silva." Paris. *Le Figaro.* May 22.

ELGAR, FRANK: "Naissances successives de Vieira da Silva." Paris. *Carrefour.* May 27.

DUNOYER, JEAN-MARIE: "Le poète parle." Paris. *Le Monde.* May 29.

SAMSON, SÉGOLÈNE: "Les portraits paysages de Vieira da Silva." Paris. *Info Artitudes,* May.

JAEGER, JEAN-FRANÇOIS: "Exposé pour un portrait successif." Paris. Catalogue preface, exhibition, Galerie Jeanne Bucher, May-June.

DUCHEIN, PIERRE: "Vieira da Silva, un vertigineux univers où l'œil se perd et se retrouve." Paris. *Le Pharmacien de France,* No. 13, June.

GUICHARD-MEILI, JEAN: "Borges, Vieira da Silva et le vertige de la Bibliothèque." Paris. *Bulletin de la Bibliothèque Nationale,* 1st year, No. 2, September.

TOWARNICKI, F. DE: L'Histoire d'un petit portrait." Paris. *Magazine Littéraire,* November.

GEORGEL, PIERRE: Introduction to catalogue, *Les Dessins d'Arpad Szenes et Vieira da Silva.* Musée National d'Art Moderne, Centre Pompidou, Paris.

VIATTE, GERMAIN: Preface to catalogue, *Les Dessins d'Arpad Szenes et Vieira da Silva.* Musée National d'Art Moderne, Centre Pompidou, Paris.

CHAR, RENÉ: *Vieira da Silva. Chère voisine multiple et une...* Album published in 99 copies. Paris.

LEMOINE, SERGE: Donation Granville, Vol. 2: *Œuvres realisées après 1900.* Dijon. Musée des Beaux-Arts.

ZANDER RUDENSTINE, ANGELICA: *The Guggenheim Museum Collection. Paintings 1880-1945,* Vol. II. New York. The Solomon R. Guggenheim Foundation.

VALLIER, DORA: *Repères. La peinture en France début et fin d'un système visuel 1870-1970.* Milan. Alfieri et Lacroix.

1977 ANONYMOUS: "Au Musée d'Etat et à la Galerie Kutter. Grandes Expositions Vieira da Silva." Luxemburg. *Luxembourg Wort.* January 26.

KANCK, JOSEPH: "Vieira da Silva au Musée de l'Etat et à la Galerie Kutter." Luxemburg. *Tageblatt.* January 26.

LASSAIGNE, JACQUES: "Voir la nuit." Introduction to catalogue of retrospective exhibition of tempera paintings, 1929-77. Musée d'Art Moderne de la Ville de Paris. February-April.

FAYE, JEAN-PIERRE: "Vieira da Silva et ses 'conséquences contradictoires'." Preface to catalogue of retrospective exhibition of tempera paintings, 1929-77. Musée d'Art Moderne de la Ville de Paris. February-April.

LEVÊQUE, JEAN-JACQUES: "Elle nous guide..." Catalogue of the retrospective exhibition of tempera paintings, 1929-77. Musée d'Art Moderne de la Ville de Paris. February-April.

LEVÊQUE, JEAN-JACQUES: "Vieira da Silva, la peinture qui tangue..." Paris. *Les Nouvelles Littéraires.* February 10.

PLAZY, GILLES: "Vieira entre deux mondes." Paris. *Le Quotidien de Paris.* February 14.

LEVÊQUE, JEAN-JACQUES: "Vieira da Silva: Une peinture prémonitoire." Paris. *Quotidien du Médecin.* February 15.

FOUCHET, MAX-POL: "Vieira da Silva." Paris. *Télérama.* February 16.

RENOUX, JACQUES: "Document de création: Vieira da Silva." *Télérama.* February 16.

ANONYMOUS: "Vieira da Silva: De Lisbonne au Musée d'Art Moderne." Marseilles. *Le Soir.* February 17.

MICHEL, JACQUES: "Les routes citadines de Vieira da Silva. Peinture pure sur papier." Paris. *Le Monde.* February 17.

ANONYMOUS: "Peinture à tempera (1929-1977): Vieira da Silva au Musée d'Art Moderne." Morlaix. *Le Télégramme de Brest et de l'Ouest.* February 19.

VOISIN, ANNE-MARIE: "T.V. Radio: Dans l'Intimité de Marie Hélène Vieira da Silva." Nantes. *Presse Océan.* February 19.

ANONYMOUS: "Dans l'intimité de Marie-Hélène Vieira da Silva. Document de création." Brussels. *Le Soir.* February 19.

SCHNEIDER, PIERRE: "Vieira da Silva sur papier." Paris. *L'Express.* February 21.

CRESPELLE, JEAN-PAUL: "Vieira da Silva: Un art d'évasion." Paris. *Le Journal du Dimanche.* February 27.

MARCHAND, SABINE: "Expositions: Vieira da Silva." Paris. *Le Point.* February 28.

OLIVER, GEORGINA: "Art: Talking the Beaubourg Inauguration Aftermath Blues." Paris. *The Paris Métro.* March 2.

DITTIÈRE, MONIQUE: "Arts: Au Musée d'Art Moderne de la Ville de Paris. Vieira da Silva — Hayden." Paris. *L'Aurore.* March 3.

HUSER, FRANCE: "Recettes et philtres d'amour. 'Je peins pour retrouver des secrets perdus,' disait Derain. 'Mon seul système est de ne pas en avoir,' répond Vieira da Silva." Paris. *Le Nouvel Observateur.* March 7.

MAZARS, PIERRE: "L'Oeil aux Aguets. Vieira da Silva: La conquête de l'espace." *Le Figaro.* March 8.

ELGAR, FRANK: "Vieira da Silva au Musée Municipal d'Art Moderne: La grande Dentellière." Paris. *Carrefour.* March 10.

BAROTTE, RENÉ: "Arts: Vieira da Silva. Ce maître de l'espace." Bordeaux. *Sud-Ouest.* March 13.

ANONYMOUS: "Vieira da Silva. Musée d'Art Moderne de la Ville de Paris." Paris. *La Vie du Rail.* March 13.

BOUCRAUT, T.: "Vieira da Silva: Peintures à tempera." Paris. *Les Cahiers de la Peinture.* March 16.

NOYER, O.: "Peinture: Vieira da Silva." Tours. *La Nouvelle République du Centre Ouest.* March 16.

NOËL, BERNARD: "Arts-Entretien: Le rayonnement chaleureux de Vieira da Silva." Paris. *La Quinzaine Littéraire.* March 16-31.

KOLTZ, JEAN-LUC: "Retrospective Vieira da Silva: Œuvres de 1931 à 1975." Luxemburg. *Letzeburger Land.* March 18.

CABANNE, PIERRE: "Vieira da Silva." Paris. *Elle.* March 21.

TENAND, SUZANNE: "Vieira da Silva: Ses peintures à tempera." Paris. *Tribune des Nations.* March 25.

SCHNEIDER, PIERRE: "One of the Best Living Painters." New York. *The New York Times.* March 30.

BAILLEUL, JEAN-CLAUDE: "Le monde magique de Vieira da Silva." Paris. *Medi Arts,* March.

ANONYMOUS: "Vieira da Silva." Paris. *L'Œil,* No. 260, March.

FRANÇA, JOSÉ-AUGUSTO: "Vieira da Silva em Paris." Lisbon. *Diário de Lisboa.* April 28.

CHARENSOL, GEORGES: "Les Beaux-Arts: Du Grand Palais au Musée d'Art Moderne." Paris. *Revue des Deux Mondes,* April 1977.

BESSA LUIS, MARIA AGUSTINA: Preface to exhibition catalogue of the Calouste Gulbenkian Foundation. Lisbon, May-June.

MELLO BREYNER ANDERSEN, SOPHIA: Poem, preface to catalogue of the Calouste Gulbenkian Foundation. Lisbon, May-June.

AGUILAR, NELSON: "Vieira da Silva: Exposição a la Fundação Gulbenkian." Lisbon. *Colóquio,* No. 33, June.

DUBY, GEORGES: "Vieira da Silva dans le mouvement de l'histoire." Paris. *XXᵉ Siècle,* No. 48, June.

VELAY, SERGE: Preface, Vieira da Silva exhibition of prints. Nîmes. La Galerie, September-October.

BERGEN, EMILE: "Vieira da Silva: Grapfisch weerk 1929-1976." Belgium. *Vooruit.* December 8.

CRESPELLE, JEAN-PAUL: "Le chant spirituel de Vieira da Silva." Paris. *Officiel du Prêt à Porter,* No. 632.

ANONYMOUS: "Ontem, na embaixada de Portugal em Paris. Conde-coração a Vieira da Silva foi a 'reparação de uma divida'." Lisbon. *Diário de Notícias.* November 29.

DIONISIO, MÁRIO: "Vieira da Silva." Lisbon. *Diário de Lisboa.* November 29.

GEORGEL, PIERRE: *100 œuvres nouvelles, 1974-1976.* Paris. Musée National d'Art Moderne, Centre National d'Art et de Culture Georges Pompidou.

MONOGRAPHS AND STUDIES

1949 DESCARGUES, PIERRE: *Vieira da Silva.* Paris. Les Presses Littéraires de France.

1956 SOLIER, RENÉ DE: *Vieira da Silva.* Paris. Le Musée de Poche, Georges Fall.

1958 FRANÇA, JOSÉ-AUGUSTO: *Vieira da Silva.* Lisbon. Artis.

1960 WEELEN, GUY: *Vieira da Silva.* Paris. F. Hazan.

1971 VALLIER, DORA: *Vieira da Silva.* Paris. Weber.

1973 WEELEN, GUY: *Vieira da Silva.* Paris. F. Hazan.

1977 WEELEN, GUY: *Vieira da Silva: Les Estampes.* Catalogue of the graphic work. Paris. A. M. G.

 TERRASSE, ANTOINE: *L'univers de Vieira da Silva.* Paris. Henry Screpel.

1978 LASSAIGNE, JACQUES and WEELEN, GUY: *Vieira da Silva.* Barcelona. Polígrafa. Paris. Editions Cercle d'Art.

LIST OF ILLUSTRATIONS

96. Women's bath in the Palacio de Comares. Alhambra of Granada.
97. Piazza del Campo. Siena.
98. Bocca della Verità. Church of Santa Maria in Cosmedin. Rome.
99. A bridge in Venice.
100. The Grand Canal in winter. Venice.
101. Above the fields, the church, the castle in ruins.
102. The Abbey of Saint-Lubin.
103. Through the glass door.
104. The forest of beams.
105. La Maréchalerie.
106. La Maréchalerie. The conversation.
107. Vieira. 1972.
108. La Maréchalerie. Through the window.
109. Vieira's studio. 1963.
110. La Maréchalerie. The stable transformed into a studio.
111. Sun, moon, front of chest with stars. Studio.
112. The Abbey of Saint-Lubin.
113. Lolita and Diogène.
114. Between house and studio, the garden. Paris.
115. Toward the garden.
116. Large fernery.
117. Brushes and pots.
118. Easels in the studio. Paris.
119. Niche with sculpture by Etienne Hadju.
120. Coptic tapestry.
121. Patchwork.
122. The library. Shelves with souvenirs of friends.
123. Above the desk.
124. The library.
125 and 126. Proposals for an ideal portrait. Cup in the form of an owl, Swiss workmanship — boxwood and vermeil (1561). Musée du Château Mouton-Rothschild, Pauillac, Gironde.
127. Painting. 1931-33. Oil on canvas, 69×24 cm. Collection Isabel de Almeida Simões and Francisco José Simões, Portugal.
128. The Cellist. 1930. Oil on paper glued on cardboard, 31×41 cm. Private collection, Paris.
129. The Cedar. 1932. Oil on canvas, 22×27 cm. Private collection, Paris.
130. Still Life with Books. 1931-32. Oil on canvas, 46×53 cm. Private collection, Paris.
131. Iron Gate (Villa des Camélias). 1931. Oil on canvas, 24×41 cm. Private collection, Paris.
132. La saisie. 1931. Oil on canvas, 16×27 cm. Private collection, Paris.
133. The Tree in Prison. 1932. Enamel paint on canvas, 41×33 cm. Private collection, Paris.
134. The Quay in Marseilles. 1931. Pastel on paper, 40×29 cm. Private collection, Paris.
135. The Swings. 1931. Oil on canvas, 130×54 cm. Private collection, Paris.
136. Villa des Camélias. 1932. Oil on canvas, 46×38 cm. Private collection, Paris.
137. The Transporter Bridge. 1931. Oil on canvas, 100×81 cm.
138. Composition. 1936. Oil on canvas, 146×106 cm. Private collection, Paris.
139. The Procession. 1934. Oil on canvas, 38×55 cm. Private collection, Paris.

140. Studio. Lisbon, 1934. Oil on canvas, 115×146 cm. Private collection, Paris.
141. The Flags. 1939. Oil on canvas, 80×140 cm. Kunstsammlung Nordrhein-Westfalen. Düsseldorf.
142. Composition (Lines). 1936. Oil on canvas, 73×92 cm. Private collection, Paris.
143. The Tiled Room. 1935. Oil on canvas, 60×92 cm. Collection J. Trevelyan, London.
144. Arpad Szenes: Marie Hélène 1. 1940. Oil on canvas, 81×100 cm. Lisbon. Musée d'Art Moderne de la Ville de Paris.
145. Portrait of Arpad. 1936. Oil on canvas, 100×82 cm. Musée d'Art Moderne de la Ville de Paris.
146. The Card Game. 1937. Oil on canvas, 73×92 cm. Galerie Jeanne Bucher, Paris.
147. La Scala (The Eyes). 1937. Oil on canvas, 60×92 cm. Galerie Jeanne Bucher, Paris.
148. Dance (Lozenges). 1938. Oil and wax on canvas, 49.5×150.5 cm. The Museum of Modern Art, New York. Mrs. Charles H. Russell Fund.
149. The Optical Machine. 1937. Oil on canvas, 64×53 cm. Private collection, Paris.
150. Rua da Esperança. Rio, 1941. Gouache on cardboard, 40.7×50.5 cm.
151. Blue Lisbon. Rio, 1941-42. Collage, gouache, and typewriter characters, 52×39 cm. Collection Helene Carlson, New York.
152. The Studio, Lisbon. 1940. Oil on canvas, 73×92 cm. Private collection, New York.
153. The Studio (detail).
154. The Métro. 1942. Gouache on cardboard, 48×97 cm. Private collection, Paris.
155. The Round Table. 1940. Oil on cardboard, 44×52 cm. Private collection, Paris.
156. The Disaster. 1942. Oil on canvas, 81×100 cm. Private collection, Paris.
157. The Disaster (detail).
158. The Disaster (detail).
159. The Chess Game. 1943. Oil on canvas, 81×100 cm. Musée National d'Art Moderne. Centre d'Art et de Culture Georges Pompidou, Paris.
160. The Liberation of Paris. 1944. Oil on canvas, 46×55 cm. Private collection, Paris.
161. Bahia Imagined. 1946. Tempera and oil, 92×73 cm. Private collection, Lisbon.
162. The Fire I. 1944. Oil on canvas, 81×100 cm. Private collection, Lisbon.
163. The Forest of Errors. 1941. Oil on canvas, 81×100 cm. Collection Marian Willard Johnson, New York.
164. Enigma. 1947. Oil on canvas, 90×116 cm. Private collection, Paris.
165. The Doors. Paris, 1947. Oil on canvas, 27×46 cm. Collection René Verdier, Villeneuve-sur-Lot.
166. Egypt. 1948. Oil on canvas, 60×73 cm. Private collection, Paris.
167. Endless Corridor. 1942-48. Oil on canvas, 81×100 cm. Collection Mrs. E. Sander, London.
168. Delft Tiles. 1948. Oil on wood, 73×92 cm. Private collection.
169. The Card Players. 1947-48. Oil on canvas, 80×100 cm. Collection M. and Mme Louis Franck, Neuilly.
170. The Battle of the Knives. 1948. Oil on canvas, 73×92 cm. Boymans-van Beuningen Museum, Rotterdam.
171. The Weavers. 1936-48. Oil on canvas, 97×146 cm. Private collection, Paris.

172. Rain. 1949. Oil on canvas, 62×92 cm. Private collection, Dusseldorf.

173. Normandy. 1949. Tempera on canvas, 41×46 cm. Galerie Jeanne Bucher, Paris.

174. Building Site. 1950. Oil on canvas, 81×100 cm. Galleria Civica d'Arte Moderna, Turin.

175. Interior. 1948. Oil on canvas, 24×27 cm. Private collection, Paris.

176. Voilà. 1949. Watercolor and typewriter characters on paper, 12.5×17 cm. Collection Collinet, Paris.

177. Carmo. Paris, 1949. Watercolor on paper mounted on cardboard, 24×19 cm. Private collection, Paris.

178. Untitled. 1949. Gouache on canvas, 45.5×38 cm. Private collection, Lisbon.

179. Painting. 1949. Oil on canvas, 65×80 cm. Private collection, Lisbon.

180. Composition (The Dream). 1949-50. Oil on canvas, 130×180 cm. Private collection, Lisbon.

181. The Angels' Watch. 1950. Oil on canvas, 60×92 cm. Private collection, Lisbon.

182. Manor in Sologne. 1949. Oil on canvas, 50×61 cm. Collection Collinet, Paris.

183. The Aviary. 1950. Oil on canvas, 81×116 cm. Collection G. Desmouliez, Montpelier.

184. Arenas. 1950. Watercolor on paper, 50×65 cm. Collection Collinet, Paris.

185. The Mirage. 1949. Watercolor and typewriter characters, 14×18.5 cm. Collection Marion Lefebre Burge, New York.

186. Checkmate. 1949-50. Oil on canvas, 89×116 cm. Private collection, Paris.

187. Library. 1949. Oil on canvas, 33×55 cm. Private collection, Lisbon.

188. Interior of a Room. 1949. Oil on canvas mounted on fiberboard, 28×36 cm. Private collection, Paris.

189. Untitled. 1950. Gouache on cardboard, 27.5×17 cm. Collection Mme Haas, Paris.

190. Music. 1950. Gouache on canvas, 50×37.5 cm. Collection Dr. C. Bouvier, Geneva.

191. Untitled. 1950. Watercolor on paper, 14.5×13 cm. Collection René Char, Paris.

192. Arraial. 1950. Gouache on paper, 37×48 cm. Private collection, Paris.

193. The Harvest. 1950. Oil on canvas, 96×130 cm. Private collection, Zürich.

194. Gothic Chapel. 1951. Oil on canvas, 65×81 cm. Collection Dr. C. F. Leuthardt, Basel.

195. The Invisible Walker. 1951. Oil on canvas, 132×168 cm. Museum of Art, San Francisco.

196. Gray Corot. 1950. Oil on canvas, 73×100 cm. Private collection, Lisbon.

197. Winter. 1951. 81×100 cm. Private collection, Lisbon.

198. The Towers. 1953. Oil on canvas, 162×130 cm. Musée de Peinture et Sculpture, Grenoble.

199. Paris at Night. 1951. Oil on canvas, 54×73 cm. Private collection, Paris.

200. Composition. 1951. Oil on canvas, 70×140.5 cm. Kunstmuseum, Basel.

201. Et puis voilà. 1951. Gouache on paper, 24×16 cm. Private collection, Lisbon.

202. Et puis voilà. 1951. Gouache on paper, 26×17 cm. Private collection, Lisbon.

203. Flags. 1952. Oil on canvas, 24×40 cm. Collection G. Desmouliez, Montpelier.

204. The Hotel Board. 1952. Tempera on plywood, 100×120 cm. Private collection, Lisbon. Part of the décor for Arthur Adamov's play La Parodie, Théâtre Lancry.

205. The Glass Towers. 1952. Oil on canvas, 60×73 cm. Private collection, Lisbon.

206. Urban Perspectives. 1952. Oil on canvas, 97×130 cm. Private collection, Lisbon.

207. Rua das Chagas. 1952. Gouache on cardboard, 42×31 cm. Private collection, Paris.

208. Battle of Reds and Blues. 1953. Oil on canvas, 130×162 cm. Private collection, Lisbon.

209. The Barrier. Paris, 1953. Oil on paper mounted on canvas, 73×100 cm. Private collection, Paris.

210. Bridges on the Thames. 1953(?). Oil on canvas, 46×55 cm. Private collection, Lisbon.

211. Australia. Paris, 1953. Gouache on paper, 28×37 cm. Private collection, Paris.

212. The Dike. 1953. Oil on canvas, 46×55 cm. Private collection, Paris.

213. Clair de lune. 1953. Gouache on paper, 36×46 cm. Private collection, Paris.

214. Biblioteca. 1953. Gouache on paper, 25×16 cm. Collection Sophia de Mello Breyner Andersen, Lisbon.

215. Rua. 1953. Gouache on cardboard, 39×31 cm. Private collection, Paris.

216. Gouache. 1953. Gouache on paper, 24×31 cm. Collection Dr. Manuel Vinhas, Estoril.

217. Untitled. 1953-54. Gouache and watercolor on paper, 36×43 cm. Collection M. and Mme C. Gourlet, Saint-Benin (France).

218. Sketch. 1953. Gouache on paper, 33×39 cm. Private collection, Paris.

219. Sketch. 1953. Gouache on paper, 32×39 cm. Private collection, Paris.

220. The Hanging City. 1952. Oil on canvas, 137×115 cm. Musée Cantonal des Beaux-Arts, Lausanne.

221. Et puis voilà. 1951. Gouache on paper, 22×17.5 cm.

222. The City. 1953. Oil on canvas, 73×92 cm. Private collection, Lisbon.

223. The Spider's Feast. 1953. Oil on canvas, 89×116 cm. Private collection, Lisbon.

224. Les pistes. 1953. Oil on canvas, 89×116 cm. Private collection, Lisbon.

225. White Composition. 1953. Oil on canvas, 97×130 cm. Kunstmuseum, Basel.

226. Brown and Black. 1954. Oil on canvas, 114×146 cm. Collection Mme Silvia von Vincenz, Basel.

227. The Flooded Dikes (Holland Landscape). 1954. Oil on canvas, 73×100 cm. Collection Marion Lefebre Burge, New York.

228. The cataclysm. 1954. Oil on canvas, 97×130 cm. Private collection, Lisbon.

229. Children's Games. 1954. Oil on canvas, 89×116 cm. Private collection, Lisbon.

230. Suspension Bridge. 1954. Oil on canvas, 46×55 cm. Private collection, Lisbon.

231. Painting. 1953-54. Oil on canvas, 89×116 cm. Private collection, Lisbon.

232. The Flooded Station. 1956. Oil on canvas, 114×146 cm. Private collection, Paris.

233. Blue Interior. 1954. Oil on canvas, 33×22 cm. Private collection, Lisbon.

234. Dark Composition. 1953. Oil on canvas, 73×92 cm. Private collection, Lisbon.

235. Rue de la Glacière. 1955. Oil on canvas, 73×116 cm. Private collection, Lisbon.

236. Vertical Landscape (Hanging Gardens). 1955. Oil on canvas, 162×130 cm. Musée National d'Art Moderne, Centre d'Art et de Culture Georges Pompidou, Paris.

237. University of Basel. A lecture by Karl Jaspers.

238. University of Basel. Tapestry, 518×342 cm.

239. University of Basel. Tapestry, 513×327 cm.

240. Grande Fugue. 1954. Oil on canvas, 81×130 cm. Städtische Kunsthalle, Mannheim.

241. Library. Paris, 1955. Oil on canvas, 100×50 cm. Fonds National d'Art Contemporain, Paris.

242. Elevated Subway. 1955. Oil on canvas, 160×220 cm. Kunstsammlungen Nordrhein-Westfalen, Dusseldorf.

243. The Burned City. 1955. Oil on canvas, 130×81 cm. Collection André Bernheim, Paris.

244. Csontvari. 1957. Oil on canvas, 81×100 cm. Collection M. and Mme Etienne Hadju, Bagneux.

245. The City. 1955. Oil on canvas, 73×116 cm. Private collection, Lausanne.

246. The Mine. Paris, 1956. Oil on canvas, 33×22 cm. Private collection, Paris.

247. Workers' Quarter. 1956. Oil on canvas, 80×80 cm. Private collection, Portugal.

248. Contrasts. 1956. Oil on canvas, 60×120 cm. Private collection, Lisbon.

249. The Library. 1955. Oil on canvas, 81×100 cm. Private collection, Paris.

250. Gare Montparnasse. 1957. Oil on canvas, 81×100 cm. Walker Art Center, Minneapolis.

251. Tempest. 1957. Oil on canvas, 81×130 cm. Private collection, Lisbon.

252. Large Constructions. 1956. Oil on canvas, 136×156 cm. Private collection, Paris.

253. Outlines of the Storm. 1956. Oil on canvas, 81×100 cm. Private collection, Geneva.

254. Knotted Landscape. 1957. Oil on canvas, 81×130 cm. Private collection, Lisbon.

255. The Martyred City. 1957. Oil on canvas, 115×138 cm. Private collection, Lisbon.

256. Future Urbanism. 1957. Oil on canvas, 27×41 cm. Private collection, Paris.

257. Sunset. 1957. Oil on canvas, 81×130 cm. Private collection, Lisbon.

258. The Gardens of Semiramis. 1958. Oil on canvas, 65×92 cm. Private collection, Lisbon.

259. Untitled. 1956-57. Tempera on paper, 67×67 cm. Private collection, Lisbon.

260. Old America. 1958. Oil on canvas, 33×22 cm. Private collection, Paris.

261. Collapsed Façades. 1957. Watercolor on paper, 68×56 cm. Private collection, Lisbon.

262. November. 1958. Oil on canvas, 114×146 cm. Private collection, Lisbon.

263. Canals in Holland. 1958. Oil on canvas, 137×114 cm. Private collection, Lisbon.

264. Periwinkle Blue. 1959. Oil on canvas, 81×100 cm. Collection M. and Mme P. Berés, Paris.

265. Fields of Sainte-Claire. 1958. Oil on canvas, 97×130 cm. Private collection, Lisbon.

266. Flanders. 1960. Oil on canvas, 147×162 cm. Cincinnati Art Museum. Cincinnati. Ohio.

267. London. 1959. Oil on canvas, 162×146 cm. Private collection, Paris.

268. Chalk. 1958. Tempera on paper, 71×70 cm. Private collection, Paris.

269. The Cascade. 1960. Oil on canvas, 81×100 cm. Collection René Char, Paris.

270. Summer. 1960. Oil on canvas, 81×100 cm. Musée National d'Art Moderne, Centre d'Art et de Culture Georges Pompidou, Paris.

271. The Lost Path. 1960. Oil on canvas, 81×100 cm. Private collection, New York.

272. The Cycle of the Seasons. 1960. Oil on canvas, 81×100 cm. Private collection, Paris.

273. The Hill. 1960. Tempera on paper, 67×67 cm. Private collection, Paris.

274. Glass and Steel. 1960. Oil on canvas, 116×73 cm. Collection Mrs. Beatrice Glass, New York.

275. Le Bal. 1960. Oil on canvas, 147×162 cm. Collection Mr. and Mrs. Edwin E. Hokin, Illinois.

276. Strong City. 1960. Oil on canvas, 162×146 cm. Private collection, Paris.

277. The Easels. 1960. Oil on canvas, 114×137 cm. The Phillips Collection, Washington, D. C.

278. The Bridge. 1954-60. Oil on canvas, 73×116 cm. Private collection, Lisbon.

279. Saint-Fargeau. 1961-65. Oil on canvas, 162×130 cm. Private collection, Lisbon.

280. Impossible Enterprise. 1961-67. Oil on canvas, 162×162 cm. Musée National d'Art Moderne, Centre d'Art et de Culture Georges Pompidou.

281. The Storm. 1961. Tempera on paper, 63×99 cm. Private collection, Paris.

282. The Sea. 1962. Tempera on paper, 50×66 cm. Collection Théodore Schempp, Paris.

283. Paris. 1961. Tempera on paper, 7.5×66 cm. Private collection, Paris.

284. The Golden City (The Illuminated Port). 1956. Oil on canvas, 81×100 cm. Musée des Beaux-Arts, Dijon. Donation Granville.

285. Nizhni Novgorod. 1961. Tempera on paper, 50×67 cm. Collection Théodore Schempp, Paris.

286. Painting. 1952. Oil on canvas, 27×16 cm. Private collection, Paris.

287. Oporto. 1962. Tempera on paper, 67×67 cm. Collection Banco Portugués do Atlantico, Oporto.

288. The Chessboard. 1962. Tempera on paper, 62×98 cm. Collection Dr. Jaeger, Paris.

289. Au fur et à mesure. 1963. Oil on canvas, 195×130 cm. Private collection, Lisbon.

290. The Rosebush. 1963. Tempera on paper, 97×62 cm. Private collection, Paris.

291. Dihedron. 1963. Oil on canvas and pasted papers. 195×130 cm. Private collection, Paris.

292. Kukan. Paris, 1963. Tempera on paper, 61×99.5 cm. Private collection, Paris.

293. The Collector's Room. 1964. Tempera on paper, 68×68 cm. Private collection, Lausanne.

294. Le martinet. 1964. Tempera on paper and pasted papers, 195×114 cm. Collection KM Corporation, Jamaica.

295. Stele. 1964. Tempera on canvas, 195×114 cm. Musée National d'Art Moderne, Centre d'Art et de Culture Georges Pompidou, Paris.

296. The House of Hercules. 1965. Oil on canvas, 81×100 cm. Private collection, Lisbon.

297. Nocturnal Interior. 1960-65. Oil on canvas, 114×146 cm. Private collection, Paris.

298. Parole II. Paris, 1965. Oil on canvas, 195×114 cm. Private collection, U. S. A.

299. Les Fruits d'Or. 1965. Oil on canvas, 60×73 cm. Collection Eugene McDermott, Dallas.

300. The Garden. 1960-65. Oil on canvas, 65×92 cm. Private collection, Lisbon.

301. Arno. 1966. Oil on paper mounted on canvas, 81×100 cm. Private collection, Paris.

302. The Attic. 1965. Oil on canvas, 24×19 cm. Private collection, Paris.

303. The Library. 1966. Oil on canvas, 130×97 cm. Private collection, Paris.

304. Contradictory Consequences. 1964-67. Oil on canvas, 195×97 cm. Private collection, Liège.

305. Equity. 1966. Oil on canvas, 97×195 cm. Private collection, Liège.

306. Rouen. 1966. Oil on canvas, 50×150 cm. Musée des Beaux-Arts, Rouen.

307. Rouen II. 1968. Oil on canvas, 27×41 cm. Musée des Beaux-Arts, Rouen.

308. Le marteau sans maître. 1967. India ink on paper, 19×11 cm. Collection René Char.

309. The Parlor. 1967. Oil on canvas, 22×27 cm. Collection Maria do Rosario Oliveira, Paris.

310. Contested Propositions. 1966. Oil on canvas, 73×116 cm. Musée d'Art Moderne de la Ville de Paris.

311. May 68. 1968. Oil on canvas, 195×97 cm. Private collection, Lisbon.

312. Memory. 1966-67. Oil on canvas, 114×146 cm. Galerie Jeanne Bucher, Paris.

313. Little Theater of Greenery. 1972. Tempera on paper, 50.5×67 cm. Galerie Jeanne Bucher, Paris.

314. Illégalité des enchaînements. 1968. Oil on canvas, 81×130 cm. Private collection, U.S.A.

315. Sleep. 1969. Oil on canvas, 93×130 cm. Private collection, Paris.

316. Le temps. 1969. Oil on canvas, 97×162 cm. Private collection, Lisbon.

317. Rome. 1969. Oil on canvas, 97×130 cm. Private collection, Lisbon.

318. Málaga. 1969. Oil on canvas, 97×130 cm. Private collection, Paris. Lausanne.

319. Les irrésolutions résolues XXVII. 1969. Charcoal on prepared canvas, 100×100 cm. Private collection, Paris.

320. Les irrésolutions résolues XXIX. 1969. Charcoal and tempera on Japan paper. 76.5×57 cm. Private collection, Paris.

321. From Mars to the Moon. 1969. Oil on canvas, 195×97 cm. Private collection, Lisbon.

322. New Amsterdam I. 1970. Oil on canvas, 195×97 cm. Private collection, Lisbon.

323. New Amsterdam II. 1970. Oil on canvas, 195×97 cm. Private collection, Lisbon.

324. Window on Courtyard. 1970. Oil on canvas, 65×81 cm. Private collection, Switzerland.

325. L'Evénement. 1962-73. Oil on canvas, 81×100 cm. Private collection, Switzerland.

326. The Echo. 1971. Oil on canvas, 97×130 cm. Private collection, Lisbon.

327. Musical Instrument. 1971. Oil on canvas, 162×130 cm. Private collection, Switzerland.

328. The Esplanade. 1967. Oil on canvas, 97×195 cm. Private collection, Lisbon.

329. Mul-ti-tude. 1972. Tempera on paper, 102×75 cm. Private collection, Paris.

330. Terre de basse nuit. 1970. Oil on canvas, 160×90 cm. Private collection, Lisbon.

331. Grass. 1973. Oil on canvas, 100×81 cm. Private collection, Switzerland.

332. Theater of Life. 1973-74. Oil on canvas, 100×81 cm. Private collection, Paris.

333. The Three Windows. 1972-73. Oil on canvas, 130×97 cm. Private collection, Switzerland.

334. The Square. 1973. Oil on canvas, 100×100 cm. Musée des Beaux-Arts, Rheims.

335. The Library. 1974. Oil on canvas, 130×97 cm. Galerie Jeanne Bucher, Paris.

336. "Irrésolutions résolues". 1969. Charcoal on canvas, 124.5×26 cm. Galerie Jeanne Bucher, Paris.

337. Freedom. 1973. Oil on paper mounted on canvas, 150×50 cm. Private collection, Paris.

338. Wedding. 1971. Tempera, 53×120 cm. Collection Galerie Alice Pauli.

339. Urbi et Orbi. 1963-72. Tempera and oil on canvas, 300×401 cm. Musée des Beaux-Arts, Dijon. Donation Granville.

340. Maze. 1975. Oil on canvas, 116×81 cm. Private collection, Paris.

341. The Thirteen Doors. 1972. Tempera on Chinese paper, 50×121 cm. Private collection, Paris.

342. Landscape of Ruum. 1973. Oil on paper mounted on canvas, 80×100 cm. Private collection, Switzerland.

343. The Black Indies. 1974. Oil on canvas, 60×120 cm. Private collection, Paris.

344. Baptistery I. 1974. Tempera on paper, 57.5×42 cm. Private collection, Paris.

345. Baptistery II. 1974. Tempera on paper, 65×51 cm. Private collection, Paris.

346. Baptistery III. 1974. Tempera on paper, 63×54 cm. Private collection, Paris.

347. Composition in Three Parts. 1976. Tempera on paper, 81×57 cm. Private collection, Paris.

348. The Good Neighborhoods. 1973. Tempera on Chinese paper, 57.5×121 cm.

349. Portioned Hillock. 1974. Oil on canvas, 100×81 cm. Private collection, Switzerland.

350. Allégresse. 1976. Tempera on paper, 57×121 cm. Private collection, Paris.

351. Tempera. 1977. Tempera on Kraft paper, 152×52 cm. Private collection, Paris.

352 to 354. Designs for the south chapel of the church of Saint-Jacques, Rheims.

355. Rheims. Church of Saint-Jacques. East chapel. Apse.

356. Rheims. Church of Saint-Jacques. West chapel. Apse.

357. Rheims. Church of Saint-Jacques. North chapel. Right window (no. 11).

358. Rheims. Church of Saint-Jacques. North chapel. West apse.

359. Rheims. Church of Saint-Jacques. North chapel (detail).

360. Rheims. Church of Saint-Jacques. South chapel (detail).

361. Rheims. Church of Saint-Jacques. South chapel (detail).

MUSEUMS AND INSTITUTIONS
POSSESSING WORKS
BY VIEIRA DA SILVA

BRAZIL
Museu de Arte Moderna, Rio de Janeiro
Museu de Arte Moderna, São Paulo

DENMARK
Royal Museum of Fine Arts, Copenhagen

FINLAND
Art Museum of the Atheneum, Helsinki

FRANCE
Musée National d'Art Moderne, Centre d'Art et de Culture Georges
Pompidou, Paris
Musée de Peinture et Sculpture, Grenoble
Musée Saint-Pierre, Lyons
Musée des Beaux-Arts, Rouen
Fonds National d'Art Contemporain, Paris
Musée d'Art Moderne de la Ville de Paris
Musée Cantini, Marseilles
Manufactures des Gobelins, Paris
Musée des Beaux-Arts, Rheims
Musée d'Unterlinden, Colmar
Société d'Art Contemporain, Dunkirk
Musées de Metz, Metz
Musée des Beaux-Arts, Dijon (Donation Granville)
Musée des Beaux-Arts, Lille

FEDERAL REPUBLIC OF GERMANY
Kunstsammlung Nordrhein-Westfalen, Düsseldorf
Museum Folkwang, Essen
Wallraf-Richartz Museum, Cologne
Wurtembergisches Staatsgalerie, Stuttgart
Niedersächsisches Landesmuseum, Hanover
Städtische Kunsthalle, Mannheim

GREAT BRITAIN
The Tate Gallery, London
Victoria and Albert Museum, London

ISRAEL
National Bezalel Museum, Jerusalem
Dimona Museum

ITALY
Galleria d'Arte Moderna, Museo Civico, Turin

LUXEMBURG
Musée d'Etat, Luxemburg

NETHERLANDS
Stedelijk Museum, Amsterdam
Boymans-van Beuningen Museum, Rotterdam

NORWAY
Sonia Henie and Niels Onstads Foundation, Oslo

PORTUGAL
Calouste Gulbenkian Foundation, Lisbon
Museu de Caramulo
Museum of Contemporary Art, Lisbon

SWEDEN
Arkiv för Dekorativ Konst, Lund

SWITZERLAND
Museum of Fine Arts, Zürich
Kunstmuseum, Basel
Musée Cantonal des Beaux-Arts, Lausanne

UNITED STATES
Museum of Modern Art, New York
Metropolitan Museum, New York
Solomon R. Guggenheim Museum, New York
Barnes Foundation, Merion, Pa.
Museum of Art, Carnegie Institute, Pittsburgh
Toledo Museum of Art
San Francisco Museum of Art
The Phillips Collection, Washington, D. C.
Philadelphia Museum of Art
Vassar College Art Gallery, Poughkeepsie, N. Y.
University of Michigan Museum of Art, Ann Arbor
Walker Art Center, Minneapolis
Hirshhorn Museum Sculpture Garden, Smithsonian Institute, Washington,
D. C.
Cincinnati Art Museum

PHOTOGRAPHS

Documents and Portraits:

Marianne Adelmann: figs. 26, 27, 33, 117, 119.
Archivo Mas: fig. 96.
Bibliothèque Nationale: figs. 68, 69, 72.
F. Catalá Roca: figs. 43, 45, 49, 95.
Patrice Clément: fig. 114.
Denise Colomb: figs. 20, 25, 64, 65, 91, 92, 103.
Dumont-Babinot: figs. 355, 357, 358, 359.
Robert Hausser: figs. 13, 15, 18.
Pierre Joly - Véra Cardot: figs. 115, 116, 118, 122, 124.
Luc Joubert: figs. 44, 47, 48, 83, 86, 90, 120.
Studio Maywald: fig. 105.
Claude Michaelides: fig. 63.
G. Pozzo di Borgo: fig. 50.
Ruy Santos and Scliar: figs. 75, 78, 79, 80.
Michel Weelen: fig. 102.
Kurt Wyss: fig. 237.
Ursa Zangger: figs. 5, 6, 7, 30, 31, 38, 39, 46, 93, 101, 102, 104, 106, 107,
 108, 109, 110, 111, 112, 113, 121, 123.

Photographic credit: Atlas Photo:

Atlas Photo: figs. 28, 37, 42, 94, 98, 99.
Pierre Bérenger: fig. 51.
Biaugeaud: fig. 41.
F. Brandier: fig. 4.
Jean-Marie Bresson: fig. 100.
Denise Colomb: fig. 97.
Michel Chapuis: Figs. 85, 87.
Yves Guillemaut: fig. 2.
Charles Lénars: fig. 82.
François Merlet: fig. 81.
Jean-Louis Moore: fig. 60.
Roger Perrin: fig. 59.
Robert Petit: fig. 94.
Verroust: fig. 52.
Etienne Weill: fig. 56.

Photographic credit: H. Roger-Viollet:

H. Roger-Viollet: figs. 1, 3, 9, 10, 11, 12, 14, 17, 19, 29, 35, 36, 40, 55, 57,
 61, 69, 70, 71, 74, 84, 88, 89.
Boyer: fig. 58.

The photographs and ektachromes of the works are by:

Rogi André, F. Catalá Roca, Dumont-Babinot, Carlfred Habach, Jacqueline Hyde, André Held/Ziolo Nᵒˢ 156, 159, 271, Claude O'Sughure, R. Rémy, Studio Dulière, Studio Lala, Studio Littré, Eileen Tweedy, Kazys Vosylius, Kurt Wyss.

Printed in Spain by La Poligrafa, S. A. - Balmes, 54 - Barcelona-7 - Spain - Dep. Legal: B - 24.007 - 1979